THE GILDED AGE IN NEW YORK, 1870–1910

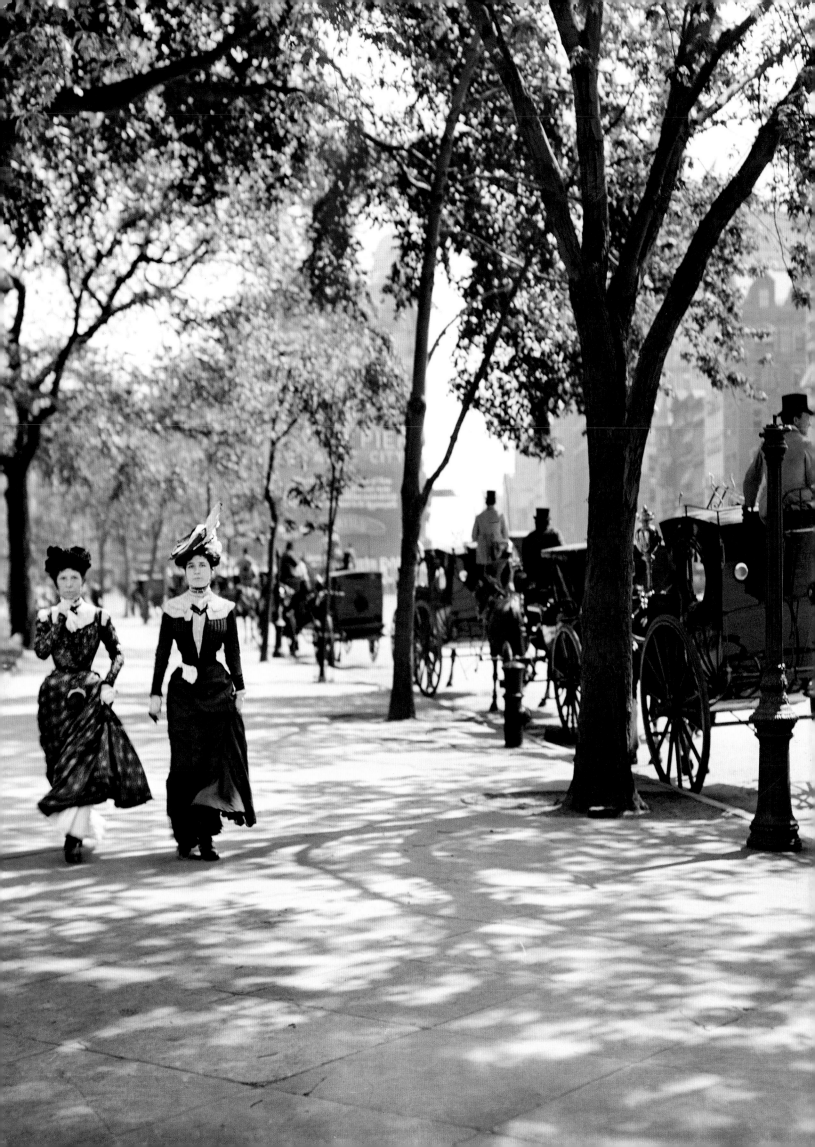

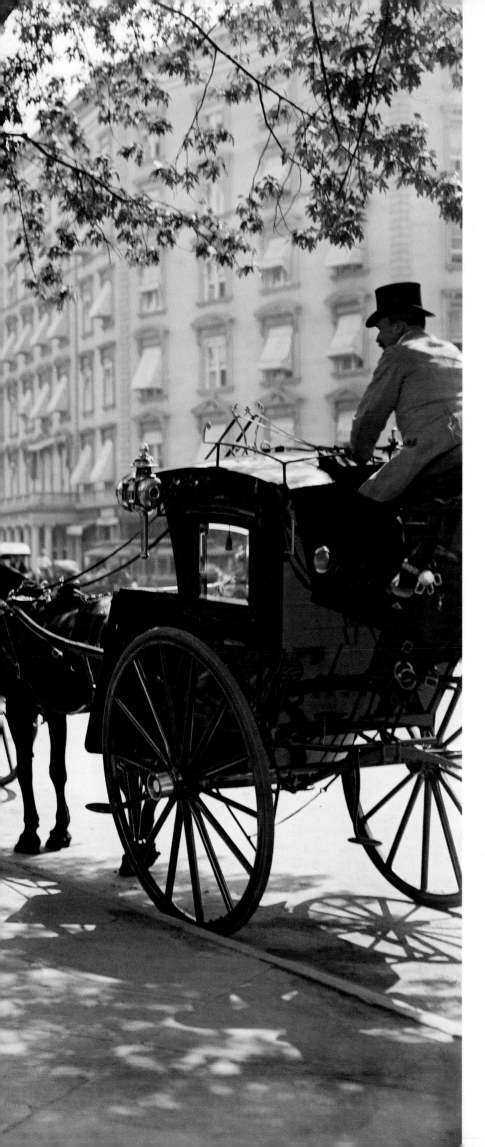

The Gilded Age in New York

1870–1910

ESTHER CRAIN

BLACK DOG
& LEVENTHAL
PUBLISHERS
NEW YORK

To my beloved father.

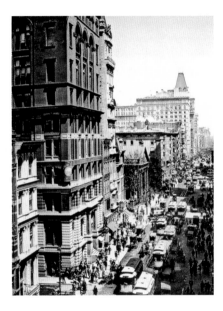

Black Dog & Leventhal Publishers
Hachette Book Group
1290 Avenue of the Americas
New York, NY 10104
www.hachettebookgroup.com
www.blackdogandleventhal.com

First Edition: October 2016

Black Dog & Leventhal Publishers is an imprint of Hachette Books, a division of Hachette Book Group.

The Hachette Speakers Bureau provides a wide range of authors for speaking events.
To find out more, go to www.HachetteSpeakersBureau.com or call (866) 376-6591.

Picture credits are on page 297.

Print book interior design by Liz Driesbach
LCCN: 2016939623
ISBNs: 978-0-316-35366-3 (hardcover), 978-0-316-35368-7 (ebook)
Printed in China
IM
10 9 8 7 6 5 4 3 2 1

Contents

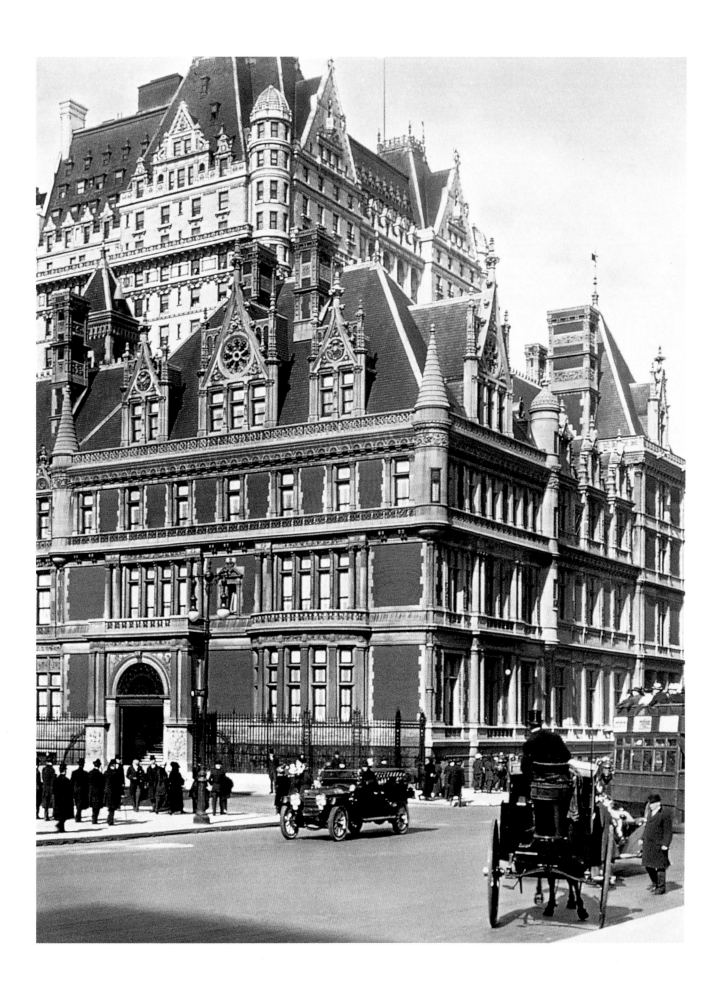

Introduction

In 1866, New York's population of just over 800,000 was concentrated below 23rd Street. Residents traversed cobblestone roads by horsecar and illuminated their homes with candles and gas lamps. The tallest structure of what could barely be called a skyline was Trinity Church's 281-foot spire on lower Broadway. For entertainment, New Yorkers paid twenty-five cents to gaze at the oddities in Barnum's Museum near City Hall, or they took in one of the musical comedies in the Theater District on Broadway near Union Square. To reach the new Central Park from downtown required a lengthy carriage ride up a bumpy Fifth Avenue past open fields; crossing the East River to the city of Brooklyn meant boarding a ferry.

By 1900, the Empire City had become the Imperial City. New arrivals poured in from across the world and helped push the population to 3.4 million. Wealth generated by Wall Street and industrial labor fueled a housing boom of opulent Fifth Avenue mansions, gable-roof apartment flats, and rows of shabby tenements. Electric streetlights bathed nighttime sidewalks in a brilliant glow, especially along the new uptown Theater District approaching 42nd Street. Steel-frame office towers rose twenty stories and skimmed the heavens. Threading the metropolis were elevated train tracks, asphalt avenues, and a graceful bridge webbed with steel cables. Trains and cable cars carried the growing middle class from new residential enclaves uptown, in Harlem, and in Brooklyn to their jobs downtown and on Sunday outings to Coney Island. At the cusp of the twentieth century, New York was bursting with beauty, power, and possibilities.

The most common observation about New York is that it never stops evolving. Yet it's hard to imagine an era in Gotham's history more transformative than the Gilded Age, roughly between the end of the Civil War and 1910. While much of the fractured nation was regrouping, New York was already on the rise, fueled by fortunes made from wartime financing and manufacturing. For the next three decades, the confident city, with its "pull-down-and-build-over-again spirit," as Walt Whitman called it, marched northward, extended skyward, and then increased its size sixfold by annexing the cities and villages that shared its harbor. New York in this exhilarating era became a hub of invention and ingenuity, pioneering telephone service, artificial light, mass transit, ambulances, and moving pictures. Social activism found momentum here, too. Movements for labor rights, children's welfare, private and public benevolence for the struggling, and for the suffrage and independence of women set the stage for the city of the twentieth century to be one of progressive ideals.

The Gilded Age in New York attempts to capture what it was like to live in Gotham then, to be a daily witness to the city's rapid evolution. Newspapers, autobiographies, and personal diaries offer fascinating glimpses into daily life among the rich, the poor, and the surprisingly large middle class. The use of photography and illustrated periodicals provides astonishing images through which we can see and comprehend the era. Some document the bigness of New York: the construction of the

The Cornelius Vanderbilt mansion, a 130-room Renaissance-style chateau on Fifth Avenue and 57th Street, epitomized Gilded Age glamour and extravagance.

Statue of Liberty, the opening of the Brooklyn Bridge, the mansions of Millionaire's Row. Others reveal small, fleeting moments: Alice Vanderbilt posing proudly in her "Electric Light" ball gown at the masquerade ball that shifted the hierarchy of society; city residents enjoying carriage rides and promenades in the lungs of the city, Central Park; a line of desperate men waiting for free coffee at the Bowery Mission, one of a growing number of mission houses that catered to New York's lost and unwanted.

Many today remain fascinated by the Gilded Age. Perhaps it's the contradictions and extremes of the era that draw us in. White marble mansions modeled after Italian palazzos lined Fifth Avenue just a streetcar ride away from the airless flats and rookeries of the East Side slums. Upstate water piped into the receiving reservoir in Central Park offered New York households fresh running water, yet it wasn't until 1901 that tenements were required to have bathrooms in each apartment. While children of the well-to-do danced around maypoles in Central Park, the children of the struggling classes sewed shirts and made artificial flowers in factories. Votes were purchased, prostitution was out in the open, and despite the wealth and glamour of Caroline Astor's fabled Four Hundred, two brutal recessions made the Gilded Age one of bracing hardship for thousands, rather than a time of frivolous balls and dinners at Delmonico's.

If there is one place in today's city that best evokes ghosts of the Gilded Age, it would be the intersection of Broadway and Fifth Avenue at 23rd Street. Here is Madison Square, in the 1860s and 1870s the center of the most fashionable neighborhood. The Theater District was centered on 23rd Street, hotels and private clubs for the prosperous lined Fifth Avenue, and Broadway was the northern end of the Ladies' Mile shopping district. The first row of electric streetlights in the city lit the night sky here in 1880. And on a wedge-shaped plot across Madison Square, a magnificent skyscraper rose. What became known as the Flatiron Building transfixed crowds that gathered outside the Fifth Avenue Hotel and watched as it climbed into the clouds in 1902. "[It] appeared to be moving toward me like the bow of a monster steamer—a picture of a new America still in the making," said photographer Alfred Stieglitz, one of many artists who found wonder and enchantment in the Flatiron.

Walk along the intersection of these three streets, or in any part of the city, really, and the phantoms of the Gilded Age start to appear. The flat-roofed tenements with their rickety fire escapes; the five-cent lodging houses where homeless working kids could grab a bed and a meal; the boats that plied the East River, taking the poor, sick, and insane to public hospitals and asylums on Blackwell's Island. The elegant mansions, the police roundsman with his nightstick, the festive German beer gardens, the women of Ladies' Mile in their crisp shirtwaists and ostrich feather hats handing packages to their drivers before heading back uptown. Underneath the facade of the modern city, the ghosts of the Gilded Age dwell.

The Dawning of the Gilded Age

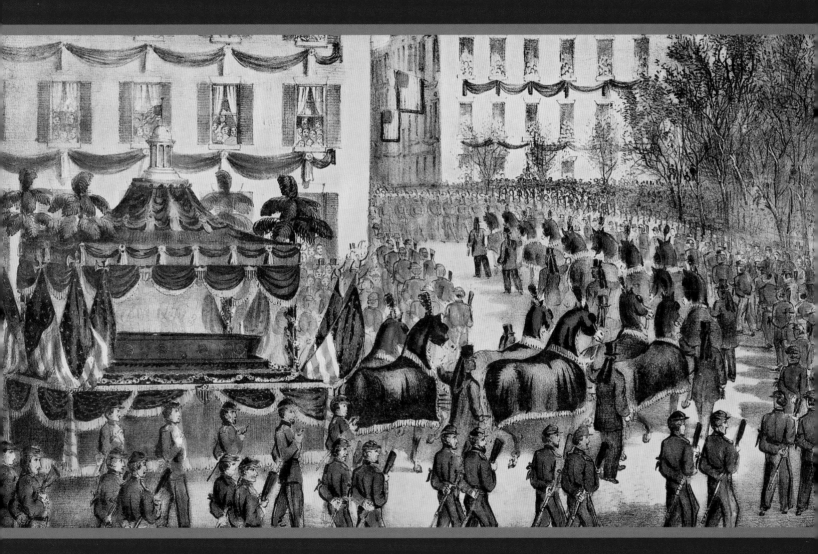

"Lincoln's death—thousands of flags at half mast—& on numbers of them long black pennants—from the shipping densely crowding the docks, the same—numerous ferry boats constantly plying across the river, the same solemn signal—black—business public & private all suspended, & the shops closed—strange mixture of horror, fury, tenderness, & a stirring wonder brewing."
—Walt Whitman, 1865

Mourning in the Metropolis

The wood and silver casket containing the body of Abraham Lincoln arrived by ferry at the Desbrosses Street wharf on April 24, 1865. Under bright, balmy morning skies, crowds of solemn onlookers watched as soldiers carefully placed the casket onto an American flag–draped hearse.

Accompanied by a cortege of politicians, military officers, and representatives of civic groups, the hearse began wending its way east, pulled by six gray horses cloaked in black cloth. "The procession moved along Desbrosses Street to Hudson Street, along Hudson to Canal, through Canal to Broadway, and thence to City Hall Park," wrote the *New York Times* on April 11, 1915. "Everywhere dense masses of people lined the way, all of whom reverently bared their heads as the procession passed."

Inside City Hall, the open casket was set on a black platform at the top of a circular staircase over the rotunda. For the next twenty-four hours, the body of the slain president lay in state, as it had done in Philadelphia, Harrisburg, Baltimore, and Washington, D.C. At each stop made by his funeral train, throngs of mourners honored the martyred leader.

For most of his presidency, New Yorkers had been sharply divided along class and ethnic lines in their affection and loyalty toward Lincoln. Yet since April 15, when word of the president's death reached the city, their grief had become immense, deep, and palpable. After hearing the news that morning, Walt Whitman, an admirer of the sixteenth president's, later described walking past shuttered stores on Broadway that were covered in black. At noon, rain began. "Black clouds driving overhead. Lincoln's death—black, black, black—as you look toward the sky—long broad black like great serpents," he wrote.

The lawyer George Templeton Strong wrote in his diary a day later on April 16: "An Easter Sunday unlike any I have seen. . . . Nearly every building in Broadway and in all the side streets, as far as one could see, festooned lavishly with black and white muslin. Columns swathed in the same material. Rosettes pinned to window curtains. Flags at half-mast and tied up with crape. . . . Never was a public mourning more spontaneous and general . . ."

Eight days after Strong's diary entry, City Hall was awash in sorrow. "Thousands passed reverently before the remains throughout the day and night, and thousands more were turned away, unable to gain admittance," the *Times* stated. "'As night came on,'" wrote one who saw the spectacle, "'the scene grew more impressive. The heavy draping of the rotunda caused the light from the chandeliers to assume a sickly glare as it was reflected from the silver ornaments of the

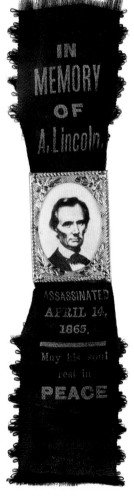

A silk mourning ribbon was worn by many to honor the Civil War president.

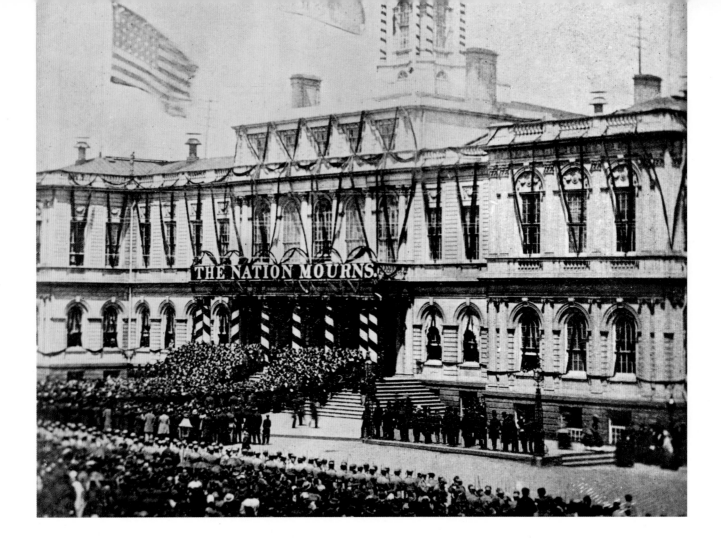

THE NATION MOURNS.

coffin and catafalque on the faces of the passing crowd.'"

One by one, an estimated 120,000 mourners paid their respects. "So short is the landing between the stairways that eight out of ten of the visitors, in their eagerness to catch an immediate glimpse, and their anxiety to maintain the look as long as practicable, forgot the step at the head of the downward flight and stumbled into the arms of the hard-worked policemen," wrote the *Times* on April 25.

By one o'clock the next day, the president's coffin was taken from City Hall and moved to a canopied funeral car. A second procession of approximately seventy-five thousand citizens passed key locations that connected Lincoln to the city. Just above City Hall, it approached the rough edges of the notorious Five Points slum, which Lincoln had visited as a presidential candidate and where he had become visibly distraught by

the destitute children he encountered. At Bleecker Street, it passed Mathew Brady's former portrait studio, where Lincoln had sat for the photo that introduced him to the nation. As the procession reached Waverly Place, it came within blocks of Cooper Union, where Lincoln had spoken in 1860 as a little-known Republican hopeful for president.

At Union Square, the northern end of New York's commercial heart, the procession stopped. Politicians honored Lincoln with speeches; clergymen offered prayers. A front-row view could be purchased, and crowds watched and listened from roofs and windows.

Late in the afternoon, the procession resumed, moving west to Fifth Avenue and ultimately to the train depot at Tenth Avenue and 30th Street. From there, the casket would go to Albany en route to burial in Illinois. After the train departed, the city was left to deal with its sorrow and await the return to normalcy.

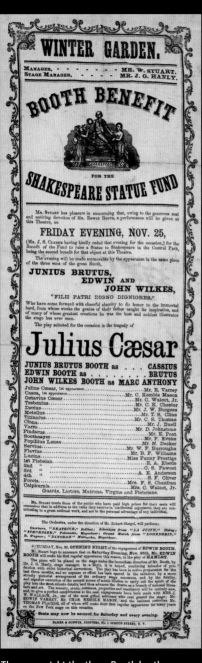

The same night the three Booth brothers appeared together in a benefit performance at the Winter Garden Theatre on Broadway at West 3rd Street, a group of Confederate conspirators launched a plot to burn down New York City by setting small fires in more than a dozen Manhattan hotels. The "diabolical plot," as the *New York Times* called it, was foiled before any real damage could be done.

It was supposed to happen on November 8, 1864—Election Day. A handful of Confederate conspirators meeting in Canada hatched a scheme to firebomb the city's major hotels. Their goal: to liberate Confederate prisoners, disrupt elections, and scare the nation into believing that the North's biggest city was still vulnerable to the South. They hoped to appeal to Copperheads and other Southern sympathizers, who might spark an uprising that could prolong the war, which was inching toward a Northern victory.

Luckily, city officials were tipped off on November 2, thanks to a telegram sent by Secretary of State William Seward. Thousands of Union soldiers were positioned around the city on the lookout for Rebel terrorism. When the conspirators arrived in New York and saw so many soldiers, they pushed the plot to later in the month.

They struck on November 25, the day after the fractured country's first official Thanksgiving. Between 8 P.M. and midnight, the conspirators set room fires in thirteen posh Manhattan hotels.

Among them were the Fifth Avenue Hotel, at Madison Square; the St. Nicholas, on Broadway at 11th Street; and the St. James, on Broadway at 25th Street. Barges along the North [Hudson] River also went up in flames. A blaze was reported at Barnum's Museum on Lower Broadway.

John Wilkes Booth happened to be in New York City that night, too. He and his two actor brothers, Edwin and Junius, were performing together for the first time, putting on *Julius Caesar* at the Winter Garden Theatre, which was adjacent to the Lafarge Hotel on Broadway and West 3rd Street.

The Lafarge was a target of the conspirators, and in the middle of Act II, fire bells began clanking. The audience of two thousand grew alarmed, unaware of the mayhem unfolding outside. "When the alarm of fire was given at the Lafarge the excitement became very intense among the closely packed mass of human beings in Winter Garden Theatre adjoining the Lafarge, and but for the presence of mind of Mr. Booth, who addressed them from the stage of the

theatre, telling them there was no danger, it is fearful to think what would have been the result," wrote the *New York Times* on November 27.

None of the fires caused serious damage or injuries, in part because city officials had maintained vigilance in case saboteurs really did try to pull off a "diabolical plot to burn the City of New York," as the *New York Times* called it on November 27, 1861. "Had all these hotels, hay barges, theatres, & co., been set on fire at the same moment, and each fire well kindled, the Fire Department would not have been strong enough to extinguish them all, and during the confusion the fire would probably have gained so great a headway that before assistance could have been obtained, the best portion of the city would have been laid in ashes," wrote the *Times*. "But fortunately, thanks to the Police, Fire Department, and the bungling manner in which the plan was executed by the conspirators, it proved a complete and miserable failure." The entire city, including Copperheads and others who sided with the South, reacted in horror.

Realizing their plan was a bust, the conspirators fled to Canada.

All ultimately escaped, but Captain Robert C. Kennedy of the Confederate Army was later captured trying to reenter the United States. Brought back to New York, he was tried at Fort Lafayette, two hundred yards of Brooklyn in New York Harbor. Kennedy was found guilty, and he was hanged at the fort's gallows on March 25, 1865—the last Rebel soldier of the war to be executed by Union forces.

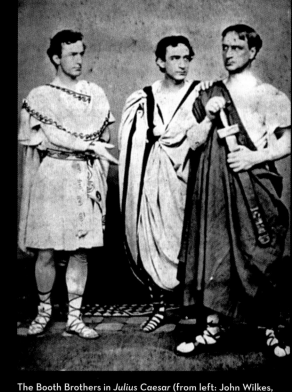

The Booth Brothers in *Julius Caesar* (from left: John Wilkes, Edwin, and Junius). A small fire in an adjoining hotel interrupted their performance at the Winter Garden Theatre in November 1864—set by Rebel conspirators trying to spark an uprising of Southern support in the metropolis.

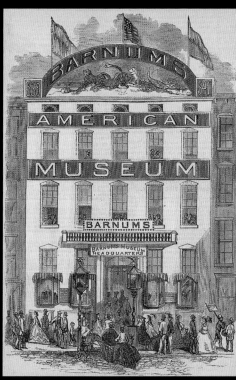

The day after a group of Southern saboteurs set fire to hotels, theaters, and P. T. Barnum's fabled museum at Broadway and Ann Streets, Barnum sent a letter to the *New York Times* in which he assured the public of his museum's readiness for any fire, calling it "as safe a place of amusement as can be found in the world." The building burned down accidentally less than a year later.

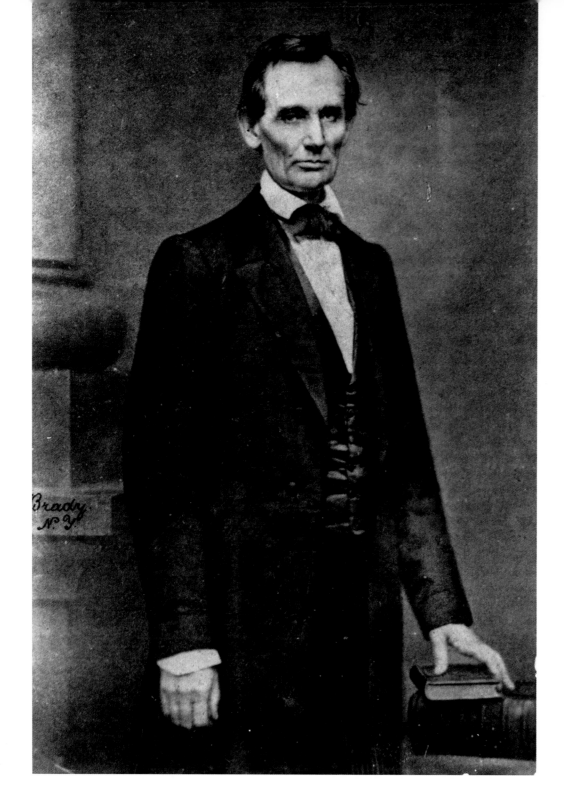

Abraham Lincoln, taken February 27, 1860: Hours before wowing New Yorkers with his historic speech at Cooper Union in February 1860, Lincoln stopped by the portrait studio of Mathew Brady at Broadway and Bleecker Street. There, Brady took the photo that helped transform the Republican presidential hopeful from political unknown to national leader.

The Rebellion in the South

L incoln's funeral procession ended the Civil War in New York City the same way it started: in a rare moment of unity. As the 1860s began, New York was a tense, fractured metropolis. Economic expansion in the 1840s and 1850s, fueled by huge waves of cheap labor in the form of German and Irish immigrants, made the Empire City the nation's capital of commerce and industry. About eight hundred

A Young Theodore Roosevelt Watches Lincoln's Funeral Procession

As the procession moved up Broadway and approached Union Square, it passed the mansion of Cornelius van Schaack Roosevelt, a wealthy exporter whose ancestors arrived from Holland in the seventeenth century. Roosevelt had invited his grandsons Theodore and Elliott (the father of Eleanor Roosevelt) to view the cortege. They're believed to be the two small figures in the window.

Four-year-old Edith Carow, Theodore's childhood playmate and future wife, was also at the

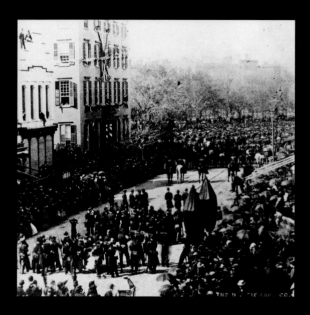

mansion. "Yes, I think that is my husband, and next to him his brother," Edith told historian Stefan Lorant. "I was a little girl then and my governess took me to Grandfather Roosevelt's house on Broadway so I could watch the funeral procession. But as I looked down from the window and saw all the black drapings I became frightened and started to cry. Theodore and Elliott were both there. They didn't like my crying. They took me and locked me in a back room. I never did see Lincoln's funeral."

thousand people called Manhattan home. Omnibuses ferried residents to and from new brick and brownstone neighborhoods past Union and Madison Squares to the commercial districts that fanned out from Lower Broadway.

Then the Panic of 1857 ushered in the worst economic downturn in a generation. Factories and businesses closed; thousands were out of work. Recovery had arrived by 1860, yet city officials feared that Southern secession would cripple New York's economy. Cotton was America's leading export. Though it grew in the soil of Southern states, city insurers, brokers, and cargo companies financed and shipped millions of dollars' worth to European textile-mill cities such as Manchester, England. Southern businessmen also regularly visited the metropolis, filling the coffers of hotels, restaurants, and fine-goods shops.

The South and New York City each made a fortune off the international cotton trade. If that collusive relationship fell apart, New Orleans publisher James Dunmore De Bow predicted, "The ships would rot at

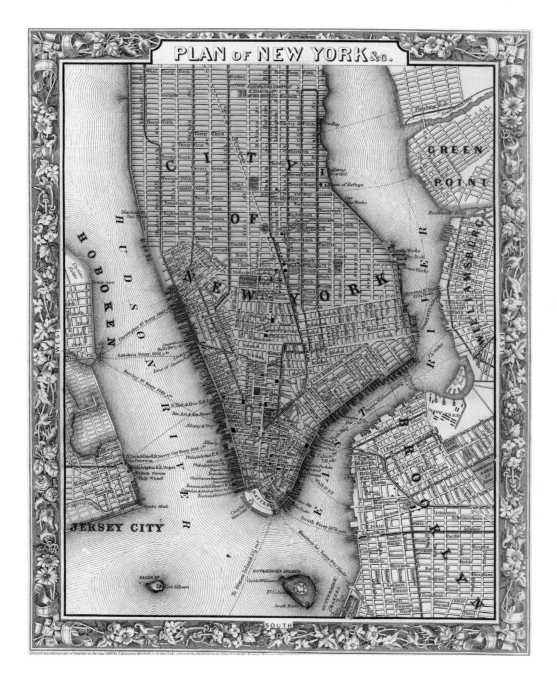

PLAN OF NEW YORK &c.

New York City in 1860 was a bustling metropolis of capital and commerce on the rise again after a recession hit in 1857. Streetcar and ferry lines fed into downtown Manhattan, the center of business and government.

her docks; grass would grow in Wall Street and Broadway, and the glory of New York, like that of Babylon and Rome, would be numbered with the things of the past."

On the eve of the 1860 presidential election, abolitionists and conservative Protestants supported the antislavery Republicans. The merchant class and working class, joined by poor immigrants and the city's political establishment, sided with the proslavery Democrats. On Election Day, city residents delivered almost twice as many ballots to Lincoln's opponents as to Lincoln. But the state gave its electoral votes to Lincoln.

As South Carolina became the first state to leave the Union in December 1860, Mayor Fernando Wood—elected on a pro-Southern platform in 1859—made a last-ditch effort to maintain trade with the South by proposing that the city secede and

form its own country. "Amid the gloom which the present and prospective condition of things must cast over the country, New York, as a *Free City,* may shed the only light and hope of a future reconstruction of our once blessed Confederacy," he told the Common Council (the city's governing body) on January 7, 1861. Wood's cronies on the council loved the idea.

Four months later, however, all sympathy for the South evaporated. On April 12, the Confederate bombing of Fort Sumter launched the Civil War. City residents united behind Lincoln's fight to preserve the Union. "President Lincoln's proclamation calling for seventy-five thousand men in order to suppress the Rebellion at the South, and to cause the laws to be duly executed, waked up the people to a realizing sense of their duty, as well as of the danger impending over them," wrote the *New-York Tribune* on April 16, 1861. "Knots and groups of men have been seen during the day standing in front of prominent buildings on Broadway and other public thoroughfares, discussing the call for men, and among them all but one sentiment appeared to prevail, and that was to 'fight in support of the American flag, and in defense of the American Union.'"

Thousands of New Yorkers signed up for the military, including fifty thousand Irish immigrants, who vied to be part of the famous Sixty-Ninth New York Regiment ("gentle when stroked, fierce when provoked" was their motto). Many of the Irish hoped that putting their lives on the line for their country would earn them the respect and dignity they had yet to secure in the city. Tens of thousands of German immigrants also volunteered for military duty, as did two thousand African Americans. In total, nearly 150,000 New York City residents would fight for the Union over the next four years.

Citywide support for the North hit its peak on April 20. An estimated quarter of a million residents gathered in what came to be known as the Great Sumter Rally in Union Square. "The excitement that prevailed is altogether unparalleled," wrote the *New York Herald* on April 21, 1861, noting the streamers that fluttered from windows, rooftops, and steeples. A giant American flag from Fort Sumter had been draped over a statue of George Washington. "Of the five stands erected for the accommodation of the public, and more especially of the orators of the occasion, each one was filled to overflowing, and the living cordon that surrounded them was packed as closely as human beings could exist amassed together."

George Templeton Strong observed the rally. In his diary that day, he wrote: "The Union mass-meeting was an event. . . . The crowd, or some of them, and the ladies and gentlemen who occupied the windows and lined the housetops all round Union Square, sang 'The Star-Spangled Banner,' and the people generally hurrahed a voluntary after each verse."

Before the bombardment of Fort Sumter launched the Civil War in April 1861, Mayor Fernando Wood, New York's Confederacy-sympathizing mayor, proposed a fantastical idea: that New York become an independent nation so trade with the South wouldn't be interrupted by war. The bombardment of Fort Sumter ended his plan.

A City Embraces "War Fever"

The giddy patriotism that seized the city continued through the spring and summer of 1861. The Stars and Stripes waved from tenement windows, store rooftops, men's hats and lapels, and even wagons, stagecoaches, and ship masts. Recruitment offices popped up block by block, and broadsides tacked to poles and fence posts urged young men to enlist.

"Respond to your country's call," one poster, for Company I in Brooklyn, beckoned, advertising $23 pay per month. Another, for the New York State Light Artillery, lured men with a promise of easy work—echoing the prevailing wisdom at the time that it would take mere weeks for the Union to crush the South. (Even Secretary of State William Seward was predicting that victory would take sixty days.) "No musket drill! No trenches to dig!" the poster read, directing potential enlistees to a recruiting station on Hudson Street.

Men in military regalia occupied city streets, saloons, and parks, as they trained and waited for orders to head south. Tent cities and barracks to house them sprang up in City Hall Park, the Battery, even newly opened yet still unfinished Central Park. Troops on their way to war would march up Broadway, to the cheers of thousands. "The aspect of Broadway was very gay indeed," reported the *New York Times* on April 20. "Minus the firing of pistols and the explosion of Chinese crackers,

Recruitment station posters advertising hefty cash bonuses helped convince thousands of men to enlist in the military, but more were needed—and in 1863, the nation instituted its first wartime draft.

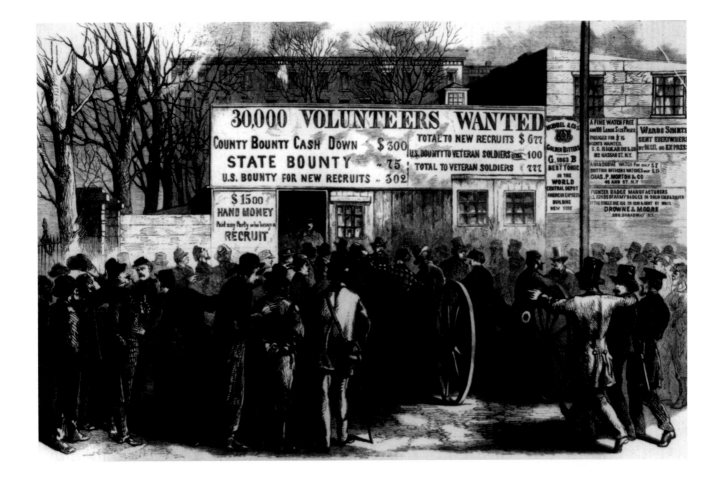

"Remember Ellsworth!"

The bombardment at Fort Sumter in April 1861 enraged Northerners and inspired thousands of city men to enlist in the military. But it wasn't until soldier Elmer Ellsworth was shot and killed by a Virginia innkeeper the following month that the city really threw its weight behind the Union.

Born in upstate New York, Ellsworth attended law school in Chicago and then clerked for a Springfield, Illinois, attorney named Abraham Lincoln. Lincoln took a shine to his bright clerk, and brought Ellsworth to Washington with him to assist in his candidacy for president. After Fort Sumter launched the Civil War and Lincoln called for 75,000 enlistees, Ellsworth went to New York to organize the 11th New York voluntary infantry regiment.

The company, made up of recruits from the city's volunteer fire departments, was a Zouave regiment. Dressed in exotic uniforms reminiscent of their namesakes, the Zouaves of the French army, they attracted attention with their signature drill formations and vivid colors.

Though he prepared for combat, Ellsworth didn't get his chance to defend the Union. After arriving in Washington, D.C., with his and other regiments on May 25, 1861, he saw a Confederate flag on top of an inn across the Potomac in Alexandria, Virginia. He went to remove it—but the innkeeper shot Ellsworth at point-blank range, killing him instantly.

His death was front-page news in New York, and it left President Lincoln grief-stricken. "So much of promised usefulness to one's country, and of bright hopes for one's self and friends, have rarely been so suddenly darkened as in his fall," the president wrote in a letter to Ellsworth's parents.

Lincoln ordered Ellsworth's casket to lie in state in the White House. From there, it went to New York, where it lay in City Hall. Nearly ten thousand city residents paid their respects to Ellsworth, the first soldier to die for the Union, and ironically, a confidant of one of the last men to lose his life to the Civil War, the martyred president.

"The feeling throughout the city yesterday was very great," wrote the *Sun* on June 1. "Men in passing the corpse in the Governor's room, clenched their hand and muttered between set teeth 'Revenge,' and women shed tears. At several places downtown were exposed pictures of Zouaves with the inscriptions, 'Revenge,' 'Remember Ellsworth.'"

Colonel Elmer Ellsworth, a young associate of President Lincoln's, was one of the first soldiers from a New York City unit killed after war broke out. The battle cry "Remember Ellsworth!" helped solidify city support for the Union.

it was many Fourth-of-Julys rolled into one. . . . Evidently, all political partisanship was [cast] aside." New Yorkers heeded the call to war so enthusiastically that almost half of the sixteen thousand troops sent to protect Washington, D.C., in those early weeks came from Manhattan and Brooklyn.

While men rushed to battle, women in New York gathered to serve as well. Within a week of Lincoln's call for volunteer troops, prominent women such as Mrs. William Cullen Bryant and Mrs. Peter Cooper organized the Women's Central Relief Association during a meeting at Cooper Union. At churches and private homes, they sewed bandages and other war necessities. Elizabeth Blackwell, one of the few female doctors in New York and a committed abolitionist, set up a nursing program at Bellevue Hospital to train women to become voluntary nurses at Union hospitals.

Nursing was one of the few vocations open to middle- and upper-class women who wanted to directly contribute to the war effort. The first meeting of trainees was "crowded with ladies," wrote Blackwell in her autobiography. At a second meeting held at Cooper Union, "the Ladies' Sanitary Aid Association, of which we were active members, was also formed," Blackwell wrote. "It received and forwarded contributions of comforts to soldiers, zealously sent from the country; but its special work was the forwarding of nurses to the seat of war." Both the Ladies Sanitary Aid Association and the Women's Central Relief Association worked with the United States Sanitary Committee, a civilian relief agency created by federal

Off the battlefields, women played a key role in the Civil War: They raised money for supplies, sewed bandages, trained nurses to work in military hospitals, and visited with injured and sick soldiers who were far from their families.

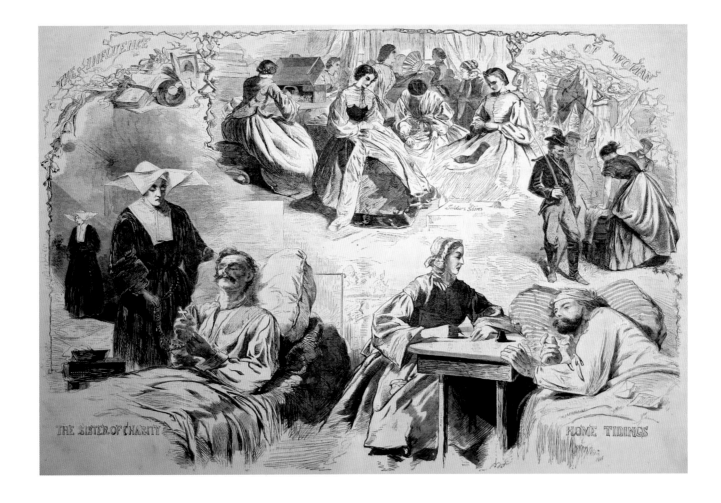

Brooklyn's Little Drummer Boy

The Civil War has been dubbed "the boys' war" because so many boys enlisted in the military. It's estimated that up to 20 percent of soldiers on both the Union and Confederate sides were under eighteen years old. With able-bodied males needed for battle, the youngest enlistees served not as fighters but as fifers, buglers, and most importantly, drummers. Drummer boys played a crucial role: On the battlefield, they had to quickly translate officers' orders into different drum rolls, so soldiers knew what was going on amid the chaos and confusion.

One Union drummer boy was Clarence D. McKenzie. Just

eleven years old when he joined Brooklyn's 13th Regiment in July 1860, Clarence received orders to ship out to Annapolis in April 1861, not long after the attack on Fort Sumter. He left his childhood home at 23 Liberty Street and boarded a Maryland-bound steamer with his regiment. For the next two months, he sent letters to his parents back in Brooklyn, assuring them that he was doing well. "Please, dear mother, send me on another cake," he wrote on May 26. "The boys took it all from me—that is a dear good mother. Your Clarry."

He never made it to the battlefield. On June 11, Clarence was accidentally shot and killed by a fellow soldier who was discharging his musket. "No blame can be attached to the man who shot him individually, as he was perfectly ignorant of the piece being loaded," the

Brooklyn Daily Eagle reported on June 13.

Clarence was the first enlistee from Brooklyn to die in the Civil War. His body was brought back to the city by members of his regiment, including his older brother, also a drummer boy. A funeral service held days later was packed with school friends and family members. "The funeral cortege set out from the residence of the deceased's parents, in Liberty Street, between three and four o'clock, and proceeded down Concord Street to St John's Church, where the coffin was removed from the hearse and reverentially laid down in front of the pulpit," reported the *Eagle* two days later, on June 15.

Thousands of mourners, who had read the story in New York papers, lined the streets in tribute. Clarence was buried in Green-Wood cemetery, the final resting place of more than five thousand Civil War soldiers. Sometime later, his grave was relocated to the Soldier's Lot section of the cemetery. In 1886, a monument was erected at the gravesite by survivors of his regiment. It depicts a uniformed boy with a drum strapped around his neck that reads "Our Drummer Boy."

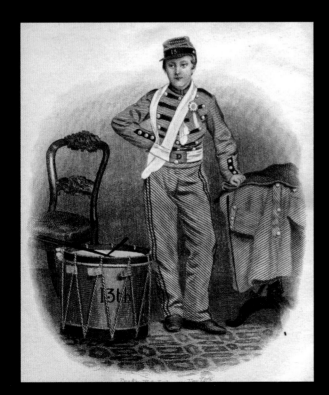

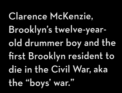

Clarence McKenzie, Brooklyn's twelve-year-old drummer boy and the first Brooklyn resident to die in the Civil War, aka the "boys' war."

legislation in June 1861. Founding members George Templeton Strong and Frederick Law Olmsted guided the organization to help get medical and other supplies to battlefields and to aid families left behind.

The first war of the industrial age didn't just unite the city in patriotic fervor, it also jolted New York's finances. After the South severed trade, the metropolis experienced a brief economic standstill. But war quickly stoked the manufacturing sector again. The army needed food, clothing, engines, tents, warships, artillery, and other items, and city factories happily took on military contracts. With production ramped up, jobs for laborers were generally easier to find.

Of course, not all workers benefited. Many employers skimped on wages, and makers of clothes, shoes, and other gear sometimes skimped on quality as well, sending the army cheap "shoddy" items, as they were dubbed, and making off with the money. But from a financial standpoint, Civil War production rejuvenated New York, with four thousand factories employing ninety thousand workers selling millions of dollars in goods and services.

Struggles Mount, and New York Simmers

In January 1863, Walt Whitman left New York and began volunteering as a military hospital nurse in Washington, D.C. A longtime contributor and former editor to the *Brooklyn Daily Eagle,* he began publishing dispatches that revealed the terrible toll war had taken on the young men sent to combat.

In a piece titled "Our Brooklyn Boys in the War," Whitman wrote: "I must devote one short paragraph to a young son of Brooklyn, Charles Parker, Co. E, shot at Fredericksburg, on the advance. (I think I heard that his father and folks lived in Main street.) Poor Charley Parker! Every one in the regiment spoke so highly of him. He was a true soldier and fell in the front ranks. He died hard, suffered much, frothed at the mouth. When our men went to bury our dead they found this young hero's body entirely stripped by the Southerners. His grave is now there, on the battle-field, close by the Rappahannock."

As the Confederates racked up victories and Union casualties mounted, New York's initial enthusiasm began to wane. No longer under the illusion that this would be a quick and easy war, the unity that city residents had showed early on began to fray. In 1862, Copperheads—Democrats strongly opposed to war policy—became more vocal. Army enlistment numbers slipped. High inflation prevented poorer New Yorkers from buying food and heating their homes. From 1860 to 1863, rents went up by 15 to 20 percent; the price of beef, flour, and milk doubled; and coal jumped by at least a third.

Far from the battlefields, families were struggling. Losses at Bull Run, Harpers Ferry, and Fredericksburg created a class of war widows and orphans, with a large increase of

The city of Brooklyn con-tributed much to the Union cause: 30,000 sol-ers marched into battle; the Navy rd produced the first ironclad arship, the *Monitor*, which bol-ered Northern naval power; and sthand reporting by the *Brooklyn aily Eagle* offered a sober look at e bloodshed on the frontlines.

But one of Brooklyn's proud-t achievements was the money ised to provide medical aid and pplies to wounded soldiers. The m, $400,000, came from sales nd tickets for the city's Sanitary air, held in winter 1864. The fair as one of several staged in cities cross the country, largely orga-zed and run by women's charity lief groups.

The fairs took their name from e newly formed U.S. Sanitary ommission, a civilian charity eaded by Central Park co-esigner Frederick Law Olmsted. ith two out of every three Civil ar deaths the result of disease ther than combat, and little vernment relief for the families soldiers, the Sanitary Commis-on played a pivotal role in aiding ured enlistees and offering aid

The Brooklyn Sanitary Fair owed its great success to women—the mothers, sisters, aunts, and daugh-ters who organized this enormous bazaar spread across several build-ings on Montague Street, including the grand Brooklyn Academy of Music. The fair opened on February 22 and featured bands, plays, a ball, and other forms of entertainment, as well as auctions and sales of merchandise donated by local man-ufacturers (including a labor-saving new household invention, the Universal Clothes Wringer).

"The decorations of the Acad-emy were very beautiful, and their patriotic nature was in fine keep-ing with the character of the great enterprise," the Fair's sponsors wrote in 1864. "From the center of the Auditorium ceiling was suspended a mass of brilliantly colored bunting . . . above the arch of the stage, in letters formed by tiny jets of gas, blazed the inscrip-tion, 'In Union Is Strength.'"

By the fair's end on March 8, thousands of visitors had brought in $400,000 to be used toward supplies, food, and medical help for soldiers on the front lines. Some of the money also helped buy cloth-

Prominent women in Brooklyn organized the city's Sanitary Fair in early 1864, a three-week extravaganza that raised $400,000 toward food, clothes, and supplies for struggling Union soldiers and their families.

hit hard by the loss of a breadwin-ner. The final tally was double the amount predicted, and the most money raised by any fair in any city to that time. (The much bigger Sanitary Fair held in Manhattan a month later, however, broke that record with more than $1 million raised.) Brooklyn residents were rightly proud.

"This announcement was received with enthusiastic cheers, and waving of handkerchiefs from the galleries," wrote the *Brooklyn Daily Eagle* on March 9, after the total sum was read aloud. "Mr. Low [A. A. Low, donor and orga-nizer of the Sanitary Fair and father of future mayor Seth Low] con-gratulated the people of Brooklyn on this result, it would carry to our gallant soldiers the assurance that the hearts of the people are still

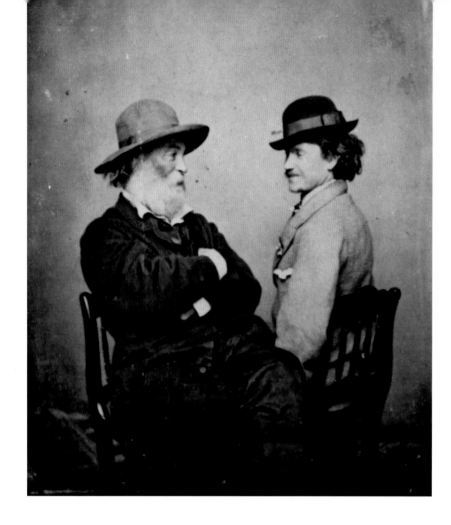

Poet and *Brooklyn Daily Eagle* correspondent Walt Whitman (with his companion, Peter Doyle) left New York in 1862 and spent the final two years of the war volunteering as a nurse in army hospitals, mostly in Washington, D.C. He wrote letters and articles for New York newspapers describing the men he helped care for. "This afternoon, July 22, 1863, I spent a long time with a young man I have been with considerable, named Oscar F. Wilder, Company G, One Hundred and Fifty-fourth New-York, low with chronic diarrhea, and a bad wound also," Whitman wrote in the *New York Times*. "He asked me to read him a chapter in the New Testament. . . . It pleased him very much, yet the tears were in his eyes. . . . He talked of death, and said he did not fear it. I said: 'Why, Oscar, don't you think you will get well?' He said: 'I may, but it is not probable.'"

children living on the streets. Cases of infanticide were also rising, as was the number of abandoned babies left on doorsteps and sidewalks. With the city's new foundling hospital converted to a military hospital during the war years, abandoned infants were typically brought to be cared for by poor women at the city almshouse on Blackwell's Island. Unsurprisingly, many did not survive.

To help families whose main breadwinner had gone to war, the Wood administration launched a relief program that gave money to wives as well as mothers whose sons had supported them. But the money came in fits and starts, forcing private charity to try to fill the gap. Desperate women staged protests. In December 1861, approximately two hundred voiced their anger at city officials during a rally in Tompkins Square. "You have got me men into the souldiers, and now you have to kepe us from starving," one mother put it.

Resentment for the wealthy was also growing. Invigorated by war contracts and a booming stock market, the rich were enjoying the good life, one of fancy carriages, dinners at Delmonico's, and gold chains and rings. The focal point of the "shoddy aristocracy," as they were dubbed, was the opening of A. T. Stewart's "Iron Palace" at Broadway and 9th Street, a five-story Venetian palazzo–inspired emporium that carried the latest luxury clothes and merchandise. While rich ladies shopped on the lower floors, eight hundred women toiled at sewing machines and dress forms on the upper floors, earning pennies to sew everything from ball gowns to military uniforms.

These displays of wealth struck many observers as inappropriate, if not obscene, during a time of war and sacrifice. It was an early hint of the great gap between the haves and have-nots, a gap that would soon become cavernous and would define the postwar Gilded Age.

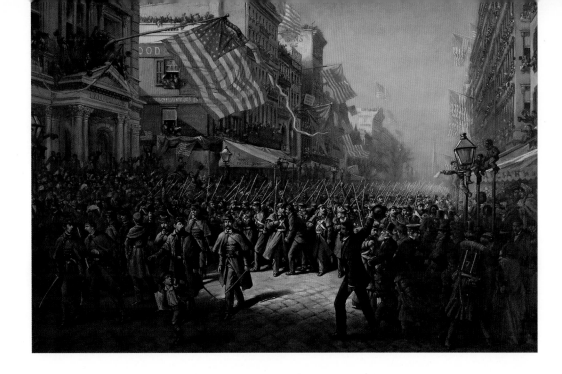

The 69th Regiment—a fearsome unit dominated by Irish immigrant volunteers and known as the Fighting Irish—was sent off to war with proud support from city residents in the poor Irish Catholic Five Points slum.

"*We don't feel the war!* is the exulting cry of the contractors, money-changers, and speculators, whose shouts of revel stifle the tearful voice of misery," stated an 1864 article in *Harper's New Monthly Magazine.* "While the national wealth has been poured out with a profuse generosity in behalf of a cause dear to the national heart, there have been immense fortunes made by enterprising money-getters, seeking only to fill their own pockets....No noble cause, such as we are struggling for, was ever won by men while besotting themselves with excess and dallying pleasure. We must feel this war, and feel it resolutely, or we shall never triumph."

While the rich were the object of antipathy, black New Yorkers were increasingly the target of resentment by Irish immigrants, who competed with them for jobs. In the 1860s, the Irish vastly outnumbered African Americans; approximately two hundred thousand New Yorkers were Irish—one-fourth of the entire city—while an estimated twelve thousand were black. Yet a Confederate defeat, many Irish feared, would bring thousands of freed Southern slaves to the city, where they would replace the Irish as laborers, longshoremen, domestics, seamstresses, drivers, and in other low-level positions.

Tensions between the two groups exploded in Brooklyn on August 4, 1862. On Sedgwick Street along the gritty South Brooklyn waterfront, packs of Irish workers rioted outside a tobacco factory that employed both whites and blacks. The African American workers were generally paid higher wages, according to the *Brooklyn Daily Eagle,* because they tended to have more experience, since many used to roll tobacco in the South. This upset the Irish, and just after 12 P.M., "a party of some 400 men and boys, some of them very much intoxicated, came rushing toward the factory from the neighborhood of Columbia and Harrison Streets and immediately surrounded the building," the *Eagle* reported on August 5.

As black workers barricaded the doors, the marauders used brickbats and stones to smash windows, then attempted to light the factory on fire. Only the presence of police stopped the riot, which made headlines in Manhattan. "The irrepressible Conflict in Brooklyn," the *Eagle* titled their article, calling the incident "one of the most disgraceful riots which has ever happened in this city." The Sedgwick Street riot would foreshadow an even more destructive one across the East River—a weeklong carnival of violence that altered New York forever.

Anger Leads to a Week of Destruction

The smoldering tensions in New York came to a head after the Emancipation Proclamation took effect on January 1, 1863, and the Conscription Act was enacted two months later in March. The latter ushered in the nation's first wartime draft and sent working-class and poor residents into a rage. One way to escape the draft was to pay $300—nearly a year's salary. Well-to-do New Yorkers could afford it. The typical immigrant? Not likely.

This fury resulted in the Draft Riots of 1863. On the morning of July 11, a Saturday, draft drawings began at the Provost Marshal's office on Third Avenue and 46th Street. The sweltering city remained quiet for two days. The following Monday, that peace was abruptly and violently shattered. By 10:00 A.M., groups of mostly Irish immigrant men assembled at the draft office and burned it to the ground. Emboldened by this destruction, they began rampaging: They

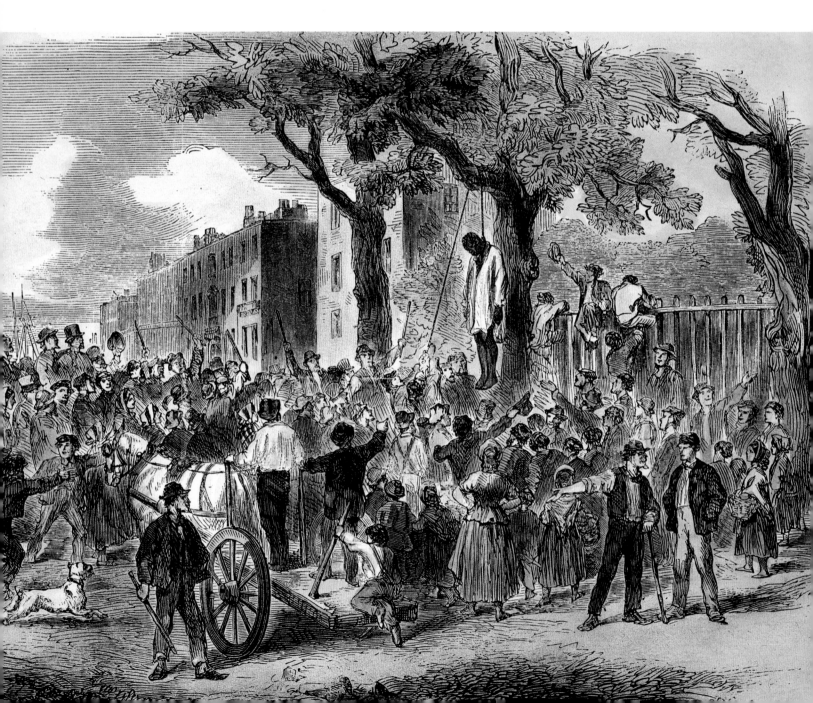

set fire to nearby buildings, cut telegraph lines, and tore up railroad tracks. The city police force, weakened because so many young men were away at war, was unable to control the growing mob.

Just past noon, a telegraph officer in New York sent this message to Secretary of War Edwin M. Stanton in Washington: "What is represented as a serious riot is now taking place on Third Avenue, at the provost-marshal's office. The office is said to have been burned, and the adjoining block to be on fire. Our wires in that direction have all been torn down. A report just in says the regulars from Governor's Island have been ordered to the vicinity." Two hours later, the same telegraph officer relayed this message: "The riot has assumed serious proportions, and is entirely beyond the control of the police. Superintendent [of Police] Kennedy is badly injured. So far the rioters have everything their own way. They are estimated at from 30,000 to 40,000. I am inclined to think from 2,000 to 3,000 are actually engaged. Appearances indicate an organized attempt to take advantage of the absence of military force."

The rioters continued their rampage all afternoon. They attacked the residence of pro-Lincoln mayor George Opdyke. Downtown near City Hall, they targeted the press offices of Newspaper Row. Shops were looted; a rifle factory was pillaged. William Steinway, a prominent German immigrant and cofounder with his father and brothers of the Steinway & Sons piano manufacturers, wrote in his diary about fending off a mob outside his Fourth Avenue factory. "Terrible excitement throughout the city, resistence to the draft," he wrote on July 13. "About 5 P.M. they appear before our factory. Charles [Steinway's brother and partner] speaks to them and with the aid of Rev. Father Mahon

they draw off towards Yorkville. . . . It was a terrible scene and we were of course all much exercised at the prospect of having the factory destroyed."

Rioters targeted the wealthy, Republicans, abolitionists, and most of all, African Americans. "The riot also took the form of a crusade against negroes, and wherever a colored man was observed, he was chased, stoned, and beaten," wrote the *New York World* on July 14. The Colored Orphan Asylum on Fifth Avenue and 43rd Street was set on fire; the children and staff miraculously escaped.

A black man walking to his home on Clarkson Street was chased and lynched. Black men were beaten, mutilated, and murdered simply for being in the wrong place at the wrong time. At 9:30 P.M., a third message was sent to Secretary Stanton: "The situation is not improved since dark. The programme is diversified by small mobs chasing isolated negroes as hounds would chase a fox. I mention this to indicate to you that the spirit of mob is loose, and all parts of the city pervaded . . . In brief, the city of New York is tonight at the mercy of a mob, whether organized or improvised, I am unable to say. As far as I can learn, the firemen and military companies sympathize too closely with the draft resistance movement to be relied upon for [the] extinguishment of fires or the restoration of order. It is to be hoped that tomorrow will open upon a brighter prospect than is promised tonight."

July 15 was another day of violence, wrote William Steinway. "Fighting on 2nd Ave near 21st street, the 7th and 71st Regiments arrive in the city . . . more fighting on 2d [sic] and 1st Aves. Stores broken into and plundered. Citizens organizing for defending private property, patrolling all night, burning of an

The body of William Jones hangs at Clarkson Street. "A crowd of rioters on Clarkson Street, in pursuit of a negro, who in self-defense had fired on some rowdies, met an inoffensive colored man returning from a bakery with a loaf of bread under his arm. They instantly set upon and beat him and, after nearly killing him, hung him to a lamppost. His body was left suspended for several hours. A fire was made underneath him, and he was literally roasted as he hung, the mob reveling in their demoniac act." —The Draft Riots in New York, July, 1863, The Metropolitan Police: Their Services During Riot Week.

he ongoing war created an endless need for supplies: clothes, tents, guns, belts, medicine, and other items were in constant demand by the military. New York's manufacturers seized this money-making opportunity. The National Arms Company, a Brooklyn-based gunmaker, pumped out weapons. Shipbuilders sprang up along the East River waterfront and in the Brooklyn Navy Yard, making wooden ships as well as the new ironclad vessels like the *Monitor*. The railroad business boomed. Just outside New York City, near the Croton Reservoir (one of the main sources of the city's water supply), Gail Borden's New York Condensed Milk Company distributed tens of thousands of cans of condensed milk to Union soldiers, who drank it on the battlefield and even in hospitals for its nutritional value.

Some of the iconic brands and businesses that are still headquartered in the city today made big bucks during the Civil War years. Brooks Brothers manufactured thousands of uniforms, and standardized sizing. The Singer Sewing Machine Company mass-produced the machines Brooks Brothers and other factories in the city's nascent garment district relied on. Tiffany & Co. made medals, swords, and surgical tools. In Brooklyn, the pharmaceutical companies that eventually became the corporate giants Squibb and Pfizer manufactured medicine and surgical supplies. American Express, headquartered downtown, shipped these and other goods to the frontlines—and they also shipped the corpses of fallen soldiers back home to their families for burial.

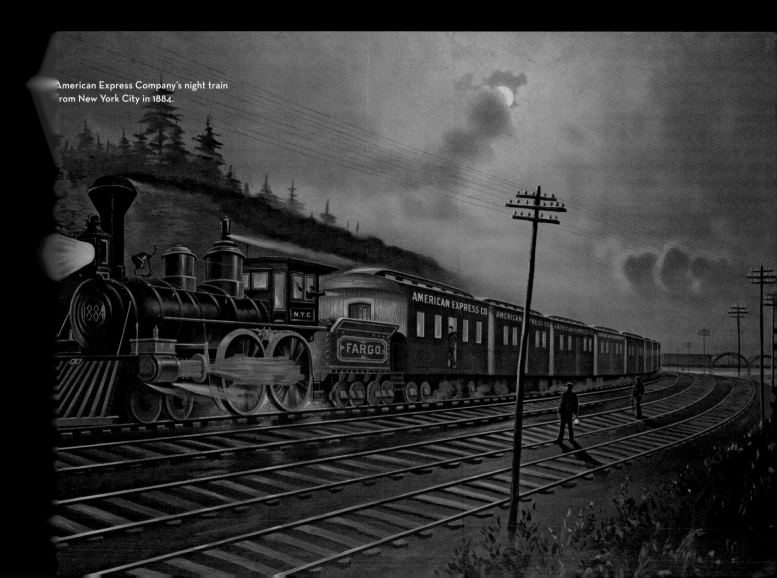

American Express Company's night train from New York City in 1884.

Irish shanty near Central Park. During the day I have walked down to the store and back again in the eve. and watch all night til nearly 5 o'clock A.M. in the shop."

It wasn't until July 16 that five regiments of New York troops were sent back to the city to restore order. Officially, 119 were killed, but other reports estimated the number to be closer to a thousand. Despite almost a week of terror, the bloodthirsty mob failed to stop the draft. Yet they did succeed in driving many African Americans out of the metropolis. This reverse migration, with families leaving black enclaves such as Bleecker and Minetta Streets and the West 30s, resulted in a 20 percent decrease in New York's black population—a trend that wouldn't reverse for decades.

The End of the War— and the Start of the Gilded Age

After four years of bloodshed, the South surrendered on April 9, 1865. It had been a long four years of uncertainty and hardship for most New Yorkers, and by the time the Union captured Richmond in early April, the city could collectively exhale. George Templeton Strong read the news about Richmond while walking past the bulletin board of the *Commercial Advertiser*, a newspaper headquartered on Wall Street. A jubilant crowd had gathered there, wrote Strong in his diary on April 3.

I walked about on the outskirts of the crowd, shaking hands with everybody, congratulating and being congratulated by scores of men I hardly know even by sight. Men embraced and hugged each other, kissed each other, retreated into doorways to dry their eyes and came out again to flourish their hats and hurrah. My only experience of people stirred up to like intensity of feeling was at the great Union meeting at Union Square in April, 1861.

A Fairy Wedding at Grace Church Charms the City

The February 10, 1863, nuptials of Charles Stratton, aka "General Tom Thumb," and Lavinia Warren bumped the war from the front pages of New York newspapers. This "fairy wedding" captivated city residents, who couldn't read enough about the two "loving Lilliputians," as the *New York Times* put it in an article the day after their enormous and elegant ceremony at Grace Episcopal Church at Broadway and 10th Street.

Stratton and Warren were already well known to New Yorkers; they were star performers at P. T. Barnum's hugely popular American Museum, on Broadway and Ann Street. After their engagement, Barnum helped turn the impending wedding into a show, which he dubbed "the biggest little thing that was ever known." A gossip-crazed city needing a break from the hardships of war loved it.

The ceremony was the social event of the season, and guests included members of the Astor and Vanderbilt families. Mathew Brady took the photos. After tying the knot, Stratton and Warren rode down Broadway to the Metropolitan Hotel on Prince Street, cheered on by twenty thousand citizens. The media chronicled every detail of the reception held there. Even their honeymoon was tabloid fodder: a trip to Washington, D.C., and a reception at the White House by President and Mrs. Lincoln.

A dose of frivolity seemed to be what a war-weary city needed. "As the time approached for the ceremony of the nuptials, the crowd increased in density, every one exhibiting the most impatient desire to catch a glimpse at the happy pair when they should arrive," wrote the *Times*. "The smiling faces of the thousands of fair ladies thus assembled contributed not a little to the attractiveness and joyfulness of the occasion. . . Order was preserved throughout the entire proceedings, and a general good feeling seemed to exist among the people."

The event was pure Barnum showmanship, but New York didn't mind. "The exquisite and the artisan, the lady of twenty and the lady of fifty, the habiliments of street, dining-room, drawing-room, and almost of nursery, commingled in charming confusion out-Barnuming Barnum in their unsurpassed conglomeration of all specimens of humanity," wrote the *Times*.

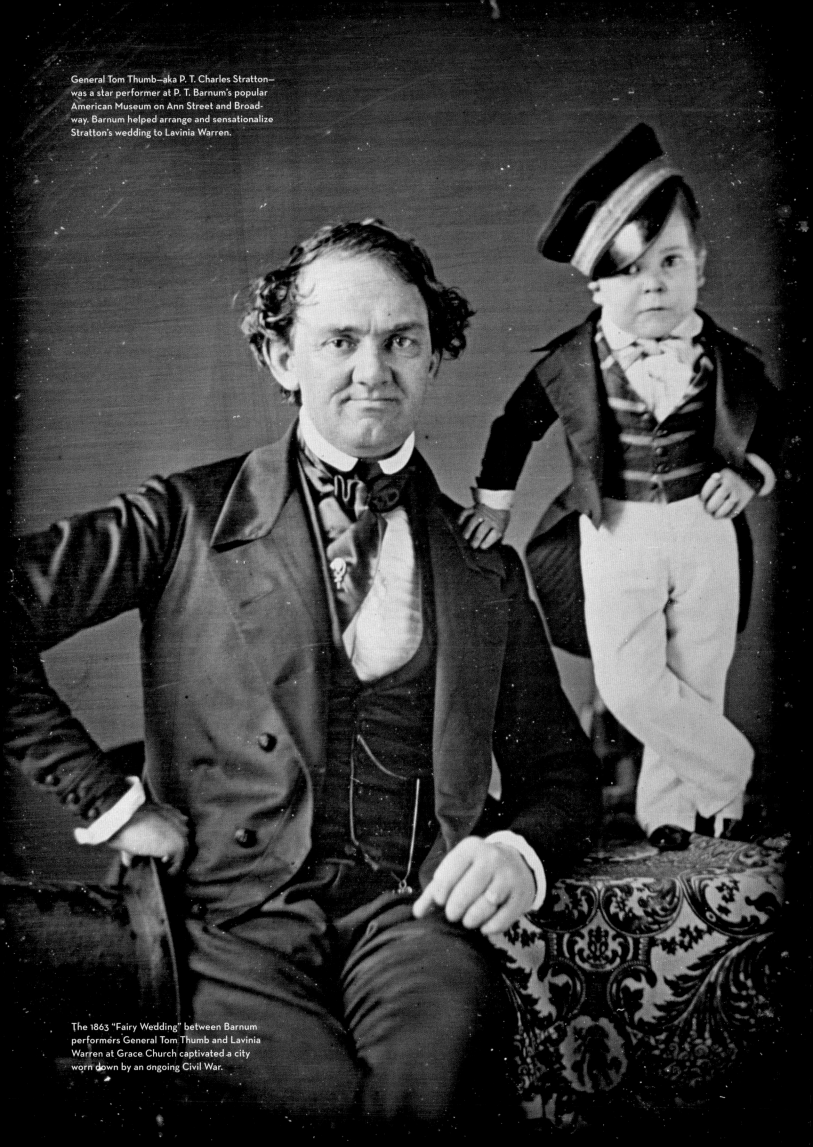

General Tom Thumb—aka P. T. Charles Stratton—
was a star performer at P. T. Barnum's popular
American Museum on Ann Street and Broad-
way. Barnum helped arrange and sensationalize
Stratton's wedding to Lavinia Warren.

The 1863 "Fairy Wedding" between Barnum
performers General Tom Thumb and Lavinia
Warren at Grace Church captivated a city
worn down by an ongoing Civil War.

But the feeling of today's crowd was not at all identical with that of the memorable mass-meeting four years ago. It was no less earnest and serious, but it was founded on memories of years of failure, all but hopeless, and on the consciousness that national victory was at last secured, through much tribulation.

The war didn't really come to a close for the city until Lincoln's murder and subsequent funeral procession. Brought together briefly in grief, and with city factories and the banking sector buzzing wildly with money and activity, New York in 1865 was poised for progress. By the decade's end, the omnibuses choking the streets would start to be replaced by elevated trains, the first of which went up on Greenwich Avenue in 1868. And after a lull during the war, workers and laborers returned to Central Park, creating the lakes, paths, bridges, and fountains that turned what was once a rocky, partly swampy rectangle of land into a lovely public park accessible to all. New York was also growing famous for its opulent department stores, like A. T. Stewart's on 9th Street, and a shopping district north and west of Union Square dubbed "Ladies' Mile."

Perhaps the only city industry that may have wished the War Between the States hadn't ended was the newspaper business. Centered at Printing House Square, across Park Row from City Hall Park, the printing plants of the city's popular morning and evening papers had churned out war news for an anxious public sometimes three times daily, and pioneered the publication of "extras" and Sunday editions. With the war over, the pressure to maintain and even boost circulation intensified. As it turned out, the city of the next three decades would supply more than enough innovation, excitement, and scandal to keep the printing presses working overtime.

The major city newspapers were headquartered at Printing House Square near City Hall, where crowds gathered daily during the war for the latest news.

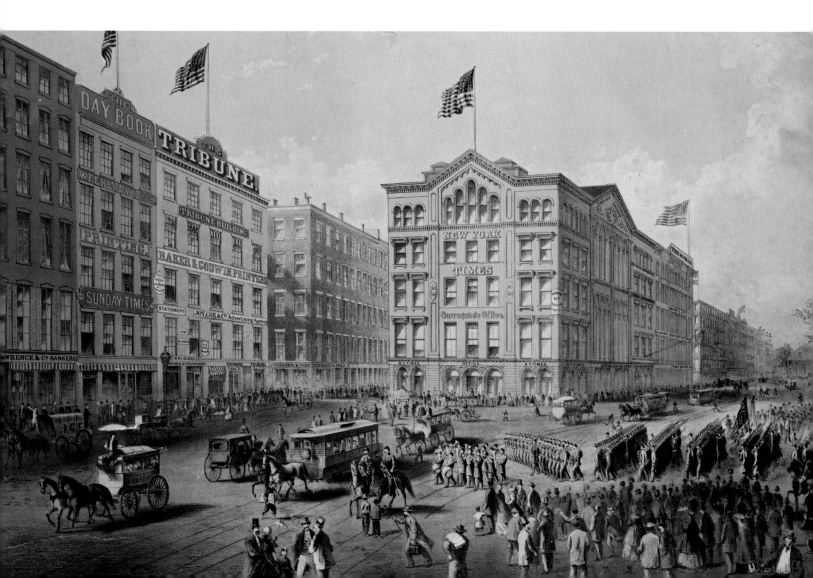

The Moneymaking City

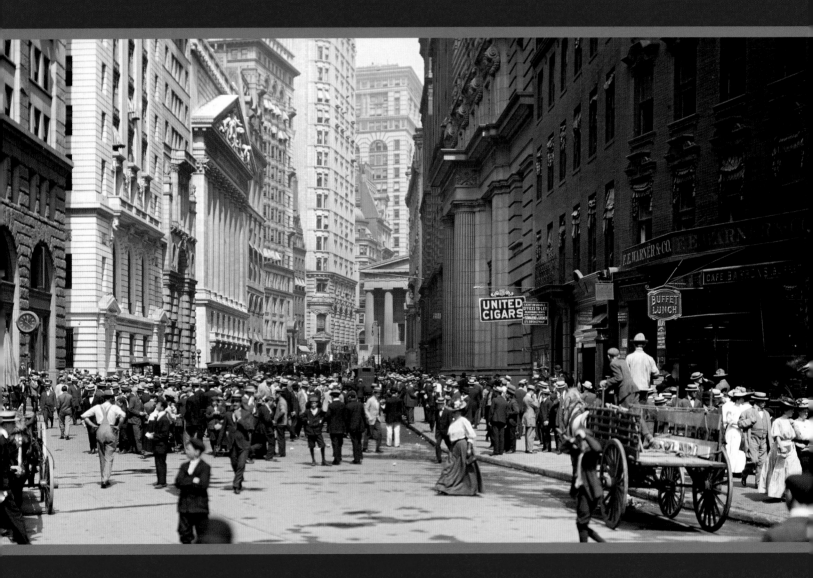

Steps away from the New York Stock Exchange building on Broad Street
(left), an open-air market of "curbstone" brokers sold small stocks and made
transactions in the street, rain or shine. The curbstone brokers moved indoors
in 1919, and in 1953 became the American Stock Exchange.

Shameless Moneymaking

In February 1867, Mark Twain arrived in New York City as a correspondent for a San Francisco newspaper. Still a little-known itinerant journalist (who six years later would coin the term "The Gilded Age" to describe the excesses of the post–Civil War era), Twain had last visited New York in 1853. Only fourteen years had passed. Yet the thirty-two-year-old found himself in an unfamiliar city, a vast, fast-paced metropolis awash in money fever.

"The town is all changed since I was here . . . ," he wrote, later writing, "They have increased the population of New York and its suburbs a quarter of a million souls. They have built up her waste places with acres and acres of costly buildings. They have made five thousand men wealthy, and for a good round million of her citizens they have made it a matter of the closest kind of scratching to get along in the several spheres of life to which they belong."

In June, he commented, "I have at last, after several months' experience, made up my mind that [New York] is a splendid desert—a domed and steepled solitude, where the stranger is lonely in the midst of a million of his race. . . . Every man seems to feel that he has got the duties of two lifetimes to accomplish in one, and so he rushes, rushes, rushes, and never has time to be companionable—never has any time at his disposal to fool away on matters which do not involve dollars and duty and business."

New York had always been a place where money changed hands. What had started as a colonial trading post two centuries earlier had evolved into the nation's business capital, due in part to the opening of the Erie Canal in 1825, and to the subsequent waves of immigrants who provided cheap, ready labor. The demand for goods during the Civil War further unleashed the city's manufacturing prowess, fattening bank accounts all over Manhattan.

By 1870, sugar refining had become New York's most profitable manufacturing industry. Massive refineries like the American Sugar Refining Company loomed along the East River, employing thousands of men and storing and processing millions of pounds of sugar.

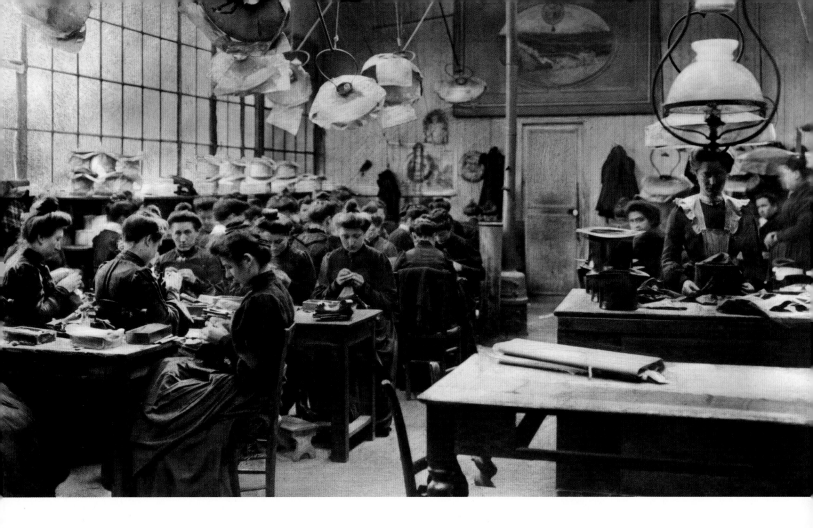

The garment industry boomed in the Gilded Age, and New York took the lead as the nation's biggest clothing-making center—with one in three city residents making a living in the garment business. More than six thousand factories employed thousands of workers, mostly young immigrant women.

But this wealth-worshipping Gilded Age city was different. After the city bankers secured $2.5 billion for the federal government to finance the war, government officials passed the 1864 Banking Act, making New York the repository of the banking reserves of the country. The business of finance began its reign. New national banks provided capital for America's developing railroad infrastructure, telegraph networks, and mining projects. The payoff for the city itself was swift: The value of real estate and personal property doubled between 1860 and 1870, to approximately $1 billion. The value of goods produced in the city also doubled, to $333 million.

The making and selling of these goods was reaching a fever pitch unlike anything the city had seen. Powerful new factories devoted to New York's most lucrative industries rose along the cityscape. Sugar refineries stuck out on the Manhattan and Brooklyn sides of the East River; the number of garment factories exploded on the Lower East Side. Across from City Hall, publishers and presses churned out newspapers, periodicals, and books at Printing House Square and Newspaper Row. Meanwhile, consumerism within the city was in full swing, exemplified by the newly christened Ladies' Mile shopping district. Centered on Broadway between 14th and 23rd streets, this stretch of fashionable New York was lined with multilevel, windowed emporiums such as Lord & Taylor and Arnold Constable that catered to the material desires of a new class of prosperous women.

In 1869, the New York Stock Exchange—which began with twenty-four brokers signing an agreement under a buttonwood tree on Wall Street in 1792—was now trading approximately $3 billion in securities annually. The incredible growth of the stock market after the Civil War enthralled New Yorkers and visitors alike, who were captivated by

The Age of Invention Transforms New York

Thanks to industrialization and a deeper understanding of science, the years following the Civil War became the Age of Invention. In three decades, technology drastically changed the city and the way New Yorkers experienced day-to-day life. Machines and devices that first seemed like curiosities became household staples for the city's middle and upper classes.

In 1877, New Yorkers crowded the auditorium of Chickering Hall, Fifth Avenue and 18th Street, to watch Alexander Graham Bell demonstrate his "electric speaking telephones." In 1880, New York's telephone system had 2,800 subscribers. By 1896, it had 15,000. Private phones were still a luxury, but anyone could access one installed in a hotel or local store.

Electric arc lights developed separately by Charles Brush and Thomas Edison began illuminating city streets and homes starting in 1880. Edison's first private customer was J. P. Morgan; by 1883, he had customers, and his incandescent electric bulbs lit up marquees, billboards, and streets, transforming New York from a daytime city to a twenty-four-hour metropolis

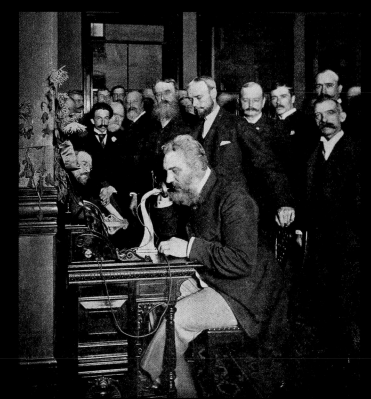

Alexander Graham Bell invented the telephone in 1877—but it wasn't until 1892 that he made the first long-distance call, from New York to Chicago.

by the turn of the century.

Edison also developed the first phonograph in 1877, and the first motion picture projector in 1889. Calling it a kinetoscope, he exhibited the projector at the Brooklyn Institute of Arts and Sciences in 1893. On April 14, 1894, a kinetoscope parlor opened at 1155 Broadway, on the corner of 27th Street—the first commercial motion picture house. For twenty-five cents, visitors could look down into a wooden box and watch several minutes of short black-and-white films.

Nikola Tesla, a Serbian immigrant who came to New York in

1884 to work for Edison developing electricity, struck out on his own and experimented with radio waves, improving communication via Morse code on ships and paving the way for radio to be broadcast into homes.

Smaller inventions also transformed life. The electric iron was invented by New Yorker Henry Seeley in 1882. Typewriters that debuted in the 1860s and fountain pens refined in the 1870s were a staple of the Gilded Age office. Steam and electric engines changed transportation, making trains and streetcars faster and travel time shorter. Thanks to

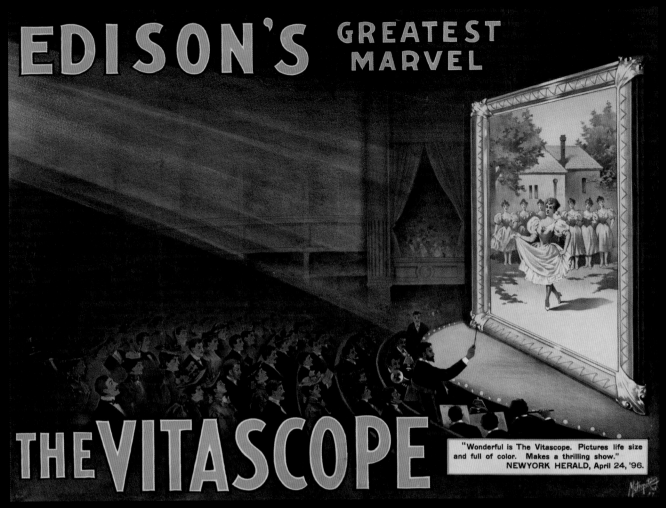

EDISON'S GREATEST MARVEL

THE VITASCOPE

"Wonderful is The Vitascope. Pictures life size and full of color. Makes a thrilling show."
NEWYORK HERALD, April 24, '96.

Thomas Edison's Vitascope was an early motion picture machine that could show short films for a large audience. The Vitascope, which debuted in 1896, eclipsed Edison's Kinetoscope, a projector that played a number of images at high speed to create a moving picture but could only be seen by one viewer at a time. The first Vitascope film demonstrated to a paying public was at Koster and Bial's Music Hall in Herald Square in 1896.

manufacturing manpower and the machine age, these inventions could be mass-produced in factories and available to the consumers who could afford them.

"Little more than a century ago, everything was slowly and imperfectly made by the tedious toil of the workman's hand; but now marvelously perfect results of ingenious manufacture are in every-day use, scattered far and wide, so that their very commonness almost prevents us from viewing them with the attention and admiration they deserve," wrote one scientist who published a guide to the outstanding inventions in the decades following the Civil War.

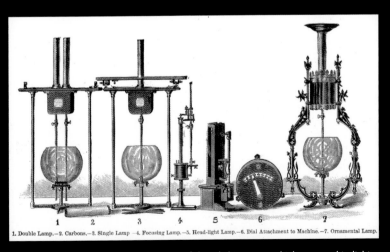

1. Double Lamp.—2. Carbons.—3. Single Lamp.—4. Focusing Lamp.—5. Head-light Lamp.—6. Dial Attachment to Machine.—7. Ornamental Lamp.

Charles Brush's first commercially successful arc light system, which was used to light sections of Broadway by 1878, inspired Thomas Edison to create his own electric light work.

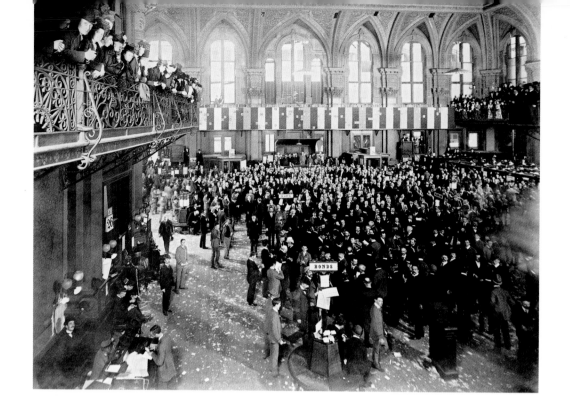

The technologically advanced "Main Board" room at the New York Stock Exchange on Broad Street in the 1880s allowed clerks to take and place orders by telegraph, telephone, and pneumatic tube.

the enormous sums made and lost on this "feverish, anxious street," looked down upon by "the stately spire of Trinity [church]," as writer Junius Henri Browne wrote in his 1868 book *The Great Metropolis: A Mirror of New York.* Newspapers and magazines covered the activity on the trading floor for readers fascinated by the high stakes—or shocked by the vulgar money-grubbing.

"The vice president stood on the rostrum like an auctioneer, hammer in hand," read an account by two English travelers, who marveled at the energy and technology in the trading room. As stocks were sold from a list printed on a blackboard, a crowd of dealers let loose "a Babel of unearthly yells, which meant bidding . . . look into any office on Wall Street, and click, click goes the machine, spinning out a paper ribbon, upon which is distinctly printed every sale as it is made."

In 1872's *Lights and Shadows of New York Life,* James D. McCabe captured the frenzy of brokers bidding on stocks. "Bids come fast and furious, hands, arms, hats, and canes are waved frantically overhead to attract the attention of the presiding officer. The most intense excitement prevails throughout the room, and the shouts and cries are deafening."

This was a much coarser stock market than the already bullish version New Yorkers knew before the war. "The men stamp, yell, shake their arms, heads, and bodies violently, and almost trample each other to death in the violent struggle," McCabe wrote. "Men, who in private life excite the admiration of their friends and acquaintances by the repose and dignity of their manner, here lose their self-possession entirely, and are more like maniacs than sensible beings."

The New York Stock Exchange wasn't the only way to play the market. New exchanges opened along Wall Street for the buying and selling of commodities such as petroleum, cotton, and corn. Meanwhile, smaller, often less scrupulous traders sold shares outdoors at the "curbstone" stock exchange near Wall Street. "A few of these operators are men of integrity, who being unable to enter the regular boards, are compelled to conduct their business this way," wrote McCabe. "They have regular places of business in some of the neighboring streets . . . but the great majority are simply sharpers, men who will not meet

Counterfeit Money

In the mid-nineteenth century, lots of paper money was in circulation. States issued their own notes, and in 1861, the federal government gave approval to the U.S. Treasury to print its own paper currency, or "greenbacks," as they were called because of their color. In 1863, Congress established a national banking system, and the U.S. Treasury oversaw thousands of national banks, which were allowed to print their own notes, issued in denominations of $1 to $1,000. All of these different bills were a counterfeiter's dream, as no one could possibly be familiar enough with each design and appearance to know which were real and which were frauds. In 1877, the Treasury Department's Bureau of Engraving and Printing became the sole producer of U.S. currency.

The Shoe and Leather Bank was a legitimate financial institution—"one of the wealthiest and most reliable," according to an 1861 *New York Times* article. But its banknotes were catnip for counterfeiters, who made elaborate forgeries and then circulated them in other parts of the country, where they wouldn't be discounted as fraudulent. The mid-nineteenth century has been described as the "golden age of counterfeiting."

their losses, and who will fleece any one, who falls into their hands, out of his last cent."

On the surface, this intense investment activity hinted at a robust economy, one that extended beyond the offices of brokers and bankers. Clerks, tellers, bookkeepers, and other salaried workers were needed in this new world of wealth-building, and the men (and sometimes women) who filled these positions earned wages that put them in the city's middle class. Many more New Yorkers made a respectable living as tradesmen, merchants, and in service professions that grew along with the banking sector. But there was little to no federal oversight regulating big banks and Wall Street, let alone the small-time brokers peddling speculative stocks. It would take several years before great numbers of unsuspecting investors caught up in money fever realized that the bull market was rigged against them.

"The mania for stock gambling which now sways such masses of people, may be said to date from the war and the petroleum discoveries," wrote McCabe in 1872's *Lights and Shadows of New York Life*. "Since then it has rolled over the country in a vast flood. The telegraph is kept busy all day and all night in sending orders for speculations from people in other States and Cities to New York brokers. Everybody who can raise the funds wishes to try his or her hand at a venture in stocks. Merchants, clergymen, women, professional men, clerks, come here to tempt fortune. Many win; more lose."

A City on the Rise

New money changed the look and shape of Gotham. "Brown-stone" houses were all the rage: in the 1860s and 1870s, rows of mud-brown homes packed the blocks between Madison Square at 23rd Street and Central Park's southern border. To some, they were elegant and refined; others found them uniform and somber. "[As] far as 59th Street, it is an almost unbroken line of brown-stone palaces...," wrote Browne. "When you enter a tall, handsome brown-stone front, exactly like its next-door neighbor, where the Wall Street banker or Beaver Street merchant resides in the midst of velvet carpets, ormolu clocks, and classic bronzes, you cannot help but be surprised. The drawing rooms look dismal; the furniture worn and scanty; the stairways treacherous and untidy; the walls soiled and of marvelous acoustic property. Nothing like comfort or content anywhere, but the opposite of what you mean when you talk of home."

The Theater District was slowly migrating from Union Square to Madison Square. The hottest ticket in town was an extravagant musical melodrama called *The Black Crook*, which premiered at Niblo's Garden at Broadway near Prince Street in the late 1860s and then moved to the Grand Opera House at 23rd Street and Eighth Avenue. Restaurants and hotels relocated alongside the new theaters. Men and women could dine together in first-class restaurants, such as Delmonico's on Fifth Avenue; unescorted women, however, would be turned away. The opulent Fifth Avenue Hotel was the clubby retreat for Wall Street power brokers in the evening. The last stock quotes of the day were routinely sent to the hotel. Bankers and brokers who had left their offices early could unwind, find out how their stocks fared, then raise a glass and toast the bonanza economy.

"[The] Fifth Avenue Hotel is a favorite resort for Wall Street at night," explained social critic Matthew Hale Smith in his 1873 book, *Twenty Years Among the Bulls and Bears of Wall Street*. "Moneyed men, heavy operators, daring speculators, the leaders of cliques and parties on the street, live in the vicinity of the hotel. They drop in during the evening, apparently unconcerned, and as if there by accident.... Most of these gentlemen leave the street at 4 o'clock.... Brokers come in from a ride, take their dinner, and then drift down to the hotel."

By the 1880s and 1890s, the Wall Street set's theaters, hotels, and restaurants moved with the flow of wealth from Madison Square to the 30s, 40s, and, by the end of the century, past Central Park and along upper Fifth Avenue. With each wave of northward migration, what used to be strictly residential enclaves were swallowed up by the commercial sector.

"Everything here gives way to business," wrote McCabe in 1872. "The changes in the city are, perhaps, more strictly due to this than to the increase of the population. It is a common saying that 'business is rapidly coming up town.' Private neighborhoods disappear every year, and long lines of substantial and elegant warehouses take the places of comfortable mansions of other days.... A few years ago the section of the city lying between Fourth and Twenty-Third streets was almost exclusively a private quarter. Now it is being rapidly invaded by business houses."

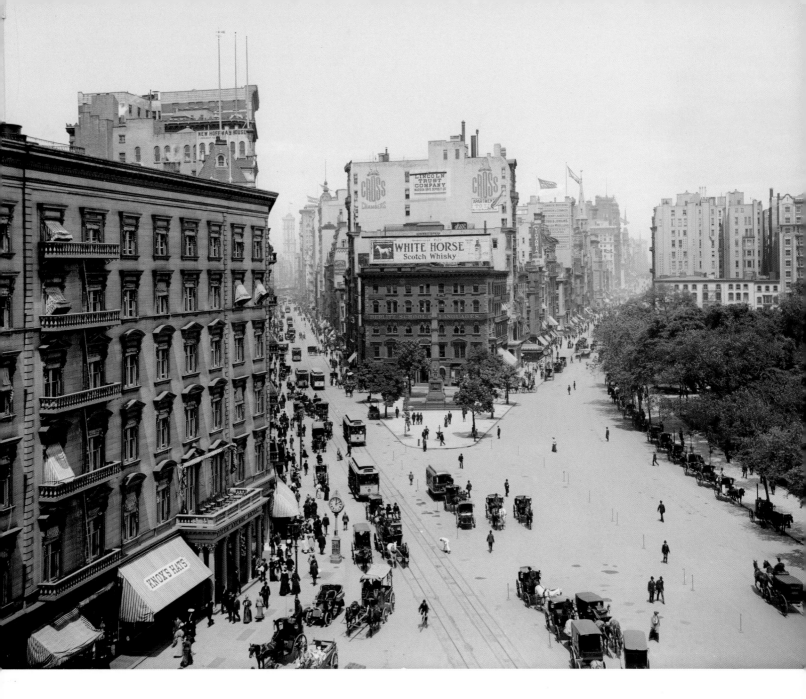

The Fifth Avenue Hotel was the grandest and most glamorous hotel of the Gilded Age. Located near posh residential enclaves and in the middle of the city's entertainment district, its gilt-wood public rooms made it a gathering place for the rich power brokers of New York.

Those business houses began transforming New York into a vertical city. Buildings were once capped at five or six stories. By the mid-1870s, eight-, ten-, and eleven-story structures shadowed the streets. The first Equitable Building, at 120 Broadway, debuted in 1870. Climbing 142 feet and the first office building to feature a passenger elevator, it's arguably the first skyscraper—a slang term at the time for the tallest mast or stack of a sailing ship or steamship. Five years later, the Tribune Building went up at Printing House Square, towering over City Hall Park at 260 feet, "like a sort of brick and mortar giraffe,"

commented a British tourist. The turreted Western Union Telegraph Building, whose lighted clock tower helped guide ship captains in New York Harbor at night, appeared at 195 Broadway in 1875. Still, Trinity Church, completed in 1846 at Broadway and Wall Street, remained the tallest structure in the city, thanks to its 281-foot spire—until the 309-foot New York World Building debuted in 1890 on Park Row.

The dawn of the skyscraper era reflected a city bursting with energy and excitement. "'Still higher' is now the motto of all New York architects," stated one publication in

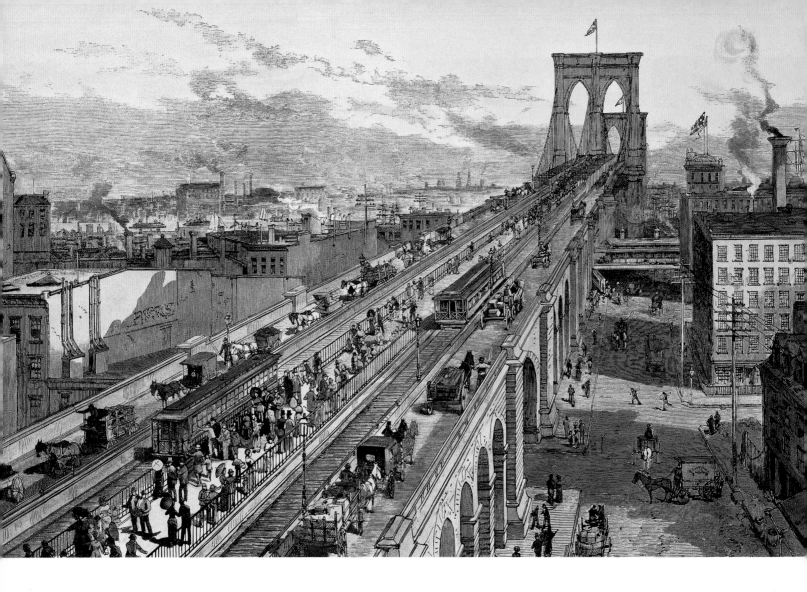

January 1873, as plans for the Western Union Building were unveiled. Walt Whitman praised these new towers as "cloud-touching edifices" and "tall, ornamental, noble buildings." But not everyone was so awed. George Templeton Strong found them to be "hideous, top-heavy nightmares."

The city was reaching new heights in other ways as well. In 1870, work began on what would eventually be called the Brooklyn Bridge, destined to be "a great avenue" linking the two cities. Brooklyn had about four hundred thousand residents at the time, many of whom commuted to New York for work. Brooklyn "is a kind of sleeping-place for New York," commented Charles Dickens in 1867, after his celebrated visit to Gotham.

The hopes of the New York Bridge Company, the private company chartered by the state to link the cities, was that a bridge would help Brooklyn blossom, attracting new residents and businesses that had been crowded out of Manhattan. It would also reduce reliance on the multiple ferry lines that shuttled passengers back and forth across the East River, "crowded with vessels of all kinds" according to McCabe. "At night, with their many colored lamps, they gave to the river quite a gala appearance," he wrote. But the boats were flimsy and often useless in bad weather or when the river became choked with ice, leaving thousands stranded.

Nothing altered New York more profoundly than the elevated railway, or "el." The first line opened in 1868 above a section of Greenwich Street to Cortlandt Street, then to West 30th Street, by 1869. By the mid-1870s,

Opened in 1883 after fourteen years of construction, the Brooklyn Bridge was dubbed the "Eighth Wonder of the World," majestically linking the cities of New York and Brooklyn and allowing travelers to cross back and forth on foot or by horse car or elevated train—much safer options than the crowded, flimsy ferries.

elevated cars powered by belching steam engines ran along Second, Third, Sixth, and Ninth avenues as far north as Central Park. Iron pillars carried their massive steel tracks three stories above the street, giving passengers of the cars (their "green and red fiery eyes staring ahead and plunging into the darkness," as one nighttime visitor described it) a newly expansive view of the city. This "ever-active volcano over the heads of inoffensive citizens" also made life miserable for the unfortunate residents whose windows were so close to the tracks that riders peered into their parlors and bedrooms all day and all night.

British writer Walter G. Marshall penned this account of riding the elevated railway after a visit to New York in the late 1870s: "As you sit in a car on the 'L' and are being whirled along, you can put your head out of [the] window and salute a friend who is walking on the street pavement below. In some places, where the streets are narrow, the railway is built right over the 'sidewalks'. . . close up against the walls of houses." For five cents (ten cents during the off hours), passengers "all ride together in a long car. . . . There is, therefore, the same fare for everybody, no matter how long or short the distance traveled over . . ."

In the 1880s, the el had reached small uptown enclaves such as Harsenville and Carmensville on the West Side, and Harlem from river to river. Parts of the Bronx had been annexed from Westchester in 1874; soon the presence of the el would bring in new residents and make the farm villages there a continuation of the urban cityscape. Elevated trains would also travel across the Brooklyn Bridge months after it opened in 1883, connecting the two busy downtowns of two thriving cities.

Wherever the el blazed its trail, development followed. Brownstones popped up near el stations that were once open fields. Many more tenements were built under and

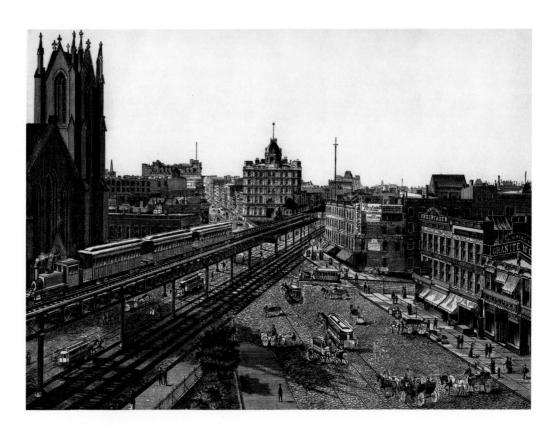

By the 1870s, elevated train tracks carried hulking steam engines up and down Manhattan's avenues and became a fixture of the cityscape. A ride cost five cents, and trains took passengers from stops in lower Manhattan up to Harlem.

beside the sooty, rattling tracks. And a new kind of dwelling, the French flat, or apartment house, emerged in 1869 on genteel side streets and avenues as well. The first of these was Stuyvesant Apartments, with sixteen suites, each with six rooms plus a bathroom, in a five-story building at 142 East 18th Street. The Stuyvesant offered middle-class New Yorkers an elegant home, though not the preferred single-family house considered a "first class" dwelling at the time.

New York's streets weren't paved with gold—in fact, far from it. A chief complaint was the terrible condition of the roadways. The uneven cobblestones laid down on busy avenues were typically caked with mud and manure, if not the rotting carcasses of dead horses. Dirt and debris blew around constantly and coated pedestrians' coats and hats. Pigs occasionally roamed courts and alleys, feeding on the trash that was routinely thrown out of windows. Tangled black cobwebs of telegraph wires crisscrossed downtown intersections.

Renowned physician Dr. Fordyce Barker forbade his convalescing patients from riding in open-air carriages on Fifth Avenue, because he believed that the jostling and rattling from the bumpy, unevenly paved road would damage their nervous systems.

But some infrastructure improvements gave the city a sheen of loveliness. The first electric lights illuminated Broadway between Union and Madison squares in 1880. Fifth Avenue's new mansions earned it the nickname Millionaire's Row. Development on the Upper East Side and then the Upper West Side resulted in wide, spacious avenues. A hilly ridge along the Hudson was acquired by the city and set to become Riverside Park. Central Park, opened in stages beginning in 1858, brought classes and factions together. "Central Park," wrote McCabe, "the chief pleasure ground of New York, has reached a degree of perfection in the beauty and variety of its attractions, that has made it an object of pride with the citizens of the metropolis."

Big Business Thrives in the Metropolis

In the late 1860s, a new type of businessman emerged. Worshipped as "captains of industry" by some, they were outright criminals to others—as this early reference, from an 1870 issue of the *Atlantic Monthly,* makes clear: "The old robber barons of the Middle Ages who plundered sword in hand and lance in rest were more honest than this new aristocracy of swindling millionaires."

Three of the most notorious were Jay Gould, Jim Fisk, and Daniel Drew. These "rogue financiers" were determined to make a fortune by controlling prices without any concern for the economic stability of the country. Other "robber barons" monopolized entire industries. In 1867, Cornelius Vanderbilt, a native Staten Islander and the richest man in America, made his fortune on steamboat ferries to Staten Island and then in the railroads. He persuaded the New York State government to let him combine the three railroads he owned into one company, the New York Central and Hudson River Railroads.

VOL. X.—No. 240.　　　OCTOBER 12, 1881.　　　Price, 10 Cents.

"What fools these Mortals be!"
MIDSUMMER-NIGHTS DREAM.

Puck

PUBLISHED BY
KEPPLER & SCHWARZMANN.

NEW YORK
TRADE MARK REGISTERED 1878.

OFFICE No. 21 – 23 WARREN ST

"ENTERED AT THE POST OFFICE AT NEW YORK, AND ADMITTED FOR TRANSMISSION THROUGH THE MAILS AT SECOND CLASS RATES."

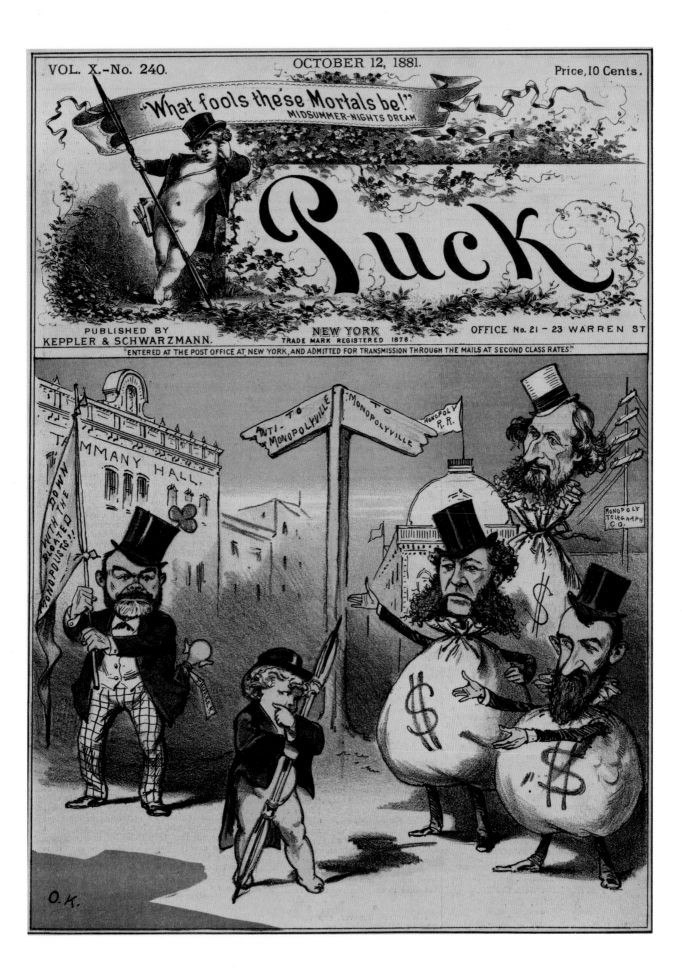

A Gold Scheme Almost Takes Down Wall Street

James Fisk in an 1869 cartoon showing the price of gold dropping $30 within an hour.

They may not be as well known as fellow robber barons Rockefeller, Carnegie, and Morgan, but Jay Gould and James Fisk were unscrupulous businessmen in their own right.

Their first collaboration in 1868 was to gain control of the Erie Railroad, whose stock was owned primarily by Cornelius Vanderbilt. Gould, Fisk, and a third financier, Daniel Drew, issued fraudulent stock to dilute Vanderbilt's shares. Their stock manipulation plan gave them control of the railroad; they even put Boss Tweed on the board of directors, no doubt in an attempt to help deflect criminal charges.

Gould and Fisk's next ploy, two years later, caused far more dam-

age. Their idea was to buy as much gold as they could to artificially inflate its price, hoard it, and then sell it at a huge profit. The problem was, in an effort to reduce the national debt (made enormous by the cost of the Civil War), President Grant's administration had

Jay Gould

planned to put U.S. gold on the gold market. Gould and Fisk couldn't let that happen; the more gold in circulation, the lower its value would be.

So in late summer, they bribed Daniel Butterfield, a general during the Civil War and now Grant's assistant secretary of the Treasury, to tip them off when U.S. gold was about to go on the market—they would sell first and reap big profits. They also enlisted the help of a city financier who happened to be Grant's brother-in-law, Abel Corbin. They arranged for Corbin to pressure Grant to stay out of the gold market.

As Gould and Fisk gobbled up gold in September, the price rose to new heights. By September 20, Wall Street speculators began suspecting a corner on the gold market. Then Grant discovered the scheme and ordered the sale of government gold on September 24. Instantly, the price nose-dived from an inflated $160 per gold coin to $133. The stock market also tanked. Gould and Fisk got out in time, but other investors went broke.

The "Gold Ring," as it became known, darkened the mood of the city's moneymaking class, who were used to celebrating, not sulking. "There was one place, at least,

This is a Photograph of the Bulletin Board in the Gold Room at N.Y. Sept. 24. 1870 the Black Friday of the Gold Panic. Was produced in Evidence before the Committee of Banking & Currency.

On September 24, 1869, the price of gold reached $160. Fisk claimed he could push it to $200. When the news of the government sale of gold became known, the price fell within minutes to $133. Stock prices subsequently fell 20 percent.

Daniel Butterfield accepted $10,000 from Jay Gould to tell him and James Fisk when the government was planning to sell gold. After the scheme was uncovered, Butterfield was forced to resign. He took his family on an extended tour of Europe, then returned to become an executive in American Express, a company his father founded.

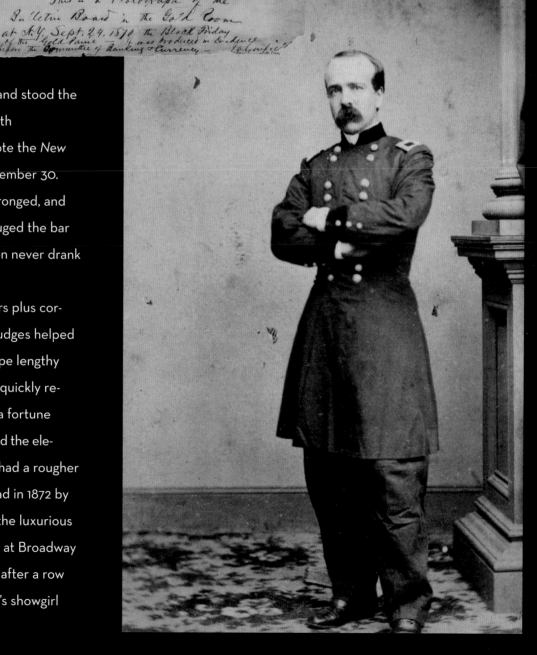

that stood the rush and stood the terrific drain with both ease and profit," wrote the *New York Herald* on September 30. "Delmonico's was thronged, and whiskey straight deluged the bar from end to end. Men never drank so fast or so steep."

Persuasive lawyers plus corrupt Tammany Hall judges helped Gould and Fisk escape lengthy prison terms. Gould quickly rebounded and made a fortune off Western Union and the elevated railroads. Fisk had a rougher end: he was shot dead in 1872 by another financier in the luxurious Grand Central Hotel at Broadway and West 3rd Street after a row over money and Fisk's showgirl mistress.

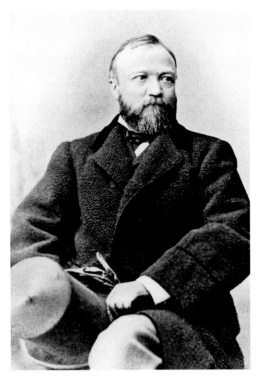

Andrew Carnegie

Though Andrew Carnegie became a philanthropist later, he was first known as a union buster who bribed politicians to help build his steel empire. J. P. Morgan solidified many competing railways into one super rail line. John D. Rockefeller's Standard Oil, which moved its headquarters to New York City in 1884, made competition-crushing deals with the railroads to control more than 90 percent of oil refining in the United States by the 1880s.

Newspapers eagerly called out these men's rapacious business practices. In a November 19, 1882, article, "The Great Oil Monopoly: How the Standard Company Robs the Public," the *New York Times* gave a blunt assessment: "While the Standard is, in the real meaning of the word, the greatest monopoly in America, as powerful in its own field as the Government itself, and holding the entire refined and crude oil market of the world in the hollow of its president's hand, its methods and dealings are the most securely

covered up and hidden from the public eye of any corporation that anywhere approaches it in size or ramifications."

The robber barons and other big businessmen weren't only facing critics in the press; they had to contend with a growing organized labor movement that demonized capitalists and demanded that city officials stand up for the rights of workingmen. Tradesmen were increasingly organizing into unions, covering everything from mechanics to piano makers to "building wreckers." After Congress approved an eight-hour workday for all laborers on federal projects in 1868, several states followed suit, including New York, which passed a law defining a day's work to be eight hours for everyone except farmhands and servants. Yet the law was not enforced. Business owners insisted that workers put in the then-standard ten-plus-hour day, or they could find another man who would.

In response, twenty-five thousand workers held an eight-hour parade in September 1871, marching from Union Square to City Hall and then to Cooper Union at Astor Place. Mass meetings followed throughout the year, and in May 1872 what was called the "Great Strike" began. More accurately described as a collection of small strikes by

"A Horrible Monster": Standard Oil, which controlled 90 percent of the oil refining business in the late 1880s, was depicted in a political cartoon as a multi-tentacled monopoly that led to "poverty, disease, and death," particularly at Hunters Point in Queens, an industrial area with a ferry terminal frequently racked by fire and fumes.

individual unions, the workingmen had one goal: to get the city to honor and enforce the eight-hour workday. Carpenters, bricklayers, coachmakers, typographers, plumbers, cabinetmakers, and upholsterers, among other trades, all walked off their jobs, with some demanding pay increases as well. Workers at William Steinway's piano factory went on strike, as did the men employed by the Singer Sewing Machine company.

The strike lasted through the end of June. At best, it could be seen as a draw. Some workingmen won their eight-hour day from their employers, while others were forced to return to work out of the "necessity of living," the *New York Times* wrote on July 9. "It were greatly to be desired that the labor and capitol interests of the City should find some ground of agreement less precarious than this."

"The great strike still pending in this city has been, in its various aspects, the most remarkable we have ever had in America," reported the *New-York Tribune* on June 24, 1872, as the strikers wound down. "Of the more than three-fourths who have struck more than one half have gained their point; but over eleven thousand are still unsuccessful and without present clear prospects of success." Labor unrest would continue through the Gilded Age, and just two years later, Tompkins Square Park would play host to a violent rally involving thousands of laborers and the police.

"Unparalleled Frauds Upon the Ballot Box"

This 1873 mechanical bank shows Boss Tweed, the notorious Tammany Hall leader. The weight of the coin causes the hand to lower and deposit the coin into his pocket.

Greed wasn't just the province of industry titans. The city's Democratic political establishment lined its coffers through fraud, kickbacks, and payoffs. The infamous William M. "Boss" Tweed was the king of it all. Born on the Lower East Side in 1823, the son of a furniture maker, Tweed first worked as a brush maker and joined a volunteer fire station. Volunteer fire companies were more like clubs in the 1840s. Many had political ties, and Tweed was recruited by city Democrats to run for alderman of the Seventh Ward (today's Lower East Side). In 1851, the twenty-eight-year-old won his first election.

Boss Tweed and the City's First Subway

On February 26, 1870, hundreds of New Yorkers—including city officials and members of the press—descended a staircase into the basement inside Devlin's Clothing Store at 260 Broadway, on the corner of Warren Street.

There, 21 feet under Broadway in a brick tunnel, they were introduced to the city's first subway: an 8-foot cylinder car powered by an enormous fan that traveled the one-block distance to Murray Street and back. The car held 22 upholstered seats, and these first passengers awaited its arrival in an elegant waiting room complete with zircon lights (as opposed to gas), a grand piano, and a fountain. "Proposed underground railroad—fashionable reception held in the bowels of the earth!" announced the headline of the *New York Herald* on February 27, 1870.

This was the public debut of the pneumatic subway, financed and built by an inventor and co-owner of *Scientific American* named Alfred Ely Beach. New Yorkers had long complained of the city's crowded street traffic, with horse cars and omnibuses clumsily carrying people to their destinations inside overloaded, filthy cars that kicked up dirt and left pedestrians notoriously covered in dust. An underground railway similar to the one launched in London in 1861 had been proposed in 1863, but had been killed by Boss Tweed, who wanted no competition for the streetcar and stage lines that paid Tweed tribute.

To get around Tweed, Beach showed guts and grit. He was able to get the work approved by City Hall by describing it as a pneumatic tube for mail, not people. Beach then built the subway tunnel in just fifty-eight days with help from workers burrowing at night and carting away dirt in secret. His plan was that once New Yorkers could see and try out his new subway, they would press city officials for the funds needed to extend the tunnel under Broadway.

For the next year, at a price of twenty-five cents, citizens could check out Beach's subway and take a ride. By all accounts, New Yorkers loved it. The subway traveled a mile per minute, and Beach hoped to build it all the way to Central Park. But popular opinion was no match for the power of Boss Tweed. While state legislators approved funding, New York governor John T. Hoffman, in pocket with Tweed, vetoed the bill. Tweed wasn't the only powerful detractor. John Jacob Astor, who owned much real estate along lower Broadway, fought the pneumatic subway on the grounds that digging a tunnel would potentially leave city buildings, even Trinity Church, toppled over.

Two years later, with Hoffman out of office and Tweed under investigation, a new bill asking for funding for Beach's subway hit state legislators. The new governor signed it. By then, however, the panic of 1873 had gripped New York, and money for mass transit had dried up. Beach didn't even have the funds to maintain his one-block subway, and the tunnel and bullet-shaped car were abandoned . . . then rediscovered in 1912 during construction of the New York BMT subway system, which Tweed and his cohorts had delayed by half a century.

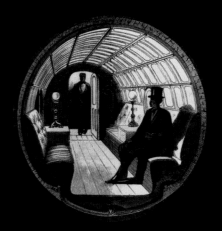

In 1870, inventor Alfred Beach secretly dug a one-block tunnel under Broadway so he could demonstrate his elegant pneumatic railroad to residents who were fed up with New York's terrible surface traffic. Boss Tweed and Tammany Hall quashed the project, in part because they didn't want kickbacks they received from the streetcar and stage-line companies to stop.

Following an undistinguished two-year stint in the U.S. House of Representatives, Tweed returned to New York City. He showed his party loyalty by accepting various board appointments, rising through the ranks to become the head, or "grand sachem," of the Society of Saint Tammany in 1863. Founded in 1789, Tammany Hall, as it was called, operated out of Nassau Street (later Union Square). It was a slick political machine that kept a tight grip on Democratic nominations in the city and state.

Tammany power came from the first massive waves of Irish and German immigrants to New York, in the 1840s. Licking their chops at all these potential new voters, Tammany members courted them hard: they helped them find jobs and fill out the paperwork (or invented bogus papers) so they could quickly become naturalized citizens, and even provided food, shelter, and jobs—all in exchange for votes. They stuffed ballot boxes, enlisted some men to vote two or three times per election, and bribed judges. Their nefarious efforts paid off in 1854, with the election of Tammany-backed Mayor Fernando Wood, perhaps one of the most unscrupulous mayors New York had ever seen.

Tweed took over Tammany Hall in 1863, the year that Irish-immigrant rage fueled the deadly Draft Riots. He was not the pure-evil cartoon character depicted by Thomas Nast, but a study in contrasts. A mountain of a man (he reportedly topped 300 pounds), with beady eyes and exaggerated features, he was also jovial and likable, quick to laugh and to write personal checks for charitable causes. He displayed keen political smarts by solidifying different Tammany factions, corrupt Republicans, and millions of lower-class, mostly Irish voters into one fiefdom. "To win success [in New York politics] requires only

an absence of principle, devotion to the boss, and a careful cultivation of the Irish vote," wrote James D. McCabe in 1882's *New York by Gaslight*.

Elected to the state senate in 1868, Tweed helped Jim Fisk and Jay Gould engineer a takeover of Cornelius Vanderbilt's Erie Railroad; in return, he was put on the railroad's board of directors. After bribing state officials to revise New York City's charter two years later, the entire city government was under his thumb. Tweed quickly got to work setting up public works projects, doling out jobs and funds to corrupt business partners, and scoring huge kickbacks for himself and his ring of cronies: Mayor A. "Elegant" Oakey Hall, Comptroller Richard Connolly, and lawyer Peter Sweeny, who was appointed head of the Department of Public Parks.

Tweed had his hand in just about every pocket. He took control of the city treasury, the courts, and the legislature. He bought property in Upper Manhattan, used city services to jack up the land's value—say, by installing sewers or curbs—and then sold it back to developers for fat profits. He skimmed money from streetcar and stage lines, and to protect this crucial cash flow, he rejected proposals to build a subway and came up with his own plan for a system of elevated railroads. Before green-lighting the Brooklyn Bridge, he demanded $65,000 and decision-making power at the New York Bridge Company.

That Tweed ran a rotten city government was no secret. "[The] general corruption in respect of the local funds appears to be stupendous . . ." observed Charles Dickens in 1867. George Templeton Strong complained in December 1868: "To be a citizen of New York is a disgrace. . . . The New Yorker belongs to a community worse governed . . .

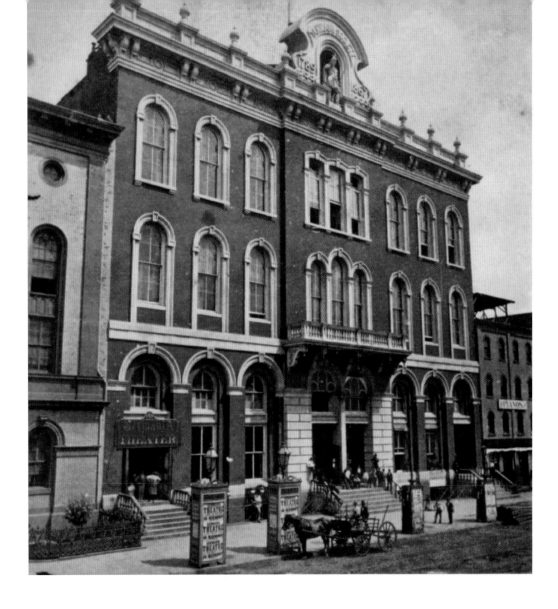

than any city in Western Christendom, or in the world." But Tweed's duplicity was tolerated for practical reasons. Well-off Protestant residents generally looked the other way, because Tweed had defused the anger of Irish immigrants and no one wanted to deal with another uprising of rampaging mobs. Also, the value of their real estate continued to skyrocket.

Immigrants, the poor, and the working classes backed Tweed because he distributed so much aid their way: turkeys at Christmas, money for coal in the winter, festivals and tickets to the circus. His public works projects and civil service jobs offered paychecks to thousands of men, and labor had his back because he supported the eight-hour workday. Tweed may have worn a diamond stickpin

on his shirt and resided in a Fifth Avenue mansion, but he knew how to win over the average New Yorker.

Two things led to his downfall. One was the Orange Riot of 1871. The Orange parade was an annual event held every July in which Irish Protestants marched up Eighth Avenue celebrating a Protestant victory in mostly Catholic Ireland from the seventeenth century. Tensions between Irish Protestants and Catholics persisted in New York and in 1870 the parade attracted Irish Catholic rioters and led to eight deaths. Tammany Hall allowed the 1871 parade to proceed with a heavy police and militia presence. But that didn't stop packs of Irish Catholics from shooting at and beating the marchers as they passed 25th Street. Sixty people from

Tammany Hall's "wigwam," or headquarters, on East 14th Street in 1880. The Tweed Ring broke apart in the 1870s, and Tweed himself died in the Ludlow Street Jail in 1878. But after a housecleaning and new leadership, Tammany corruption and patronage continued.

both sides were killed, and Protestant elites lost confidence in Tammany Hall's ability to quell rowdy Irish Catholics.

Also in July of 1871, with the Orange Riot still making headlines, the *New York Times* ran a series of articles demonstrating how Tweed had stolen millions from the city. The *Times* had been hammering Tweed for months, but the exposé prompted public calls for a city investigation. In October, Tweed was arrested. On November 1, 1871, the *New York Sun* printed this blistering indictment: "Mr. Tweed is identified with the greatest robberies recorded in the history of mankind. From the treasury of this city sums of money have been robbed upon fraudulent bills and by the aid of forged endorsements, varying in amount, according to the estimates of the experts who have examined the accounts, from six million to 20 million dollars. . . . Nevertheless, there is no doubt who it is that is most guilty."

To his critics, Tweed reportedly bellowed, "What are you going to do about it?" He got his answer in 1873, when he was indicted for forgery and larceny. Despite strong support from his base, he was put on trial; the jury deadlocked. After a retrial, he was sentenced to twelve years in prison. "The powerful influences which so long shielded the Tammany thieves from the penalties of the law have at last been overcome, and it is now possible to mete out to all of them the punishment they so richly deserve," wrote the *New York Times* on November 27, 1873. "There is no cause to doubt these officials, and the public have reason to hope that in the end justice will overtake all of those shameless and daring robbers who gained power by unparalleled frauds upon the ballot-box, and used it to enrich themselves out of the public Treasury."

Tweed didn't disappear quietly. After serving a year at the Ludlow Street Jail, which he ironically had helped build, his sentence was overruled. He was re-arrested on civil charges and sent back to Ludlow Street, but on a visit home in 1875, although accompanied by a prison warden, he managed to escape and flee to Cuba and Spain. Incredibly, he was spotted (and identified via a Thomas Nast cartoon) and delivered back to Gotham. He promised to tell all in exchange for a merciful sentence, but Tweed died of pneumonia behind bars at Ludlow Street in 1878 before his trial began. "I hope they are satisfied now," he told his doctor as he lay dying in his cell, according to the *Sun*. He was buried in Green-Wood Cemetery in Brooklyn. A testament to his power grabs and patronage, the Tweed Courthouse, built with stolen and siphoned money, still stands on Chambers Street.

Tweed's legacy is mixed. Some regard him as the ultimate thieving politician; others say that despite the pockets he lined, he protected his poor and working-class constituents in a way that traditional government would not, and his public works projects set an example for progressivism and helped improve the infrastructure of the city. Of course, his demise wasn't the end of Tammany corruption and vote-buying; the machine would wield power for decades, buying off city officials who would look the other way and ignore patronage and fraud on Election Day. But no subsequent leader was as brazen and brilliant a political animal as Tweed. His shamelessness inspired this rhyme, "Boss Tweed Escapes!" from a popular ballad:

THERE WAS TWEED
Under his rule, the ballot box was freed!
Six times as big a vote he could record
As there were people living in the ward!

Political Cartoonist Thomas Nast Takes Down Tammany Hall

As an illustrator for the top periodicals of post–Civil War New York, Thomas Nast perhaps had more influence than most of the newspaper writers penning articles and editorials from Park Row.

Born in Germany, Nast arrived in New York as a child during the great wave of German immigration in the 1840s. He grew up on William Street—not far from City Hall, Five Points, and Park Row's many newspaper offices. Nast began his career in 1855 at *Frank Leslie's Illustrated Newspaper*. A Republican progressive, he earned fame thanks to his vivid, allegorical images of Civil War battles and the New York City draft riots. After the war, he created the first images of modern-day Santa Claus and the Republican elephant.

His most famous works, however, were his savage portrayals of Boss Tweed and the corrupt Tweed Ring, which debuted in *Harper's Weekly*. Disgusted by Tweed and his cronies, Nast ridiculed members of the Ring as mice, tigers, and vultures; his images of Tweed as a power-hungry, sleazy politician, most notably with a bag of money for a face, seriously annoyed the head of Tammany Hall. "Stop them damn pictures," Tweed reportedly said. "I don't care what the papers write about me. My constituents can't read. But, damn it, they can see the pictures." In 1871, Tweed offered Nast a $500,000 bribe if he'd quit and move to Europe. That only compelled Nast to create more damning cartoons of Tweed and his pals.

Nast's campaign, along with a series of articles by the *New York Times,* led to an 1871 investigation into Tweed's activities that ultimately put him behind bars for the rest of his life. Even when Tweed managed to escape from the Ludlow Street jail and flee to Spain in 1876, Spanish officials were able to identify the American and turn him over to New York City authorities thanks to Nast's political cartoons.

William M. "Boss" Tweed was skewered for years by cartoonist Thomas Nast in the pages of *Harper's Weekly*, and that didn't stop even after Tweed's 1871 arrest on larceny charges. "Can the law reach him? The dwarf and the giant thief," the caption reads. Nast is credited with helping to take down Tweed and put an end to his corrupt ring.

Economic Collapse in the Two New Yorks

In hindsight, it's easy to see the inevitable. Bloated markets engineered by greedy industrialists, combined with a national financial scandal in Washington under President Ulysses S. Grant, slowed the flow of railroad financing. Tweed's corrupt regime had left the city in deep debt, too.

The final blow came with the failure of the banking house Jay Cooke & Co. Cooke's firm had been the chief financier of the Union Army and was now a major investor in railroads. When markets stalled and bond prices sank, Cooke couldn't meet loan payments. His firm declared bankruptcy on September 18, 1873, immediately setting off bank runs, a ten-day closure of the New York Stock Exchange, and a worldwide depression that officially ended in 1879 but took more than two decades to truly cease.

"Terrible panic of Wall Street," wrote William Steinway in his diary. It was September 19. "Many prominent firms fall, and runs on banks . . ." On September 30, he commented, "Financial crisis seems to have reached all parts of the country, it looks very badly." On October 2: "Financial situation growing worse for mercantile circles." Steinway seemed to be realizing what the rest of the city was also coming to terms with: this wouldn't be a problem for New Yorkers only, but a far-reaching financial catastrophe.

The *New York Herald* reported from the Fifth Avenue Hotel: "By nine o'clock the corridors were densely crowded with the bull and bear fraternity, and the most startling rumors had gained general credence, to the effect that three trust companies would shut their doors today. A leading broker remarked, 'If that is true, hundreds will be ruined, and the occupation of Wall Street will be gone.'"

New York had experienced recessions before, but the crash was the first of the Industrial Age. Thousands lost everything. Eighty-nine of the 364 railroads throughout the country went bankrupt. Eighteen thousand businesses failed, and the national unemployment rate in 1876 hit 14 percent. New Yorkers who had amassed enough wealth retreated to Fifth Avenue mansions, private clubs, and summer homes. Tradesmen who had won the eight-hour day a year earlier found themselves jobless—and blamed by some for their unemployment. "It is a cause of regret that so many men should be deprived of situations on the verge of cold weather . . . [but] by their combinations and dictations they have raised the cost of production enormously, put the prices of everything artificially high, and left the proprietors but little room for profit; and the moment the least financial disturbance occurs, many of these employers are obliged to fail, or turn most of their hands adrift," one newspaper finger-wagged on October 4.

The Panic of 1873, which left an estimated 25 percent of the city out of work and swelled the number of evictions, highlighted the deep gap between New York's rich and poor. "We are reaching the end of a wild era of speculation, and we are reaching it, perhaps out of necessity, through individual suffering and sorrow," wrote the *Brooklyn Daily Eagle*.

Riot in Tompkins Square Park

In January 1874, working-class New Yorkers were angry. The recession that had started four months earlier had eliminated jobs; 110,000 men were out of work. City officials turned a deaf ear on calls to create a public works program. The growing "work or bread" move-

ment was sweeping economically battered cities nationwide, and it took hold among New York's lower-income workers as well. At the time, no labor laws or consistent social safety nets existed to help struggling residents—and wealthier New Yorkers were

ideologically opposed to the city offering any kind of relief.

So the Committee of Safety— an umbrella group of unionists, socialists, and labor reformers— called for a demonstration. It was advertised in newspapers as a "monster mass meeting of the

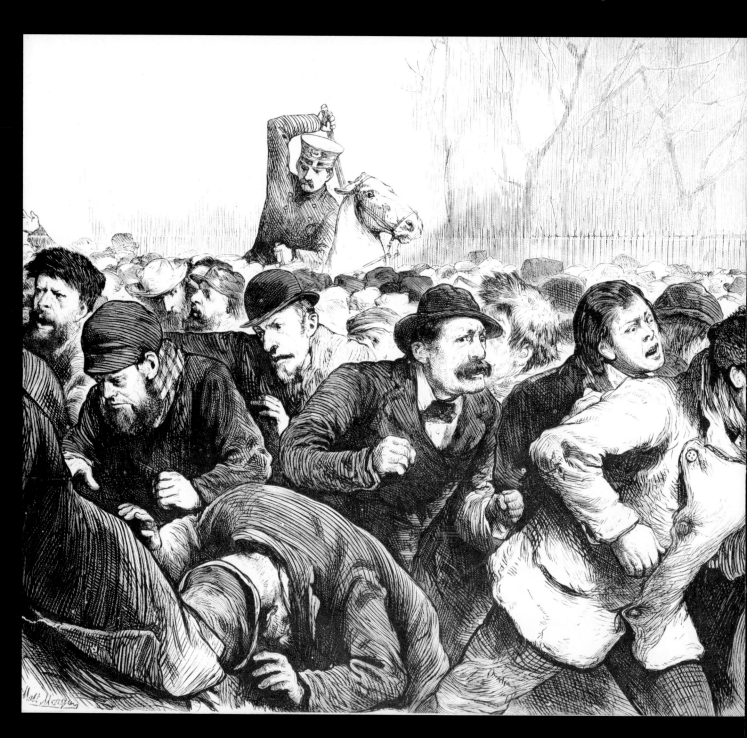

unemployed" in Tompkins Square Park, followed by a march on City Hall. At the time, Tompkins Square was a swamp-turned-park that had doubled as a military parade ground during the Civil War. Often the site of rallies, it was the center of an increasingly crowded district of tenements populated by Irish and German shipbuilders and other laborers.

On the bitterly cold morning of January 13, workingmen's groups, made up mostly of Germans but also of Irish, Polish, French, and American-born men, assembled at the park. They didn't know that overnight, the city had secretly rescinded their permit to hold a demonstration, and it sent mounted police to disperse the seven thousand marchers. At 11:00 A.M., violence broke out. A young Samuel Gompers, the future labor leader, observed the incident.

"By the time the first marchers entered the Square, New Yorkers were witnessing the largest labor demonstration ever held in the city," wrote Gompers in *Seventy Years of Life and Labor*. "When the demonstrators had filled the square, they were attacked by the police. 'Police clubs,' went one account, 'rose and fell. Women and children went screaming in all directions. Many of them were trampled underfoot in the stampede for the gates. In the street

bystanders were ridden down and mercilessly clubbed by mounted officers.'"

More than forty arrests were made. City newspapers generally dismissed the marchers as "foreigners," "communists," and fomented by "idleness." On January 14, the *New-York Tribune* put their coverage on the front page, calling the marchers "reckless." At Tompkins Square Park there were "a large number of idle and vicious men who were gathered on the ground, conversing in little knots, and frequently their whispers swelled to loud and angry tones, the import of which was revealed by the threatening doubling up of fists toward the policemen who were stationed not far away."

The *Brooklyn Daily Eagle* put an anti-immigrant spin on the riot two days after it had ended: "The riot in New York was the natural sequence of the distress caused among the laboring classes by dull times and no work, but the trouble was fomented by the foreign workmen who have come to this country, bringing with them their Communist principles."

In the immediate aftermath, the nascent movement for workers' relief lost momentum. With private charities overwhelmed, the poorer classes were often left to fend for themselves.

Samuel Gompers wrote that "mounted police charged the crowd on Eighth Street, riding them down and attacking men, women, and children without discrimination. It was an orgy of brutality. I was caught in the crowd on the street and barely saved my head from being cracked by jumping down a cellarway."

With nowhere to go, the poor and working class bore the brunt of the crisis. An estimated 25 percent of the city's one million residents were out of work. Thousands were evicted. Thanks in part to Tweed's corruption, in 1874 the Department of Public Charities and Correction ran out of funds to distribute to needy families. Cash relief was handed out again in 1875, then shut off permanently a year later. Private charities stepped in instead.

Men with no jobs became angry, restless, and desperate, leading to a bloody riot at Tompkins Square Park in January 1874 and another in 1877. New Yorkers were realizing that the financial gulf between workers and those who employed them appeared wider than ever. Dividing the classes even more was a new kind of homelessness that appeared on city streets: that of the idle "tramp," a single man roaming the city for food and shelter with no connection to family or work. Middle- and upper-class New Yorkers feared the city would be soon overrun with vagrants.

On February 9, 1874, months after the Panic set in, the *New York Herald* commented, "The story of the destitution prevailing among the poor of New York which we publish today will startle our well-to-do readers in their comfortable homes. It is not pleasant to reflect that there are two New Yorks, the one plunged in the most abject misery, wanting all the necessaries of life, shivering from cold, borne down by disease, crowded into the unwholesome tenement houses of the poor quarters, which are now, in truth, dwellings of sorrow and affliction.

"Yet while the prosperous citizens go merrily over the beautiful snow to the music of tinkling bells, the poor, huddled together in fireless rooms, chatter and shiver in the piercing night winds, slowly starving to death. . . . In the midst of plenty they starve, and the pangs of hunger are rendered more difficult to bear by the sight of the good things they must not taste."

Industry collides and explodes in Thomas Nast's take on the Panic of 1873, triggered by the bankruptcy of government bond agent Jay Cooke & Company, backer of the Northern Pacific Railroad.

In the best of times, Mulberry Street was a poor neighborhood, but the effects of the recessions of 1873 and 1893 made residents, many who worked as vendors, laborers, and ragmen, even more desperate.

The Rise of the New Rich

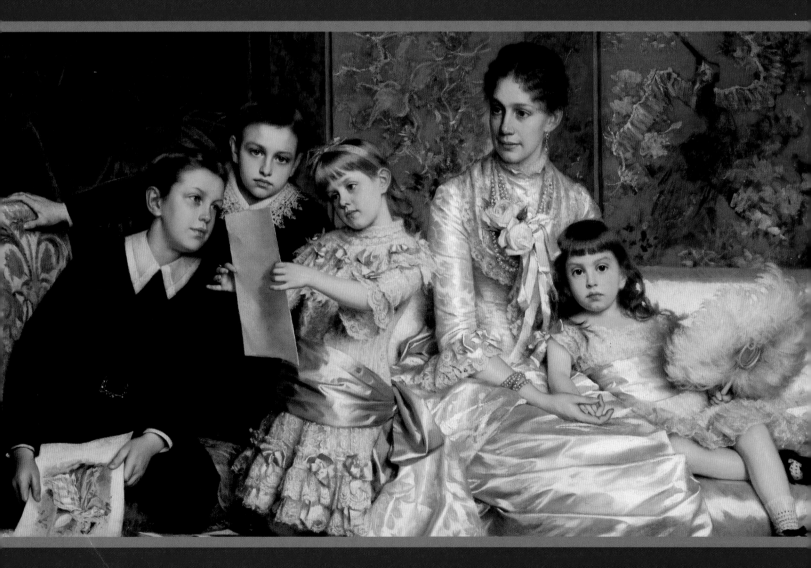

In 1880, Mrs. Cornelia Ward Hall, wife of millionaire John H. Hall, commissioned noted Italian painter Michele Gordigiani to compose a family portrait of herself and four of her children, dressed in their finest silk and lace in sumptuous surroundings.

Old Money vs. the New Rich

S ociety in New York has become the
most extravagant in the world," wrote
James D. McCabe in his 1882 book
New York by Gaslight. Like many journalists
at the time, McCabe was astounded by the
way the "mad race for wealth," as another
observer called it, transformed social and
domestic life in the city. "No where on the
globe are such immense sums spent. Extrav-
agance is the besetting sin of metropolitan
social life. Immense sums are expended an-
nually in furnishing aristocratic mansions,
in dress, entertainments, and in all sorts of
folly and dissipation. . . . Each member of
society strives to outshine or outdress his or
her acquaintances, and to do so requires a
continual struggle, and a continual drain on
the bank account."

New York has always had its exception-
ally rich. But as the Gilded Age progressed,
the gap between the silk-stocking set and
everyone else—the comfortably well-off,
the middle and working classes, and the
poor—stretched wider than ever. "The
wealth concentrated in the hands of resi-
dents of New York is almost inconceivable,"
stated Moses King in *King's Handbook of New
York City,* published in 1892. "Many vast
fortunes have been made here; and many
enormously wealthy Americans have come
here to live and enjoy the fortunes accu-
mulated elsewhere." According to King, "at
least two New-Yorkers are worth more than
$100,000,000 each; six more have above
$50,000,000 each; more than thirty are
classed as worth between $20,000,000 and
$40,000,000; and 325 other citizens are rated
at from $2,000,000 to $12,000,000 each."

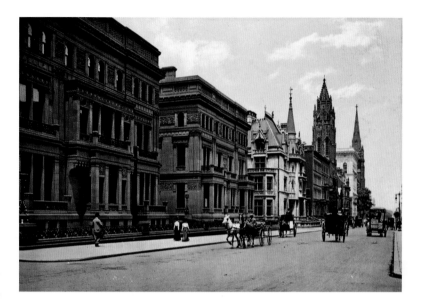

The very rich were not a unified group.
Two distinct factions battled for social su-
premacy: old money and the new rich. Old
money viewed themselves as "the old Knick-
erbockers," the descendants of the original
Dutch families who arrived in Manhattan in
the seventeenth century. "[They] have fine
houses generally, in town and country, have
carriages and furniture with crests, though
their forefathers sold rum in Hanover Square,
or cast nets in the East River," wrote Junius
Henri Browne in 1869's *The Great Metropolis:
A Mirror of New York*. Old-money gentlemen
didn't have careers. They may have dabbled
in business, but they lived off the proceeds of
land that family members had the foresight
to buy generations earlier.

These Knickerbockers wore coats of arms
and went on solemn drives in Central Park in
their "heavy chariots." They spent summers
in Newport, Rhode Island, in palatial homes
they referred to as cottages. Many remained
in posh enclaves such as Stuyvesant Square
and Gramercy Park, even though the fashion

Looking north on Fifth
Avenue at 51st Street at
the turn of the century
is the Vanderbilt family
"triple palace," three
distinct mansions in
one that were home to
the families of William
H. Vanderbilt and his
daughters Margaret
Vanderbilt and Emily
Vanderbilt. Vanderbilt's
son William and his
wife, Alva, occupied the
Richard Morris Hunt–
designed châteauesque
mansion across 52nd
Street; this was the site
of Alva's heralded (1883)
masquerade ball.

Delmonico's, opened by two Swiss brothers in 1827 on William Street, was the grandest restaurant of Gilded Age New York. Its early success encouraged other first-class French restaurants to open in the metropolis, ushering in the popularity of haute cuisine. For most of the nineteenth century, Delmonico's menus were also printed in French, a language its upper-crust patrons were likely to be somewhat familiar with. Dishes often had American inflections, such as "Terrapene à la Maryland," and the vegetables came from a large garden the restaurant owned in Williamsburg, Brooklyn, so it could grow its own produce.

Delmonico's kitchen at Fifth Avenue and 44th Street in 1902. This location was as elegant as the two previous Delmonico's, at 14th Street and Fifth Avenue and at 26th Street and Fifth Avenue, seen here, yet it had one modern convenience—electricity.

was to relocate to Fifth Avenue. "They are frequently persons of cultivation, and were it not for their affectation of superiority, would, as a class, be decidedly clever people—even if many of them are stupid," wrote McCabe. "They are extremely exclusive, and rarely associate with any but those who 'can show as pure a pedigree.' Their disdain for those whose families are not as 'old' as their own is oftentimes amusing, and subjects them to ridicule, which they bear with true Dutch stolidity."

While old money congratulated themselves on their lineage in the ballroom at Delmonico's and the barroom at the Union Club, the second group, the new rich—the so-called shoddyites, who prospered during the Civil War selling subpar goods or in the postwar boom on Wall Street—pressed their noses to the glass, hungry for social acceptance. "They constitute the majority of the fashionables, and their influence is felt in every department of domestic life," wrote McCabe. "They are ridiculed by every

satirist, yet they increase. . . . They occupy the majority of the mansions in the fashionable streets, crowd the public thoroughfares and in [Central Park] with their costly and showy equipages, and flaunt their wealth so coarsely

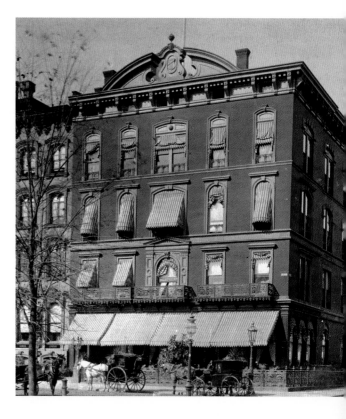

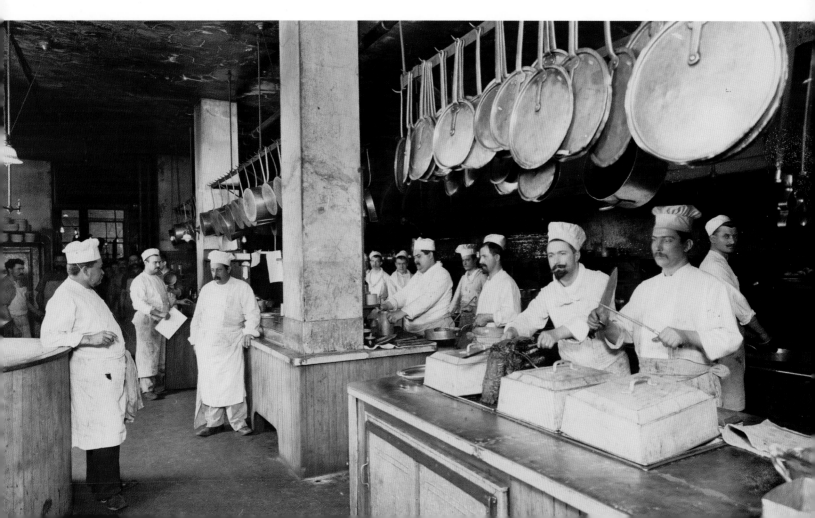

The Summer "Cottages" of New York's Richest Families

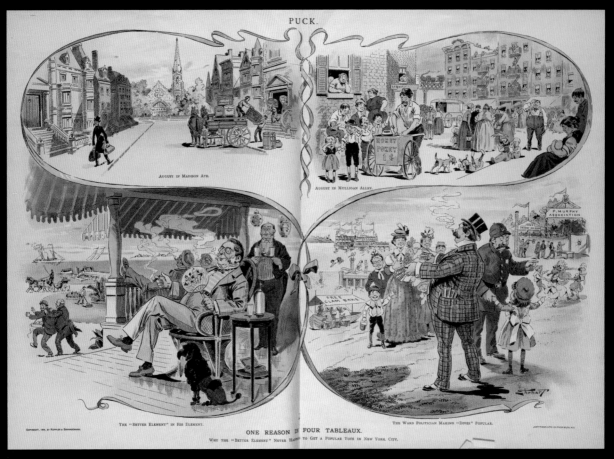

PUCK.

AUGUST IN MADISON AVE.

AUGUST IN MULLIGAN ALLEY.

THE "BETTER ELEMENT" IN HIS ELEMENT.

THE WARD POLITICIAN MAKING "DIVES" POPULAR.

ONE REASON IN FOUR TABLEAUX.
WHY THE "BETTER ELEMENT" NEVER HAPPENS TO GET A POPULAR VOTE IN NEW YORK CITY.

While New York's "better element" depart their Madison Avenue mansions to summer by the sea, the poor remain in the overheated city—where politicians buy their votes with free amusements, as this *Puck* cartoon from 1900 suggests.

Every June, the most prestigious families of the Gilded Age city relocated their social swirl to Newport, Rhode Island, a breezy seaside resort on an island between the Atlantic Ocean and Narragansett Bay. Before the Civil War, Newport attracted Southern planters looking for relief from the Georgia and Carolina heat. By the 1870s, it was the summer seat of New York society, where the Astors, Vanderbilts, and other families went about hosting balls, cotillions, and dinners with the same snobbishness as if they were in Manhattan.

The "cottages" they lived in, as they called their mansions, were beautiful monuments to wealth and power. Mrs. Astor bought Beechwood in 1881; she dropped two million dollars refurbishing it and held her annual summer ball there. After finally breaking into the Four Hundred in the 1880s, Alva Vanderbilt and her husband, W. K. Vanderbilt, moved into the enormous Marble House, a white Federal-style mansion that required 500,000 cubic feet of marble during construction. Mamie Fish commissioned "Crossways," a cliffside colonial estate where she ended the summer season with her annual Harvest Festival Ball. Cornelius Vanderbilt II and his wife Alice built "The Breakers," perhaps the most extravagant mansion of all, a seventy-room Renaissance-style palazzo.

The society goings-on in Newport were chronicled obsessively by the papers on Newspaper Row. While sweltering in their tenements and modest flats, New York-

ers could read about the outdoor parties overlooking the water and the carriage rides the rich took along Bellevue Avenue. Newport had all the trappings of wealth, the papers wrote. But it was also shallow and restrictive.

"Of course, the majority of the fortunate ladies and gentlemen who live in their own houses, drive tandems, ride English hunters, and belong to 'the set' have, after a fashion, a very pleasant time here," commented the *New York Times* in June 1877. "It must be remarked, however, that the fashion is a somewhat peculiar one. It consists chiefly in bringing city manners, habits, and customs into the country. The people referred to do not bathe in the ocean . . . they do not walk, they do not row, they seldom sail, and if they fish they hire men to bait their hooks for them. They strictly observe all the formalities and ceremonies of city life—drive out in the afternoon— and, I had almost forgotten their principal occupation—they dress themselves two or three times a day, and in the evening the ladies criticize each other and talk about their clothes. This is the sum and substance of summer life in Newport."

Alice Gwynne Vanderbilt (wife of Cornelius Vanderbilt II) hosts a charity bazaar in Newport in 1900. From June through September, New York society relocated to Newport, where they resumed the same swirl of balls, parties, and charity events as in New York City.

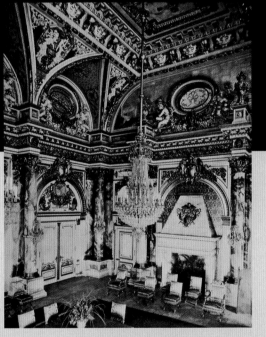

An interior room in the Breakers, the most opulent and ornate mansion in the summer society colony at Newport.

The Breakers was the Newport, Rhode Island, summer home of Cornelius Vanderbilt II. Completed in 1895, it was another Richard Morris Hunt beauty, designed to look like an Italian Renaissance palace and perched on thirteen acres of cliffside property overlooking the Atlantic Ocean.

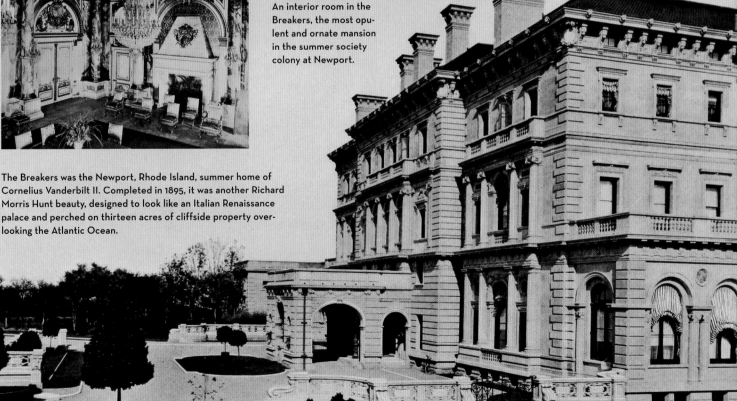

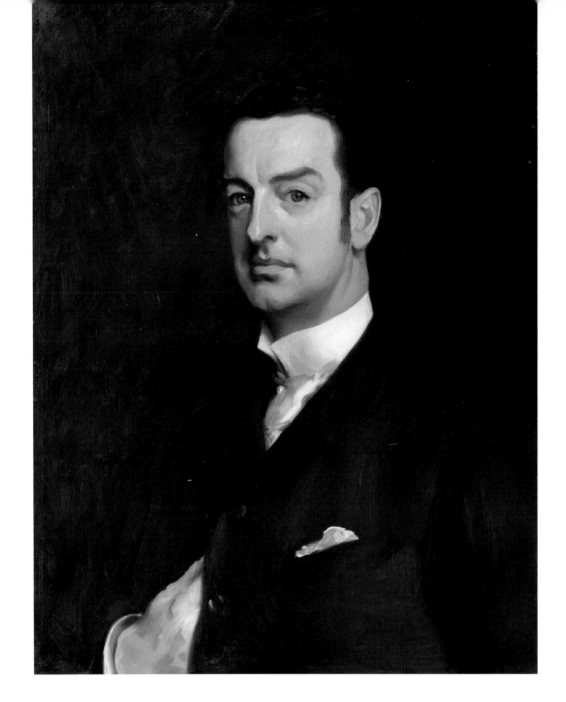

John Singer Sargent's 1890 portrait of Cornelius Vanderbilt II, grandson of railroad magnate Commodore Vanderbilt and a prominent member of the new rich that tried to buy their way into the city's old money society. Sargent was kept very busy during the Gilded Age painting portraits of the city's power brokers and their families.

and offensively in the faces of their neighbors, that many good people have come to believe that riches and vulgarity are inseparable."

The contempt old money had for these arrivistes, who "perfumed the air with the odor of crisp greenbacks," one newspaper sneered, caught the eye of Mark Twain. "The old, genuine, travelled, cultivated, pedigreed aristocracy of New York," wrote Twain in 1867, "stand stunned and helpless under the new order of things. . . . They find themselves supplanted by upstart princes of Shoddy, vulgar and with unknown grandfathers. Their incomes, which were something for the common herd to gape at and gossip about once, are mere livelihoods now—would not pay Shoddy's house rent."

Poking fun at the social pretentions of the new rich was a popular pastime. Critics around the country took shots at their coarse manners and morals. "They are very fond of frequenting the watering places, notably Saratoga—they do not affect Newport, where Knickerbocker or Mayflower blood, backed by a big income, asserts itself—and of attracting attention by their gaudy turnouts and their miscellaneous prodigality," read the front page of a newspaper in North Carolina

in 1884. "The members of other circles rigorously avoid these shoddyites, as they are commonly called, and the shoddyites have, therefore, little society save of their own sort."

Their attempts to enter society were thwarted by the doyennes of old money, who closed ranks and shut them out. "The old Knickerbockers, as they style themselves, insist upon it that they should have the first place in society; and, as most of them inherited real estate from their ancestors, that they were too conservative to sell, and too parsimonious to mortgage, they can support their pretensions by assured incomes and large bank accounts, without which gentility is an empty word, and fashion a mockery and torment," wrote Browne. The battle between old and new money kept the society pages buzzing for decades—and symbolized the rottenness behind the gilded facade of the late nineteenth-century city.

The Queen of New York Society

The self-appointed grande dame of New York's social swirl was Caroline Webster Schermerhorn Astor—or Mrs. Astor, as her calling card read. She was born in 1830 to a clan with deep roots in colonial New Amsterdam that made its money in the shipping industry. Growing up, she and her family lived exceedingly well (yet unpretentiously, as Dutch tradition dictated) in the city's richest neighborhoods, first near Bowling Green and then on Lafayette Place, an exclusive area before the Civil War that had been developed on land owned by John Jacob Astor, America's first multimillionaire and the grandfather of her future husband.

Caroline Schermerhorn married William Backhouse Astor Jr. in 1852. Early in her marriage, she lent her Knickerbocker sensibility to the new home she had built on Fifth Avenue and 34th Street. Constructed in 1856 on an Astor-owned corner parcel given to the couple as a wedding gift, the "mansion," as it was called, was actually a large, refined brownstone. It had opulent interiors, drawing rooms to show off Mrs. Astor's art collection, and horse stables. But unlike the ostentatious dwellings many new-money families would soon build around her (such as department store magnate A. T. Stewart's spectacular marble-fronted palace, which went up on the opposite corner in 1870), her home was a study in understatement. Visitors to the city would never have guessed that this elegant yet restrained house would be the scene of the most exclusive social events in the coming decades.

She was always socially ambitious. But with her children grown and her husband preferring to sail his yacht in Florida rather than go to parties with his wife, the stout, homely Mrs. Astor, who wore her jet-black hair in a pompadour, took a commanding interest in the city's social scene. In the 1860s, society was led in part by her mother-in-law, Margaret Astor. When Margaret died in 1872, Caroline was ready to assert her position and create a New York aristocracy that preserved the dominance of old-money families in the face

The Opera House War

ocated on Broadway and 39th Street, the block-long Metropolitan Opera House caught fire in August 1892. Some thought it was an opportune time to redesign the architect J. Cleveland Cady's poorly thought-out interior, which Cady boasted he had designed without having ever been inside a theater before. An 1892 op-ed in the *New York Times* argued, "From the beginning the Metropolitan Opera House was confessedly a failure as a structure . . . the walls remain to remind the passer-by that a temple of art may be inartistic to a painful degree . . . unless the old lines (of the interior) are changed, the fire will certainly not prove to have been a blessing in disguise." Rebuilt in 1893, the interior featured a golden auditorium, a sunburst chandelier, and an arch around the stage with the names of six famous composers inscribed on it.

The snobbishness on the part of old-money New Yorkers toward the new rich played out in the city's most venerable opera hall. That was the Academy of Music, founded in 1854 on 14th Street just east of Union Square,

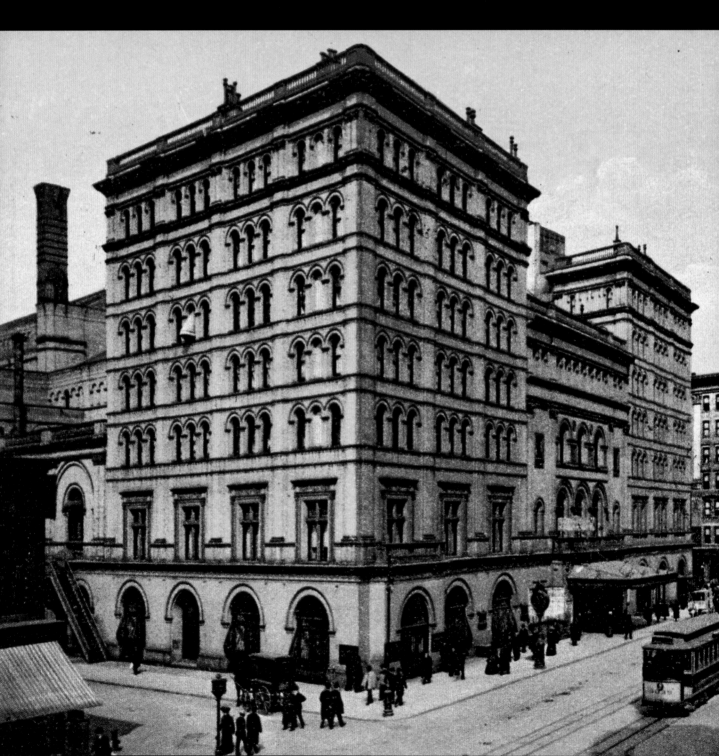

then the affluent hub of New York society.

The Academy had its faults: It was poorly lit and ventilated, and the narrow horseshoe shape made it hard for many patrons to see the performance. But seeing the opera wasn't the point—being seen was. Which is why it became the choice venue of Mrs. Astor and the rest of the Knickerbocker aristocracy, who ritualistically attended the opera there on Mon-

day and Friday evenings, arriving at the end of the first act and spending the second intermission catching up with one another.

These society men and women viewed the venue as their clubhouse. They contributed money toward building it and thus retained tight control over the eighteen box seats. Even though the Academy of Music could seat 4,600 patrons, it was the box seats that the new rich wanted— the "shabby red and gold boxes," as Edith Wharton recalled them in *The Age of Innocence*—not the floor seats, which often went empty. Stories abounded of new rich Vanderbilts or Goulds offering up to $30,000 for a box seat. But the Knickerbocker set "showed no willingness to part with them to any of the increasing number of New-Yorkers who were entitled to aspire to the financial and social distinction of an opera box," as *Harper's Weekly* put it.

So after the 1880 season, the disgruntled new money families came up with a plan. Led by Alva Vanderbilt, wife of W. K. Vanderbilt, seventy subscribers ponied up $15,000 to $20,000 each to fund their own opera house. They bought the land and hired a prominent architect, who designed a building with three tiers of box

The Metropolitan Opera House located on Broadway and 39th Street caught fire in August 1892.

seats. City newspapers excitedly covered the construction, detailing which wealthy New Yorkers—among them Jay Gould, J. P. Morgan, and Cornelius Vanderbilt II—would buy a box seat.

Opened to great fanfare in 1883, the Metropolitan Opera House, on 39th Street and Broadway, had a prime location in the new Theater District and featured thirty-six opera boxes (each valued at a minimum of $10,000!) arranged in a "diamond horseshoe" along a red and gold interior. The first day of the 1883 season coincided with opening night at the Academy of Music, and the society pages had fun comparing the crowds at each. "The first night at the Academy of Music and the Metropolitan Opera House showed that there were enough of people in New York to patronize the opera company on a great occasion, but the second night proved indubitably that both houses will lose money," commented the *Brooklyn Daily Eagle* on October 28, 1883.

The Met, as it was called, quickly overshadowed the Academy of Music and its stuffy old guard. The Academy of Music limped along, hosting an increasing number of masked balls and other nonmusical events, before finally shutting its doors as an opera house in 1886—a symbolic nail in the coffin for the Knickerbocker establishment.

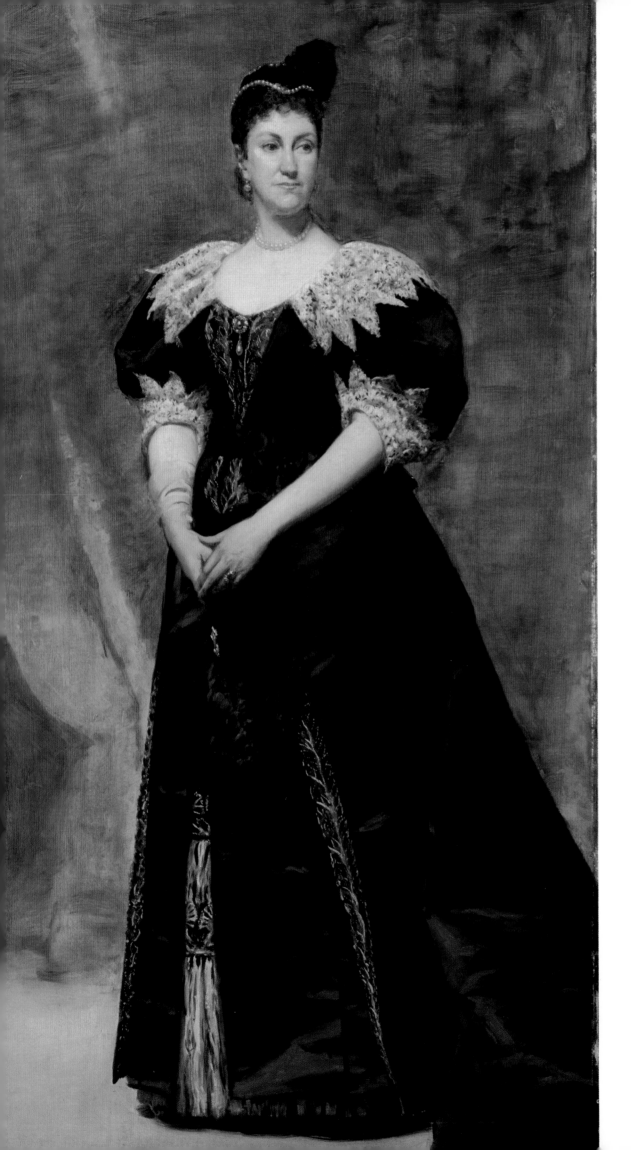

The aristocratic portrait of sixty-year-old Caroline Astor was painted in Paris by Carolus-Duran in 1890. Like other New York society women, Mrs. Astor, as she was known, spent much of each spring in her Paris residence. The portrait hung in her New York mansion; it was her custom to greet visitors while standing alone in front of it.

of all the "shoddies." Mrs Astor had another reason to take over the social calender: She had four daughters she wanted to introduce into society at extravagant coming-out parties so they could find appropriate husbands. The whole point of society was, after all, to keep wealth and power in the hands of a select number of families.

To create her "untitled aristocracy," as an observer described it, she teamed up with a character equally as obsessed with society as she was. Ward McAllister was a Georgia-born lawyer and gadfly. McAllister had family money, was married to an heiress, and had no interest in traditional work. He had lived in Europe for years before returning to New York after the Civil War, where he schooled himself in royal etiquette and traditions. The formidable, standoffish Mrs. Astor and the pudgy, pompous McAllister invented elaborate rules designed to repel the riff-raff. This queen bee and her self-proclaimed social arbiter (who also substituted for Mrs. Astor's uninterested husband when she needed an escort) created an insular world based on lineage and inheritance.

Self-appointed taste-maker Ward McAllister's comeuppance came when he published *Society As I Have Found It* in 1890. In it he wrote, "The highest cultivation in social manner enables a person to conceal from the world his real feelings. He can go through any annoyance as if it were a pleasure; go to a rival's house as if to a dear friend's; 'Smile and smile, yet murder while he smiles.'" The revealing book angered many of his old-money patrons, who valued privacy and kept their circle closed to outsiders.

The social season in New York ran from November through February. By Lent, society would head to Europe, then return to the States in May or June for the long summer season in Newport, Rhode Island, where the rules of society were once again followed. Each week during the New York season, old money gathered at weekly dinner parties at Mrs. Astor's, nights at the opera at the Academy of Music on 14th Street, horse shows, debutante balls, and "germans," or dances, typically held at Delmonico's. Invitations to hundreds of events were delivered to select New Yorkers each season.

The pinnacle events were the Patriarchs' balls. The Patriarchs were a hierarchy, conceived by McAllister, of twenty-five select "gentlemen" who descended from at least three generations of wealth and standing in New York. Each member hosted a ball, with the press reporting on the festivities in gossip columns: the elegant gowns, the expensive flowers, the twinkling golden lights, the white swans brought in from Prospect Park purely as decoration. By reading the morning newspaper, the entire city could swoon, or scoff, at the glitzy doings of the New York swell set.

"At Delmonico's last night the Patriarchs gave another of those brilliant private balls which have formed such a marked feature of the fashionable season," the *New York Times* wrote on February 10, 1880. "The society, now in its seventh year, was originally founded for the purpose of giving social entertainments of undoubted tone and exclusiveness, and embraces in its membership some forty-five to fifty gentlemen from the higher social circles in the City." The Patriarchs' balls featured men and women with last names like Livingston, Belmont, Rhinelander, and Fish. Their parties were late-night affairs, with three hundred

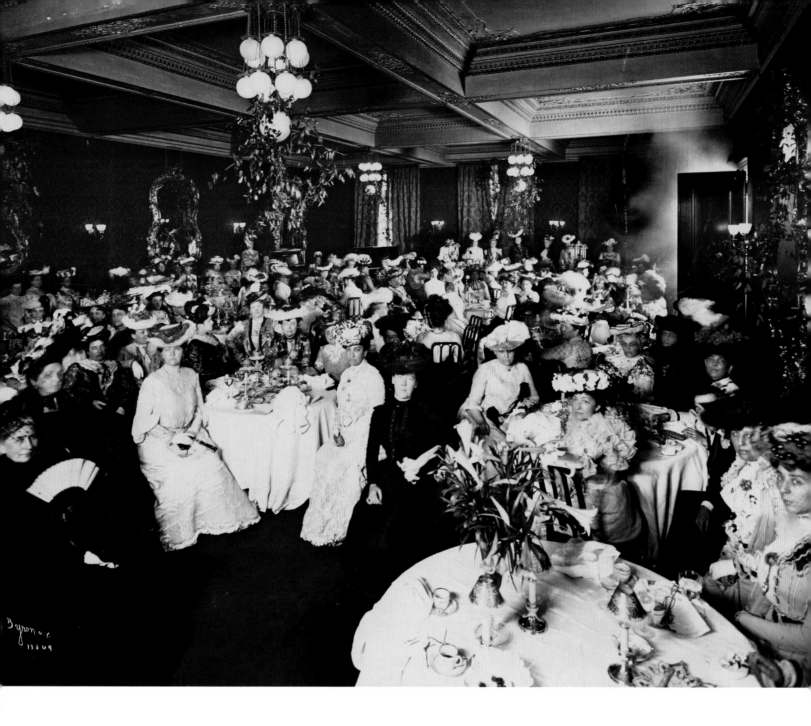

or so guests arriving by coachman-driven carriages at 11:00 P.M., having supper at midnight, and dancing quadrilles (a kind of square dance performed by four couples in a group) until 3:00 or 4:00 A.M.

Mrs. Astor held her own luxurious ball every January, in the ornate ballroom she built on to her mansion where the stables had once stood. The night of her ball, the facade of the Astor home would be ablaze in lights, and guests would walk through three drawing rooms to be greeted by Mrs. Astor sitting on her throne-like couch, her

diamond tiara perched on her head. Her silk gown, stylish with puffy sleeves and a pointed bodice, was always made by Charles Frederick Worth, the preeminent dress designer of New York society who met with his clients in his studio in Paris. As she received her guests, her life-size portrait loomed on the wall behind her.

Guests who attended Mrs. Astor's annual balls were part of the "Four Hundred"—a list of the only people in the city who mattered socially, at least according to Mrs. Astor and McAllister. The number was based on

The rich dine in an elegant private room at Delmonico's in 1890. Delmonico's was one of the first restaurants to welcome women, so long as men escorted them.

the number of people who could fit comfortably in Mrs. Astor's ballroom, McAllister later admitted. But McAllister invented a more tantalizing reason for settling on four hundred. "Why, there are only about 400 people in fashionable New York Society," McAllister told the *New-York Tribune* in 1888. "If you go outside that number you strike people who are either not at ease in a ballroom or make other people not at ease. See the point?"

Mrs. Astor's reign on the city's social calendar held strong through the 1880s. But the ironclad rules governing who gained entrance and who did not began to loosen. In 1883, she was forced to open society to the Vanderbilts after Alva Vanderbilt, wife of W. K. Vanderbilt and daughter-in-law of Commodore Vanderbilt, refused to invite Mrs. Astor's daughter, Carrie, to her own magnificent masquerade ball, which was also a housewarming soirée for her new Fifth Avenue château (see sidebar photo, page 73). To score a much-desired invitation, Mrs. Astor had to call on Mrs. Vanderbilt, an extraordinarily rich woman whom Mrs. Astor had long dismissed as coming from "railroad money." Slowly, other new money families wrangled their way into society as well.

McAllister allowed the *New York Times* to publish the list of the Four Hundred in 1892, just before Mrs. Astor's ball that year. At one time, the names (only 319, actually) would have titillated New Yorkers. Now, they were greeted with waning interest. Mrs. Astor and other society friends shunned McAllister after he published his self-important autobiography, *Society As I Have Found It,* which divulged many details about the Four Hundred. Old money may have been snobs, but they also valued their privacy. In the 1890s, the New York Social Register, a directory that began

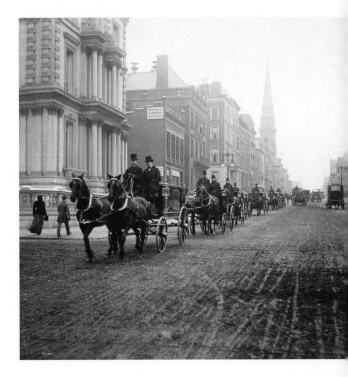

appearing in 1886, expanded the number of the socially relevant to two thousand. Being part of the cream of the crop lost its exclusivity.

McAllister died in 1895 after falling sick while dining at the Union Club. Many society swans attended his funeral at Grace Church, but Mrs. Astor was not among them; she had already set sail for her annual winter trip to France. "Ward McAllister is dead," announced the *New York World* on March 3, 1895. Of the status-conscious man the press had mocked as "McLister," the newspaper wrote: "He was the prince of American snobs, of whom he wrote so much. . . . For twenty years this Southern-born gentleman has been the factotum of New York City's swellest set and the arbiter of the way they should go."

Mrs. Astor went on playing society gatekeeper year after year and holding sumptuous balls eagerly covered by city papers. But times were changing. After the city experienced another terrible recession sparked by the Panic

The Costume Ball That Changed New York Society

In early 1883, all of New York's old-money society turned its attention to what would become one of the most notorious parties of the Gilded Age: Mrs. Alva (W. K.) Vanderbilt's "fancy dress" masquerade ball. Social butterflies kept the city's top dressmakers and tailors busy sewing elaborate costumes; young ladies gathered to practice "quadrilles," a popular ballroom dance that arranged four couples in a rectangular formation.

The Vanderbilt ball "has been on every tongue and a fixed idea in every head," wrote the *New York Times* on March 27, 1883, the eve of the ball. "Amid the rush and excitement of business men have found their minds haunted by uncontrollable thoughts as to whether they should appear as Robert Le Diable, Cardinal Riche-lieu, Otho the Barbarian, or the Count of Monte Cristo." Women, meanwhile, decided between going as royalty or a historical figure, or dressing as something more timeless: night, morning, or one of the four seasons.

Twelve hundred invitations had been hand-delivered before Lent. But Caroline "Carrie" Astor, the twenty-two-year-old daughter of society scion Mrs. Astor, had not received an invitation. The snub was a deliberate and shrewd move on Alva Vanderbilt's part. Every year, Mrs. Astor threw a lavish ball at her fabled mansion on Fifth Avenue and 34th Street. It was the social event of the season, but she only invited those she and her chamberlain, Ward McAllis-ter, deemed social equals. Alva Vanderbilt wanted to go, but year after year, Mrs. Astor refused to invite her.

By hosting her own spectacular masquerade ball at her new château-like marble mansion on Fifth Avenue and 52nd Street and not inviting Carrie Astor, Mrs. Van-derbilt forced Mrs. Astor to find out why her daughter had been

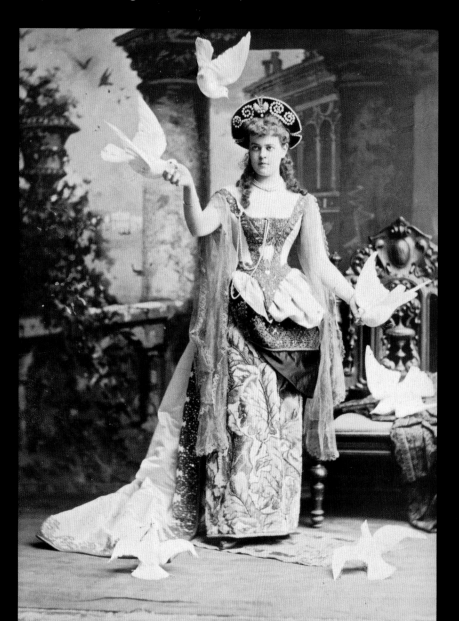

Alva Vanderbilt, wife of William K. Vanderbilt, dressed as a Venetian princess at her infamous "housewarming" costume ball in March 1883. To impress her 1,200 guests, she released live doves at the ball.

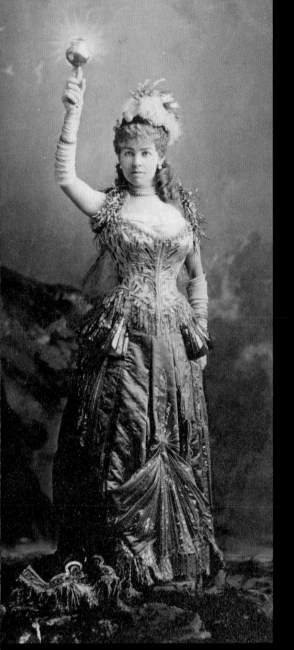

lessly wrote up the scene at the Vanderbilt mansion that night. At 11 P.M., "Pretty and excited girls and young men who made desperate efforts to appear blasé were seen to descend [from carriages] and run up the steps of the brilliantly lighted hall," wrote the *Times*. "Club men who looked bored arrived singly and in pairs and quartets, in hired cabs, and whole families drove up in elegant equipages with liveried coachmen and footmen."

The best costumes, of course, were also noted. While Alva went as a Venetian Renaissance princess and other guests came as Queen Elizabeth, Daniel Boone, and Father Knickerbocker, perhaps the most creative costume was Alice Vanderbilt's "electric light." The wife of Cornelius Vanderbilt II, Alice hired Charles Frederick Worth, the most famous and expensive couturier in Paris at the time, to design her illuminated gown. Made from white satin, velvet, and silver bullion and trimmed with diamonds, it contained hidden batteries, so Alice could flip a switch and light herself up like a torch. Her dress was an ode to the age of electricity, which the city had just entered, thanks to Thomas Edison's new power station and the electric streetlights popping up on lower Fifth Avenue.

snubbed. Alva claimed that she couldn't invite Carrie because Mrs. Astor had never made a call to her home. The social custom of calling was an important society ritual; it was a symbol that one family socially recognized another. To secure an invitation for her daughter to the most buzzed-about ball of the year, Mrs. Astor called on Mrs. Vanderbilt, and she was propelled to the top of high society.

Reporters who had staked out space outside the château breath-

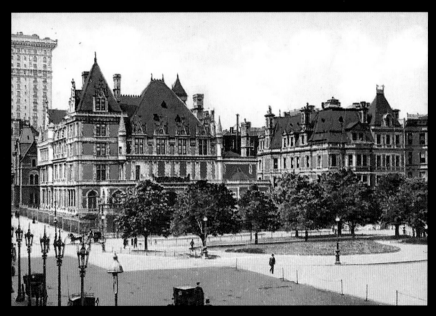

Alva Vanderbilt's showstopping château-like mansion at 660 Fifth Avenue, where her infamous costume ball was held.

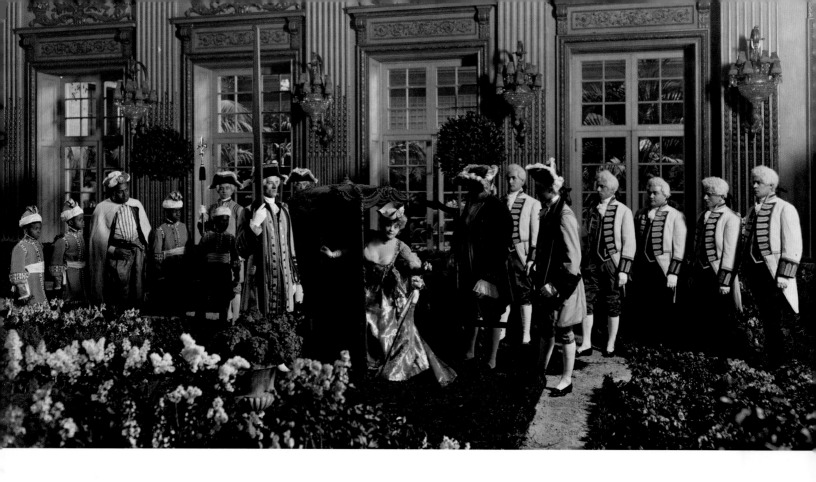

of 1893, the mood of Gotham shifted from frivolous to more somber. When the Bradley Martin Ball was held at the new Waldorf-Astoria in 1897, with seven hundred revelers dressed as kings and queens and feasting on a

midnight supper consisting of twenty-eight courses, it struck a sour chord with some New Yorkers. The same year, Patriarchs disbanded due to lack of interest.

In a magazine interview excerpted by the *New York Times* in 1908, the year of her death, Mrs. Astor sounded off from her new marble mansion at Fifth Avenue and 65th Street. "I am not vain enough to think New York will not be able to get along very well without me. Many women will rise up to take my place. But I hope my influence will be felt in one thing, and that is in discountenancing the undignified methods employed by certain New York women to attract a following. They have given entertainments that belong under a circus tent rather than in a gentlewoman's home. Their sole object is notoriety, a thing that no lady ever seeks, but, rather, shrinks from." Mrs. Astor wasn't ready to wave the white flag, but it seemed clear: The new rich had triumphed.

Insurance company heir James Hazen Hyde threw a lavish French-themed costume ball that filled two ballrooms at Sherry's in January 1905. One of the legendary parties of the Gilded Age, the ball was attended by six hundred guests, who partied in a garden decorated to resemble Versailles and danced until a third and final supper was served at seven o'clock the next morning.

James Hazen Hyde's portrait, by Theobald Chartran. Bold and charming, Hyde inherited the billion-dollar Equitable Life Insurance Society upon his father's death in 1899. When Equitable board members found out about the ostentatious and expensive ball Hyde threw in 1905, they claimed that Hyde paid for it with company dollars—triggering a scandal that forced the twenty-three-year-old to flee New York for Paris.

Living the Gilded Age Good Life

Old money and new rich could agree on one thing: To live fashionably well in New York, one needed a fortune to pay for it. "The question is very frequently asked, 'Is living in New York very expensive?' An emphatic affirmative may be safely returned to every such interrogatory," wrote McCabe. A wealthy household could expect to pony up well into the five figures to live in luxury each year. "Fifty thousand dollars per annum may be set down as the average outlay of a family of five or six persons residing in a fashionable street, and owning their residence. For those who own their houses, keep a carriage, and do not 'live fashionably,' or give many entertainments, the average is from fifteen to twenty thousand dollars." At the time, the average yearly salary in the city came in at about $2,000, putting the good life out of reach for all but a small group of fortunate residents.

The first order of business for a rich New Yorker was to purchase a house—preferably a single-standing mansion of white marble, granite, or brick, or a brownstone with an ornamental facade. Fifth Avenue was prime, but it was also the priciest. Madison Avenue to the East would do. "The dwellings are chiefly of brownstone, and rival the Fifth Avenue mansions in external and internal splendor," wrote McCabe. The cost: from $75,000 to $150,000 and upward, depending on the level of luxury. For a rich enough buyer, a mortgage could be obtained. McCabe wrote of some of the new rich living in "heavily mortgaged" homes to "provide the means of keeping its occupants in style."

With the price of a home so high, and opulent dwellings always in short supply, many well-off residents opted to live in a hotel. At the posh Fifth Avenue Hotel on 24th Street, two chambers and a parlor suite cost $30 a night. All of the first-class hotels had "hotel livers" as permanent residents; they numbered in the thousands. "None of them will receive a family for less than $6000 or $7000 per annum," wrote McCabe. As with single-family homes, the best hotels also offered living quarters with an indoor bathroom, still a luxury in New York in the Gilded Age. Up until the 1880s, only an estimated 15 percent of city residents had one.

Financier J. P. Morgan moved into this 1854 mansion on Madison Avenue and 36th Street in 1882. Situated in Murray Hill, the Morgan mansion has the distinction of being the first private home in Manhattan to have electricity, thanks to an underground steam plant. Morgan's son Jack Morgan recalled, "I still remember the . . . excitement and interest that I felt on the occasion of my return from school for the Christmas holidays in 1882 when, at the coming of dusk, the [electric] lights began to glow. That was the second time I had seen that form of light."

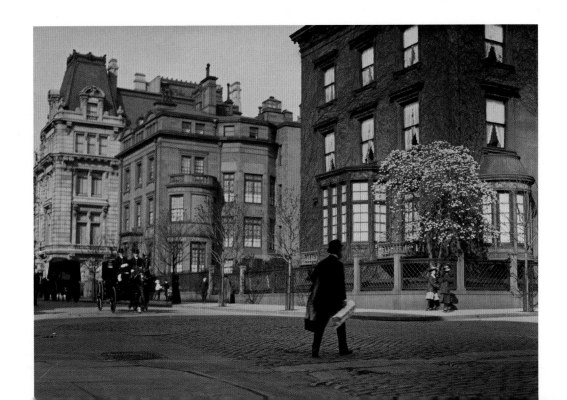

New Yorkers Conduct Business and Pleasure at New Luxury Hotels

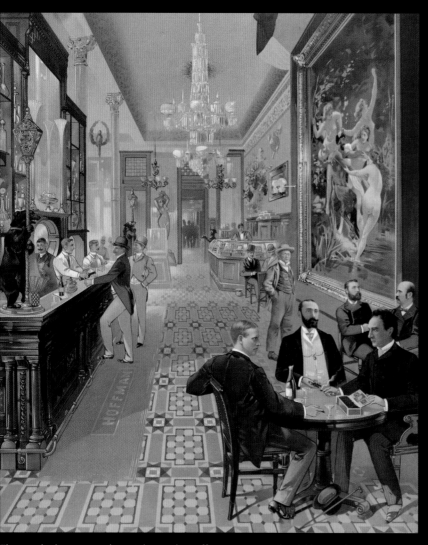

The grand saloon, or gentleman's bar, at the Hoffman House was the clubhouse of the city's top power brokers, especially Democratic politicos. Men could down cocktails (reportedly the Manhattan was invented here) and make deals with the famous *Nymphs and Satyr* painting dominating the room.

FIFTH AVENUE HOTEL

The Fifth Avenue Hotel led the way. Opened in 1859 and dubbed "Eno's Folly" thanks to its out-of-the-way location at the southwestern corner of Madison Square, it soon became the political and cultural hub of post–Civil War New York City. An elegant hotel with a primitive elevator, "no other single hotel in the world has ever entertained so many distinguished people," commented King, including heads of state and presidents. It was also a favorite haunt for Boss Tweed, Jay Gould, and Cornelius Vanderbilt.

HOFFMAN HOUSE

Built in 1864, the Hoffman House on 25th Street and Broadway became famous for its lavish, art-filled grand saloon, where the racy William-Adolphe Bouguereau painting *Nymphs and Satyr* was on display. Tourists flocked to gawk at the naked figures, which could be covertly viewed in the large mirror over the bar. "The gentlemen's café and the ladies' dining room share with Delmonico's the patronage of the wealthy and fashionable class," wrote King.

The Gilded Age saw the opening of many fashionable first-class hotels, all exemplifying the "perfection of luxurious living," as Moses King put it in *King's Handbook of New York* in 1892. The lives of the rich coalesced around them, located between 23rd and 59th streets on Fifth Avenue and Broadway: Some wealthy residents lived in hotels; others socialized in the barrooms (men only, of course) and visited restaurants before and after the theater (men and women could dine together). "Now New York has over one hundred thoroughly good hotels, with a score standing pre-eminently at the head of the list," wrote King.

HOLLAND HOUSE

Holland House arrived on Fifth Avenue at 30th Street in 1891, just as many old-money residents of the neighborhood were relocating farther north along Fifth Avenue. Holland House dazzled guests with its drawing rooms, portico driveway, and third-floor restaurant, hosting celebrities and carriage parades organized by wealthy riders called "Tally-Ho" parties. It was also just blocks from Delmonico's on 26th Street.

WALDORF-ASTORIA

In 1893, William Waldorf Astor opened the thirteen-story Waldorf Hotel on Fifth Avenue at 33rd Street, on the site of his former mansion. The grand hotel was the first to have electricity throughout and private bathrooms. Four years later, the Waldorf was linked to the seventeen-story Astoria Hotel, built by Waldorf's cousin, John Jacob Astor IV, on the site of Mrs. Astor's former mansion. The new Waldorf-Astoria opened in 1897. It was the largest hotel in the world at the time, and pioneered the idea of room service dining.

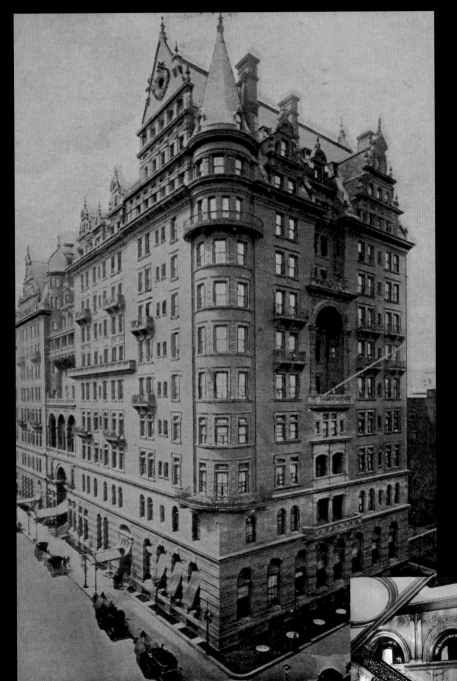

The Astoria Hotel merged with the Waldorf Hotel in 1897, and the two were joined by a marble corridor—nicknamed Peacock Alley for the many rich and powerful New Yorkers who socialized and showed off there.

"This Hotel Is a Palace," the *New York Times* proclaimed on February 13, 1893, just before the Waldorf Hotel opened its chambers to the public. Built by William Waldorf Astor (nephew of Caroline Astor, whose own mansion was next door), the hotel cost $3 million. "The design has been to provide a series of magnificent homes," the *Times* stated about the luxurious accommodations and public rooms. "The fashionable society of the town will co-operate to make brilliant the opening of the house." In three years, the equally magnificent Astoria Hotel would rise next door.

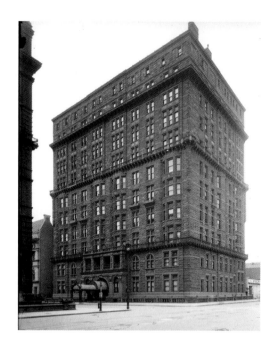

In the 1880s and 1890s, a new housing option emerged for the well-to-do: an apartment. These "French flats" became popular for middle-class families in the metropolis in the 1870s, and more luxurious apartment residences, with many chambers, bathroom, library, and servants' quarters, began catching on as well. "Apartment-life is popular and to a certain extent fashionable," wrote Moses King in 1892. "Even society countenances it, and a brownstone front is no longer indispensable to at least moderate social standing. And as for the wealthy folk who are not in society, they are taking more and more to apartments."

The highest-class residences were generally close to Central Park, such as the Osborne and the Rembrandt, both on West 57th Street, the Navarro Flats on Central Park South, and the Dakota on 72nd Street at Central Park—with amenities such as elevators, steam heating, kitchen ranges, and fireproof walls. Mrs. Astor thumbed her nose at apartment life, deriding it as "living on a shelf." But this alternative to owning a home and the expenses that come with it posed an attractive option. Rents ranged from $2,000 to $7,000,

while the cost of purchasing an apartment in one of the few cooperative buildings, like the Navarro Flats, could hit $20,000.

Once settled in a suitable living situation, the new rich spared no expense. Homes needed furniture; children required tutors and school and dance class tuition. Gentlemen paid hundreds of dollars per year to belong to elite clubs such as the Union Club, the Century Club, and the Manhattan Club. An equipage or fancy carriage ran at least $1,500. Hansom cabs could be hailed in the city for one dollar per hour, should a gentleman need to get to a dinner or a lady want to take one during a shopping trip. A comfortable household had at least two servants; the rich had a staff of them. "The wages of these per month are, as follows: cook, $16–$20; chambermaid, $12–$15; nurse, $12–$16," wrote McCabe.

Clothing was a significant expense. A fashionable woman "must have one or two velvet dresses which cannot cost less than $500 each; she must possess thousands of dollars worth of laces, in the shape of flounces, to loop up over the skirts of dresses, as occasion shall require," wrote McCabe. "Nice white

When the rusticated brownstone apartment residence the Osborne was completed in 1885, the area near 57th Street and Seventh Avenue was still sparsely populated. The Osborne was one of the first "French flats" to offer luxurious, multi-room quarters to well-heeled tenants. But apartment living was a hard sell at first. The year the Osborne opened, just twenty-nine families moved into the building's forty-eight apartments.

In 1870, Lord & Taylor moved uptown from Grand Street and Broadway to a new five-story cast-iron building on Broadway and 20th Street. The mansard-roofed store was designed by the architect James H. Giles and cost nearly $500,000. In the first three days after it opened, ten thousand customers used its steam-powered elevator. Lord & Taylor became one of dozens of emporiums in the district dubbed "Ladies' Mile."

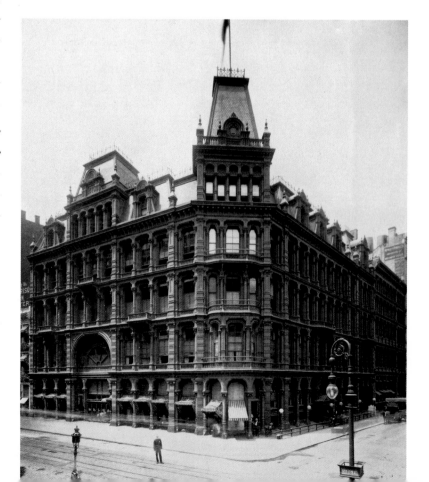

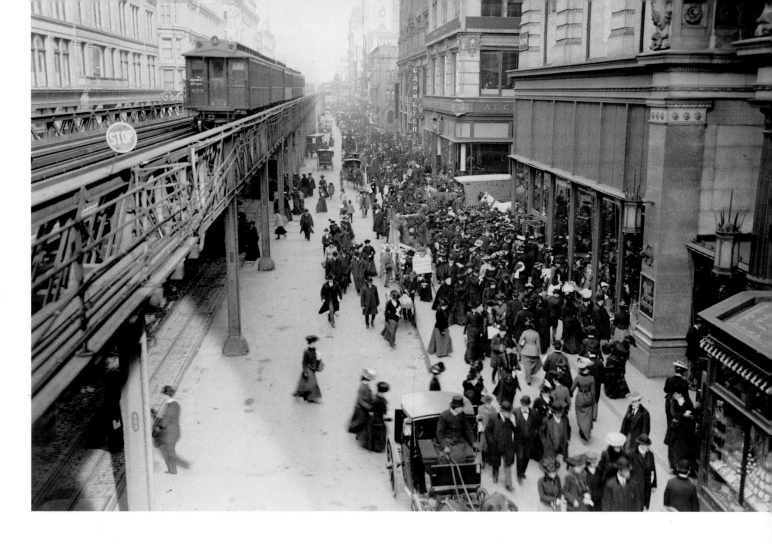

Shoppers on Sixth Avenue walk beneath the shadow of the Sixth Avenue el. The entrance to Siegel-Cooper's six-story emporium on 19th Street is seen on the right. When it launched in 1896, it was the largest store in the world. The "big store," as it was called, contained 35,000 square feet and stretched all the way to Fifth Avenue. Its neighbors along this stretch of Ladies' Mile included Hugh O'Neill's and Adams & Co., both dry goods merchants.

A. T. Stewart owned New York's most magnificent department store, at 10th Street and Broadway, seen on the right near Grace Church, at the beginning of what became Ladies' Mile. Uptown on 34th Street and Fifth Avenue, in 1870 he built himself an equally magnificent white marble mansion, with its own water tanks supplying fresh running water.

llama jackets can be had for $60; *robes princesse,* or overskirts of lace, are worth $60 to $200. . . . Then there are evening robes in Swiss muslin, robes in linen for the garden and croquet-playing, dresses for horse races and yacht races, robes de nuit and robes de chambre, dresses for breakfast and for dinner, dresses for receptions and for parties, dresses for watering-places, and dresses for all possible locations."

To purchase these fine garments, prosperous women patronized dry goods stores along "Ladies' Mile," a trapezoid-shaped shopping mecca roughly from 14th Street and Broadway to 23rd Street and Sixth Avenue. A. T. Stewart's Iron Palace was the area's southern anchor at 10th Street and Broadway. Arnold Constable and Lord & Taylor were blocks away up Broadway, while Siegel-Cooper could be found to the west at Sixth Avenue and 18th Street. The enormous Stern Brothers store on

23rd Street just off Sixth Avenue was at the north end. During the afternoon shopping hours the streets were crowded with victorias, broughams, and coupes, and a procession of well-dressed women packed the sidewalks.

A trip to the stores along Ladies' Mile was one of the highlights of Naomi R. King's

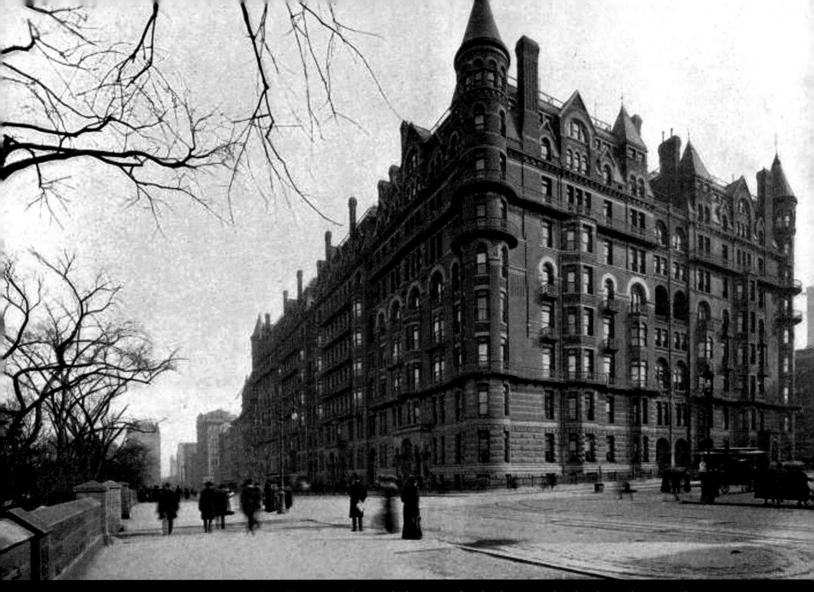

Jose Francisco de Navarro's gigantic eight-building Navarro Flats complex between 58th and 59th streets and Sixth and Seventh avenues. The separate town house–like buildings were supposed to make apartment-style living seem fashionable and appealing to rich New Yorkers, who still viewed a single-family mansion as the most luxurious type of housing. Despite the attention the co-op received, sales were slow, and the Navarro Flats were sold under foreclosure.

French Flats:
A New Kind of Fashionable Living

In the mid-1860s, New Yorkers generally had three types of living accommodations to choose from: crowded tenements (where half a million city residents lived at the time); boardinghouses, which could be luxurious and refined or poor and ill-kept; or single-family houses, expensive and always in short supply. To meet the needs of middle-class merchants and professionals, a new type of housing arose: the French flat, or apartment house.

The name of these new dwellings stemmed from their popularity in Paris, and like all things Parisian, the French flat was warmly received by the late nineteenth-century New York metropolis. "They have become the fashion, and in certain ways are very convenient," commented *Harper's Weekly* in an 1882 article. "Some of those that are very elegant bring from $2500 to $4000, and are readily taken."

That was about the going price range for a modest single home, the article noted, yet French flats offered another benefit to

mid-level-income New Yorkers. "But it should be remembered that very expensive apartments are a saving, in that they require less furniture and fewer servants, a smaller outlay of every kind, than an entire house, and at the same time enable their tenants to present an equally fair appearance in the eyes of the world."

The first to open its doors, in 1870, was the Richard Morris Hunt–designed Stuyvesant Apartments, on 18th Street between Irving Place and Third Avenue. Five stories high and featuring a handsome mansard roof, a Gothic brick and stone facade, and two entrances per apartment (one for residents, the other for servants), the Stuyvesant was a curiosity at the time. Many predicted New Yorkers would never go for life in a multi-home dwelling; it was too scandalous and lacked the privacy upscale urbanites were used to. But before it was completed, every five-room apartment had been snapped up, with rents running up to $120 per month (as there was no elevator, the higher the floor, the lower the rent).

After an interruption when the Panic of 1873 set in, more flats soon followed: the Chelsea on 23rd Street between Seventh and Eighth avenues, the Gramercy Park in that East Side enclave, the Gorham on Broadway and 19th Street, the Knickerbocker on Fifth Avenue and 28th Street. As the Upper East and West Sides opened up to development and the concept of apartment living shed the last of its unsavory associations, truly luxurious dwellings were built to appeal to the rich: the Dakota on Central Park West and 72nd Street, the Osborne on Seventh Avenue and 57th Street, and the Navarro Flats on Central Park South and Seventh Avenue.

The Navarro was a spectacular apartment complex made up of eight independent houses in a single dwelling. One of the first co-op buildings, it was designed to house Gilded Age plutocrats and featured its own well, steam heat, fireproof construction, and a rooftop solarium—in addition to high-ceiling, seven-bedroom homes. Apartments went on sale in 1882, but within fifteen years, the Navarro went bankrupt. "The sale of the Navarro Flats under foreclosure for only $200,000 more than the mortgages on them indicates unmistakably that the era of the palatial apartments in New York is already over," wrote the *New York Times* in 1888. That prediction didn't pan out, but co-op living did scare off many buyers for decades.

The Dakota, another early luxury apartment building, offered unheard-of amenities at the time of its completion in 1884, including electricity, central heating, dumbwaiters that could be sent down to a central kitchen to convey meals to residents, private croquet lawns, a gym, and a playroom for kids.

trip to New York in January 1899. Twelve-year-old King, from a wealthy Indiana family, arrived in Manhattan with her parents to visit relatives. "We got off [the Broadway car] at 23rd Street and Josie took us to the Stern Brothers, one of the large and select dry goods houses where we saw the latest fashions," King wrote in her journal. She saw "all the new spring styles [and] the new spring color: amethyst, purple, or violet in all shades [and] stripes extending to gentlemen's cravats in Roman colors." An afternoon at Siegel-Cooper, with its beautiful fountain, awed King. "It took the whole afternoon to look at the things in it," she wrote.

Fashionable garments were necessary for parties, balls, and weddings, and the rich who held these celebrations spared no expense. A society wedding was a breathtaking affair. "The Low-Pierrepont wedding came off Thursday, December 9th, and it was supremely gorgeous!" wrote Julia Newberry, a fifteen-year-old from Chicago who was spending the fall and winter of 1869–70 in New York City. Newberry was living at the fashionable Brevoort House hotel near Washington Square Park with her mother and sister, who was a bridesmaid in a society wedding in Brooklyn Heights.

"No one but invited guests were admitted [to the church], and the seats were soon filled with what the 'papers' would have called the 'elite' of Brooklyn and New York," continued Newberry. "The organ played a variety of

As Ladies' Mile expanded from Broadway between 14th and 23rd streets to Sixth Avenue during the Gilded Age, New York's biggest department stores opened new branches there to keep up with the crowds. This view east from Sixth Avenue on 23rd Street shows the Stern Brothers and Best & Co. department stores.

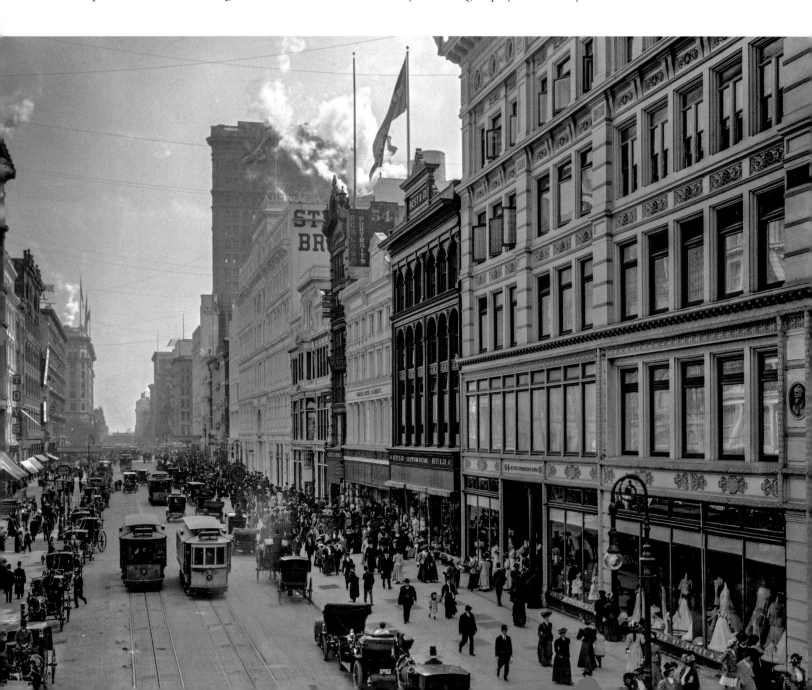

A 1900 *Puck* cartoon spoofing New York society shows a rich yet frail man thumbing through his invitations while his servants prepare his medications. This society snob isn't willing to give up his social life, even for his health.

Charles Frederick Worth was New York society's favorite dressmaker. Before the start of every social season, rich women like Caroline Astor traveled to his studio in Paris, where Worth would design their fancy dress ballgowns, along with other pieces of their wardrobes. This satin evening gown trimmed with gold lace was designed for Mrs. Calvin S. Brice in 1897.

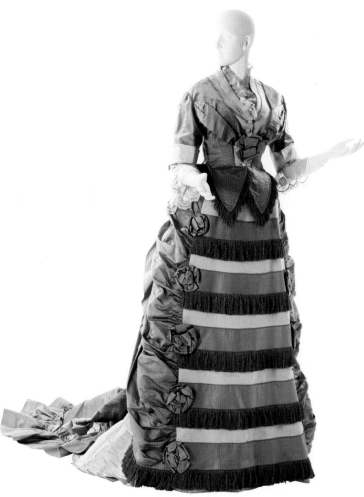

lively tunes, and finally at one o'clock swelled into a wedding march, and the bridal procession entered. . . . The great Paris 'Worth' made the [bride's] dress, and consequently nothing could be handsomer; white satin with a long train, and sprays of white orange blossoms falling all over it, and to crown all a beautiful real lace veil, made expressly for her."

The recessions sparked by the Panics of 1873 and 1893 walloped most New Yorkers. But the new rich were less vulnerable when the economy hit the skids. As unemployment skyrocketed and charities were deluged with requests, the very rich were insulated from it all. On a typical evening, "Brilliant carriages, with liveried coachmen and footmen and sleek horses, dash up and down the avenues, depositing their perfumed inmates before brilliantly-lighted, high-stooped, brown-stone fronts, whence the sound of merry voices and voluptuous music comes wooingly out, through frequently opened doors, into the chilly night," wrote Junius Browne.

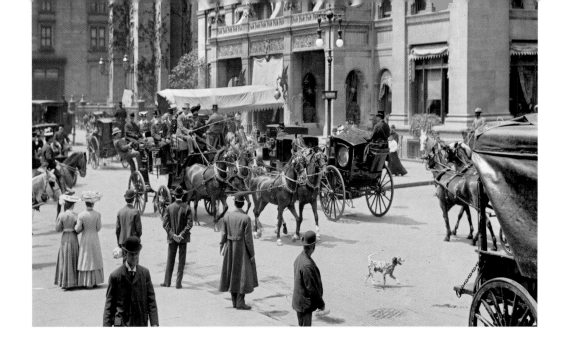

To keep themselves entertained, the rich saw A-list actors at Wallack's Theatre. They gathered in their carriages at the Holland House hotel on 30th Street and Fifth Avenue for "Tally-Ho" coaching parties. They enjoyed multi-course suppers at high-society haunt Sherry's. They took leisurely rides in horse-drawn sleighs through Central Park when the drives were blanketed with snow. They built summer castles in Newport; went to the races at Saratoga; enjoyed sea breezes in Long Branch, New Jersey; and sailed to Europe for weeks at a time in the spring. The society pages of the newspapers kept dutiful track of who was out of town and where they went.

"Something has happened. . . . I never expected it, for all along Mamma and Papa have said that we were *not* going to Europe, but now as you can guess, we are!!!" wrote Gertrude Vanderbilt Whitney in her diary in April 1890. Whitney, then fifteen, was the

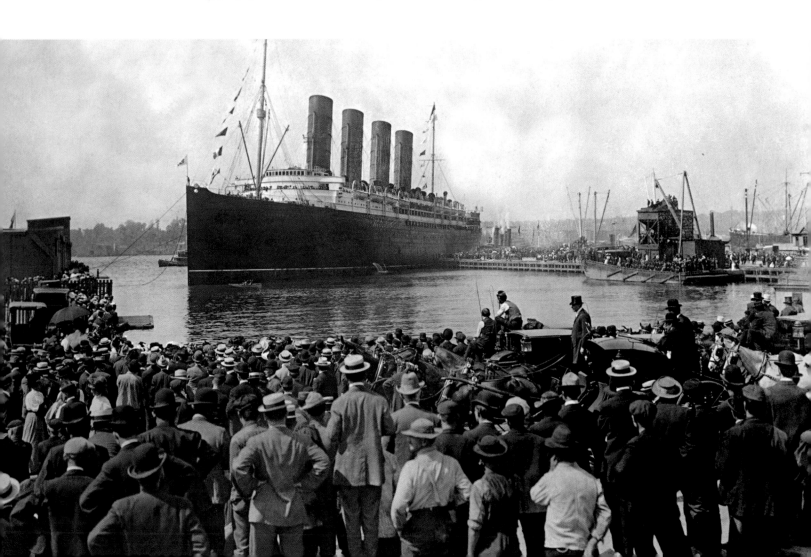

great-granddaughter of Commodore Vanderbilt; she resided in her family's château on Fifth Avenue and 57th Street. "And the Saturday after next . . . I have always longed to go for four or five weeks, and that is just what we are going to do. I am so perfectly delighted. . . . I suppose it is because I love the trip (the ocean) and then Paris!"

For folly, the rich hosted expensive dinners at top restaurants for their pets. Mamie Fish, wife of railroad magnate Stuyvesant Fish, arranged one in honor of her dog, who showed up at the table wearing a $15,000 diamond collar. They also organized parties on horseback, like the famous supper held by millionaire industrialist C. K. G. Billings for thirty-six guests in the ballroom at Sherry's in 1903. Diners sipped champagne from tubes attached to bottles in the horse's saddlebags, and they consumed their dinner from trays on their saddles. Even the horses ate; they were fed from troughs.

Many in New York felt that worshipping money was the religion of the rich. But the city's wealthy took churchgoing seriously—even if it was just another social outing. Society scions arrived in their carriages in time for 10 A.M. Sunday services at St. Thomas Episcopal Church on Fifth Avenue and 53rd Street and the Fifth Avenue Presbyterian Church on Fifth and 55th Street.

Rumor had it that the men and women who packed these pews were so flush, the ministers in each preached to $250 million every week. When church was over, the wealthy went on "promenades" up and down Fifth Avenue to see and be seen. "The congregations of distant churches all find their way to the avenue, and for about an hour after church the splendid street presents a very attractive spectacle," wrote McCabe. Then it was off to dinner back home at 1 P.M.—early, because on Sundays servants were typically given the rest of the afternoon off.

The Invisible Middle Class

In 1877, Addison Allen, a teenager from New Jersey, moved with his parents and siblings to East 127th Street, in one of the city's few middle-income neighborhoods. The diary he kept for three years offers a glimpse of what daily life was like for the families of merchants, artisans, salesmen, clerks, and other professionals who occupied the vast but not very visible middle class there, estimated at up to a third of the city's population.

Allen went to school, played ball and marbles with his friends, chopped wood for his family, picked grapes, and attended church. "Today I went to school and when I came home at two, John Van Orden came around and he and I went around to 130th Street but soon I came home, I lost my rubber ball...," he wrote on June 22, 1877. Two days later, he jotted his day down again. "This morning Walt Aaron and I went to the 130th Street church, at 2 o'clock I went to Sunday School." On July 4th, the school term had ended, and he shot off firecrackers. "I was firing off all day.... In the afternoon we had ice cream and berries and went to Central Park. They were shooting off firecrackers there in the evening."

Like other professionals at the time, his father could take a summer vacation—Allen wrote about going to the Catskills in 1877 and then the Jersey shore in 1878. When he needed clothes, he shopped at Macy's downtown with his mother. He saw the circus and a performance of *H.M.S. Pinafore*, and in the fall celebrated Thanksgiving with a turkey and mince pie. Before Christmas, the boys in his class chipped in five dollars to buy their teacher a gift. On Christmas

Day 1877, he opened his presents at home. "I got a printing press and a book, a large paper of candies, and as Auntie Harriet and Uncle Andrew came last night they gave me a nice two-bladed knife.... Mamie got a doll and a doll's carriage, some candy, a book, and a gold chain.... I have enjoyed myself very much."

It wasn't true that New York only had two classes, the rich and the poor, as James McCabe wrote in 1872. "The middle class,

Grand Central Station in 1900. This renovated and renamed building replaced the original Grand Central Depot, built by Cornelius Vanderbilt and opened in 1871. After the Civil War, trains grew in popularity, but a city law banning passenger trains south of 42nd Street meant that depots were scattered on the outskirts of the city. Vanderbilt, who earned his riches in shipping, created one centralized station, making travel more convenient and coherent—and making himself a second fortune as a railroad magnate as well.

A Broadway streetcar stops for passengers at 23rd Street in 1895. By the end of the Gilded Age, Madison Square had lost some of its luster. Wealthy residents had moved up Fifth Avenue past Central Park, though many of the grand hotels remained.

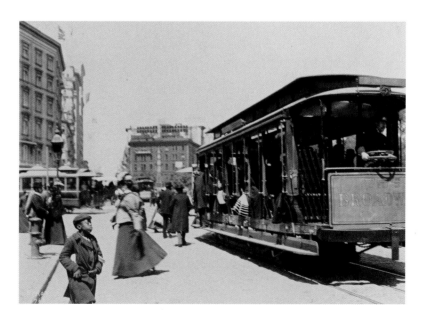

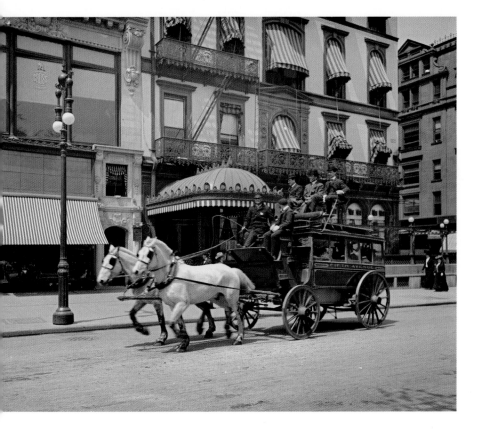

The Fifth Avenue stage passes the former Delmonico's, renamed Café Martin, at 26th Street in 1900. Delmonico's had just decamped to Fifth Avenue and 44th Street, following the flow of society uptown. The stage was one way (along with the elevated railways and streetcars) to travel up and down the avenues in Gilded Age New York. "On the stage I rode by choice on the outside, either perched up behind the driver or, if I was lucky, along side him," recalled Hamilton Fish Armstrong, who was a schoolboy in the turn-of-the-century city. "You mounted to this vantage point by the hub and two widely spaced iron footholds. Thence, as the stage rumbled heavily along, New York unrolled before you."

which is so numerous in other cities, hardly exists at all here," he claimed. It did exist, but it was inconspicuous. Members of the middle class staffed banks and insurance companies; they worked as salesmen (and in some cases saleswomen) and managers at department stores. They were engineers, accountants, and lawyers. They embarked from ferries and elevated trains on weekday mornings clad in white dress shirts, hence their white-collar nickname. Their typical salary came in at about $2,000 a year.

Of course, that made it difficult to buy a house in Manhattan. So they rented an apartment in one of the new French flats designed for middle-class New Yorkers. Or they paid to live in a boardinghouse, where boarders had their own living quarters yet shared meals and a bath. "Broadly stated, it is not possible to get board and room in a respectable house in a fairly good locality for less than $7 or $8 a week," wrote Moses King in 1892. Harlem,

where Addison Allen's family lived, was becoming a popular middle-class neighborhood. Greenwich Village, Chelsea, and the side streets of major avenues also filled with professionals, as did Brooklyn neighborhoods like Clinton Hill and Brooklyn Heights. In these enclaves, a family could have a servant, take the elevated to Central Park or the ferry to Brighton Beach or Coney Island for amusement, and decorate their parlors with knickknacks and knockoff art.

Occasionally, the plight of the middle class was discussed in the papers. In 1882, a writer in the *New York Times* addressed "the large class of people between these two extremes— the thousands who, while not exactly poor, are very far from rich." The wealthy could take care of themselves, and the poor had benevolence societies to give them a hand, the writer concedes. But the "vast luckless middle class" of "clerks and small tradesmen, of literary and profession men with scanty incomes and increasing families," had few options in the Gilded Age city. "Nobody writes tracts about them, or takes up subscriptions on their behalf," said the article, calling attention to the lack of suitable housing, which drove some in the middle class to abandon city life and commute from New Jersey or Westchester.

"Attention has been called to the fact that middle-class people and the artisan class are crowded out of New-York, leaving only the rich and the poor," a minister wrote in the *New York Times* in 1881. "This is very much to be deplored. I have some artisans in my congregation, but I wish I had more. It is an element I should like to see more largely represented in our churches, but the high rentals, except in tenement houses, crowd them out of the city."

Prosperity Transforms
the East Side and West Side

The mansions began to line Fifth Avenue in the 1860s. By the 1890s, rows of marble or granite capitalist castles—owned by families with names like Vanderbilt, Gould, Frick, and Carnegie—lined the main drag of the city's "Millionaire's Colony" from above 50th Street to 72nd Street and beyond. The avenue that Henry James had once described as "established repose" was now the most dazzling in the city. "To live and die in a Fifth Avenue mansion is the dearest wish of every New Yorker's heart," wrote McCabe in 1882.

The first to venture north of 42nd Street was Mary Mason Jones, a society dowager with a bold spirit and an enormous bank account. (She was also a distant relative of writer Edith Wharton, who would base the character of Mrs. Manson Mingott from *The Age of Innocence* on her.) In 1868, Jones left her home on Waverly Place for her new palace on Fifth Avenue and 57th Street, part of the mansard-roof "Marble Row" of mansions spanning the entire block. Through the 1880s she occupied her mansion with her daughter, other family members, and a team of servants, renting the adjoining marble mansions to other wealthy New Yorkers, including Brooklyn sugar baron Henry Havemeyer.

A decade later, Alva (Mrs. W. K.) Vanderbilt hired Richard Morris Hunt to design and build a showstopping French Renaissance mansion that would break up the rows of brownstones and assert her place as the powerful wife of one of the wealthiest men in the city. "Petite Château," as it was called, was

Richard Morris Hunt designed many of the most famous mansions of the Gilded Age, including the one owned by jewelry and banking millionaire Henry Gurdon Marquand at Madison Avenue and 68th Street. Built in the early 1880s, it featured this elaborately carved "Byzantine" bedroom.

finished in 1883. To celebrate—and challenge Mrs. Astor as a society host—Alva threw a legendary housewarming party and masquerade ball in March of that year. A mansion like hers, she believed, would make it impossible for Mrs. Astor to continue blocking her out of society. She was right.

Up Fifth Avenue and past Central Park, the line of European-influenced domestic fortresses and grand hotels continued. William Waldorf Astor, nephew of Mrs. Astor, built himself a cream-colored château on 56th Street and Fifth Avenue. Two more Vanderbilt palaces went up between 57th and 58th streets. In the 1880s, John D. Rockefeller moved his family into an elegant brownstone with a Turkish bath, smoking room, garden, and two-story carriage house on 54th Street.

Touring this stretch of Fifth Avenue during her 1899 trip to New York City, Naomi King wrote: "Here was quite a different scene: carriages crowding along, people jostling each other rushing ahead all bent on getting somewhere. . . . We passed Mr. Cornelius Vanderbilt's mansion, Mrs. W. K. Vanderbilt's elegant residence. . . . A little farther on we saw

Charles Lewis Tiffany House in the 1880s. The mansion was actually four houses in one, stacked around a courtyard. The interiors had Art Nouveau touches like stained glass and mosaics.

Vignettes from an 1886 *Harper's Weekly* illustration of the Marquand mansion and Tiffany House, the McKim, Mead, and White-designed, fifty-seven-room home of jewelry business owner Charles Lewis Tiffany and his artist son, Louis Comfort Tiffany, at Madison Avenue and 72nd Street.

old Mr. Vanderbilt's residence and a wealthy gentleman Mr. Rockefeller whose mansion is even finer than the Vanderbilts'. . . . We saw the beautiful Savoy [hotel] and the [New] Netherlands [hotel]; they stood side by side towering up into the sky facing Fifth Avenue."

Not everyone was awestruck by the architectural wonders along Millionaire's Row. Many observers felt that these European-inspired châteaus and palazzos were out of place in New York. "Facing the Central Park, each millionaire seems to have commissioned his architect to build him a mansion of any ancient style from Byzantine to the last French Empire, provided only it was in contrast to his neighbors," commented a British traveler. "Many . . . are interesting . . . and some . . . beautiful, but the general effect of such rampant eclecticism is rather bewildering."

Even Mrs. Astor gave in to the desire to move uptown and live in a showstopping palace, and finally abandoned her dignified 34th Street brownstone. She had to, of course; her nephew had sold his family mansion next door and built the Waldorf Hotel in the

shadow of her ballroom. In 1893, she commissioned Richard Morris Hunt to design for her a new French Renaissance palace on 65th Street. Now a widow, with her son living in an adjoining mansion, she continued to host events inside her sumptuous four-story ballroom that could fit more than a thousand guests. She ceased playing society queen bee, however, when her health declined in 1906, forcing her to spend the rest of her life confined to her mansion.

Fifth Avenue only had so many available mansions and prime real estate lots for sale. So, moneyed New Yorkers shut out of Millionaire's Row fanned out eastward to the upper ends of Madison and Lexington, commissioning costly town houses on these quiet, elevated train–free avenues. "The district between 60th and 82nd Streets, Fifth and Madison Avenues, has been so picked out, restricted, and developed that it has become like Murray Hill, only with more expensive mansions," wrote the *New York Times* in 1894.

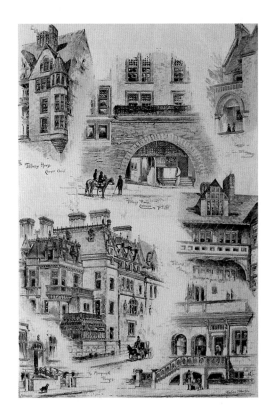

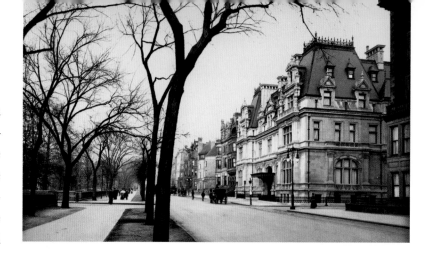

On the west side of Central Park, in a neighborhood still called the West End, spectacular residences like the Dakota lured the well-heeled to a part of the city that until the 1880s was a collection of villages: Harsenville, Stryker's Bay, Bloomingdale. By 1900, the rural feel had vanished—save for the occasional wooden shack and farm animal—replaced by grand mansions and cooperatives on West End Avenue and the Boulevard (Broadway). Lovely rows of brownstones with ornate facades and wide, inviting front entrances also appeared in the West End, and they were heralded as less monotonous than the uniform brownstones of Fifth and Madison avenues. Riverside Drive, the winding avenue on the heights above the Hudson River, rivaled Fifth Avenue in the number of mansions located there, including the gargantuan Beaux-Arts and French Renaissance Schwab mansion. Built in 1906 by steel baron Charles M. Schwab, it featured seventy-five rooms and a $6 million price tag.

As the rich migrated northward, businesses and commercial concerns took over their formerly residential neighborhoods. Middle-class and then working-class New Yorkers moved in, ready to carve older brownstones and mansions in Greenwich Village, Chelsea, and Madison Square into more modest quarters. Lower Fifth Avenue, Gramercy Park, and Stuyvesant Square were still elegant (if stuffy) enclaves. Lower Manhattan below Houston Street, however, contained the deepest concentration of poverty in the city. Any trace of the rich on these streets had long been wiped away.

With her mansion on 34th Street overshadowed by the new Waldorf Hotel (built by nephew William Waldorf Astor) next door, Caroline Astor had a newer, more opulent home designed for her in 1893, at 840 Fifth Avenue at 65th Street facing Central Park. Her new palace had a four-story ballroom that could hold 1,200. The widowed Mrs. Astor lived there with her son and his family until her death in 1908.

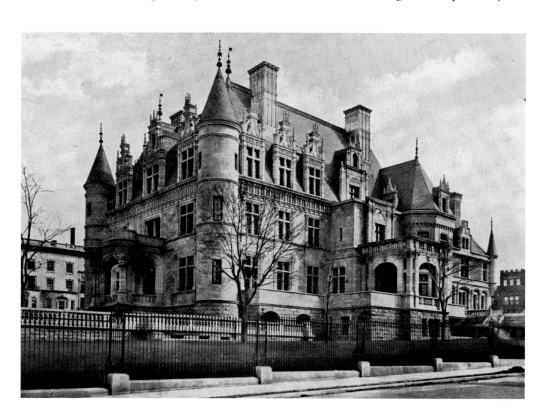

Most of the city's rich built their mansions on Fifth Avenue. But just after the turn of the century, steel magnate Charles M. Schwab opted to put his château on 73rd Street and Riverside Drive, which was supposed to be the new Millionaire's Row. Though many mansions were built there overlooking the Hudson River, Riverside Drive never truly rivaled Fifth Avenue as the city's premier address. Schwab's home, however, became the biggest private residence in Manhattan, with seventy-five rooms, three elevators, a chapel, a bowling alley, and an indoor pool.

A City of Newcomers

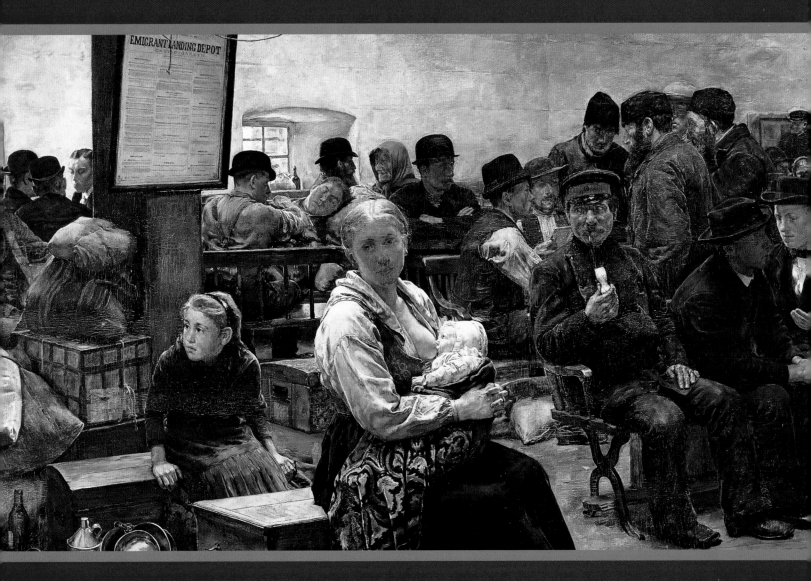

Charles Frederick Ulrich's 1884 painting *In the Land of Promise, Castle Garden* depicts a cross section of new arrivals waiting, wondering, hoping.

A Wide-Open Door

If you were an immigrant arriving in New York City from across the Atlantic during the first half of the nineteenth century, you would receive no official welcome. No barge approached your ship to safely ferry you and other passengers to shore. No one ushered you into a building and asked for your name. No clerk helped you locate family, lodging, or work.

Instead, after up to three months in steerage, under extremely cramped and unsanitary conditions while subsisting on food you packed for your trip, you would unceremoniously disembark directly onto the wharves at the East River or the Battery. You'd walk a bit to chaotic, briny South Street, its slips filled with sailing vessels, or up Lower Broadway, choked with mud and traffic. Amid the crowds and omnibuses and street vendors hawking sweet corn, you would be left to find your way.

Hungry for workers, the young city had few immigration laws. The Naturalization Act of 1790 limited citizenship to "free white persons" of "good moral character." A city ordinance from 1790 mandated that sick passengers be dropped off at the Marine Hospital on Staten Island while the ship waited there in quarantine—a detour that time-pressed captains notoriously ignored. In 1819, a federal law required that ship manifests list travelers' names, so Congress could keep tabs on

Lithographer John Bachmann's *Birds Eye View of New York and Environs* shows how the city looked to newcomers sailing into Castle Garden in 1865.

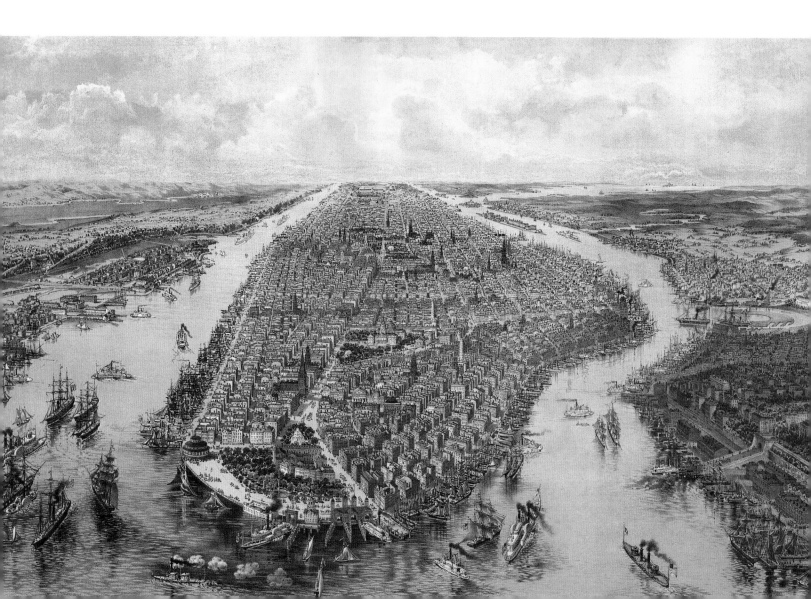

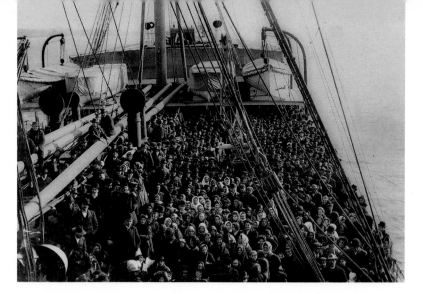

Immigrants pack the deck of an Atlantic liner in 1906.

space, flimsy wooden boards for bunk beds, and very little privacy. Disease, especially a form of typhus known as "ship fever," was routine. Death during the journey was not uncommon.

Immigration slowed dramatically in 1861, after the start of the Civil War. Yet with wartime production booming, workers were needed more than ever: to toil in factories, on railroads, and in mines. The military also demanded a steady supply of manpower to replace those who died or were wounded in battle. To encourage recent arrivals to enlist, a new federal law stipulated that any immigrant who fought for the Union would be granted automatic citizenship after he was discharged. (A recruiting station went up at the Battery in Lower Manhattan. Army reps who spoke a variety of foreign languages successfully convinced many new male arrivals to accept a $300 cash bonus and fight for their new country.)

After the Civil War, immigration rates rebounded, soaring strongly through the 1880s and 1890s. Many of these migrants made the trip because they had heard about plentiful jobs and a powerhouse economy; others were spurred on by the Homestead Act of 1862, which offered free land to those willing to

how many people entered the nation. That statute also capped the number of passengers per vessel and mandated that fresh water and "salted provisions" be available. Amid concerns that newcomers were ending up at the almshouse at Bellevue Hospital, the state Passenger Act of 1824 obliged shipmasters to record the name, occupation, birthplace, age, and physical condition of every passenger, so officials could weed out those who risked becoming a ward of the state.

With minimal regulations and little enforcement, the door to New York was wide open. Millions poured in—from northern and western Europe at first, then southern and eastern Europe—changing the face of Gotham and reshaping its population. In the 1820s, nearly four out of five residents were native-born; by 1850, it was one out of two, and throughout the Gilded Age, that number shrank to one in four. Between 1815 and 1915, three quarters of the thirty-three million immigrants who arrived in the United States entered through Manhattan. They departed from London and Dublin, Le Havre and Hamburg, Glasgow and Liverpool. They boarded vessels that were subleased by unscrupulous shipping agents, who sometimes overloaded them with more than a thousand passengers per trip. Most of the newcomers crossed the ocean in steerage accommodations that offered six to eight feet of

During the Civil War, a military recruiting station, complete with a military band, was set up just outside Castle Garden. Army officers convinced many newcomers, mostly German and Irish, to accept cash in exchange for putting on a Union blue uniform and going into battle.

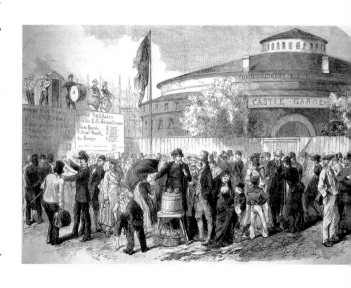

settle in the West. Some were escaping poverty or persecution in Europe. Ship conditions were still poor, but the great steamships now plying the ocean reduced travel time to two to three weeks. Single men and women as well as entire families booked passage, then resettled into distinct ethnic enclaves carved out of mainly Manhattan and Brooklyn.

The lax regulations in place early in the nineteenth century, however, couldn't handle the onslaught of hopefuls who came in later decades. (The number of arrivals went from 11,501 in 1829 to 114,000 in 1846.) Passengers dropped off by ships were often left milling around the Battery, where they ran the risk of being robbed and left destitute. While the city debated what to do, immigrant societies stepped in to help. English immigrants could turn to the St. George's Society; the Scottish had the St. Andrew's Society; Germans relied on the German Society. Irish, Spanish, French, and Dutch societies also offered aid. They warned their countrymen about hucksters, gave out small amounts of cash, shepherded them into jobs, and often advised them to travel farther into the United States, where they might find better-paying work and a lower cost of living.

Overwhelmed by demands for assistance, the benevolent societies successfully pressured the state to form a Board of Commissioners of Emigration in 1847. It was the first government-run organization to bring order to the immigration process. The Commissioners of Emigration began enforcing and enacting laws relating to ship conditions. They fought back against disreputable boardinghouse operators, railroad agents, and other businesses that routinely made a killing off new arrivals. They sent health officers on board ships docked in the harbor, taking many of the sick to the new Emigrant Refuge and

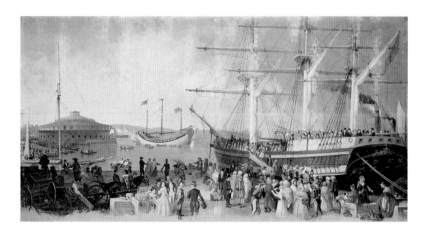

Hospital built on Ward's Island in 1847. (Others went to the Marine Hospital, until it was burned down by disease-fearing locals in 1858.) They established an emergency medical fund for the thousands who arrived ill or broke, or both.

"The problem to be solved was to protect the new-comer, to prevent him from being robbed, to facilitate his passage through the city to the interior, to aid him with good advice, and, in cases of most urgent necessity, to furnish him with a small amount of money," wrote Friedrich Kapp, one of the commissioners, in 1870. "In short, not to treat him as a pauper, with the ultimate view of making him an inmate at the Almshouse, but as an independent citizen, whose future career would become interwoven with the best interests of the country."

The Commissioners of Emigration couldn't guarantee that newcomers would be treated fairly, or that they would be able to fully assimilate into urban life. They couldn't make a dent in the anti-immigrant sentiment from so-called Nativists that permeated the metropolis—a metropolis owing much of its Gilded Age wealth to cheap, foreign-born labor. But the new regulations helped cut down on the chaos and confusion upon landing in New York City. They put immigrants on solid footing before they fanned out along Broadway to start their new lives.

Passengers disembark a sailing ship at the wharves of the Battery near a not-yet-open Castle Garden (left) in Samuel B. Waugh's *The Bay and Harbor of New York*. The final canvas in a fifty-scene panorama, Waugh's painting shows upper-class passengers milling about in bright colors, a comment on their bright future in the city in the late 1840s. Meanwhile, poor immigrants, mainly Irish (caricatured as apelike peasants who misspell their new country's name as "Ameriky"), carry or wait beside shabby trunks, remaining in the shadows.

In April 1870, Danish-born Jacob Riis, who would make his mark in New York as a journalist and social reformer, was one of those immigrants about to bound up Broadway. After a "long and stormy" voyage he made on his own at age twenty-one, Riis's ship arrived from Glasgow to New York. "She had come up during the night, and cast anchor off Castle Garden," wrote Riis in his autobiography, referring to the heralded immigrant processing center built in 1855. "It was a beautiful spring morning, and as I looked over the rail at the miles of straight streets, the green heights of Brooklyn, and the stir of ferryboats and pleasure craft on the river, my hopes rose high that somewhere in this teeming hive there would be a place for me."

Destination: Castle Garden

"We were ferried over to Castle Garden," wrote Abraham Cahan, a Lithuania-born author and journalist who founded the *Jewish Daily Forward,* in his 1917 semiautobiographical novel, *The Rise of David Levinsky.* "One of the things that caught my eye as I entered the vast rotunda was an iron staircase rising diagonally against one of the inner walls. A uniformed man, with some papers in his hands, ascended it with brisk, resounding steps till he disappeared through a door not many inches from the ceiling. It may seem odd, but I can never think of my arrival in

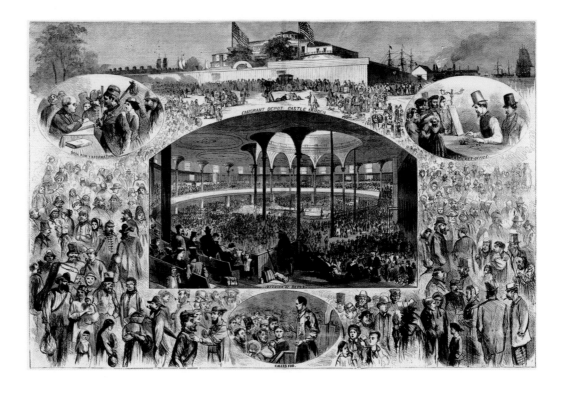

The fort turned concert hall turned immigration depot Castle Garden, in a *Harper's Weekly* illustration from September 1865. Every day, thousands of people from all across Europe filled the main hall, where they registered with officials, underwent a medical checkup, looked for work, and were reunited with friends and relatives who had already made the journey.

this country without hearing the ringing footfalls of this official."

Castle Garden, or the Emigrant Landing Depot, was the major achievement of the Commissioners of Emigration. Opened in August 1855, the building had been a concert hall, resort, and restaurant for the upper classes who lived along once-fashionable Bowling Green and State Street; it was famously remembered as the venue where "Swedish Nightingale" Jenny Lind gave a series of sold-out concerts in the early 1850s. Before that, Castle Garden was a never-used fort ready to safeguard the city during the War of 1812. It had been on an island, which was connected to the mainland just before the Depot opened.

Run by the state with proceeds from a ship tax, Castle Garden was the nation's first immigrant-processing station. No wonder Yiddish-speaking New Yorkers began referring to any tumultuous place as a *kesselgarden*. Just one hundred Castle Garden employees were tasked with registering up to nine thousand arrivals daily. Yet despite all the people who packed its waiting rooms and formed lines at the registration counter, the depot was a marvel of planning and efficiency, a "great artery of life and labor," as one immigrant who passed through put it. First, ships would dock at the quarantine station six miles south of the city, after which officials would board to take a head count of passengers, inspect them for illness, and note any who had died during the voyage.

After a few days' wait, ships were then allowed to travel to the wharves off Castle Garden. Customs officials boarded to safely accompany luggage and passengers by barge to the Castle Garden pier. Baggage was weighed, inspected, and stored temporarily. "Battered old chests, barrels, and great bundles of clothes and bedding are packed together, much against the wishes of their owners, who are in terror of losing all their worldly treasure," reported *Scribner's Monthly* in 1877. "The officers then set to work, with turned-up sleeves, and faces expressive of repugnance. Some of the unmarried men have no baggage at all, except a small bundle tied in a handkerchief and slung over a stick."

This magnificent view of New York comes from Currier and Ives. *Port of New York, Birds Eye View from the Battery, Looking South* shows the view from the recently shuttered Castle Garden in 1892.

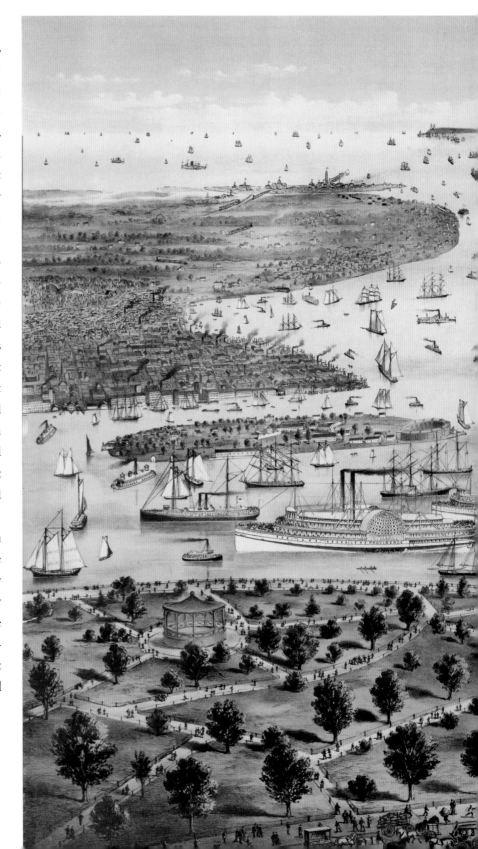

Up to seven thousand new arrivals made their way to Castle Garden every day. This *Harper's Weekly* illustration from 1880 shows a chaotic crowd made up of many nationalities. "It is curious to see such a heterogeneous crowd land," commented a *Harper's* writer. "The Swedes are easily distinguished by their tanned-leather breeches and waist-coats . . . you can not miss the Irishman with his napless hat . . . the Englishman you know by his Scotch cap, clay pipe, and paper collar . . . The Teuton you detect at once by his long-skirted, dark blue woolen coat, high-necked and brass-buttoned vest."

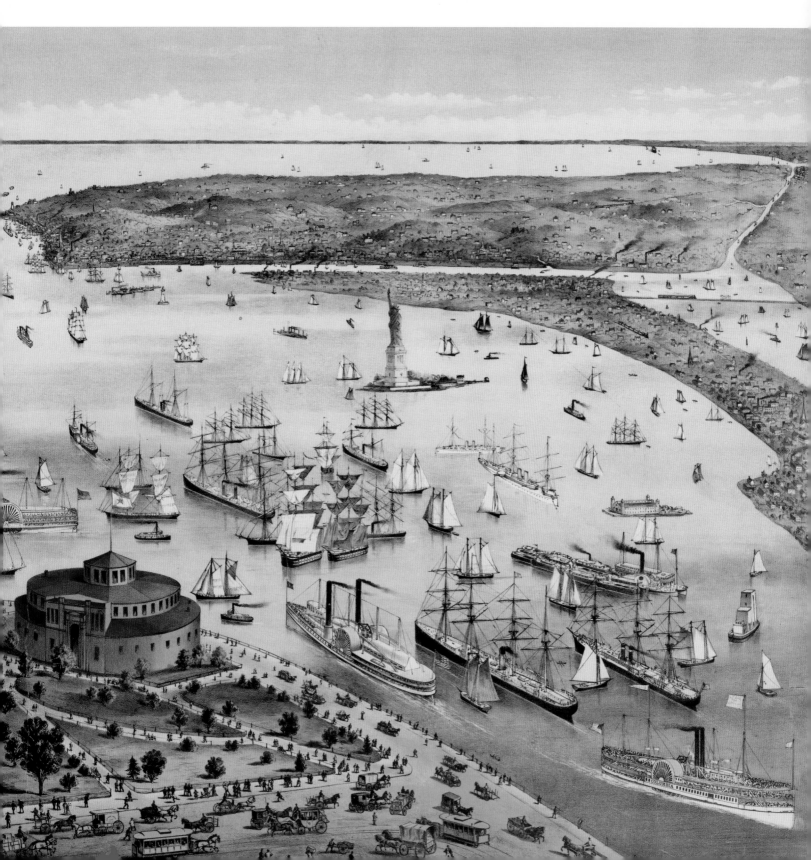

Castle Garden in Ashes

The first curtain of smoke rising from the floor was spotted by a gate tender on July 9, 1876, while the city was enduring a heat wave. An alarm sounded, workers rushed over, and one ripped open the floorboards. At that moment, about 5:00 P.M., great bursts of flames appeared and spread through the upper part of the main building at Castle Garden, the circular former concert hall and fort where thousands of immigrants brand-new to New York waited every day, seven days a week, to be processed and admitted to the nation.

"The huge body of flame rose high in the air and lighted up the harbor for miles and cast a lurid glare on the shipping. The Battery, filled with an immense crowd of spectators, was a light as noonday, and the glare of the conflagration reflected on the crowded roofs of the tenements along State Street and Battery place," reported the *New York Times* the next day.

The fire spread down to the docks, where barges ferried passengers from their ships, and also to baggage area. "During this time the immigrants themselves were doing all in their power to save their own effects, and it was amusing to see their anxiety as they risked their lives to save what to the ordinary observer appeared to be of small value. One old fellow ventured into the blinding smoke and reappeared with what appeared to be a plan of his native village. Two old Bavarian women worked liked slaves in bringing out trunks, chests, and feather beds, belonging to themselves and their more helpless neighbors."

By 8:00 P.M., firefighters had the blaze out—but not before the domed roof of the rotunda caved in and many smaller structures burned beyond repair. City officials decided to rebuild, using the buildings not touched by flames as the makeshift depot. The main center reopened in November.

"The building is light and airy, and is a great improvement on the old one," the *Times* weighed in. Yet something valuable could not be rebuilt: the names and personal information of those who had arrived at Castle Garden since it first opened in 1855. "All the books and records, excepting the more valuable papers, which were contained in safes, were destroyed," reported the *Times*.

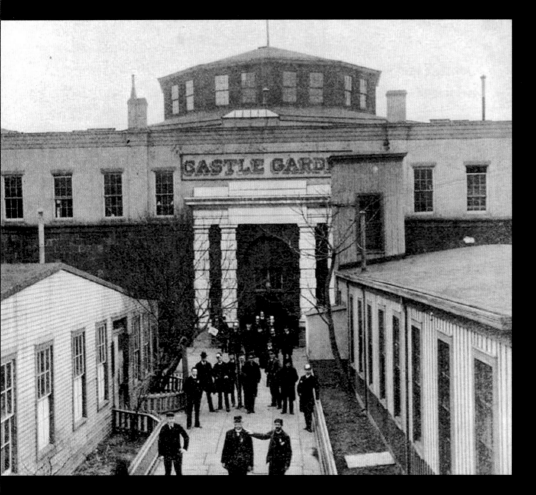

Castle Garden after it was rebuilt.

"In and Out of Castle Garden," from an 1887 issue of *Harper's Weekly*, depicts different stages new arrivals went through, from coming into New York Harbor to registering in the main hall to exchanging money, and finally departing the depot and lingering at Battery Park.

The Pennsylvania Railroad Ferry Station was located near Castle Garden. The ferries took passengers and their luggage over the Hudson River to awaiting trains in New Jersey.

Inside, passengers underwent a second medical check; the sick were taken to Emigrant Hospital at Ward's Island. Once given the all clear, newcomers filed into the grand interior rotunda, where clerks recorded their names, home nations, and how much money they had brought. Finally, new arrivals could enter a waiting area, rest their feet, buy coffee and fresh food, and figure out their next move. "You could at first imagine . . . that all those human beings seated on the benches had assembled to witness some theatrical entertainment," wrote an English

steerage passenger in 1866. The "Germans and Dutch, who form by far the most numerous body, [were] parceled off into the eastern portion of the building . . . which contains indiscriminately English, Irish, Scotch and French. Two large iron stoves . . . throwing out considerable heat, occupy each end of these apartments, one being set apart for the males and the other for the females."

"Greenhorns," as the newcomers were dubbed, who planned to go on to other parts of the nation were directed to the correct railroad terminal in Manhattan or Hoboken, New Jersey. "After being on the water for 61 days, three having died naturally and one fallen overboard, we were all glad to once more be on land, and we were soon walking up the streets of New York as happy as Columbus when he landed at San Salvador," wrote Charles P. Anderson, a German immigrant who arrived with his family aboard the steamer *Humboldt* in July 1866. "We remained [at Castle Garden] until late in the evening, then we all marched down the streets and embarked on a steamer. Next morning we landed and continued our journey westward, by rail, until we arrived at St. Louis."

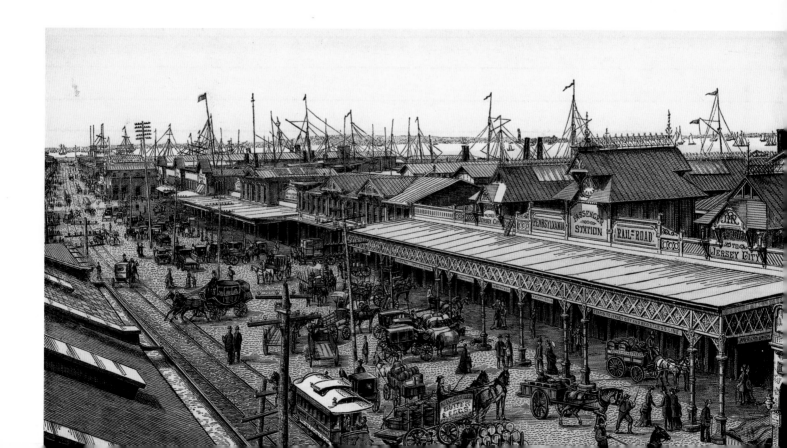

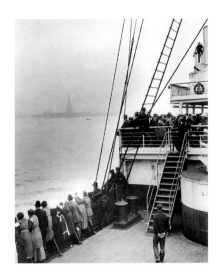

If they sought housing, they could access a list of inexpensive licensed boarding-houses located on nearby Washington Street. Swindlers and con artists were kept at bay by a tall fence around the building. A vibrant labor exchange matched employers with immigrants looking for work, both male and female. "Most of the strong, healthy girls and young women, principally Irish, succeed, through the agency of the Labor Department of the Commissioners, in obtaining situations as housemaids, nursemaids, milliners, sewing-machine hands and dressmakers, and in a few days bid adieu to the sheltering care of Castle Garden," wrote the English steerage passenger. Once these preliminaries were

taken care of, immigrants were free to disappear into the streets of Manhattan.

Castle Garden brought much-needed authority and order to the immigration process. "The Landing Depot is fitted up with quarters for the emigrants and their baggage, and with various stores at which they can procure articles of necessity at moderate prices," wrote James D. McCabe in his 1872 book, *Lights and Shadows of New York Life.* "As most of them come provided with some money, there is an exchange office in the enclosure, at which they can procure American currency for their foreign money. . . . Attached to the establishment is an official, whose duty it is to furnish any information desired by the emigrants, and to advise them as to the boarding houses of the city which are worthy of their patronage."

After eight million men, women, and children passed through its doors, Castle Garden closed in 1890. The depot was deemed too small to handle the ever-increasing number of arrivals, and the federal government was ready to assume the responsibility of processing immigrants. A barge office served as a makeshift depot until 1892, when the Ellis Island Immigrant Inspection Station became the entry point. Before surging into Ellis Is-

Immigrants swarm the deck of a steamer as it approaches the Statue of Liberty in New York Harbor in the early 1900s. The sight of the symbol of freedom was a milestone marking the end of the journey across the Atlantic.

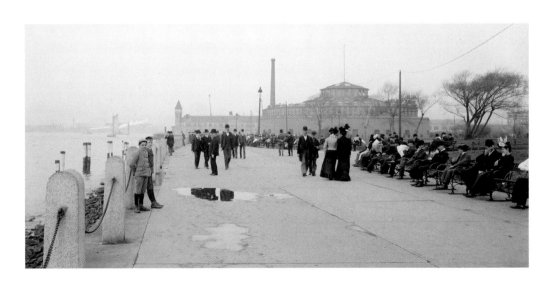

Battery Walk at Battery Park, with Castle Garden behind it. No longer receiving immigrants, Castle Garden became the home of the New York City Aquarium in 1896.

land's three-story wooden depot, immigrants were greeted by the Statue of Liberty in the harbor, a sight that made a distinct impression. "We came by steerage on a steamship in a very dark place that smelt dreadfully," recalled young sweatshop worker Sadie Frowne in 1902, three years after arriving from Poland. "It took us 12 days to cross the sea . . . but at last the voyage was over, and we came up and saw the beautiful bay and the big woman with the spikes on her head and lamp that is lighted at night in her hand (Goddess of Liberty)."

Ellis Island opened at the end of the nineteenth century and received immigrants for six decades. But it was Castle Garden that welcomed newcomers during the bulk of the Gilded Age. Native New Yorkers were unlikely to ever visit, but the depot captured the imagination of journalists, who wrote colorful features that gave city residents a peek at the humanity inside. An 1871 *Harper's Weekly* article offered a rich, lively account:

> *[As we] approached the entrance to Castle Garden we found it almost impossible to make our way through, the passage was so blocked up with vehicles, peddlers of cheap cigars, apple-stands, and runners from the different boarding-houses and intelligence-offices that abound in the neighborhood. We presented our passport to the officer on guard at the entrance, were admitted, and ushered into the yard of the Garden, amidst a crowd of passengers, children, and baggage of all kinds.*
>
> *Truly it looks like a "castle," but the "garden" is less observable. Open port-holes stare us in the face as we approach. . . . Passing through the gateway, we have on the left side a roomy and cleanly kept wash-room for females, and on the opposite side one for males, both plentifully supplied with soap, water, and large clean towels on rollers, for the free and unlimited use of all immigrants. . . . Father and son, sister and brother, meet here in fond embraces, with tears of joy, after years of absence. What shaking of hands, and assurances of love, and inquiries for those dear to the heart, that are still thousands of miles away. . . .*
>
> *The lights were shining feebly on the Battery. The lamps are but few and far between, and an almost total darkness prevails at some places. Behind me were the crowds of immigrants still emerging from Castle Garden, whose dome loomed up splendidly out of a sea of darkness—a beacon for the guidance of immigrants who arrive on our shores.*

Between 1855 and 1890, eight million newcomers came through Castle Garden—or two out of every three immigrants to the United States at this time. By 1900, the former immigrant landing depot that once jutted out into the harbor was now surrounded by landfill at the lower end of Battery Park.

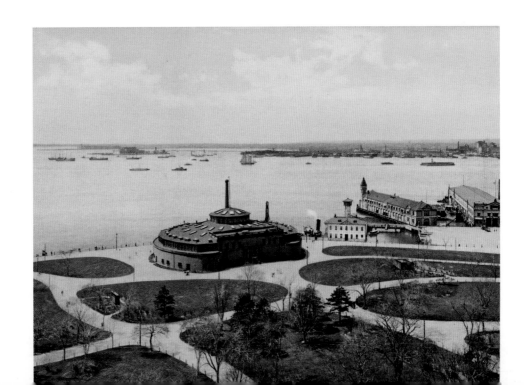

A City Newspaper Publisher Helps Save the Statue of Liberty

Lady Liberty has symbolized freedom in New York Harbor for more than a century. But getting her to the city and placing her in the harbor was tricky. It took a sensational city newspaper's help to do it.

In the early 1870s, Frederic Auguste Bartholdi began work on the design of a monumental sculpture honoring American democracy and freedom that was supposed to commemorate the centennial of 1776. While the French were taking charge of building the statue and assembling her in the United States, the Americans were supposed to create the pedestal she would stand on. That required fund-raising. Statue officials tried to convince Americans to donate, even displaying the statue's arm and torch in Madison Square Park from 1876 to 1882 to generate excitement. But the Panic of 1873 had left many New Yorkers without a lot of cash to spare.

Then, Joseph Pulitzer, publisher of the *New York World*, began a drive to convince Americans to donate $100,000. "We must raise the money!" he wrote in an article on March 16, 1885. "The *World* is the people's paper, and now it

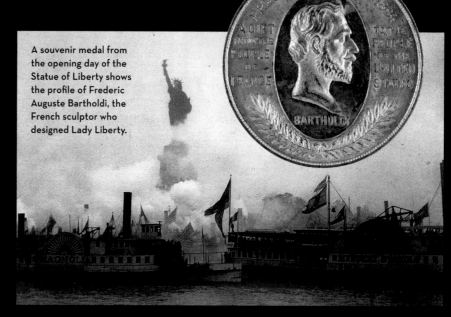

A souvenir medal from the opening day of the Statue of Liberty shows the profile of Frederic Auguste Bartholdi, the French sculptor who designed Lady Liberty.

The view on October 28, 1886, from the steamer *Patrol* during the military and naval salute upon the president's arrival for the statue's dedication ceremony. In his speech, President Grover Cleveland stated, "A stream of light shall pierce the darkness of ignorance and man's oppression until Liberty enlightens the world."

appeals to the people to come forward and raise the money. The $250,000 that the making of the Statue cost was paid in by the masses of the French people—by the working men, the tradesmen, the shop girls, the artisans—by all, irrespective of class or condition. Let us respond in like manner."

Pulitzer, a Hungarian immigrant who bought the *World* and turned it into one of the most popular papers in the city, promised to print the name of every person who gave so much as a penny. By August, enough money was raised—mainly from hundreds of thousands of individuals, including children, who gave less than a dollar.

With financing complete in 1885, the pedestal itself was finished a year later. A French frigate brought the statue over in June 1885 in 350 pieces. It took four months to reassemble it on a small harbor island then known as Bedloe's Island (later changed to Liberty Island, in 1956).

After a morning parade from Madison Square to Battery Park watched by hundreds of thousands of New Yorkers in a cold, driving rain, *Liberty Enlightening the World* was dedicated on October 28, 1886, with President Grover Cleveland in attendance along with hundreds of other city officials and a thrilled public—a decade later than originally planned.

The First Great Wave of Humanity

On June 2, 1836, Philip Hone, mayor of the city in the 1820s and a successful merchant, wrote in his diary: "There arrived at this port, during the month of May, 15,825 passengers. All Europe is coming across the ocean; all that part at least who cannot make a living at home; and what shall we do with them?"

New Yorkers of Hone's Anglo-Protestant background would be asking that question for decades. The first massive wave of immigrants—a tsunami, really—hit the city's shores from 1840 through the 1870s. Previous arrivals had looked like New Yorkers: white and mostly British. Now, the dominant ethnic groups moving into the city's weathered neighborhoods were what qualified as foreign at the time: non-English-speaking Germans and Irish Catholics. Through the 1850s, 40 percent of immigrants to the city were Irish, 32 percent were German, and a mere 16 percent came from England.

The Germans were not a united group. They were farmers, artisans, and professionals who hailed from various nation-states suffering from crop failures and the upheaval of a botched revolution: Prussia, Bavaria, the Rhineland. Some of the young, mostly single men and women were unschooled and poor; others were educated and middle class. Once in New York, their occupations ran the gamut. They started businesses, worked as craftsmen, ran saloons, built pianos, and found jobs as servants.

Like all immigrants, they clustered in enclaves, mainly Kleindeutschland, the "Little Germany" neighborhood bounded by the Bowery and East River from Division to 14th streets (Avenue B was known as "The German Broadway" for its music halls, oyster parlors, and theaters). By 1865, about sixty thousand German-born residents lived in or on the outskirts of Kleindeutschland. Others settled in the uptown neighborhood of Yorkville, on the Upper East Side. Thousands of Germans also moved into Brooklyn, specifically in Williamsburg and Bushwick, nicknamed Dutchtown, which soon became home to Brewers Row—a stretch of more than a dozen breweries founded and run by

The German Immigrant Savings Bank opened in 1872 on the east side of Union Square at 14th Street, on the outskirts of the city's bustling Little Germany neighborhood known as "Kleindeutschland." Besides a successful bank, the city's German population established a free library, medical dispensary, schools, and newspapers.

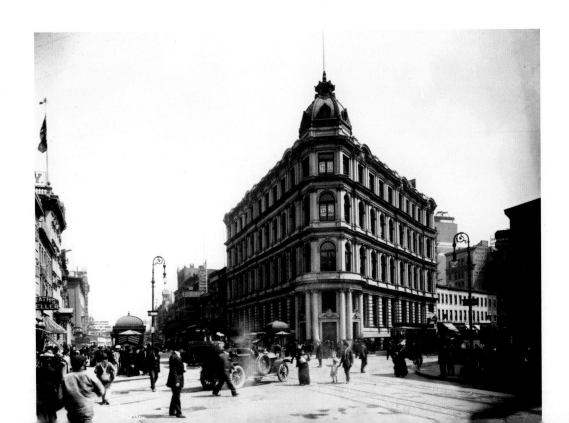

Germans. Germans flocked to College Point in Queens, and the lower Westchester (soon to be the Bronx) villages of Mott Haven, Port Morris, and Morrisania.

New York at midcentury had more German-speaking residents than any other place in the world except for Berlin and Vienna, and their influence could be seen all over the metropolis. German houses of worship—mostly Lutheran, but some Catholic and a few Jewish—sprouted up; sporting clubs, lecture halls, libraries, and concert halls for the many German singing societies appeared. German workers re-created the guild system they were used to back home, forming early versions of unions that advocated better working conditions and wages. They introduced kindergarten to city schools, peddled hot dogs (topped with sauerkraut) on the streets, and popularized Christmas trees laden with lights and ornaments.

The German beer garden, a cavernous space where entire families came to eat, drink, and be entertained on evenings and Sundays, became part of the cityscape. One of the best-known was Atlantic Garden, on the Bowery, which seated three thousand people and stretched all the way to Elizabeth Street. This restaurant-theater hybrid caught on with non-German New Yorkers as well. "[Atlantic Garden] became very popular, and it was customary, particularly among the Germans, to take their families there in the evening and enjoy the music, which was a special feature, and the 'variety'—which was at that time a conspicuous novelty," wrote the *New York Times* in 1910.

James D. McCabe wrote about Atlantic Garden in 1872's *Lights and Shadows of New York Life*: "The buzz and the hum of the conversation, and the laughter, are overpowering, and you wander through the vast crowd with your ears deafened by sound. Suddenly the leader of the orchestra raps sharply on his desk, and there is a profound silence all over the hall. In an instant the orchestra breaks forth into some wonderful German melody, or some deep-voiced, strong singer sends his rich notes rolling through the hall. The auditors have suddenly lost their merriment, and are now listening pensively to the music . . . thinking no doubt of the far-off fatherland, for you see their features grow softer and their eyes glisten."

Irish Catholics coexisted on the edges of Kleindeutschland with the Germans. They also occupied the fetid, sprawling Five Points slum north of City Hall, the area surrounding the Brooklyn Navy Yard, and various shantytowns all over Manhattan and Brooklyn. Unlike the Germans, they were largely poor, unskilled farmers fleeing poverty and oppression in their native country—and then the deadly potato rot beginning in 1845, which left millions starving. The Irish Catholics were disliked and unwelcome, considered the "counterbalance" to the hardworking and law-abiding Germans, in the words of one writer in the periodical *The Nineteenth Century* in 1884. Their religion, with its unfamiliar traditions, set them apart early on. A fierce hatred for all things English and a reputation for drunkenness also made them outsiders. "Our Celtic fellow citizens are almost as remote from us in temperament and constitution as the Chinese," wrote lawyer and diarist George Templeton Strong in 1857.

German immigrants dress in traditional garb at the Liederkranz Club, one of dozens of singing societies founded by Germans in the nineteenth century. The club president was William Steinway, a successful German immigrant and partner in the Steinway Piano company. Under his leadership, the club established a home at Park Avenue and 58th Street in the 1880s.

Atlantic Garden was the biggest of the German beer gardens, many of which lined the Bowery and catered to German-speaking, lager-drinking families as well as native New Yorkers who enjoyed the variety shows and festive atmosphere. "Here one can sit and smoke, and drink beer by the gallon, listen to music, move about, meet his friends, and enjoy himself in his own way—all at a moderate cost," wrote one observer.

Employed mostly as laborers and drivers at first, the Irish suffered in New York: They had high poverty, unemployment, and arrest rates. Irish criminal gangs roamed the city, and they were despised for instigating the deadly 1863 Draft Riots. The Orange Riots of 1870 and 1871 further solidified prejudice against them. It's not clear how often help wanted ads indicated that Irish applicants wouldn't be considered. But an 1863 ballad sung by vaudeville star and theater owner Tony Pastor, "No Irish Need Apply"—about a country lad who is met with anti-Irish sentiment when he goes looking for work—became popular in New York and must have resonated with Irish Catholics.

After the Civil War, more Irish women than men arrived in New York, accepting positions as cooks, maids, and schoolteachers (in 1870, 20 percent of teachers in the city were Irish). By the end of the 1870s, Irish Catholic men had gained a foothold, filling the rosters of the police and fire departments and other civil service positions—thanks in part to their loyalty to political patrons such as Mayor Fernando Wood and Boss Tweed, of Tammany Hall infamy. Irishmen also became tavern owners, and they made up the ranks of the workers who helped build the city's

infrastructure: its tunnels and bridges, parks and water pipes. By 1900, they also made up 95 percent of the longshoremen who toiled on city docks.

While acknowledging the hardships they endured here, Irish immigrants often urged loved ones back home to make the journey as well. Margaret McCarthy, a twenty-three-year-old who had come to New York on her own just a year earlier, wrote the following letter to her family in 1850 (at that time, more than two hundred thousand Irish Catholics made their home in Manhattan): "The immigrants ha[ve] not money enough to take them to the interior of the country which obliges them to remain here in [New] York and the like places for which reason causes the less demand for labor and also the great reduction in wages," wrote McCarthy. "For this reason I would advise no one to come to America that would not have some money after landing here that would enable them to go west in case they would get no work to do here. But any man or woman without a family are fools that would not venture and come to this plentiful country where no man or woman ever hungered or ever will . . ."

Anti-Irish sentiment lingered, this 1882 *Puck* cartoon reveals; it depicts the Irish as the only ethnic group disrupting Uncle Sam's Lodging House.

The women and children boarded the excursion boat *General Slocum* at East 3rd Street just before 9 A.M. on June 15, 1904. Their neighborhood church, St. Mark's Lutheran, on East 6th Street in Little Germany, was holding its annual Sunday school outing. The mostly immigrant mothers and small kids were excitedly heading up the East River through Hell Gate and then to a picnic spot on the Long Island shore.

The paddle-wheel ship *General Slocum* on fire in the East River. An investigation after the disaster revealed that the ship carried shoddy life vests and rafts and a crew untrained in fire safety. The captain was sentenced to ten years in Sing Sing for criminal negligence.

"The 400 children romped on the decks," explained a December 1904 article in *Munsey's Magazine*. "The sky was unclouded, the flags fluttered their stripes and stars in the summer breeze; and with land close on either side, the fear of death or danger occurred to no one."

Ten minutes after departing the dock, a fourteen-year-old boy noticed a fire had broken out in a storeroom near the bow. He informed the captain, who ignored him, according to *Munsey's*. A short time later, other ship captains plying the East River at about 86th Street saw fire and smoke and tried to alert the *Slocum's* crew, but the ship steamed ahead.

As the ship reached 110th Street, "yellow flames were leaping upward and aft, toward the unsuspecting passengers," stated *Munsey's*. By now, deckhands could be seen trying to unravel a fire hose, but it burst in three places. The paddle-wheel boat forged ahead; the captain later said he was trying to make it to North Brother Island, where passengers could rush off on land. But the speed made the fire more intense trapping women and children in flames and forcing them to jump overboard to escape.

"From this moment horror was piled upon horror," reported *Munsey's*. "The port rail of the after deck gave way, and a hundred

people were shot into the water like a cartload of refuse. Then a sudden burst of flame tumbled all three decks into a pit of fire." When the *General Slocum* finally made it to North Brother Island, the fire continued to rage, killing hundreds more. By the time it was all over, 1,021 people, almost all women and children from Little Germany, had perished.

The *General Slocum* was a horrific tragedy that cut into the heart of a vibrant immigrant neighborhood. "Many entire families were destroyed, and remained until late

next day unidentified," wrote *Munsey's*. Men who went to work in the morning rushed home to find out that their wife, their child, or their entire family was gone. For days, funeral processions packed the streets of Little Germany; hearses brought many victims to a Lutheran cemetery in Middle Village, Queens.

Heartbreak turned to outrage after an investigation revealed that the *General Slocum*'s fire safety equipment, life vests, and lifeboats were all but useless. The ship's captain was sentenced to

ten years in prison for negligence, and the *General Slocum* remains one of the worst disasters in city history—leaving behind thousands of survivors who left Little Germany en masse for the German immigrant neighborhood of Yorkville, presumably to escape painful memories.

Victims and debris from the *General Slocum* wash ashore on North Brother Island. Approximately 1,021 of the estimated 1,342 passengers on the paddle-wheel steamboat died after a fire broke out on board on June 15, 1904. The cause was believed to be a cigarette or match accidentally tossed into a barrel of hay below deck. Victims, mostly women and children from the city's Little Germany neighborhood, either perished from the fire or drowned after leaping into the East River. It remains New York City's worst maritime disaster.

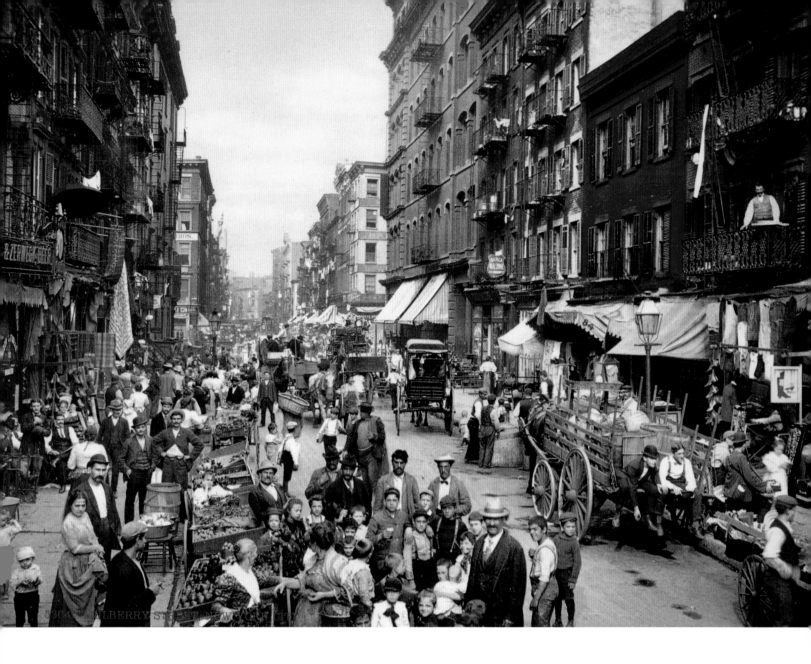

The Second Wave Washes Ashore

By the time the Germans and Irish had established themselves, a second surge of immigrants was on its way to the city. In the 1880s and 1890s, millions of Italians, Bohemians, Hungarians, Romanians, Poles, Finns, Greeks, Turks, and Syrian Christians came ashore—altering the city's demographics so profoundly that by 1910, with a total city population of about 4.7 million, approximately 2 million were foreign-born. Poor, less educated, and from the peasant classes, as the Irish had been, they were more likely to stay in New York after passing through Castle Garden or Ellis Island.

These new immigrants crammed into squalid areas of Lower Manhattan, generally on the East Side, that were abandoned by Germans and Irish who had moved up the economic ladder. Within their enclaves, the newcomers worked as small merchants,

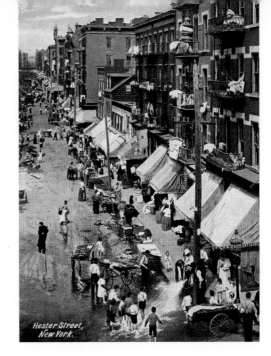

Hester Street,
New York.

Once a seedy part of Five Points, Mulberry Street by the 1890s had become the "Main Street of Little Italy," transformed by Italian immigrant vendors, merchants, and laborers. They were not warmly embraced by the city, however. On January 8, 1882, the *New York Times* wrote, "The most undesirables of our immigrants in recent years have come from the South of Europe, and of these the Italians are most numerous, nearly 14,000 of whom arrived at Castle Garden during the year past. They are very apt to herd together in the large cities and recruit the lowest ranks of the laboring populations. This is due in some measure to the fact that the emigration of criminals and paupers and worthless people generally from Italy have been rather encouraged of late."

A warm day at the intersection of Hester and Essex streets in the Jewish Quarter, or The Ghetto, about 1900. By 1910, this densely packed corner and the surrounding streets contained almost 550,000 residents, near the highest population density of any city in the world at the time.

Hester Street, in the heart of New York's Jewish "Ghetto" in 1903. The Russian and Eastern European immigrants who flocked this Lower East Side neighborhood in the 1880s and 1890s arrived with limited skills and faced widespread prejudice. As a result, they made their own opportunities, becoming peddlers and pushcart operators until they could establish a foothold in the retail trade with a storefront.

pushcart operators, factory workers, garment pressers, and fruit peddlers. Entire families often did work at home piecemeal; in dark, airless tenement living rooms that looked out onto grimy airshafts they rolled cigars, sewed clothes, and shelled nuts. The sheer numbers of them, with their alien customs, sometimes charmed, sometimes repulsed New Yorkers, who could read about them in newspapers and periodicals if they lived too far away to encounter them on the streets.

"On the fire-escapes and balconies, on Mondays or any other of the various wash-days that race or creed or custom prescribes, their garments flap in the wind and, on some streets, lend human interest to continuous frontages as far as the eye reaches," reported *Harper's Weekly,* of a stretch of the Lower East Side that included the Jewish Ghetto of Rivington Street, Little Italy, on Mulberry Bend, and the Chinatown surrounding Pell Street. "Food is convenient at every turn. Mott Street market-men sell Chinese roast pig already roasted, and Heaven knows what curious Oriental dainties that look as though they had crossed the sea. Mulberry Street abounds in sidewalk vendors of bread which seems to have no remarkable quality (except, maybe, its cheapness), and strange white Ital-

ian cheeses, made evidently in America for the Italian market, encased in skins and shaped like tenpins. The great Jewish Quarter has its butcher shops with Hebrew signs, and, in the spring, its provision of unleavened bread for Passover."

These East Side immigrant enclaves were "training schools for American citizens," in the words of *Harper's Weekly.* "Life on the Lower East Side is even more transitory than most life in New York. Most of the population there is of comparatively recent acquisition. Habits of life are more often brought there than formed there. . . . It is the crop that the East Side raises that makes it important—the great crop of American

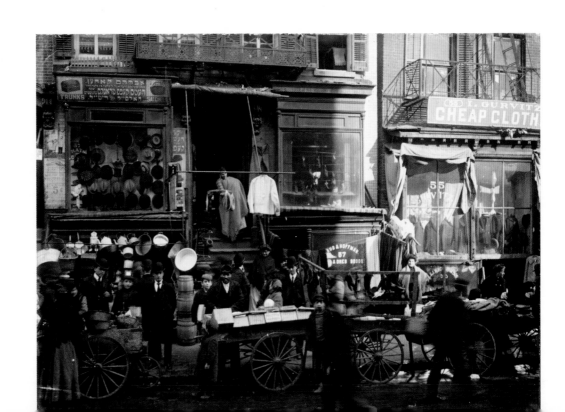

Where the Newcomers Settled

As immigrants began arriving en masse in New York City in the 1840s, each ethnic group settled its own enclave. The biggest was Kleindeutschland, aka "Little Germany." Bounded roughly by the Bowery, 14th Street, Division Street, and the East River, it was a thriving, vibrant stronghold of tens of thousands of German immigrants through the end of the Gilded Age. Avenue B, the main artery, was known as the "German Broadway" for its music halls; Tompkins Square Park was at the center, surrounded by shops, beer halls, schools, libraries, sport clubs, and other hallmarks of a vibrant, thriving neighborhood, with subsections for immigrants hailing from different parts of Germany, such as Bavaria and Prussia.

South of Kleindeutschland but worlds away was Five Points, the notorious slum packed with poor Irish Catholics that extended from about City Hall to Canal Street. The name came from the five-pointed intersection where decrepit wooden houses, rundown Federal-style homes, and two-story saloons and bars converged. Five Points' crooked alleys and dead-end "roosts" allowed criminals and gangs to lay low and tarnish the reputation of the hardworking Irish immigrants (and African Americans) who began calling it home in the 1830s and 1840s.

The second wave of immigrants in the 1880s moved into Kleindeutschland and Five Points and remade these neighborhoods as their own. Eastern European Jews turned Second Avenue from Houston to 14th Street into the "Yiddish Broadway," building theaters and concert halls. South of Houston and centered around Rivington Street, the Lower East Side was re-colonized mainly by Russian immigrants and called, with some derision, "The Ghetto" on city maps and in newspaper articles.

The Chinese, who began arriving in the 1850s and 1860s after working in the mines of the California gold rush and building railroads, carved out a small piece of Five Points at Mott and Doyers streets. Christened Chinatown and considered exotic and strange by many New Yorkers, it was a

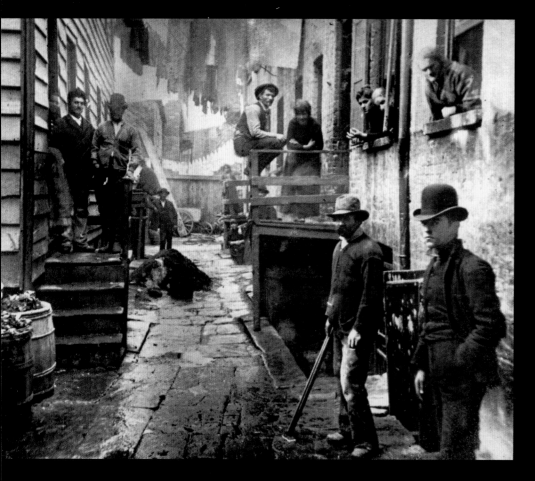

Author and reformer Jacob Riis, an immigrant who passed through Castle Garden in 1870, took this 1888 photo of Bandit's Roost, located on Mulberry Bend in the Five Points slum. Five Points' snaking alleys and dead-end courtyards helped make it a breeding ground for disorder and criminal activity.

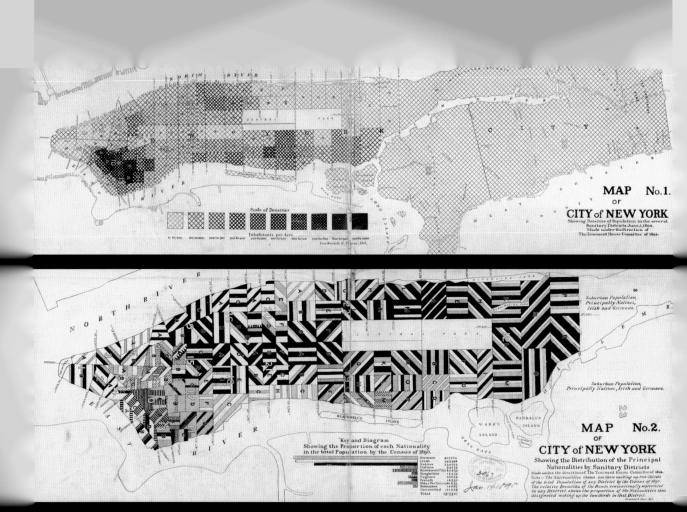

The Tenement-House Committee Maps were drawn by F. E. Pierce in 1894. The first map shows population densities in Manhattan. The second map shows the distribution of ethnic groups in distinct neighborhoods. Both demonstrate Jacob Riis's conviction that "a map of the city, colored to designate nationalities, would show more stripes than the skin of a zebra, and more colors than any rainbow."

self-supporting community that offered a safe haven for Chinese newcomers, the flow of which slowed drastically after the passing of the 1882 Chinese Exclusion Act. Another slice of Five Points, the Mulberry Bend area, became Little Italy in the 1880s and 1890s, home to new arrivals from Italy's poorer, largely agricultural south. The once-upper-class brownstones of Greenwich Village south of Washington Square also became home to Italians, who peddled fruit, opened groceries, did manual labor, and worked as skilled artisans and craftsmen.

A smaller number of Greeks, Turks, and Syrian Christians rebranded Washington Street on the Lower West Side "Little Syria" in the 1890s. This Syrian Quarter, as it was also dubbed, was home to thousands of peddlers, shop owners, factory workers, and owners of cafés and restaurants. "Little Hungary" also popped up at the end of the nineteenth century. This tiny enclave along East Houston Street became known as "Goulash Row" for its restaurants and cafés.

After the turn of the century, some of these ethnic enclaves

moved with the flow of the city uptown. The Irish settled into Hell's Kitchen, Washington Heights, the Bronx, Brooklyn, Queens, and parts of Harlem; Italians built New Little Italys in East Harlem, the Bronx, and South Brooklyn. Though many Germans had already left Kleindeutschland for the East Side neighborhood of Yorkville (86th Street, the main street, was now the German Broadway), it wasn't until the *General Slocum* tragedy in 1904 when thousands of families relocated to Yorkville and also to Astoria in Queens.

voters, from the reaping of which there is no evasion or escape."

Smaller groups of immigrants re-colonized other parts of the city. East Houston Street was home to a community dubbed Little Hungary; the restaurants here comprised "Goulash Row." A French Quarter with bakeries, wine stores, and cafés existed south of Washington Square Park extending to Broome Street. Amelia des Moulins, a dressmaker who came to New York in 1899 from Paris, recalled going from Ellis Island to a tenement on West Broadway. "We were horrified when we found that we must pay $2 for a miserable room, but we could do no better," she said. "We only had 10 francs left, and all the first week after our landing we lived on potatoes—that we roasted over the gas flame—and stale bread."

Lower Washington Street became the Syrian Quarter, made up of Syrian Christians, Armenians, and Greeks. "New York astonished me by its size and magnificence, the buildings shooting up like mountain peaks, the bridge hanging in the sky, the crowds of

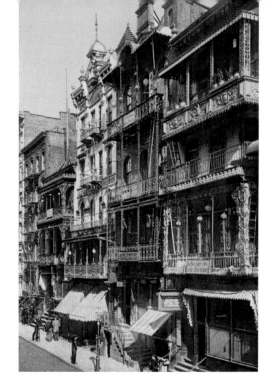

A row of old-law tenements outfitted with ornate facades on Mott Street. By the 1880s, approximately 1,100 Chinese immigrants, mostly men, lived on Mott and neighboring Pell and Doyers streets. After the Chinese Exclusion Act was passed in 1882, immigration plunged. In the early 1900s, Chinatown remained a "bachelor society" containing roughly 7,000 Chinese men and just 70–150 Chinese women residents.

ships and the elevated railways," recalled a Greek immigrant who settled here before the turn of the century. "I got work immediately as a push cart man. There were six of us in a company. We all lived together in two rooms down on Washington Street and kept the push carts in the cellar. . . . There are about 10,000 Greeks in New York now, living in and about Roosevelt, Madison, and Washington Streets. . . . Only about 10 percent go home again, and of these many return to America, finding that they like their new home better than their old one."

For the most part, New Yorkers didn't care for the new arrivals—though some enjoyed the new fad of "slumming," or going sight-seeing, in poor neighborhoods. Perhaps no group aroused more derision than the Chinese. The approximately 1,100 shop-keepers, textile workers, and vendors (typically selling candy and cigars) who settled on the southern edge of Five Points near Mott Street by 1880 had migrated to New York from the West Coast. "Celestials," as they were called, were viewed as exotic and "heathen." Relatively few Chinese women lived in Chinatown, and Chinese men (some of whom took Irish immigrant wives) were associated with gambling and opium dens. "It

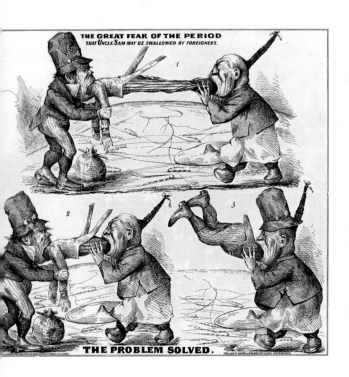

A period cartoon illustrates the fear many New Yorkers had about immigrants—that too many were arriving too fast for the city to absorb them.

is at night only that you may see the Mongol quarter of New York in its quickened phases, for the people come to life with darkness and disappear with the dawn," observed a magazine writer in 1909.

With so much suspicion cast on them, it's no surprise that the Chinese were treated differently than immigrants from Europe. In 1882, Chinese laborers were banned from entering the United States under the federal Chinese Exclusion Act—the only non-wartime law barring a specific ethnic group. The Act also prohibited Chinese immigrants already here from becoming citizens. In 1902, Congress renewed the Chinese Exclusion Act, with the ban extended indefinitely.

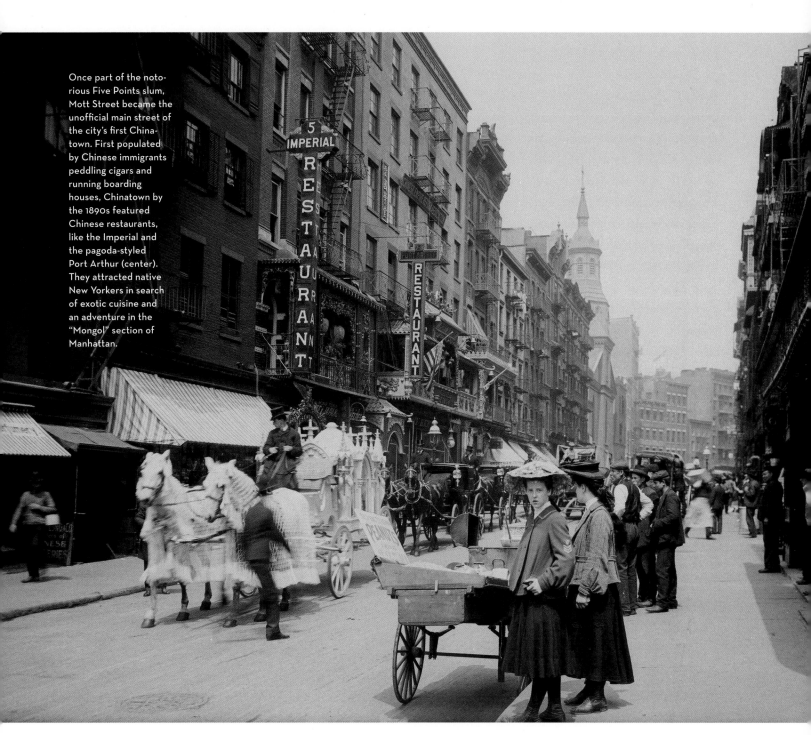

Once part of the notorious Five Points slum, Mott Street became the unofficial main street of the city's first Chinatown. First populated by Chinese immigrants peddling cigars and running boarding houses, Chinatown by the 1890s featured Chinese restaurants, like the Imperial and the pagoda-styled Port Arthur (center). They attracted native New Yorkers in search of exotic cuisine and an adventure in the "Mongol" section of Manhattan.

A Mixed Reception

Notwithstanding the present rush of immigration at this port the demand for labor at the Castle Garden Labor Bureau is greater than the supply," stated the *New York Times* on May 6, 1887. "Each day there are calls for 100 more laborers than can be obtained."

Unskilled labor was crucial to the Gilded Age; the city's economy depended on manufacturing. And the growing wealth among residents created a demand for service workers: coachmen, cooks, maids. Labor leaders weren't exactly rolling out the welcome mat, though. Poor and working-class New Yorkers feared that immigrants would undercut their wages and steal their jobs. Union organizers compelled Congress to pass the Alien Contract Labor Law. Signed in 1885, it would prevent American businessmen from hiring a contractor to procure cheap immigrant labor. Yet the law didn't do much to stop this padrone system, and more calls were made to impose further restrictions.

Newcomers in the second half of the nineteenth century also faced lingering Nativist sentiment from the 1840s and 1850s. Nativists felt that immigrants, especially Catholics, posed a threat to democracy, because the Nativists believed that Catholics pledged allegiance to the pope.

The Nativist movement was funneled into the Order of the Star Spangled Banner, a secret society founded in 1850 by New Yorker Charles B. Allen. That soon grew into the Know Nothings, a secretive faction of self-described Protestant native-born Americans who responded to questions from outsiders about the group by replying, "I know nothing."

The Know Nothings racked up some local political victories, but they ultimately failed to gain national traction in the 1850s.

One political party happy to court the immigrant vote through the nineteenth century was the Democrats, specifically those affiliated with Tammany Hall. Tammany bosses offered new immigrants, especially the Germans and Irish, assistance finding work, living space, and money for food and rent. The idea was for the immigrants to cast their ballots for the Democrats on Election Day—and this implicit exchange scored the Democrats many victories.

But even New Yorkers who weren't opposed to immigration in general felt strongly about restricting "undesirables": namely the Chinese, southern Italians, and Eastern European Jews. Ellis Island Commissioner William Williams was firmly in the opposition camp, as he explained in a 1909 interview with the *New-York Tribune*. Undesirables were "illiterate, poverty stricken persons of low vitality, who, although they are physically able to perform only the cheapest kind of manual labor, will live nowhere but in our largest cities. I claim that they are a drag upon the American wage-earner, that their competition tends to lower the standard of living in this country, and that they are mentally and morally unfit for the right kind of citizenship. . . . I am powerless to turn them back. Nevertheless, it is my belief that they ought to be turned back—that every immigrant who lands upon our shores should be a national asset and not a social liability."

As if anti-immigrant sentiment wasn't enough to contend with, new arrivals also

had to be on guard for swindlers. "As soon as a ship, loaded with these emigrants, reaches our shores, it is boarded by a class of men called runners, either in the employment of boarding-house keepers or forwarding establishments . . . ," recounted Friedrich Kapp. "If they cannot succeed in any other way of getting possession and control over the object of their prey, they proceed to take charge of their luggage, and take it to some boarding-house for safe-keeping. . . . The keepers of these houses induce these people to stay a few days, and, when they come to leave, usually charge them three or four times as much as they agreed or expected to pay."

Runners were the least of it. "The bloodsuckers and the greedy vampires were waiting outside the Barge Office, seeking to take advantage of immigrants' misery and ignorance, ready to attach themselves to the first unsuspecting greenhorn," one Italian immigrant complained in 1890. "There are several types. There is the pseudolawyer who offers you his unnecessary services with payment in advance. There are those who will send telegrams to relatives and friends

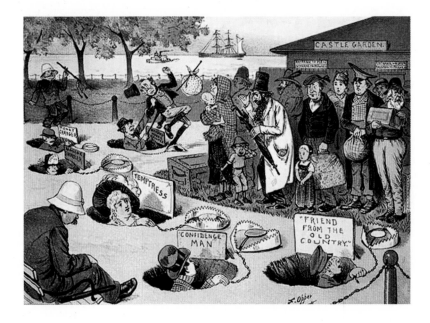

"The Castle Garden Immigrant Catchers," an 1882 cartoon from *Puck*, shows the dangers lying in wait for immigrants as soon as they exit Castle Garden and step foot on Manhattan soil.

in Italy; the telegrams are never received. Money exchangers are ready to give you dollars for your *lire* at a rate many times the actual one. Once away from the docks, a second wave of bloodsuckers descends on the immigrant . . . all of these vampires work the crowd with the aim of relieving the wretched new arrivals of their remaining ready cash."

In the 1880s, fears that foreign countries were sending criminals and the mentally ill to America—reinforced by testimony from social reformers who claimed that newcomers were filling up insane asylums—led to a series of laws limiting immigration. By 1906, federal legislation blocked a long list of undesirables: convicts and polygamists; anarchists, saboteurs, and political extremists; epileptics, beggars, lunatics, and those convicted of a "misdemeanor involving moral turpitude." A bill that sought to exclude immigrants who couldn't read at least forty words in any language was passed by Congress but vetoed by President Grover Cleveland in 1896.

One group that was often turned away under a late nineteenth-century law was the sick, or, as the law called them, "persons suffering from a loathsome or a contagious disease." Since Castle Garden had opened, ships were made to wait in quarantine before passengers could disembark; any passenger reported to be ill was removed to Ward's Island. But in the 1890s, with outbreaks of contagious diseases such as cholera occurring, officials became more vigilant about enforcing existing quarantine rules.

"April 23, 1863, what is now known as the General Quarantine Act was passed . . . establishing a general system of quarantine for the port," stated a *Harper's Weekly* article from September 1879. Swinburne Island in 1860, and Hoffman Island in 1873."

Cholera Breaks Out on Board

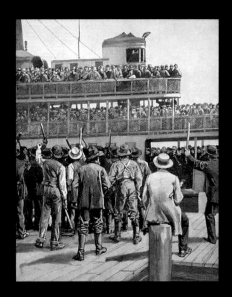

The cover of the September 24, 1892, issue of *Harper's Weekly* shows an armed mob on Long Island attempting to prevent the landing of the *Normandia*, a New York–bound ship filled with passengers about to be quarantined on Fire Island as a precaution against cholera. Ultimately the crowd, like others that had tried to stop quarantined passengers from landing at Sandy Hook in New Jersey, was dispersed, and the quarantine carried out. "The disgraceful exhibitions of fear made by the residents of Islip and those of New-Jersey in the relation of establishment of quarantine stations at Fire Island and Sandy Hook warn the people of this city that if cholera should invade the country, it would in all probability spread, as it would be difficult to obtain a sufficient supply of help with the necessary courage to carry out the sanitation law," a disgusted health official told the *New York Times* the next day.

In an era before antibiotics and hygiene science, a single case of a serious contagious disease—cholera, smallpox, and typhoid were the three biggest worries—could start a pandemic in the city. With thousands of people entering New York City from all over Europe every day, immigration officials took the safeguards they created seriously. One mandated that before a ship could unload her passengers at Castle Garden (or, later, Ellis Island), it had to anchor at a quarantine station in New York Bay. A health officer would then board the ship, examine passengers for any signs of illness, and take a look at the ship's records to see if anyone had died at sea from what might turn out to be a contagious infection. The sick were then taken to the Emigrant Hospital on Ward's Island; about nine thousand new arrivals were cared for and treated here every year.

In August 1892, the *Moravia*, a steamer carrying Russian Jews from Hamburg, Germany, languished in the harbor, waiting to be inspected. When the health officer boarded, the captain assured him that the ship had received a clean bill of health back in Hamburg. Yet a report by the ship doctor noted twenty-two deaths on board. It wasn't unusual for passengers to die en route, but twenty-two deaths was high. The deaths were determined to be from cholera—a bacterial infection spread via human waste through contaminated water. The original source was a cholera outbreak back in Hamburg. Apparently, the bacteria stowed away on the *Moravia*.

The *Moravia* was immediately sent to a quarantine station off Staten Island. Passengers exhibiting symptoms were taken to Swinburne Island; healthy passengers had to be disinfected at Hoffman Island. In the next few weeks seven more ships coming from Hamburg were found to have cholera-infected passengers or cholera-related passenger deaths. "Dante has described the wretchedness of Hell; it would take his pen to figure to you the filth, misery, and abject condition of this mass of humanity, packed under the most auspicious conditions for the rapid propagation of an epidemic," stated a scientific paper on the 1892 outbreak.

To make sure no other ships carried cholera, a twenty-day quarantine period for all ships arriving from Europe was established, halting traffic and inconveniencing thousands of passengers. City streets were washed and disinfected, in case passengers of a previous ship had brought cholera on shore. Once the outbreak had been contained by mid-September, 120 people were confirmed dead. The outbreak raised alarm all over the city, and prejudice against Russian Jews, already considered unclean, intensified as well.

Immigrants suspected of having smallpox were detained behind a fence on Hoffman Island in lower New York Harbor in 1901. Hoffman and Swinburne islands were man-made quarantine islands created off of Staten Island in the 1860s and 1870s. They replaced an earlier quarantine hospital on Staten Island that was burned down by residents in 1858. Passengers who were exposed to contagious disease on immigrant ships were brought to Hoffman Island to be monitored. Anyone showing symptoms went to a hospital on Swinburne Island for treatment.

Ships headed for the city waited at Hoffman Island for a quarantine officer to arrive. "When the Boarding Officer from the *Illinois* finds any yellow fever or cholera patients on the incoming vessels, a signal is set, and one of the steamers belonging to the quarantine service comes and bears away the sufferers to Swinburne Island," the *Harper's* article continued. "Immediately upon reaching there they are stripped of their clothing, which is at once burned in a furnace constructed for that purpose, and they are placed in the sick wards."

The city compiled annual records of how many immigrants arrived at Castle Garden and Ellis Island. But until 1908, officials didn't track the percentage of these newcomers who eventually returned to their homeland. This reverse exodus had many causes—economic hardship, family obligations, homesickness, a plan to only stay a year or two in the first

place before returning home. Southern Italians had the highest return rate, according to the 1908 numbers, with 61 percent going back to Italy. Hungarians, Slovaks, Croatians, and Slovenians also had high exodus rates. Ninety-five percent of Jewish immigrants stayed, however, and the Irish, English, and Scandinavians also tended to remain.

Who stayed and who went back home was a topic of concern to Ellis Island Commissioner Williams. "Some persons believe that the ebb and flow of immigrants during periods of prosperity and hard times is good for the country—that it is a safety valve through which dangerous and explosive elements escape, to the peace of society and the welfare of all," he told the *New-York Tribune* in 1909. "But such an opinion may be entirely fallacious. . . . It is sensible to think, however, that the good go, and that the bad remain."

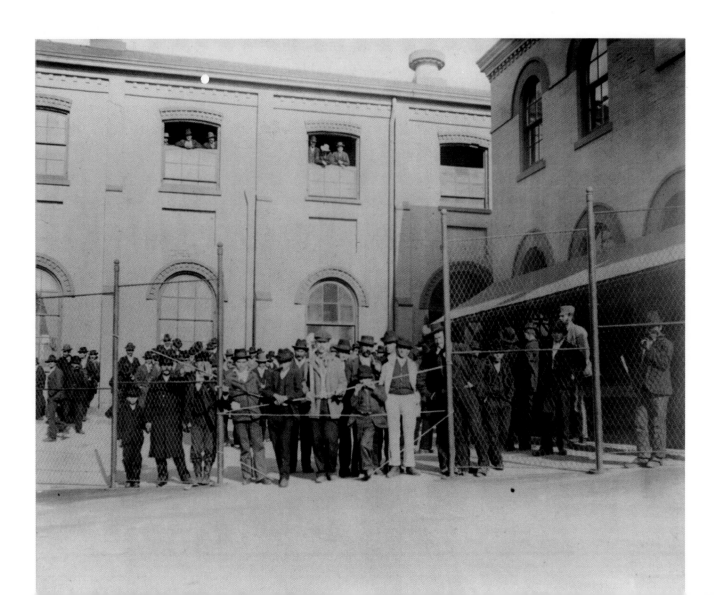

Ellis Island Opens

hen Castle Garden became the city's immigrant processing depot in 1855, it brought much-needed order to the registration and inspection of thousands of new arrivals daily to New York's shores.

But Castle Garden had its problems. Reports of corruption were rampant. Railroad tickets were marked up and sold for profit; "runners" from boardinghouses often slipped into the main waiting room, looking for new arrivals to prey upon. Some employees got their jobs through political patronage, and sexual misconduct and prostitution plagued the building. Also, with mass migration from Europe exploding in the 1880s, Castle Garden was too small

and ill equipped to deal with the surge.

After an investigation, Congress closed the state-run Castle Garden in 1890. From then on, the federal government would take charge of the immigration process rather than leave it to the states. The new federal Bureau of Immigration began registering newcomers at a barge office in Battery Park. Meanwhile, government officials took up the task of creating a new, modern immigrant receiving center, one that fended off swindlers and helped keep better track of who was entering the United States.

They found a place for it on a spit of land called Ellis Island in New York Harbor, closer to the New Jersey coast. Immigration officials built a $500,000 receiving

station here, which opened on January 1, 1892. An Irish seventeen-year-old traveling with her brothers named Annie Moore was the first newcomer to sign her name to the registration book. For the next sixty-two years, twelve million more passed through Ellis Island. (A fire destroyed the original buildings in 1897, but they were rebuilt by 1900.)

The federal takeover of immigration didn't stamp out all corruption and graft, of course, but conditions did improve when Theodore Roosevelt ordered a cleanup in 1901. The watershed year for immigration was 1907, when an all-time high of 1.2 million people passed through Ellis Island. By World War I, the number of newcomers dropped, and their numbers plunged further as the United States passed the Quota Laws of 1921 and the National Origins Act in 1924. Ellis Island remained open until 1954, when it processed its last immigrant, a Norwegian merchant seaman.

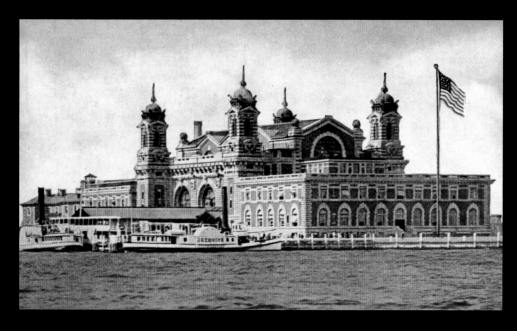

The main building at Ellis Island in 1900, which replaced a wooden building that burned down, along with many immigration records dating back to 1855, in an 1897 fire.

The Poor and the Rise of Social Welfare

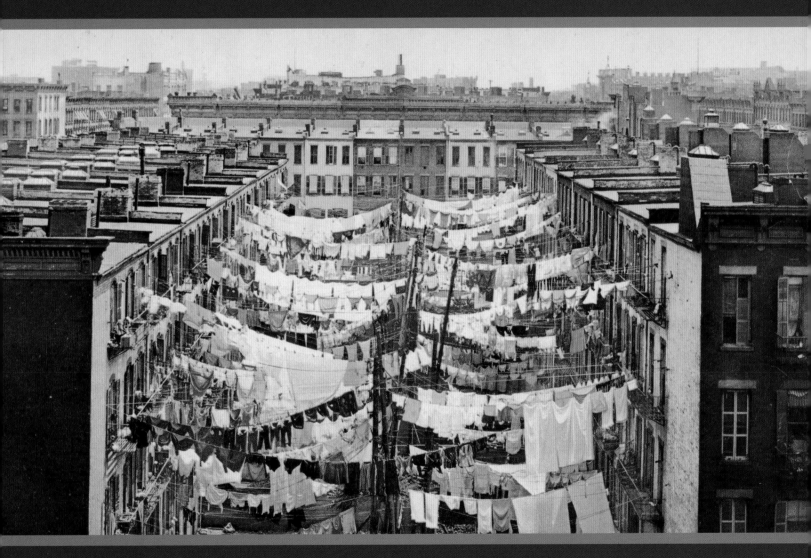

Laundry hangs in the yards behind two rows of tenements between Park Avenue and 107th Street. Tenements were not required to have running water in every apartment until the Tenement House Act of 1901. Clothes were often brought to the street in wooden tubs and washed with water from a fire hydrant.

Destitution and Hardship

"Poverty is a terrible misfortune in any city," wrote James McCabe in 1872. "In New York, it is frequently regarded as a crime. But whether the one or the other, it assumes here proportions it does not reach in other American communities. The city is overrun with those who are classed as paupers, and in spite of great efforts made to relieve them, their suffering is very great."

While the upper classes of Fifth Avenue held court in the illuminated parlors of their brownstones, less than a mile away in Lower Manhattan, struggling residents spent their days and nights in the dim back rooms of sooty tenements. As the 25 New Yorkers who were worth at least $2 million collected hefty salaries as bankers and business leaders, the poor pocketed $2-$3 a day shoveling dirt from construction sites, picking up refuse, or sewing garments in a factory. While the children of the wealthy learned quadrilles at dancing school and took up the roller-skating fad with their nurses in tow, their less fortunate counterparts were hawking newspapers and polishing boots, or roaming the "kindergarten of the streets," as one magazine writer put it.

Despite its wealth and financial power, New York always had a vast impoverished underclass. "If some potent magician could lift the veil which shrouds, in alleys, dark streets, garrets, and a thousand other habitations of want, the miseries that are every day going on among us—how would the spectacle distress and terrify the beholder!" wrote Walt Whitman of the city's poor. The financial boom of the post–Civil War years, coupled with a population surge during the Gilded Age, split the classes further apart and turned Manhattan from Franklin Square to 14th Street into a ribbon of poverty. By 1870, Manhattan was home to approximately 940,000 people. The percentage classified as poor isn't clear, but close to 500,000 city residents lived in tenements. Just twenty years later, when the city's population reached 1.5 million, 1.1 million called tenements home.

The numbers of the poor soared during times of economic crisis. During the Panic of 1873, a quarter of all New Yorkers were thrown out of work. Ninety thousand homeless men and women slept on the basement floors of police precincts, which served as public shelters at the time. Arrests for vagrancy doubled. In Brooklyn, relief rolls increased sharply, and the city responded by limiting needy families to $1 a week of food or coal.

The economy rebounded in the 1880s, only to take a hit again after a wave of bank failures resulted in the Panic of 1893. By the end of that year, 16,000 city businesses had closed. Manhattan had 110,000 laid-off residents; Brooklyn reported 25,000 unemployed. Twenty thousand jobless New Yorkers were living on park benches, in the streets, or on the rag-stuffed mattresses at lodging houses. "This winter will go down in history as the blackest in the history of New York," wrote the *New York World* on January 8, 1894. Two days later, Mayor Thomas Gilroy addressed the Board of Aldermen, "Distressing destitution and hardship are imminent in thousands of homes among those worthy and willing to work."

Adding to the ranks of the have-nots were the thousands of immigrants arriving at Castle Garden and then Ellis Island every week. The majority came with little savings or education, and they competed with earlier newcomers and native New Yorkers for the same unskilled labor jobs: diggers, haulers, domestics, dock workers. With no other options, they packed into neighborhoods already overrun with poverty. "Day after day you will see express wagons and trucks leaving the immigration station at the Battery, loaded to crowding with the latest arrivals, who are being taken as residents to one or another colony of this crowded section," observed Theodore Dreiser in *The Color of a Great City*. "All are poverty-stricken, all venturing into this new world to make their living. The vast majority have absolutely nothing more than the ten dollars

which immigration inspectors are compelled to see that they have when they arrive."

Whether native-born or newcomer, the poor colonized their own New York. The rich had Fifth Avenue, and the poor had Five Points, Manhattan's most notorious slum since the 1830s. "Turning out of glittering and crowded Broadway through Worth Street nearly opposite the New-York Hospital, two minutes' walk brings us to the Five Points, with its narrow, crooked, filthy streets; its low, foul, rickety frames; its ancient, worn-down, unsavory tenements," wrote Junius Henri Browne in 1869. "The first thing that impresses you is the swarm of children in every street, before every house and shop, and at every corner . . . the offspring of vice is as prolific as the offspring of poverty, and both are there."

The House of Industry Sets Up in Five Points

In 1861, the Five Points House of Industry celebrated its tenth anniversary. A *New York Times* article detailed numbers from the institution's annual report: "1,633 persons have received partial or entire support from this charity during the past year. 835 of whom were children; 285,215 meals have been distributed, gratuitously during the year, at an average cost of 2 cents per meal; 864 children have been enrolled on the school register, and the average daily attendance has been 254."

Homeless young boys in their communal bedroom at the Five Points House of Industry, a mission house that opened in 1853. Most of the children who lived there were not true orphans; they had at least one parent living who was unable to take care of the child due to poverty, alcoholism, or both.

In the nineteenth century, an evangelical zeal to aid the poor swept through New York. Methodist clergyman Lewis Morris Pease was one of these Christian reformers. In 1850, he ventured into the squalid, lawless Five Points district and established the Five Points Mission, one of the city's first mission houses, offering lodging, food, clothes, and schooling to poor residents.

After parting ways with the Mission in 1851—Pease realized he was more committed to offering the poor hands-on help rather than pressuring them to convert to Protestantism—he founded a mission just across Worth Street called the Five Points House of Industry.

By 1853, the House of Industry included five separate houses, "which he filled with the occupants of the wretched hovels of

the vicinity," wrote James D. McCabe in 1872. "He procured work for them, such as needle-work, basket-making, baking, straw-work, shoe-making, etc. . . . The expenses of the Mission were then, as now, paid from the profits of this work, and the donations of persons interested in the scheme. Five hundred persons were thus supported. Schools were opened, children were taught, clothed, and fed, and religious services were regularly conducted."

In later years, the House of Industry focused on children's welfare; an infirmary and dispensary were added, and twelve hundred local children attended the House school. As the nineteenth century drew to a close, Five Points—though still poor—was no longer the horrific slum it had been decades earlier. By 1913, the House of Industry had moved out, its old quarters set to be razed to make room for a new county courthouse. All

traces of the city's worst slum, and the missions that eased its suffering, would soon meet the wrecking ball.

Jacob Riis brought his camera into the House of Industry, where he captured prayer time. "It is one of the most touching sights in the world to see a score of babies, rescued from homes of brutality and desolation, where no other blessing than a drunken curse was ever heard, saying their prayers in the nursery at bedtime," wrote Riis in his 1890 book *How the Other Half Lives*. "Too often their white night-gowns hide tortured little bodies and limbs cruelly bruised by inhuman hands. In the shelter of this fold they are safe, and a happier little group one may seek long and far in vain."

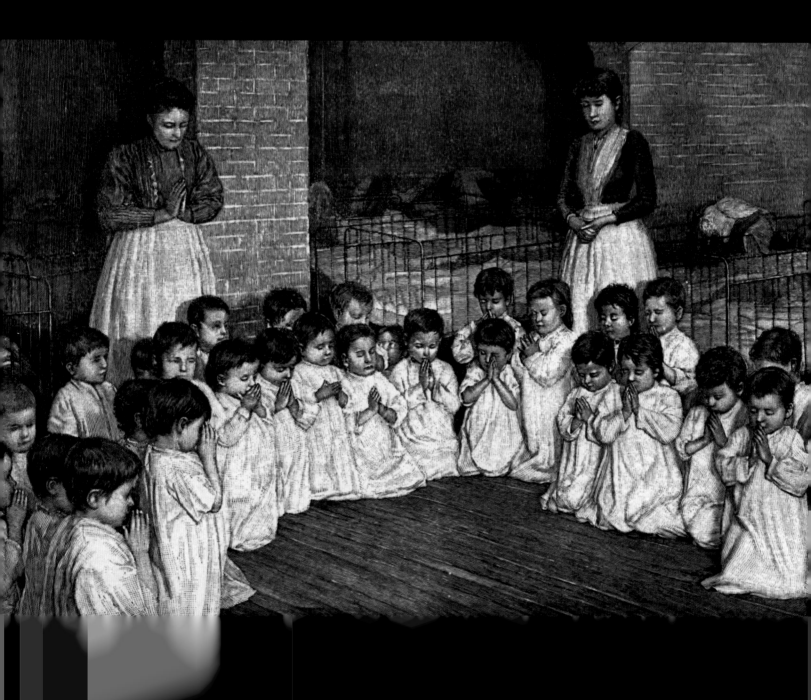

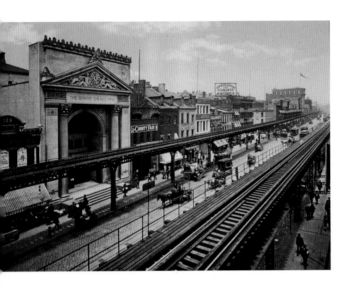

Five Points splintered apart by the 1880s and 1890s, broken into various Lower Manhattan "poverty hollows," as they were dubbed, along ethnic lines. The streets there—"Mulberry and Mott, Elm and Centre, Pell and Dover, James and Roosevelt Streets," Browne wrote, along with the "Jewish Quarter" between Houston and Delancey Streets—teemed with the poorest classes. The down-and-out also fanned out to the Lower West Side, Hell's Kitchen, and the East Side gashouse district. Pockets of indigent men and women scraped

by in a small shantytown off 42nd Street and the East River called Dutch Hill. In Brooklyn, the poor lived in part of Fort Greene. They also occupied a stretch of Myrtle Avenue that was nicknamed "Young Dublin" for the Irish immigrants who slept there in shanties.

Getting by in the late nineteenth-century city with little money or means was tough. No labor laws protected workers; public relief was discouraged and mostly discontinued by the mid-1870s. The end of the Tweed regime and the recession of the 1870s put a stop to Tammany Hall's handouts of coal and food in exchange for votes. Brooklyn too suspended its relief program. *What should we do to help the poor?* was a constant topic of discussion. While politicians, religious leaders, and social reformers debated, the poor lived on the edge. A work injury, epidemic, or fire could wipe out what little they had. The granite almshouses on Blackwell's Island—home to about 1,100 destitute men and women, or "human driftwood" according to one periodical—was a desperate New Yorker's last resort.

Tenements: "Nurseries of Pauperism and Crime"

In 1893, Lillian Wald—then a twenty-six-year-old nurse teaching a class to immigrant women on the Lower East Side—was asked by a little girl to help her mother, who was bedridden in their Ludlow Street apartment, as she recalled in her memoir *The House on Henry Street*, published in 1915:

The child led me over broken roadways . . . over dirty mattresses and heaps of refuse . . . between tall, reeking houses whose laden fire escapes, useless for their appointed purpose, bulged with household goods of every description. . . . Through Hester and Division streets we went to the end of Ludlow; past

odorous fish-stands, for the streets were a market-place, unregulated, unsupervised, unclean. . . .

The child led me on through a tenement hallway, across a court . . . up into a rear tenement, by slimy steps whose accumulated dirt was augmented that day by the mud of the streets, and finally into the sickroom. All the maladjustments of our social and economic relations seemed epitomized in this brief journey and what was found at the end of it. . . . Although the family

of seven shared their two rooms with boarders—who were literally boarders, since a piece of timber was placed over the floor for them to sleep on—and although the sick woman lay on a wretched, unclean bed, soiled with a hemorrhage two days old, they were not degraded human beings.

Shocked by this "baptism by fire," Wald decided to make housing reform part of her life's work. She founded the Henry Street Settlement later that year.

Flimsy fire escapes laden with drying clothes were a common sight in tenement districts, like this Belgian Block stretch of Elizabeth Street in 1912.

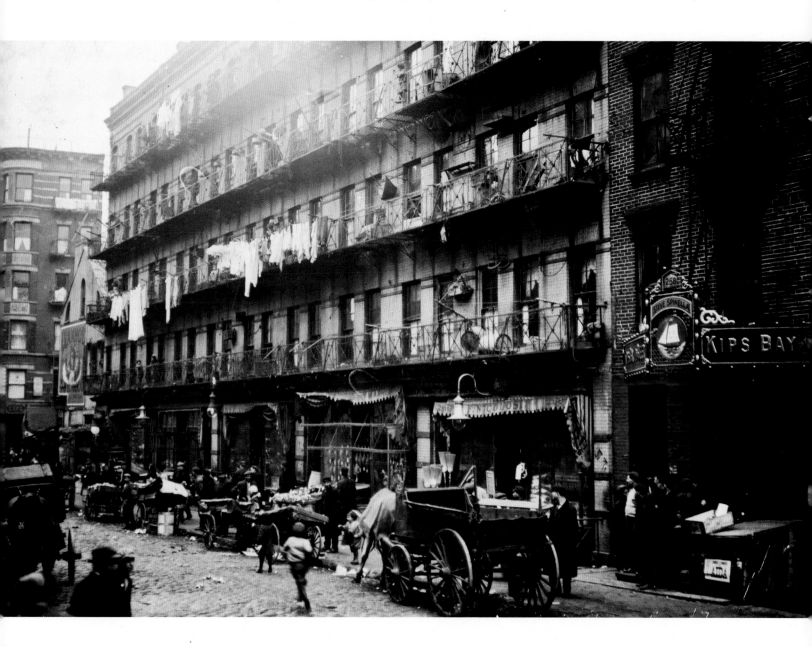

Horror in a City Lunatic Hospital

"Who is this insane girl?" asked a *New York Sun* article on September 25, 1887. The story told of a "modest, comely, well-dressed girl of nineteen, who gave her name as Nellie Brown, [who] was committed by Justice Duffy of Essex Market yesterday for examination of her sanity." The unknown girl was then taken to Bellevue, and though doctors were sure she was insane, they were puzzled as to who she was and where she was from.

Ten days later, they and the rest of the city would find out. The "insane girl" was Nellie Bly, the pen name of Elizabeth Jane Cochran, a twenty-three-year-old investigative reporter originally from Pittsburgh who was sent by Joseph Pulitzer's sensational *New York World* to get herself committed to the Women's Lunatic Asylum on Blackwell's Island and write a story about the conditions she encountered there.

Various city newspapers had covered the disturbing, criminal conditions at the asylum over the years since it opened in 1839. It was one of many public buildings on the island, including an alms-house, penitentiary, and hospital for incurables that housed the city's poor, petty criminals, and sick. But it was Bly's experience that prompted an outraged city to demand change. Her series of articles chronicled ten days in the overcrowded, rat-infested building, eating rotten food, "showering" with buckets of cold water, and enduring forced isolation.

"From the moment I entered the insane ward on the island, I made no attempt to keep up the assumed role of insanity," she wrote in the series, which caused such a sensation, it was published as a book called *Ten Days in a Mad-House*. "I talked and acted just as I do in ordinary life. Yet strange to say, the more sanely I talked and acted, the crazier I was thought to be by all. . . ."

"What, excepting torture, would produce insanity quicker

Nellie Bly's series of articles about the New York City Lunatic Asylum on Blackwell's Island in the *New York World* was later published as a book, *Ten Days in a Mad-House*.

Nellie Bly wasn't the first reporter to write about the terrible conditions at New York's charitable hospitals—but the twenty-three-year-old rookie reporter's undercover exposé was the one that seized the city's attention and prompted real reform.

than this treatment?" she wrote. "Take a perfectly sane and healthy woman, shut her up and make her sit from 6 A.M. to 8 P.M. on straight-back benches, do not allow her to talk or move during these hours, give her no reading and let her know nothing of the world or its doings, give her bad food and harsh treatment, and see how long it will take to make her insane. Two months would make her a mental and physical wreck."

Responding to national criticism triggered by Bly's searing articles, the city drastically increased funding to the Commission of Public Charities and Corrections so that upgrades would be made

brought in to supervise overwhelmed staff; regulations were put in place to prevent overcrowding. Bly herself was invited to tour the facilities a month later, and she reported that many of the worst offenses had been corrected. In a follow-up article in the *World*, she concluded, "I have

one consolation for my work—on the strength of my story the committee of appropriation provides $1 million more than was ever before given, for the benefit of the insane." The Lunatic Asylum closed for good in 1894, its patients transferred to a facility for the insane on Ward's Island.

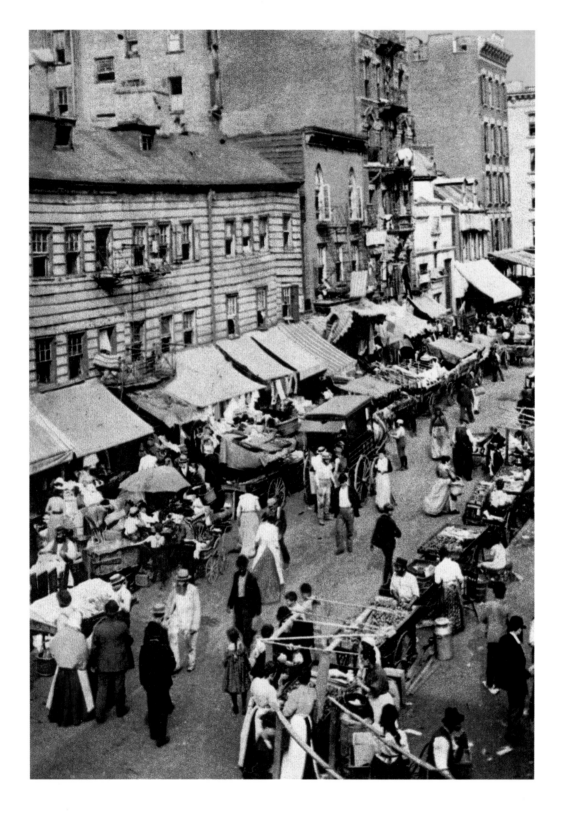

Nothing symbolized the hard life of the poor like the tenement house. The first tenements were "tenant houses": single-family eighteenth-century homes sliced into small units in the early nineteenth century. Rooms were often damp and sunless, and they had no running water (a pump in the back supplied fresh water, though it often froze in the winter). Instead of an indoor privy, an outhouse in the backyard that was

unconnected to the city sewer system had to be shared by all residents. Some of the most wretched tenant houses were part of a hidden city of back houses—nicknamed "roosts" or "rookeries"—that stood in the shadows of a front tenement amid a rabbit warren of courtyards and alleys. Colorful names like Bottle Alley, Blind Man's Alley, Bandit's Roost, and Ragpickers Row made light of the despair.

In 1833, it is believed, developers put up the first intentional tenement, on Water Street. As immigrants poured into Lower Manhattan, the East Side, and Five Points, thousands of cheaply made dwellings spread across the cityscape. Poor and working-class residents crammed into these flat-roofed, five- or six-story structures, "packed like herring with human beings," commented the city Board of Health in an 1873 report. The population density, combined with primitive living conditions, bred disease. An 1849 cholera outbreak that swept through Lower Manhattan killed more than five thousand people; in the 1890s, entire streets were dubbed "lung blocks" because so many tenement dwellers had tuberculosis. Made with substandard materials, buildings frequently went up in

flames or buckled. One headline-grabbing collapse happened on Grand Street and West Broadway in November 1881. More than twenty residents were trapped when the three-story building crumbled down over them. Before the collapse, tenants had notified the landlord about dangerous cracks in the walls and even filed a complaint with the Bureau of Inspection of Buildings. But nothing was done to declare the tenement uninhabitable and warn residents to leave.

As the army of tenement-dwellers increased, officials took notice. An 1864 survey by the Council of Hygiene and Public Health found that about half a million New Yorkers (out of a city population of 726,386) lived in one of approximately 15,000 tenements. Most were occupied by working families, who labored at home doing piecemeal work or toiled in a factory or on the nearby waterfront. "They herd here because the rents of single houses are out of proportion to, or beyond their means, and because they are convenient to work," wrote James McCabe in 1872. Social reformers worried that they bred crime. In 1872, reformer Charles Loring Brace, a founder of the Children's Aid Society, wrote about children "swarming in tenement-houses" and the "wretched rooms" where they were taught to beg and steal.

In 1867, an investigation by the state legislature found that the lack of light, ventilation, and fire escapes put 52 percent of tenements "in a condition detrimental to the health and dangerous to the lives of the occupants." This concern about tenement safety and sanitation led to the Tenement House Act of 1867. It was the first city law that mandated change: Fire escapes were now required, and for every twenty tenants, there had to be at least one indoor water closet connected to the sewer, if possible. Cellar apartments were outlawed.

OUR RELIGIOUS LANDLORDS AND THEIR ROOKERY TENANTS.

When Homeless Kids Boarded "Orphan Trains"

"To sleep in boxes, or under stairways, or in hay-barges on the coldest winter nights, for a mere child was hard enough; but often to have no food, to be kicked and cuffed by the older ruffians, and shoved about by the police, standing barefooted and in rags under doorways as the winter storm raged, and to know that in all the great city there was not one single door open with welcome to the little rover—this was harder," wrote Children's Aid Society founder Charles Loring Brace in his book *The Dangerous Classes of New York and Twenty Years' Work Among Them* (1872).

In 1848, Charles Loring Brace, a young divinity student, visited Manhattan. What he found shocked him: hordes of vagrant children, dirty and ragged, working and living on the streets. That year, city officials estimated that about three thousand "street Arabs" eked out a living as newsboys, bootblacks, vendors, prostitutes, or criminals. More appalling to Brace was that police could arrest these homeless boys and girls and condemn them to live in adult asylums.

Incarceration wasn't the answer, Brace felt; nor were orphanages. "The child must have sympathy, individual management, encouragement for good conduct, pain for bad, instruction for his doubts, tenderness for his weakness, care for his habits, religious counsel and impulse for his particular wants," he wrote. "He needs, too, something of the robust and healthy discipline of everyday life. . . . How can all this be got in an asylum or orphanage?"

After founding the Children's Aid Society in 1853, he came up with an idea that would remain controversial for decades: sending New York's street children to towns and cities across the country, hoping that farm families would take them in and provide a good home away from the vice of city slums.

The first "orphan train" left New York in 1854. For the next seventy-five years, at least a hundred thousand children—some abandoned by parents, others signed over by alcoholic or destitute mothers and fathers—went east, west, and south. Most didn't actually go far; a third found homes in New Jersey, upstate New York, and Pennsylvania. Historians who later tracked down some of the children discovered that, by and large, they lived ordinary lives with their new families. In a 1910 report, the Children's Aid Society estimated that 87 percent had benefited from being removed from the city.

Throughout his life, Brace questioned whether sending children away, never to see their birth families again, was the right move. "When a child of the streets stands before you in rags, with a tear-stained face, you cannot easily forget him," he wrote. "And yet, you are perplexed what to do. The human soul is difficult to interfere with. You hesitate how far you should go."

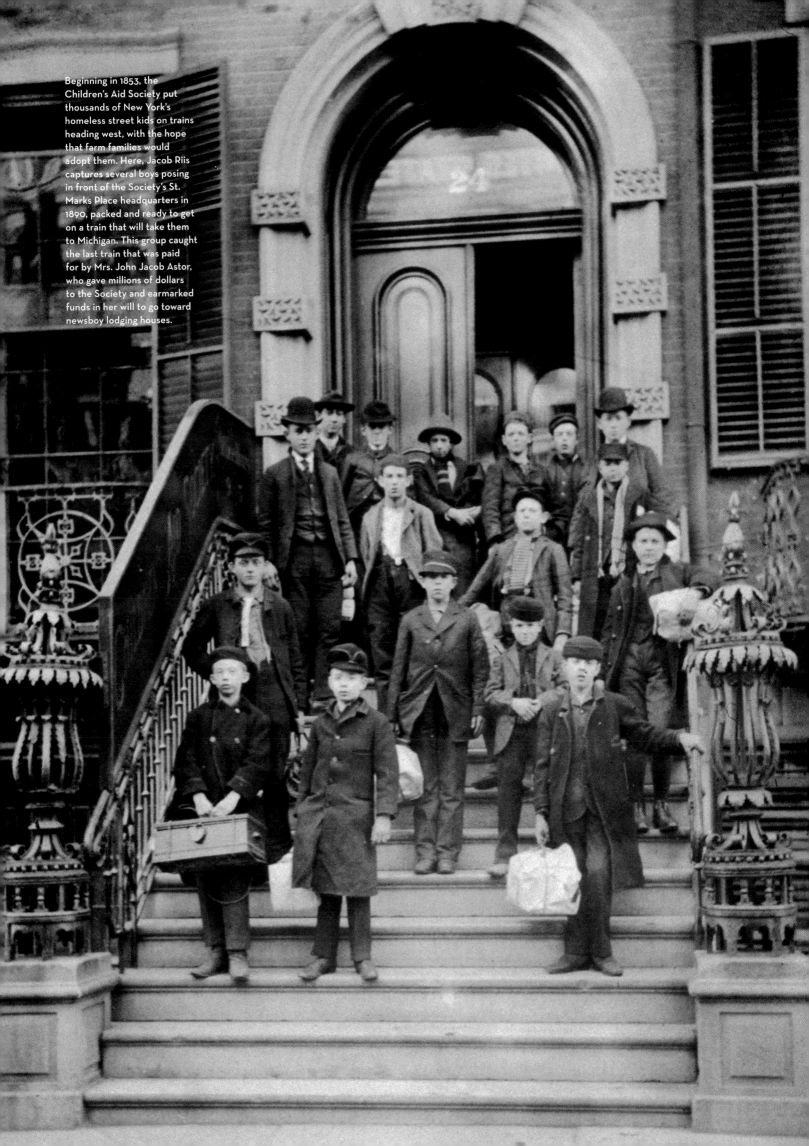

Beginning in 1853, the Children's Aid Society put thousands of New York's homeless street kids on trains heading west, with the hope that farm families would adopt them. Here, Jacob Riis captures several boys posing in front of the Society's St. Marks Place headquarters in 1890, packed and ready to get on a train that will take them to Michigan. This group caught the last train that was paid for by Mrs. John Jacob Astor, who gave millions of dollars to the Society and earmarked funds in her will to go toward newsboy lodging houses.

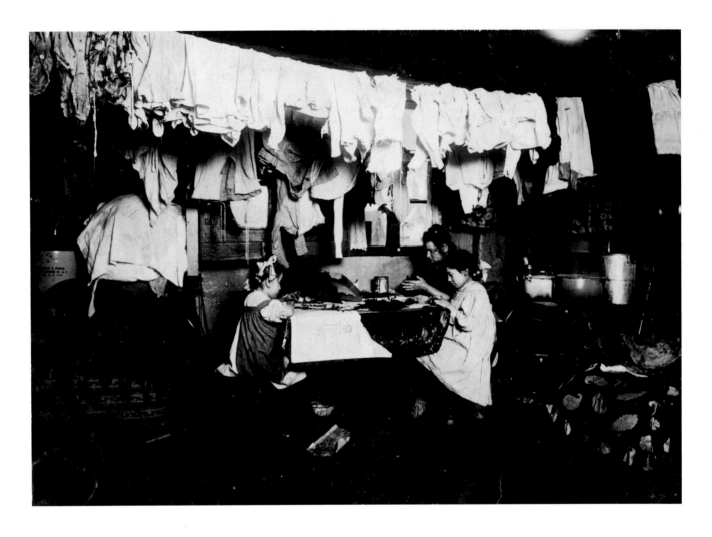

A second bill in 1879 limited the size of the tenement to allow more room between buildings, and it mandated that shared water closets be installed on each floor. Windows had to open to the outside to improve ventilation. This gave rise to the "dumbbell" tenement, with interior room windows facing dark, putrid airshafts.

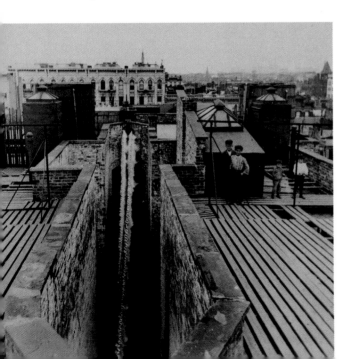

The new regulations, though, barely made a difference. "The windows on the sides open into the alleys and receive the poisonous gases which arise from them," wrote James McCabe in 1882. "Water is laid on each floor. The apartments for a family consist of a kitchen, which is also the living, or sitting-room, and one or more bed-rooms. . . . In the winter time it is close and unhealthy, and in the summer the heat of so many cooking-stoves renders it almost unbearable." William Elsing, a missionary writing in *Scribner's Monthly* in 1892, agreed. "The new houses are not much better lighted than the old ones," he wrote. "The airshafts are too narrow to convey much light to the lower floors. . . . In the winter, just before the gas is lighted, dungeon darkness reigns. When groping my way in the passages

In a dark, cramped tenement attic at 143 Thompson Street in 1912, members of the Ceru family, including the children, do piecemeal work for a factory making artificial leaves.

The airshaft of a dumbbell tenement. So named because of their pinched-in-the-middle shape, they were actually an improvement over the earliest tenements and were created after the 1879 Tenement Act mandated that all new tenements have a window in every room. Unfortunately for tenants, the window often opened into a sometimes noisy, filthy airshaft just a few feet wide.

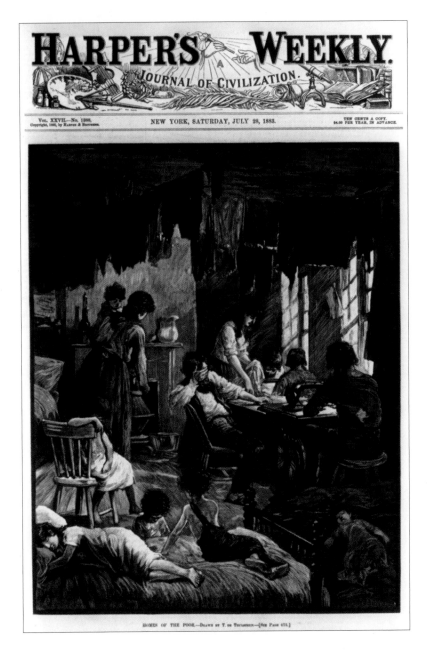

HARPER'S WEEKLY.
JOURNAL OF CIVILIZATION.

Vol. XXVII.—No. 1388.
Copyright, 1883, by Harper & Brothers. NEW YORK, SATURDAY, JULY 28, 1883. TEN CENTS A COPY.
$4.00 PER YEAR, IN ADVANCE.

HOMES OF THE POOR—Drawn by T. de Thulstrup—[See Page 474.]

The inside of a tenement, from an 1883 *Harper's Weekly.* Many families both lived and worked in their apartments, turning living rooms and bedrooms into mini-factories.

I usually imitate the steam crafts in a thick fog and give a danger-signal when I hear someone else approaching. I proceed with caution, for more than once I have stumbled against a baby who was quietly sitting in the dark hall or on the stairs."

Though poorly designed, not all tenement apartments were repugnant. "The great brick buildings with their network of iron fire-escapes in front, their numerous clothes-lines running from every window in the rear, the well-worn stairs, the dark halls, the numerous odors, pleasant and otherwise, coming from a score of different kitchens presided over by housewives of various nationalities—these are all similar," wrote Elsing. But "the moment you enter the rooms, however, you will find every variety of homes, many of them poor, neglected, wretched, and dirty; but others clean, thrifty, and attractive." The typical three-room apartment, with a kitchen (and a wood or coal stove that left a sooty residue on walls and furniture) and two bedrooms, cost $8 to $12 a month; a four-room apartment, which had a parlor, ran $12 to $16 per month. The cheapest setup in one of the older tenements was the attic. "The rent of one or two unfurnished attic rooms ranges from $3 to $5 per month," stated Elsing.

Rents like those took up one-fourth the annual salary of the average working man. No wonder tenements were lucrative for landlords. William Astor owned entire blocks of East Side tenements; he made almost three times the money off tenements with several small apartments—and therefore a bigger rent roll—than if his buildings had contained fewer, more spacious units. Trinity Church owned many tenements on the West Side near Hudson and Clarkson streets. The influx of immigrants proved to be a financial boon. "With their coming in masses, shrewd landlords began to put in flimsy rear tenements and, because of the demand, to raise rents until one family had of necessity to huddle in a single room and even to take in boarders," wrote the *New York Times* on July 30, 1899. Tenants had few rights and landlords few responsibilities.

Calls for additional reform came after more building collapses and fires, as well as the publication of Jacob Riis's *How the Other Half Lives* in 1890. The horrors Riis uncovered—infant death rates as high as one

Jacob Riis: From Poor Immigrant to Reformer

Jacob Riis took hundreds of photos on his tour of the city tenements; he published them himself in 1890's *How the Other Half Lives*. This family (below) all lived in a one-room flat, with a window that appears to open into an airshaft, providing little ventilation.

In 1870, Jacob Riis, then 21, left his native Denmark, spent two weeks in steerage on a steamship, and arrived at Castle Garden. Alone and penniless like so many other new immigrants, he struggled to gain a foothold. Eventually Riis found jobs as a carpenter, a bricklayer, and then a journalist—finally securing a position as a police reporter for the *New York Herald Tribune* in the 1880s.

His years covering murder and corruption on the night shift took him to New York's most crime-ridden and destitute neighborhoods. Shocked by the conditions he routinely encountered—the filth, sickness, and desperation of the city's poor and working class—he decided to write about what he saw and advocate for reform. An article entitled "How the Other Half Lives" ran in *Scribner's Magazine* in 1889 accompanied by many of Riis's own photographs of tenement cellars, child workers, "street Arabs," and other images of the city's poorest classes. It was the genesis of his book of the same name, which appeared in 1890 and triggered an uproar across the metropolis.

Social reformers had long railed against the horrible conditions in city slums. But nothing shook New Yorkers like Riis's descriptions and stark photographs of the men, women, and children who lived in squalid tenements. "The tenements today are New York, harboring three-fourths of its population," he wrote. "When another generation shall have doubled the census of our city, and to that vast army of workers, held captive by poverty, the very name of home shall be as a bitter mockery, what will the harvest be?"

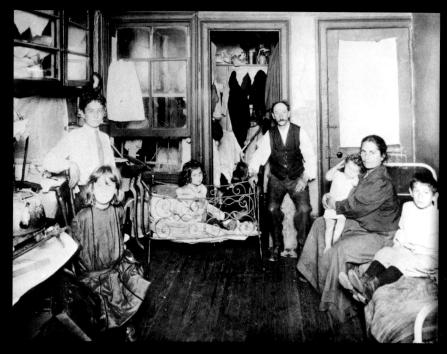

Excerpt from *How the Other Half Lives*: "Be a little careful, please! The hall is dark and you might stumble over the children pitching pennies back there. Not that it would hurt them; kicks and cuffs are their daily diet. They have little else. Here where the hall turns and dives into utter darkness is a step, and another, another. A flight of stairs. You can feel your way, if you cannot see it. Close? Yes! . . . Here is a door. Listen! That short hacking cough, that tiny, helpless wail—what do they mean? They mean that the soiled bow of white you saw on the door downstairs will have another story to tell—Oh! a sadly familiar story—before the day is at an end. The child is dying with measles. With half a chance it might have lived; but it had none. That dark bedroom killed it."

in ten, a dozen adults living in one 13-foot room—led to the "New Law" Tenement House Law of 1901. Lot sizes increased to provide more sunlight; all windows had to open to fresh air, not an airshaft; and running water and toilets were required in each unit. The law didn't make unsafe, unsanitary tenements disappear. But it helped improve conditions for the now 2.3 million New Yorkers—an astonishing three-fourths of the city population, as of 1901—who made their homes in the 82,000 tenements spread out in all five boroughs of the newly consolidated metropolis.

The Two Castes of New York's Poor

Just like the rich, the poor were divided into two camps during the Gilded Age. There were the "deserving" poor—people facing poverty through no fault of their own: orphans, the ill, the aged. The other group was the "unworthy" poor, who were thought to have brought their suffering upon themselves. These were the idle, the alcoholics, the gamblers, and others beset by vices.

"The deserving poor are numerous," wrote James McCabe. "They have been

Tenement fire escapes had many functions: laundry racks, storage spaces, and makeshift play areas for kids.

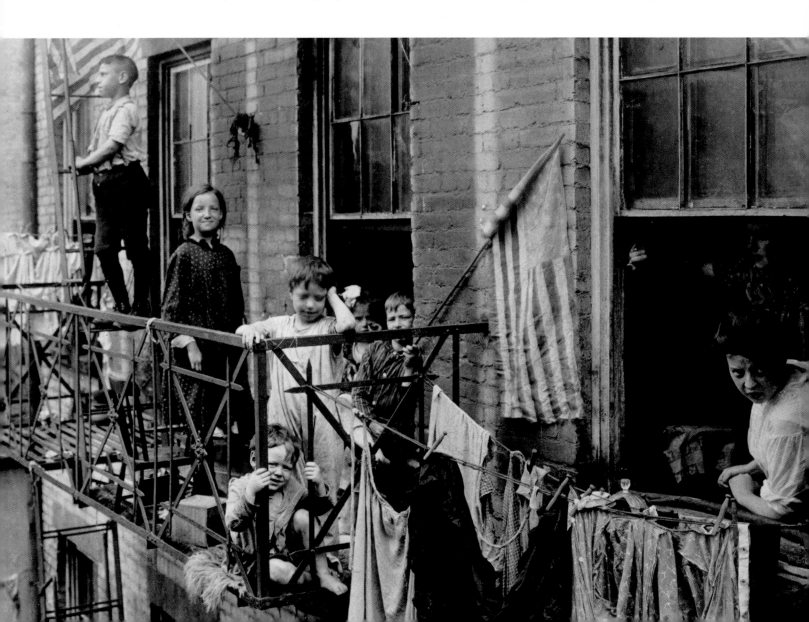

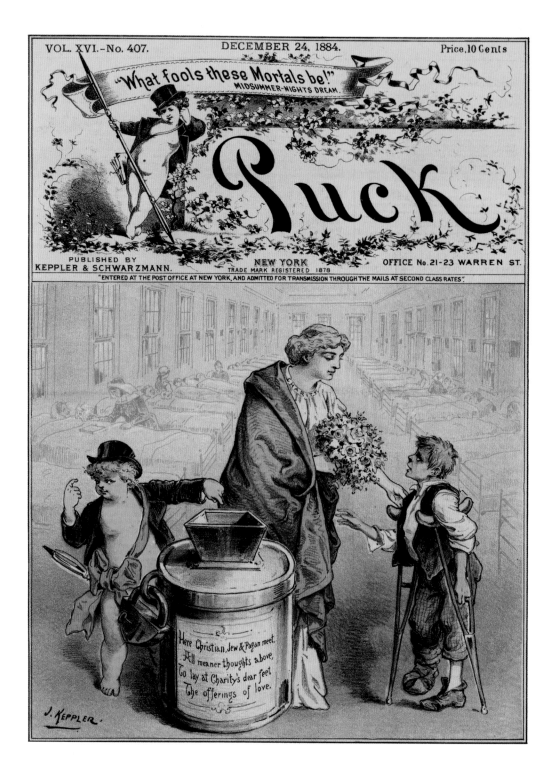

VOL. XVI.—No. 407. DECEMBER 24, 1884. Price, 10 Cents.

"What fools these Mortals be!"
MIDSUMMER-NIGHTS DREAM.

Puck

PUBLISHED BY
KEPPLER & SCHWARZMANN. NEW YORK OFFICE No. 21-23 WARREN ST.
TRADE MARK REGISTERED 1878
"ENTERED AT THE POST OFFICE AT NEW YORK, AND ADMITTED FOR TRANSMISSION THROUGH THE MAILS AT SECOND CLASS RATES."

Here Christian, Jew & Pagan meet,
All meaner thoughts above,
To lay at Charity's dear feet
The offerings of love.

J. KEPPLER.

Puck magazine's impish mascot reminds readers in December 1884 to give generously on "Hospital Sunday," an annual event when New York's churches donated the contents of their collection boxes to city hospitals.

brought to their sad condition by misfortune. A laboring man may die and leave a widow with a number of small children dependent on her exertions. The lot of such is very hard. . . . The deserving poor rarely come on the streets to seek aid, but the beggars crowd them, as they know the charitable institutions of the city would at once detect their imposture." The concept of the worthy and unworthy poor was not new. But it gained support in the late nineteenth-century city. Capitalism was generating many personal fortunes, and there was a sense that opportunity would be available to anyone

The Municipal Lodging House, opened in 1909 on 25th Street at the East River, was the first city shelter for homeless and hungry men and women. Three meals a day were served in the enormous dining room of the former factory. Before it was built, New Yorkers with no home were permitted to sleep on police precinct floors overnight, or they were put up in private lodging houses run by charities.

willing to work hard and avoid moral and character flaws.

New York had great sympathy for those unwillingly destitute. Private charities dedicated to eradicating poverty sprang up—yet they made a point to assure donors that no help would go to the wrong crowd. The *New York Herald*, which launched charity drives in the 1890s, made it clear that it did not give handouts to the unworthy. "Free Distribution of Food in the New Herald Building," a headline read on January 2, 1894. "New York's deserving poor crowded in, the day long, and received cereals, canned soup, milk, and coffee, and orders for wholesome meat and coal, insuring at least a brighter beginning of the new year."

If you were needy yet able-bodied, particularly if you were a man, your situation generated less compassion. Men who lost their jobs following the Panic of 1873 and gathered at rallies, calling for a public work-relief program, were lectured on self-sufficiency. "A spirit of manly courageous self-reliance is the best friend a working-man can have at any time, and especially in a season of industrial depression," stated the *New York Daily Graphic* on November 10, 1873. "There is no use in railing at the rich, nor in scowling at capitalists, nor in condemning corporations, simply because one's pocket is empty and he happens to be dinnerless."

Not until the brutal depression winter of 1894 did the city finally launch a work-relief program. The labor movement had been rallying for one, and anarchists like Emma Goldman publicly encouraged the unemployed to steal food to fend off hunger. "If you are hungry and you need bread, go and get it—the shops are plentiful and the doors are open," she reportedly said. Under the leadership of the Parks Department, the new program created jobs for two thousand out-of-work New Yorkers. It was the first work relief program in decades. Yet it was shut down in months, under fire for awarding jobs to the politically connected.

Generating even less sympathy, or perhaps outright disdain, were the armies of tramps that began appearing on city streets in the 1870s, begging along 14th Street, Fifth Avenue, 23rd Street, and other high-traffic intersections. Tramps were considered idle by choice. "[A]rrayed as they are, and as unkempt and unwashed, not even the lowest-priced lodging houses of the Bowery would receive them, and most certainly they would not pay the price of fifteen or twenty cents which would be required to house them, even if they had it," wrote Theodore Dreiser, of these men with "dirty skins, dirty clothes, and their large feet encased" in torn shoes. "And as for applying to a police station at any time, it were better that they did not. In bitter weather an ordinary citizen might do so with safety and be taken care of, but these, never. They would be driven out or sent to the Island."

In a city that offered almost no public relief outside of the almshouses and hospitals on Blackwell's Island, the basements of police stations, coal giveaways for the needy in bitter weather, and later, government-financed lodging houses, the "undeserving poor" were left to navigate hunger and homelessness on their own.

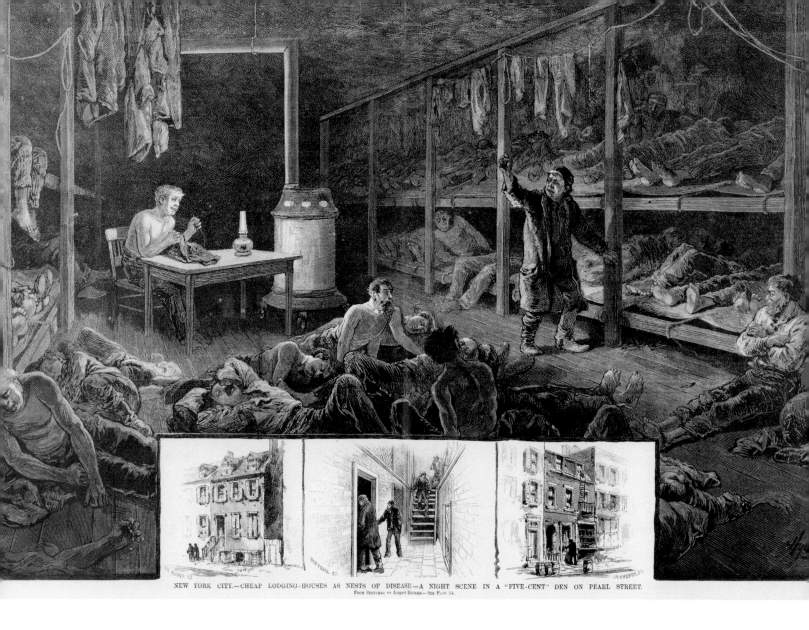

NEW YORK CITY.—CHEAP LODGING-HOUSES AS NESTS OF DISEASE—A NIGHT SCENE IN A "FIVE-CENT" DEN ON PEARL STREET.
From Sketches by Joseph Becker.—See Page 54.

The Rise of the Benevolent City

On a chilly night in December 1876, Louis Fleischmann noticed a group of ragged men hovering over a steam grate outside his Vienna Model Bakery at Broadway and 10th Street, next door to Grace Church. It was almost midnight. Though the bakery shop had long since closed for the evening to its well-heeled customers, workers in the basement busily baked Fleischmann's heralded rolls and loaves for the next morning. Fleischmann—an Austrian immigrant who had arrived in New York just two years earlier—watched the men on the street inhale the aroma rising from the warm ovens. He went outside and offered them some of the unsold bread from the day. They eagerly accepted.

The next night, more men showed up, forming a line at the back door. Another business owner might have notified the police, fearing his good deed had attracted vagrants to one of the city's most fashionable neighborhoods. But Fleischmann, whose prosperity coincided with the brutal recession

"New York City– cheap lodging-houses as nests of disease– a night scene in a 'five-cent' den on Pearl Street," read the caption to this illustration from *Frank Leslie's Illustrated Newspaper* in 1882. The only alternatives for destitute men were police precinct basements or park benches.

brought on by the Panic of 1873, had a different idea. He "decided that he would feed every hungry man who applied, and he directed that the bread which is returned from grocery stores, and which he had been selling for half price, be devoted to that purpose," recalled a September 25, 1904, article in the *New York Herald*.

For more than four decades, Fleischmann's bakery distributed bread to every man who queued up at the bakery after midnight. "[Here] is a small fraction of the millions that has not had its supper. Here are men whose lives are not running well—400 small worlds gone to shipwreck," stated a *New York Press* article in 1902. "Professional charity workers have looked with disfavor on Mr. Fleischmann's manner of giving; it comes under the head of 'pauperizing,'" wrote the *Herald*. "But the wealthy baker's reply has been: 'If a man will stand on the curb for two or three hours for half a loaf of bread or a few rolls, he's hungry.'"

Fleischmann's breadline was one of many charitable efforts conceived by Gilded Age New Yorkers. "For all who live in a great city like our own, and share its many privileges, there are also many great responsibilities," stated a December 1865 report from the New York City Mission and Tract Society. Inspired by Christian moralizers and the "scientific charity" movement—or simply the fear of a tramp or workingman's uprising—well-off residents heeded the call to help. By 1892, more than five hundred institutions and benevolent societies in Manhattan offered various types of assistance.

Private charities began flourishing at the right time. By the late 1870s, the city had significantly reduced public aid to individuals. "Indoor relief" still existed; alms houses and hospitals on Blackwell's Island, for

example, epitomized this kind of institutional aid. But "outdoor relief"—handouts of coal, food, or even cash given directly to those in need—was drastically cut back. One reason had to do with city finances. After the Panic of 1873, the Commission of Public Charities and Correction was swamped with requests for aid. Yet Tammany Hall politicos in the Tweed era had bilked the treasury of so much cash that the city government was nearly broke.

With Tweed out of power and city coffers close to empty, Tammany Hall's under-the-table system of giving indoor relief to constituents was threatened. It had been the way New York's Tammany-held government aided the poor for decades: Bosses would keep an eye on families in their wards and supply food, coal, cash, and clothes to those in need. "If there's a fire in Ninth, Tenth, Eleventh Avenue, for example, any hour of the day or night, I'm usually there with some of my election district captains as soon as the fire engines," explained George Washington Plunkitt, an ex-Tammany "sachem," or leader, during the Tweed years. "If a family is burned out, I don't ask if they are Republicans or Democrats.... I just get quarters for them,

Lillian Wald Spearheads Social Change

Like many upper-class young women in the 1890s, Lillian Wald dedicated her life to helping the urban poor. She began a career in nursing, which blossomed into a lifetime of serving New York's tenement district as an advocate for better schools, more playgrounds, women's rights, and the labor movement.

Lillian Wald can take credit for launching two vital services that helped ease suffering and sickness in the tenements of the East Side. In 1893, after the Rochester native graduated from New York Hospital Training School for Nurses, Wald set up the first visiting nurse service in New York. Her idea was to have "public health nurses," a term she coined, pay regular visits to the tenements in the poorest parts of the city.

Rather than wait for residents to get sick and then seek medical help, trained nurses would help address the underlying social and economic problems that led to poor health and disease. She realized "that there were large numbers of people who would not, or could not, avail themselves of the hospitals," she wrote in her memoir *The House on Henry Street*. "It was estimated that ninety percent of the sick people in cities were sick at home . . . and a humanitarian civilization demanded that something of the nursing care given in hospitals

The Lower East Side.

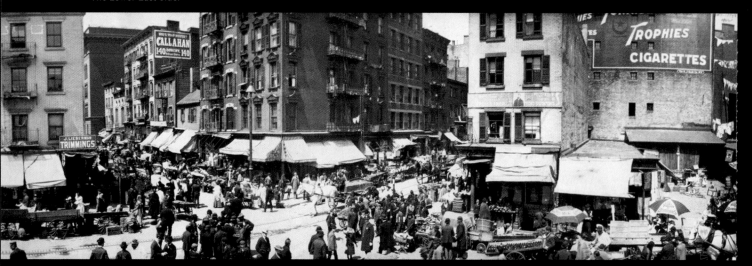

should be accorded to sick people in their homes."

After partnering with a nursing school friend, Wald, from an affluent family, moved into a room on Jefferson Street to be closer to the people she planned to serve. "We were to live in the neighborhood as nurses, identify ourselves with it socially, and in brief, contribute to it our citizenship," she wrote. Making her rounds to different tenement buildings by walking from rooftop to rooftop, carrying a black bag of medical

supplies, she sought out the sick or ailing. She and her squad of nurses helped treat contagious illnesses, assisted in difficult births, and taught classes on hygiene and health, charging fees only if a patient could afford to pay.

In 1895, Wald founded the Henry Street Settlement. Settlement houses were a more secular version of mission houses; they were community spaces that offered meals, education, and job training to disadvantaged residents in an era in which govern-

ment-run social services barely existed. With generous funding from rich New Yorkers such as banker Jacob Schiff, the Henry Street Settlement built playgrounds, ran after-school programs for the children of working mothers, and helped fight for labor rights.

Girls learning to knit in the dining room of the Henry Street Settlement, founded by progressive reformer Lillian Wald, in 1910.

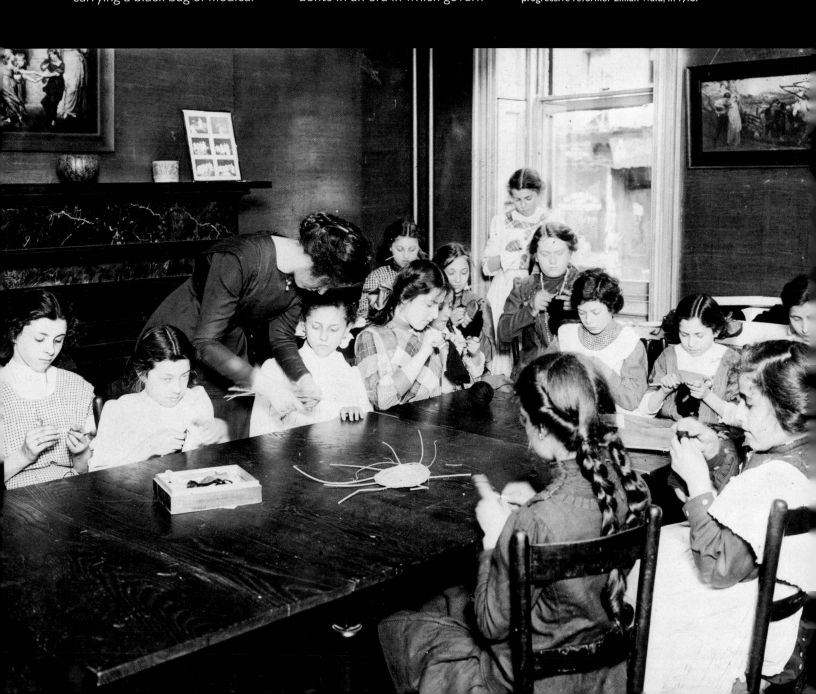

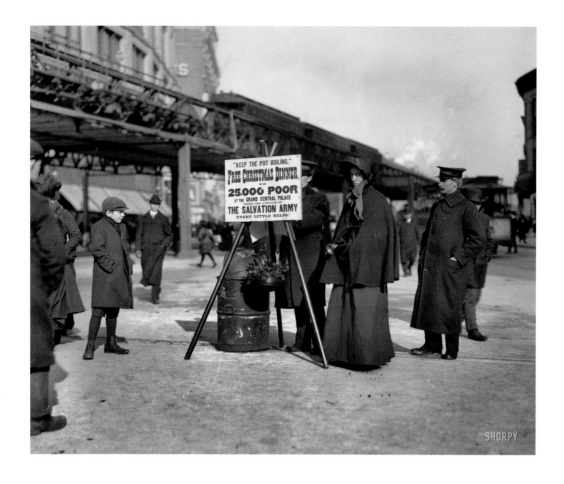

Every Christmas season beginning in the 1890s, the Salvation Army set up sidewalk kiosks advertising their Red Kettle campaign, which asked New Yorkers to donate money to fund a sit-down dinner on Christmas Day for the city's hungry. The Salvation Army was one of dozens of charitable organizations large and small that helped feed, clothe, and shelter those in need, especially when their numbers increased after the Panics of 1873 and 1893.

buy clothes for them if their clothes were burned up, and fix them up til they get things runnin' again. It's philanthropy, but it's politics too—mighty good politics. Who can tell how many votes one of these fires bring me? The poor are the most grateful people in the world, and, let me tell you, they have more friends in their neighborhoods than the rich have in theirs."

Another factor was the growing acceptance of "scientific charity"—the idea that providing relief to the poor fostered dependency and hurt them in the long run. Popular sentiment was that city government, already squeezed by recession, should stop distributing direct relief because it's in the best interests of the poor themselves. Seth Low, a Brooklyn reformer and mayor who would go on to be the mayor of consolidated New York in 1902, suggested that

outdoor relief "saps the habits of industry, discourages habits of frugality, encourages improvident and wretched marriages, and produces discontent." Josephine Shaw Lowell,

The Five Points Mission, established in 1850, aimed to improve "the moral and social elevation of the degraded poor" through education, prayer, and offerings of food and clothing. This was the second home of the Mission, located across the street from the original headquarters in Five Points' Old Brewery building.

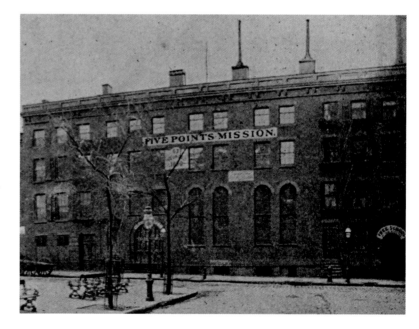

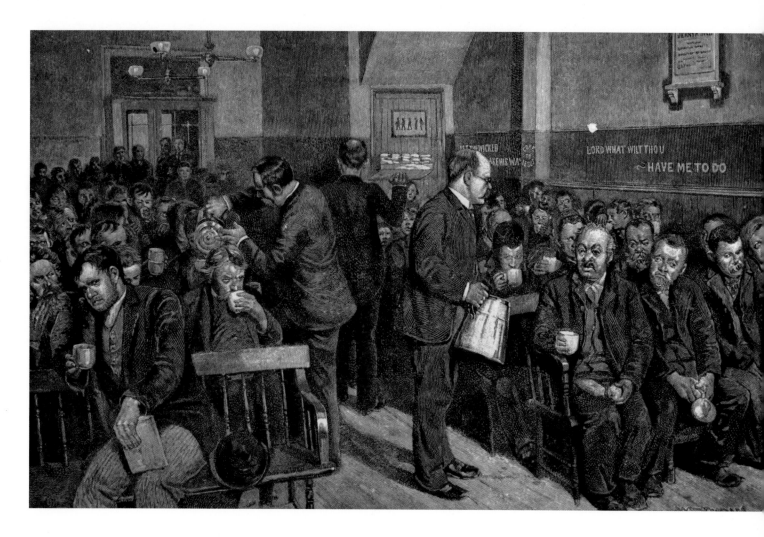

a Civil War widow who started the Charity Organization Society of New York City (also called Associated Charities) in 1882, maintained that almsgiving led to idleness. The New York Association for Improving the Condition of the Poor—which saw a fivefold increase in the number of needy applicants from 1873 to 1874—questioned the effectiveness of direct financial aid alone.

Fortunate New Yorkers donated generously to these two organizations, both of which conducted home checks of applicants to make sure they were truly in need and often required recipients to put in a day's work chopping wood or doing some other task before obtaining aid. "Thousands of our wealthy and generous families have found that the cessation of miscellaneous almsgiving at

their doors and elsewhere, and the substitution therefore of the present charity, has not only been more effective, but has materially reduced able-bodied vagrancy," wrote Junius Henri Browne in 1869's *The Great Metropolis: A Mirror of New York.*

Some New Yorkers viewed helping the poor as a religious mission, giving rise to the mission house movement. One of the first neighborhood missions appeared in 1850 in Five Points, and by the 1880s, dozens had been established in the slums to inspire hope and purpose in the poor. Supported by Christian ministries, they offered meals, schooling, clothes, lodging, Bible study, and regular sermons to anyone who asked for aid. Other missions included the Eighth Ward Mission (on Charlton Street); the St. Paul's Mission

House (on Cortlandt Street); the McAuley Mission, founded in 1872 on Water Street by Irish immigrant and ex-convict Jerry McAuley; the Howard Mission; the Home for Little Wanderers, on the Bowery; and the Bowery Mission, which catered to men.

Of the Bowery Mission, where missionaries sermonized in a large hall with stained glass windows and high-backed Gothic benches, Theodore Dreiser observed: "It really does not ask anything of its adherents or attendants, or whatever they might be called, except that they come in. No dues are collected, no services exacted. There is even a free lunchroom and an employment bureau run in connection with it, where the hungry can get a cup of coffee and a roll at midnight and the jobless can sometimes hear of something to their advantage during the day. . . . For those individuals who frequent this place of worship are surely, of all the flotsam of the city, the most helpless and woebegone."

In the 1880s, neighborhood missions were supplanted by a new kind of charity: settlement houses. Here, young, educated men and women "settled" among tenement dwellers and factory workers. In 1886, the Neighborhood Guild, on Forsyth Street, was the first to open. Lillian Wald founded the Henry Street Settlement in 1893; Mary Simkhovitch started Greenwich House on Barrow Street in 1902. They provided schooling, day care, literacy and citizenship classes, libraries, health care, and even bathing facilities. Stripped of religious overtones, they were funded by progressive-minded philanthropists such as Jacob Schiff and J. P. Morgan. Rather than focusing on the individual problems of poor residents, settlement houses advocated social reform as a way to eradicate poverty. They organized residents to push for better housing, more parks, and strong labor laws.

Most settlement houses set themselves up in the teeming slums of Lower Manhattan. The White Rose Mission was established in 1897 on East 86th Street and then later in Harlem in the West 130s. Launched by Victoria Earle Matthews, a former slave–turned–social reformer, the settlement house focused on African American women newly arrived in New York City from the South or the Caribbean who were seeking opportunities not open to them in their hometowns. The mission offered classes, traveler's aid, affordable accommodations, and a savings bank, but most important, it was a refuge and social center for women of color. Though New York had no official segregation, visitors might not know it from the way blacks and whites lived in distinct neighborhoods, worked in different jobs, and socialized along the color line.

"New York is munificent in its charities and means of relieving incapables," said James B. Reynolds, the head worker of the University Settlement, in an 1895 *New York Times* article. "Nothing could be more orderly than the system of the Associated Charities. But a similar scheme is needed to bring together the supply and demand for labor. To help people to help themselves is better than to wait till they are no longer able to help themselves. Following the awakening of interest in the political welfare of the city must come an awakening to the demands of social reform, and this cause demands urgency quite as much as the other."

Helping the Sick, the Old, the Young, the Alone

Two women comfort a dying patient at the Hospital for Incurables on Blackwell's Island in an 1868 *Harper's Weekly* sketch. Blackwell's Island was home to the city penitentiary, Smallpox Hospital, Charity Hospital, and almshouses. "Attached to the almshouse are the Hospitals for Incurables, which consist of two one-story buildings," an observer wrote, one for men and one for women. "In these buildings are quartered those who are afflicted with incurable diseases, but who require no medical attention."

The rise of Gilded Age benevolence in New York coincided with medical advancements: the pioneering of surgery, infection control, and medicine. As a result, grand hospitals and dispensaries went up all over Manhattan, especially along the new, wide uptown avenues—where city officials often gave away land to charitable institutions to encourage development.

"There are nearly eighty of these 'inns on the highway of life where suffering humanity finds alleviation and sympathy,' and many of them are among the largest and most magnificent buildings in the city," wrote Moses King in 1892's *King's Handbook of New York City.* "The wealthy patient may command all the luxuries a fine private home could give, and the poor man unable to pay may enjoy comforts impossible to him in his own narrow dwelling. Fully 100,000 patients are treated yearly in these curative institutions, more than three-quarters of them without any payment for the care and skill which restore them to health or smooth the pathway to the grave; and the death-rate is less than eight percent."

Bellevue, the city's oldest public hospital, located on First Avenue and 26th Street, was a leader in emergency care. (Bellevue also instituted the first ambulance service in 1869,

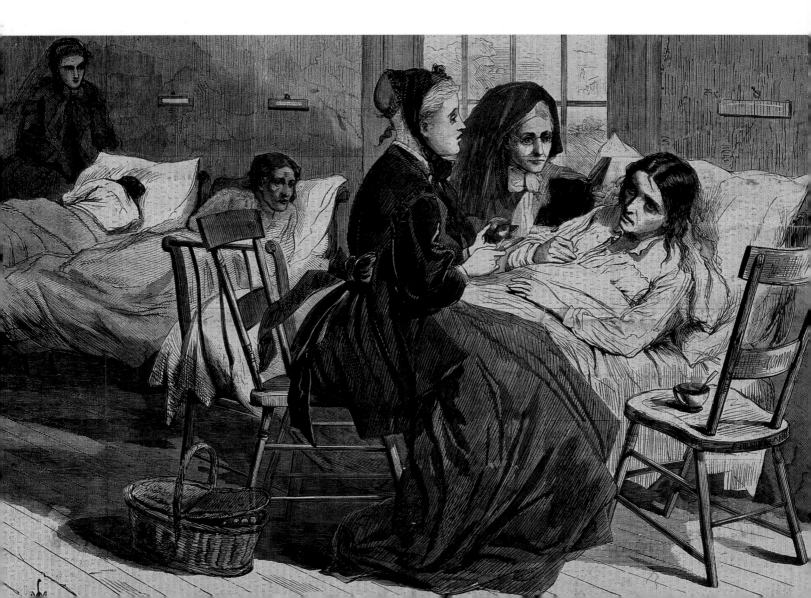

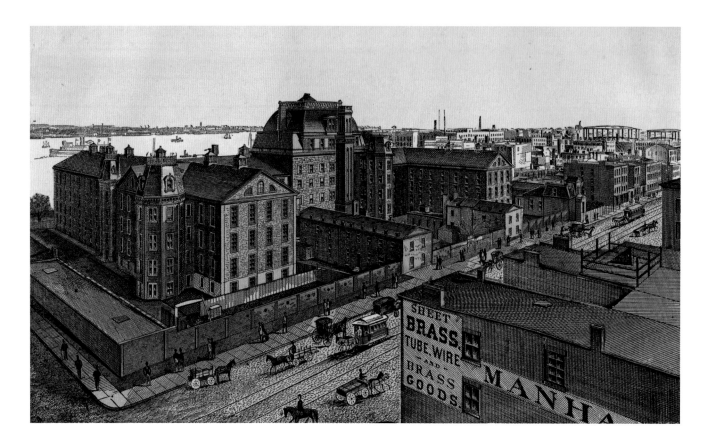

with two horse-drawn carriages answering calls.) Roosevelt Hospital, opened in 1871 by descendants of the old New York family, earned distinction as "the most complete medical charity in every respect," according to one surgeon. On First Avenue and 64th Street stood the recently renamed Colored Home and Hospital, a combined hospital and nursing facility as well as a home for the indigent aged catering specifically to African American residents, including those who had been slaves before the city abolished slavery in 1827. And the Sloane Maternity Hospital and the Vanderbilt Clinic, dedicated in 1887, were endowed by one of Manhattan's richest families. Protestant, Jewish, and Catholic organizations started medical centers and neighborhood hospitals. Even doctors founded hospitals; J. Marion Sims, who developed a technique to repair fistulas caused by childbirth, launched the Woman's Hospital, which moved to 50th Street between Park

and Lexington avenues in the 1860s and then the New York Cancer Hospital, on Central Park West and 106th Street, in 1884. His efforts restored the health of thousands of women, and he charged nothing.

Facilities for the old also became part of the cityscape. Moses King described them as "half-a-dozen comfortable and well-maintained homes for aged women, as well as for aged couples, and for men and women suffering from friendlessness and penury." The Little Sisters of the Poor, a Catholic order of nuns, operated two homes for nearly five hundred "inmates." A *New York Evening Telegram* reporter visited one on January 26, 1886, and quoted the mother superior: "We often have fifteen applicants in a day and are forced to turn them away because we have no room for them," she said. "We would like to have another wing to our Home and to have steam heating apparatus. In the very cold weather we cannot keep our building

Bellevue Hospital, with its gray stone buildings spread out along the East River at 26th Street, wasn't just one of New York's premier medical facilities; it also housed the city morgue, which handled about two hundred of the city's anonymous casualties a year—including abandoned infants, drunks, suicides, and victims of accidents. "It is a gloomy-looking place, this morgue, and always crowded," noted one writer.

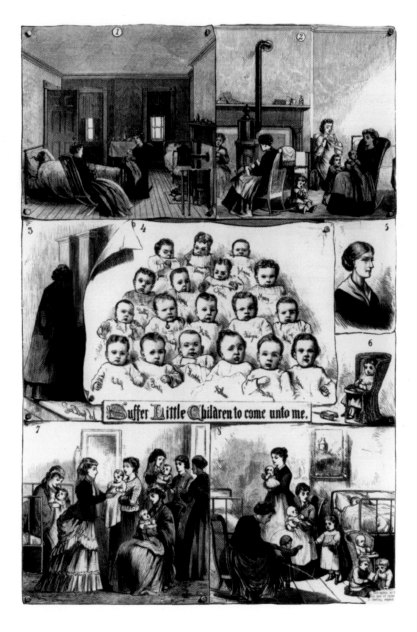

The New York Infant Asylum opened its doors in a house on Clinton Place (later renamed 8th Street) in 1871 and was dedicated to taking care of unwanted foundlings until they could be placed in an adoptive home. The asylum also took in their unwed and indigent mothers and was one of several foundling hospitals that opened after the Civil War to take care of a sharp increase in unwanted and abandoned infants.

warm enough, and our old people suffer very much . . ."

Religious and civic groups also built city orphanages. While such institutions always had been present in New York, in the Gilded Age the need for them grew. Thousands of New York City soldiers who perished on Civil War battlefields left behind children who often couldn't be properly cared for by widowed mothers. One orphanage specifically for the sons and daughters of military men was the Union Home and School for Soldiers' Children, in a former mansion at Eighth Avenue and 58th Street. The home took in as many as five hundred boys and girls at once, many found abandoned on the streets. The harsh economy of the 1870s and 1890s left parents with no option but to place a child in a home. Not everyone believed orphanages were the best place for youngsters, though—Charles Loring Brace, head of the Children's Aid Society, vehemently tried to keep destitute children out of institutions. But desperate parents had few choices.

The Sheltering Arms, The Children's Fold, and St. Christopher's Home housed from dozens to hundreds of kids up to age seventeen who attended school in the orphanage and were often taught a trade. St. Christopher's, on Riverside Drive and 112th Street, was founded in 1882 as a home for "destitute and orphan Protestant children" from age two to ten. "About 100 inmates are received yearly, who are taught some useful occupation to enable them to obtain self-supporting employment," wrote Moses King. "Admission is free to those whose parents or friends are unable to contribute to their support."

After rioting mobs burned the Colored Orphan Asylum to the ground during the 1863 Draft Riots, it was rebuilt in 1867 on Amsterdam Avenue and 143rd Street, a more bucolic and likely safer stretch of the city than the previous location on 43rd Street and Fifth Avenue. The city's Common Council earmarked $50,000 to rebuild the orphanage. Fewer than half of the children in orphanages were actually parentless; their guardians often used the orphanages as a temporary care center while they were going through rough times.

Perhaps no charity institution exemplified the social problems of the late nineteenth-century city as did the Foundling Asylum. Infant abandonment was a serious

Outbreaks of Disease Grip the City

During the Gilded Age, doctors began to understand the basics of germ theory and how microorganisms were spread through contaminated water and food, causing outbreaks of disease. Yet many people didn't understand or accept the connection between health and hygiene. And even if they did, the conditions of New York's working-class and poverty-stricken districts—a lack of clean running water, coupled with airless living spaces and streets soiled by manure and household garbage—put vast numbers of residents at risk for epidemics.

Cholera struck in 1866. The Metropolitan Board of Health got to work removing manure from empty lots, disinfecting houses, and quarantining the sick, which cut the death count to just over a thousand. (Cholera epidemics in previous years killed many times that number.) In the 1870s and 1880s, outbreaks of smallpox, meningitis, and diphtheria killed at least eighteen thousand New Yorkers in total. Tuberculosis (TB), or "the white plague," was a top killer in the city; anti-spitting notices went up in public places, like streetcars, to inform people about how tuberculosis is transmitted. Open-air hospitals were built, and the tenement law of 1901, which mandated fresh air in all apartments, may have helped push TB down to the third most common cause of death after 1910.

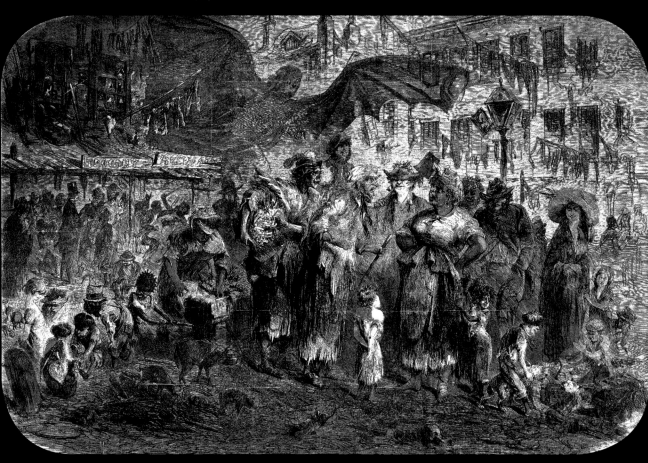

In 1866 a deadly cholera epidemic hit the city, mainly in the slums, killing 1,137 New Yorkers. It could have been much worse, as the city's previous cholera epidemics were. Wealthy residents and officials knew that cholera outbreaks were striking in Europe, and before the disease could reach America, they helped organize the Metropolitan Board of Health and Sanitation Departments, which got to work getting rid of the city's piles of horse manure, animal carcasses, and rotting food. Their efforts are credited with slowing the spread and extent of the outbreak.

An outbreak of typhus, spread via infected lice, sickened about two hundred mostly Jewish immigrants in 1892 on the Lower East Side. Twenty-four of them died; officials determined that the early victims arrived in New York from Europe on the same ship. A similar but distinct illness, typhoid fever, triggered frequent outbreaks in the city. The infection—fatal 20 percent of the time—is transmitted when food or water is contaminated with the urine or feces of a typhoid carrier. In 1906, about 3,500 typhoid cases occurred in the city.

After two outbreaks on Long Island struck in 1904 and 1907, offi-cials realized that each victim had one thing in common: All had consumed food prepared by an itiner-ant Irish immigrant cook named Mary Mallon. When investigators tracked Mallon down—she was employed by a household on Park Avenue—they ran tests and discovered that although she exhibited no symptoms of the disease, her system was loaded with typhoid bacteria. In 1907, against her will but for the sake of public health, she was forced into quarantine on North Brother Island. In 1910, health officials released her on the condition that she never work in a kitchen or handle food again. Four years later, however, she was discovered to be the source of a deadly outbreak in a New Jersey sanitarium and another at Sloane Maternity Hospital in Manhattan. Returned to North Brother Island, she lived in quarantine there until her death in 1938.

A *Harper's Weekly* illustration from August 10, 1889, shows a doctor examining a child in a tenement. The cramped, unventilated dwellings attracted filth and disease.

From 1900 to 1907, dozens of people from seven different families on Long Island and in Manhattan mysteriously came down with the bacterial infection typhoid. An inspector hired by one of the families traced the source of the illness to a forty-year-old Irish immigrant cook named Mary Mallon (foreground), who had worked in the homes of all the families. "I never had typhoid in my life and have always been healthy," Mallon told a reporter. "Why should I be banished like a leper and compelled to live in solitary confinement with only a dog for a companion?"

her travel diary in 1899. During her visit to New York, King's host took her to tour the institutions of Randall's Island. She wrote:

We . . . went to the baby residence, the home of the little waifs who were picked up out of the city's ash barrels and dark alleyways. They looked so frail in their white cot beds. We looked at so many, many of them, there seemed to be no end. Last we came to a baby who we were told had been abandoned the night before by its mother. Its little face was hardly larger than an egg, and it was so small that it could not be dressed but was wrapped in cotton. We saw one dear little baby dying with pneumonia. Another that the nurse told us would not live till morning. There were so many babies and yet not one little face that looked like another.

problem in postwar New York. If found alive on a street corner or stoop, a baby would be taken to the almshouse at Blackwell's Island or to Infants Hospital on Randall's Island, where its fate was grim, as twelve-year-old Naomi King, a wealthy Indiana girl, noted in

Large public institutions were no place for fragile infants, but until 1869, there was no other option. That's when three nuns put a wicker cradle on the front steps of their East 12th Street brownstone, and announced that they would care for all unwanted babies. That very night, a newborn was left in the cradle. By the end of the month, forty-five babies had appeared on the doorstep of the Foundling Asylum, as the nuns named it. Pinned to some of the infants' blankets were heartbreaking notes from despairing mothers. "My dear good Sister," read one, "please accept this little outcast son of mine trusting with God's help that I will be able to sustain him in your institution. I would not part with my baby were it in any way possible for me to make a respectable living with him, but I cannot, and so I ask you to take my little one. . . . His name is Joseph Cavalier." The Foundling Asylum grew so quickly that the

The wicker cradle placed outside the East 12th Street home of the Foundling Asylum, a signal to new mothers who considered abandoning their babies on the street or in an ash can that the asylum would take in and care for their infants. The very first night the cradle was placed on the doorstep, a newborn was left inside it.

In 1869, Sister Irene Fitzgibbons cofounded the Foundling Asylum, a modest Greenwich Village home where desperate new mothers could drop off babies they were unable to raise. By the late 1880s, the asylum had cared for and found permanent homes for thousands of abandoned babies. In this 1888 Jacob Riis photo, Sister Irene stands with some of her young charges at the New York Foundling Hospital on East 68th Street, a new facility for the renamed organization.

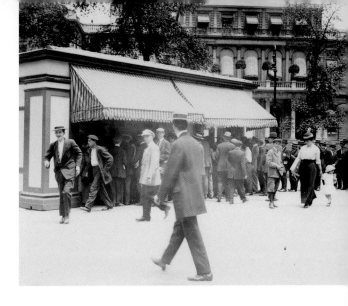

sisters moved to larger quarters, on Lexington Avenue and 68th Street, in the 1870s. Its name changed to The New York Foundling Hospital in the 1880s, after launching one of the city's first day nurseries for the preschool-age children of working mothers.

Smaller, specialized charities ministered to the margins. A home for needy actors operated near Madison Square. The Needlework Guild sewed clothes for the institutionalized. St. Bartholomew's Chinese Guild, on St. Marks Place, was devoted to the "spiritual elevation" of Chinese immigrants. The Working Women's Protective Union sought "to stand between the female wage-earner and the employer who would defraud her of her scanty wage," wrote Moses King. Some charities masqueraded as actual businesses, aiming to serve those in need who were too proud to accept help. That was the case with the five St. Andrew's One Cent Coffee Stands that opened at downtown intersections in 1887. Each stand sold extremely cheap cups of coffee, along with one-cent food items, such as soup and a sandwich. Public contributions helped pay costs. "That it is appreciated by the thousands of newsboys, emigrants, poor families, and street waifs whom it relieves, there is abundant evidence," wrote temperance advocate and clergyman Charles Force Deems in *Frank Leslie's Sunday Magazine* in 1887.

Individual citizens, like Louis Fleischmann, contributed greatly. Nathan Straus, a co-owner of Macy's department store, gave away millions. In addition to establishing low-cost lodging houses, coal warehouses, and grocery stores on the Lower East Side after the Panic of 1893, Straus set up the first of eighteen pasteurized milk stations. Children were encouraged to drink milk because it was nutritious, but without pasteurization to kill bacteria, milk routinely sickened and even killed those who drank it. By investing in sterilization and distributing the clean milk in city-park milk depots, Straus made it safe.

On April 15, 1894, when asked by the *New York Times* about his efforts, Straus replied, "I am entirely satisfied with the result of the work . . . I can see, and I do not hesitate to say, that an immense good was accomplished, but it was not charity, it was merely justice to the poor."

Poor immigrant mothers and children line up at the pharmacy window of the city-run Eastern Dispensary on Essex Street, one of several medical facilities staffed by doctors in the poorer wards of the city. The Eastern Dispensary, free for paupers but on a sliding scale for those who could pay, treated at an average cost of fifteen cents per person.

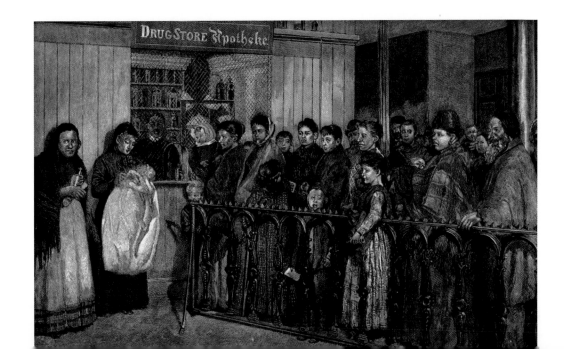

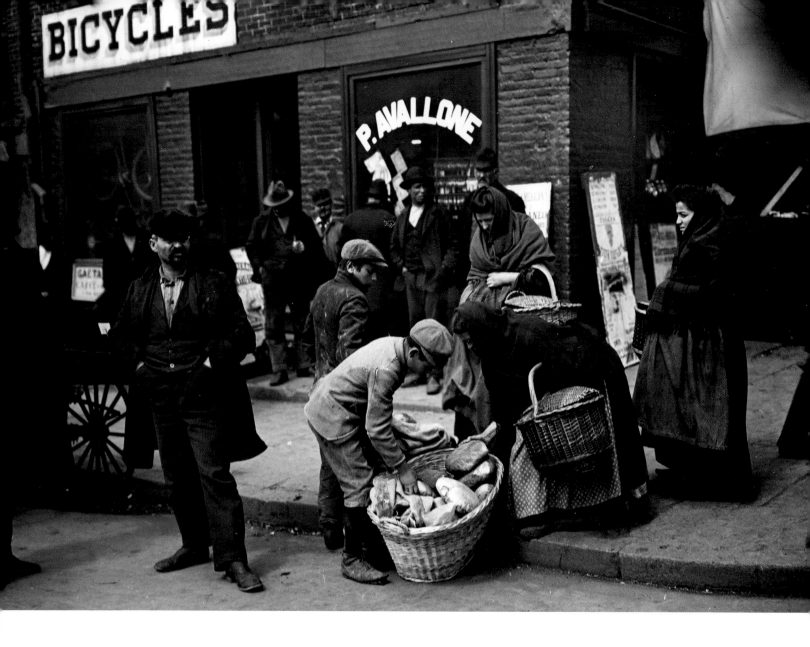

Saving Women and Children

Several meetings have been held recently in our churches with reference to the formation of 'midnight meetings for fallen women,' such as have been opened in London for the benefit of this unfortunate class," wrote the *New York Times* on January 28, 1867. "It is always ungracious to criticize a new organization of charity. . . . It must be remembered, in the first place, what these 'unfortunate women' are. They are mainly, as is well known, young husseys

of foreign birth who are too lazy to work . . . or who have come to love dances and liquor. . . . But few of them comparatively are the innocent 'victims of man's deception,' or are driven to this course by circumstances such as are overwhelming."

The *Times* had little enthusiasm for the efforts to help prostitutes, unwed mothers, and other unchaste females. But "the lost sisterhood" was considered one of the lowest vices in late nineteenth-century New York,

A Mulberry Street woman peddles bread, 1900. Mulberry Street was the heart of the city's fast-growing Italian immigrant neighborhood; the street was typically packed with vendors selling bread, clams, and fruits and vegetables.

Protecting the "Mute Servants of Mankind"

Henry Bergh first made his case on February 8, 1866, during a well-attended lecture in front of Manhattan's elite at Clinton Hall on Astor Place. Animals, primarily horses, did the city's hard labor, pulling streetcars and transporting goods. Yet, too often, the estimated two hundred thousand workhorses in the city were overworked and abused, and were frequently left to die in the streets. The average lifespan of a working horse at the time was just two to four years. England had established a society protecting animals. New York should do the same, urged Bergh, the fifty-three-year-old scion of a shipbuilding family.

The speech convinced audience members to sign Bergh's "Declaration of the Rights of Animals." With further support of prominent residents such as financier August Belmont, Cooper Union founder Peter Cooper, and John Jacob Astor Jr., Bergh founded the American Society for the Prevention of Cruelty to Animals, the first animal welfare group in the nation, later that year. The city then passed the nation's first animal anti-cruelty law, and the ASPCA was granted the power to enforce it.

Bergh and his team of agents soon became a familiar sight on streets, docks, and alleys. They typically encountered horses being whipped and starved by owners and drivers; dogfighting rings; cats being set upon; pigeons shot and left to slowly die; and other examples of mistreatment. The ASPCA quickly grew and added services. Horse-drawn ambulances for injured horses debuted in 1867. Drinking fountains were installed for thirsty horses across the city. Portable horse showers appeared in the summer, so overheated horses had a chance to cool down. Horses were even fitted with straw "sombreros" that shielded the animals' eyes from the harsh hot sun.

"Sick and broken-down or crippled horses are taken from their drivers on the streets, and sent to the hospital of the Society, where they are properly cared for," wrote James D. McCabe in his 1882 book *New York by Gaslight*. "In aggravated cases [Bergh] does not stop with relieving a tortured animal, but causes the arrest and punishment of the perpetrator of the cruelty."

By the turn of the century Bergh and his group increased their focus to small animals and

In the 1870s, the ASPCA initiated a program to make cool, clean drinking water available to city horses. In the early 1900s, straw horse "sombreros," seen on the horse on the right, were distributed to shade their eyes from the sun.

pets. The ASPCA established shelters for the thousands of stray dogs found all over the city. Besides being used for fighting, dogs on treadmills sometimes powered machines in factories. Once they were injured or too old, they were turned out on the street. Instead of having dogcatchers round them up and drown them en masse in the East River, as the city typically did to address its stray dog problem, Bergh helped open shelters that would handle abandoned animals more humanely.

Bergh also co-founded, eight years later, the New York Society for the Prevention of Cruelty to Children, which was modeled after the ASPCA. Incredibly, until 1874, animals had more protection from abuse under the law than children did.

and, as a result, these women were the recipients of much Gilded Age benevolence. Some "Magdalene" missions appeared in the 1830s, but an increasing number were founded in the 1870s and 1880s. Their names gave away their noble purpose: The House of Mercy, The Midnight Mission, the New-York Magdalen Asylum, and the Florence Night Mission for Fallen Women.

The latter, housed in a humble structure on Bleecker Street near the Bowery, opened in 1883. "Any mother's girl wishing to leave a crooked life, may find friends, food, shelter, and a helping hand by coming just as she is, to the Florence Night Mission," read the mission's card, which was handed out along the gritty streets nearby. Hundreds of women and girls did seek aid there, at least temporarily. Whether any of the women were "reformed," or simply spent a few nights before returning to their old lives, is hard to know.

Equally noble in the eyes of reformers was improving the lives of children. Thousands of youngsters lived on the streets, scratching out a meager living as bootblacks, newsboys, sweatshop workers, or thieves. Child labor laws and a compulsory school law (requiring all children from ages eight to fourteen to attend fourteen weeks of school per year) were routinely ignored. One groundbreaking piece of legislation, the Children's Law

According to one minister, the Florence Night Mission for Fallen Women, at 21 Bleecker Street, was perfectly situated "between the uptown feeders and the downtown cesspools which they supply." The mission offered prayer sessions and social services for prostitutes and homeless women.

Jacob Riis photographed a ragged group of "street urchins" in Mullens Alley, off of Cherry Street, part of the decrepit slum district on the East Side near the East River. Published in his 1890 book *How the Other Half Lives*, this disturbing image and others shot by Riis himself shocked the city and helped usher in reforms.

of 1875, made it illegal for the city to condemn homeless children to adult almshouses. Charles Loring Brace's Children's Aid Society advocated for the passing of this law, hoping to keep destitute kids out of wretched poorhouses, funneling them instead to local foster families or aboard "orphan trains" to new homes across the country.

The Children's Aid Society was the main agency taking up the cause of child welfare. Brace and his colleagues pioneered kindergartens and opened twenty-two industrial schools. They couldn't end all child labor, or even force employers to pay kids the same wages they would pay an adult for the same job. But they did construct five lodging houses specifically for working boys (and one for working girls) by 1890. In these refuges, children were guaranteed a warm bed, decent meals, and the opportunity to attend night classes. By 1895, an estimated 250,000 children had passed through the lodging houses that dotted the poorer sections of Manhattan, from Rivington Street on the Lower East Side, to West 18th Street in Chelsea, to Avenue B at Tompkins Square Park.

"What sort of home is it that their money helps to provide?" asked Helen Campbell, social reformer and author of *Darkness and Daylight: Lights and Shadows of New York Life,* of the Children's Aid Society's newest lodging house, on Duane and Chambers streets. "The cleanliness is perfect, for in all the years since its founding no case of contagious disease has occurred among the boys. Their first story is rented for use as shops. The next has a large dining-room where nearly two hundred boys can sit down at table. . . . The next story is partitioned off into a school-room, gymnasium, and washrooms. . . . The two upper stories are large and roomy dormitories, each furnished with from fifty to one hundred beds or berths,

arranged like a ship's bunks, over each other." Boys paid six cents a night for one of these bunks and ten cents for a private room.

In 1874, the Society for the Prevention of Cruelty to Children joined the Children's Aid Society in the battle for child welfare. The Society focused on establishing laws that prevented mistreatment; at the time, it was not illegal for parents to physically abuse their children. In the first months of its existence, the Society investigated hundreds of complaints of child abuse. Other laws protecting children hit the books: An 1886 act barred children under age fourteen from toiling in sweatshops and factories for more than sixty hours per week. And a revamped statewide school law, effective in 1895, required that all children from eight to sixteen years old attend school from October to June, with some exceptions if a child of at least twelve was "lawfully engaged in any useful employment or service."

Children were still turned out to the streets and forced to work. And after age twelve, they didn't have to be in school. But the new laws were small victories. The fight for further reforms to child labor and education would continue after the turn of the century.

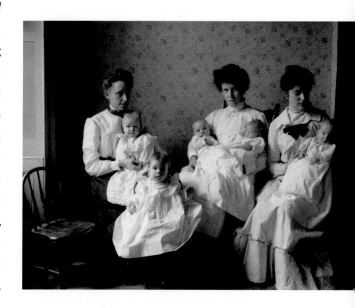

Caregivers and babies in 1908 at the Children's Aid Society, one of New York's oldest and best-known private charities, founded in 1853 "to ensure the physical and emotional well being of children and families, and to provide each child with the support and opportunities needed to become a happy, healthy, and productive adult."

The Newsboy Strike of 1899

For the thousands of newsboys (and occasional newsgirl) who hawked papers day after day, life was not easy. Some were homeless runaways; others had families but chose to wander the streets. They slept in stairwells, on sidewalks, and in the many lodging houses set up by the Children's Aid Society that cost a nickel for a clean bed. Most newsboys, or "newsies," worked nights, which made it tough to go to school in the morning. They wore ragged clothes, didn't wash often, and were considered a nuisance as they swarmed New Yorkers to try to sell as many newspapers as possible.

"You see them everywhere, in all parts of the city, but they are most numerous in and about Printing House Square, near the offices of the great dailies," wrote James D. McCabe in 1872's *Lights and Shadows of New York Life*. "They rend the air and deafen you with their shrill cries. They surround you on the sidewalk, and almost force you to buy their papers . . . they will offer you their papers in such an earnest, appealing way, that nine times out of ten, you buy from sheer pity for the child."

They made their money, an average of twenty-six cents a day, like this: The boys would purchase their papers directly from the newspaper, then hit the streets, the taverns, even brothels, looking for sales. They pocketed the money they made but they were not refunded for newspapers that failed to sell, so making a profit was never a guarantee. Several times in the 1880s and 1890s, the newsboys went on strike, seeking more favorable conditions. But their efforts didn't work until the Newsboy Strike of 1899.

It started in 1898, when a spike in readership brought on by great interest in the Spanish American War made newspaper publishers hike the price of their papers—with a bundle of one hundred jumping to sixty cents from fifty cents. Since the newsboys were selling more copies, there was no change in the amount of money they earned. But after the war ended, while most publishers went back to the original price, two of the city's tabloid dailies—the *Evening World* and the *New York Evening Journal*—did not. The newsboys felt they were getting ripped off.

On July 20, led by a canny older boy named Kid Blink, they decided not to sell newspapers owned by Joseph Pulitzer, who published the *World*, and William Randolph Hearst, who published the *Journal*. Rallies attracted two thousand newsboys. For days, they marched across the Brooklyn Bridge, disrupting traffic. Small groups of newsies gathered at Union Square, Columbus Avenue, and other city hotspots, rallying support. Pulitzer tried to hire men to do the newsboys' jobs, but he couldn't find enough scabs to take over.

The strike wasn't exactly a success; neither publisher lowered the price of a bundle of papers, but they did agree to start buying back any unsold copies the boys found themselves stuck with.

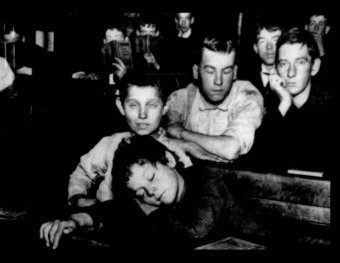

A night school classroom with sleepy students at the Seventh Avenue Lodging House at 34th Street, run by the Children's Aid Society. The Society operated several lodging houses across the city that offered more than just a place to sleep. One reporter wrote "Here the homeless street boy, instead of drifting into thieves' dens and the haunts of criminals and roughs, is brought into a clean, healthy, well warmed and lighted building where he finds room for amusement, instruction, and religious training, and where good meals, a comfortable bed, plenty of washing and bathing conveniences are furnished at a low price"—typically five or six cents per

A group of newsboys carrying paper bundles on the Brooklyn Bridge at 3 A.M. on Sunday, February 23, 1908. The newsboy strike of 1899 inspired later newsboy strikes and struck a chord for the labor movement, though it ended in a draw and didn't make the job any easier.

A Cleaner, Healthier Manhattan

For a metropolis filled with so much forward-thinking benevolence, much of its infrastructure—sidewalks, sewers, and transportation options—was not quite so progressive. True, New York had an abundance of clean water, thanks to the Croton Aqueduct, an engineering wonder opened in 1842. And the elevated trains made getting uptown and downtown faster and easier. But other factors affecting the health and welfare of the city desperately needed to be brought up to speed.

An 1866 report by the newly formed Metropolitan Board of Health had this to say about the city's sanitation:

> *The streets were uncleaned; manure heaps, containing thousands of tons, occupied piers and vacant lots; sewers were obstructed; houses were crowded, and badly ventilated, and lighted; privies were unconnected with the sewers, and overflowing; stables and yards were filled with stagnant water, and many dark and damp cellars were inhabited. The streets were obstructed, and the wharves and piers were filthy and dangerous from dilapidation; cattle were driven through the streets at all hours of the day in large numbers, and endangered the lives of the people.*

Board officials had their hands full. Over the next decades, they investigated cases of transmissible disease, quarantined the afflicted, and waged public campaigns against tuberculosis, diphtheria, cholera, typhoid, and other deadly diseases spread by contaminated water and waste, especially in crowded, filthy

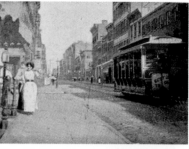

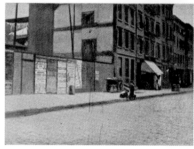

tenements. Leaflets in several different languages were handed out in every tenement district in the city, reminding people about disease-prevention tactics. The Department of Public Works built fifteen outdoor baths for the poor in different city neighborhoods; the Association for Improving the Condition of the Poor opened "peoples' baths" that charged five cents to use the facilities. In an 1894 Tenement House Commission report, commissioners wrote that "several hundred thousand people in the City have no proper facilities for keeping their bodies clean." The baths were designed to help people keep themselves clean, but they proved especially popular during the sweltering summer months and were a healthier alternative than swimming in the polluted, sewage-filled rivers.

Homes and privies were connected to sewers, and the feral swine—New York's garbage patrol since colonial days—were banned south of 85th Street so that a professional Department of Sanitation could take over. Street

What a difference professional street cleaning made on some city blocks. These photographs, published in *Harper's Weekly* in 1895, show the dirt and grime on East Houston and 4th streets before the Sanitation Department came in. Two years and many cleanings later, both streets practically gleam.

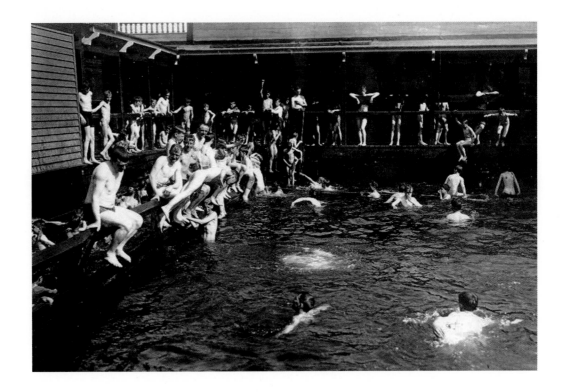

Before 1901, when New York City built its first municipal bathhouse, city dwellers could visit one of the floating bathhouses along both the East and Hudson rivers, including this one in Battery Park. The first two were inaugurated in 1870, and by 1890, the city was operating fifteen free baths, serving an average of 2.5 million men and 1.5 million women a year. Bathhouses were used at first for cleansing, but over the years they gradually became more like the recreational swimming pools of the early twentieth century.

Summer on Hester Street in 1905, with storefront awnings drawn to block out the sun and a fire hydrant spraying cool water on children in the street. Hester Street was one of the main thoroughfares of the Jewish Quarter. Seventy-three percent of the 1.3 million Jewish immigrants who came to New York between 1881 and 1911 settled in this densely populated East Side district.

sanitation was slow going at first. Rudyard Kipling complained during a visit to the city in 1892 that New York was "bad in its paving, bad in its streets, bad in its street-police, and but for the kindness of the tides would be worse than bad in its sanitary arrangements."

New York's streets were cleaner for another reason in the 1890s: horse cars were being replaced by electric-run cable cars, which partially did away with piles of waste and the flies they attracted. In his short 1902 sketch "In the Broadway Cars," Stephen Crane described the sound made by these hygienic, quieter vehicles as the "uninterrupted whirr of the cable." The elevated railroads, meanwhile, continued to spit smoke into the air below their trestles. City officials, however, were making plans to put many of the railways underground, a move that would eliminate the noxious fumes and ashy dust. "One has a vision of bright, electrical subways, replacing the filth-diffusing railways of to-day, of clear, clean pavements free altogether from the fly-prolific filth of horses . . .

of grimy stone and peeling paint giving everywhere to white marble and spotless surfaces, and a shiny order, of everything wider, taller, cleaner, better," wrote H. G. Wells on his first visit to New York. "So that, in meanwhile, a certain amount of jostling and hurry . . . may be forgiven."

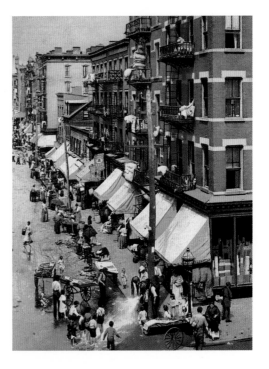

The White Wings Take to the Streets

New York City's Department of Sanitation was established in 1881—but streets were still filthy. Trash was routinely tossed out tenement windows; ashes, animal waste, and food piled up, attracting flies and vermin and spreading potentially lethal diseases. Something had to be done to sanitize the modern city.

In 1894, newly elected mayor William Strong—who had campaigned as a reformer who would clean up city government—hired sanitation engineer Colonel George Waring to head the department. Waring wasted no time. He drew on his military background to organize the street cleaners and sweepers into a corps of men who wore police-like caps and all-white uniforms, to communicate sanitation and cleanliness.

Nicknamed the White Wings, his army of cleaners swept and washed sidewalks and streets, emptied garbage and ash cans, and transported debris, snow, and anything else clogging the streets to garbage dumps or the rivers. Waring not only cleaned the city, but made it safer and healthier. "It was Colonel Waring's broom that first let light into the slum," wrote Jacob Riis in his 1900 book on progress in the slums, *A Ten Years' War*. "Colonel Waring did more for the cause of labor than all the walking delegates of the town together, by investing a despised but highly important task with a dignity, which won the hearty plaudits of a grateful city."

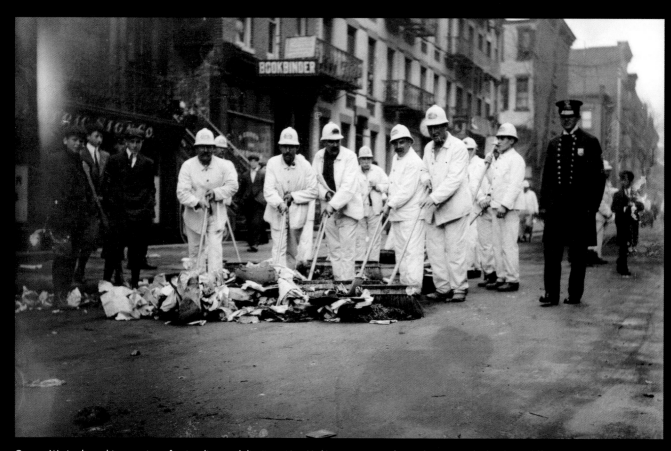

George Waring brought respect, professionalism, and dignity to New York's sanitation workers, who were tasked with the difficult job of keeping the city clean. His "White Wings" were easy to spot, thanks to their bright, military-like uniforms and hats. "A distinguishing and conspicuous uniform is necessary to keep some of the members of the force at work. . . . There are some men, even among the noble army of sweepers, who would prefer a pack of cards and a warm corner to a windy street in cold weather, and I am informed that this was in old times a rather common practice," wrote Waring.

The City at Play and at Rest

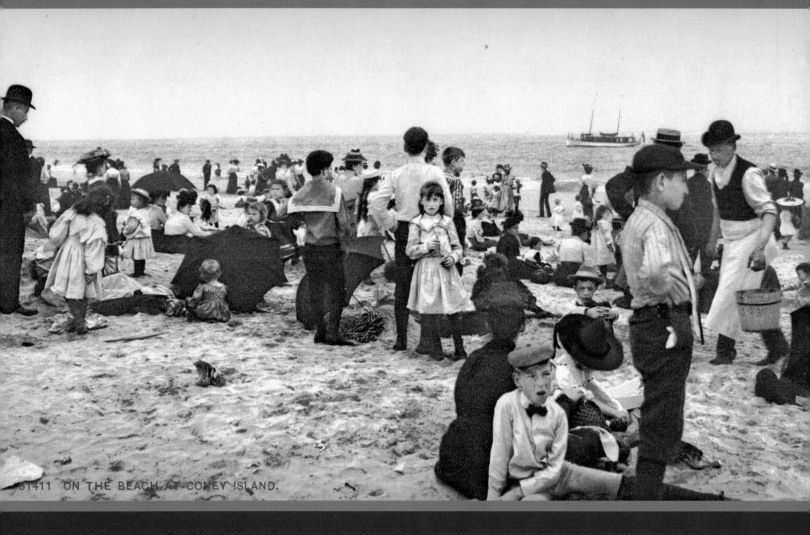

51411 ON THE BEACH AT CONEY ISLAND.

Decades before the arrival of the boardwalk and amusement parks, Coney Island was a small summer resort popular with beachgoers from Brooklyn and Manhattan. As editor of the *Brooklyn Daily Eagle* in 1848, Walt Whitman used to visit the "long bare unfrequented shore . . . and where I loved, after bathing, to race up and down the hard sand, and declaim Homer or Shakespeare to the surf and seagulls by the hour."

Central Park: The Lungs of New York

May 3, 1890, was a lovely, sunny spring Saturday in the city. Thousands of New Yorkers celebrated the spectacular weather the same way: by taking in the delights of Central Park. "Central Park was literally alive with pleasure seekers yesterday," the *New York Times* wrote. "There were dozens of May Day parties that brought out the children, and the soft spring air, the warm sunshine, and the budding trees proved sufficiently attractive to insure the presence of countless older people. The bridle paths were filled with men and women on horseback, the drives were crowded with gay equipages, and the promenades were so thickly peopled that pedestrianism was a wearisome labor."

The park, 843 landscaped acres in what was set to become the population center of the city, offered recreation for everyone. Several riding clubs held a parade in the afternoon, which attracted a cavalcade of riders, horses ("groomed until their coats glistened like satin in the sunshine"), and cheering spectators at the starting point at "The Circle" at Eighth Avenue and 59th Street.

The fields and play areas were packed with children. "Gaudy Maypoles dotted the sward of Central Park in all directions, and dozens of May queens reigned coyly in white dresses, long veils, and crowns of spring flowers. Games of baseball were indulged in by the boys, and the babies had a merry time rolling on the grass and picking the yellow dandelions. The boats of the lakes were liberally patronized, and the menagerie was crowded, the monkey cage, as usual, holding

Frederick Law Olmsted and Calvert Vaux called the Central Park Mall an "open air hall of reception." A grand carriage drive shaded by towering elms, seen here in 1900, it became one of the most popular places to stroll and take in the fresh air. A cast-iron bandstand hosted bands that played concerts for thousands of park-goers.

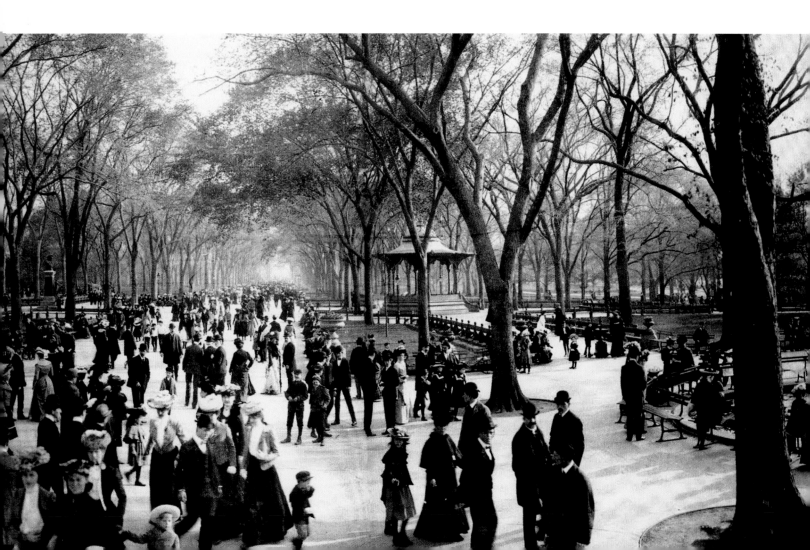

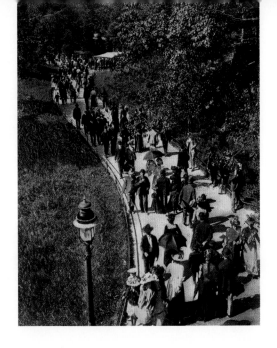

Well-dressed men and women promenade along a walking path in Central Park in the early 1900s.

the place of honor in the affections of the little ones." The Seventh Regiment Band played Beethoven and "The Star Spangled Banner" on the mall: "All in all, New-York derived a great deal of enjoyment from Central Park yesterday."

Since its opening in stages between 1858 and 1872, Central Park has been the "big playground," as the *Times* nicknamed it, an escape from the teeming streets and dusty air of a city that was just starting to understand the importance of leisure time. The idea for the park was first proposed in the 1840s, amid New York's tremendous population growth and rapid industrialization. "The heats of summer are upon us, and while some are leaving the town for shady retreats in the country, others refresh themselves with short excursions to Hoboken or New Brighton, or other places among the beautiful environs of our city," wrote William Cullen Bryant, editor of the *New York Evening Post*, on July 3, 1844. "If the public authorities, who expend so much of our money in laying out the city, would do what is in their power, they might give our vast population an extensive pleasure ground for shade and recreation in these sultry afternoons, which we might reach without going out of town."

Bryant's editorial called for an accessible public park that would offer rest and relaxation for all classes. As the Common Council began batting around the idea, other benefits of building a park emerged. Construction meant the creation of thousands of jobs, which were sorely needed by the massive tide of German and Irish immigrants. A great urban park would also rival London's Hyde Park and Paris's Bois de Boulogne, putting New York on par with European cities. A green space could give the elite a new gathering place for walking and carriage driving; at the time, the only roads for driving in Manhattan were Bloomingdale Road on the West Side and Harlem Lane uptown. Women, who ordinarily had few opportunities for recreation and exercise, could stroll, enjoy refreshments, and ride horses while unescorted by men— away from the lingering stares of lower-class males, a frequent complaint from respectable ladies who felt unsafe promenading down Fifth Avenue in the mid-nineteenth century.

Building a park was also seen as a moral imperative. Some public figures and social reformers felt that a great park would help civilize the immigrant and working classes. Andrew Jackson Downing, a prominent landscape architect, wrote in the journal *Horticulturalist* that a park would provide "the refining influence of intellectual and moral culture" and "raise up the man of the working men to the same level of enjoyment with the man of leisure and accomplishment." Downing called for an enormous green space modeled after London's Hyde Park that would allow the social classes to mingle in harmony. He bemoaned the lack of open space reserved for parks in the original city street grid, which was mapped out in 1811. "What are called parks in New York are not even apologies for the thing; they are only squares or paddocks," he wrote.

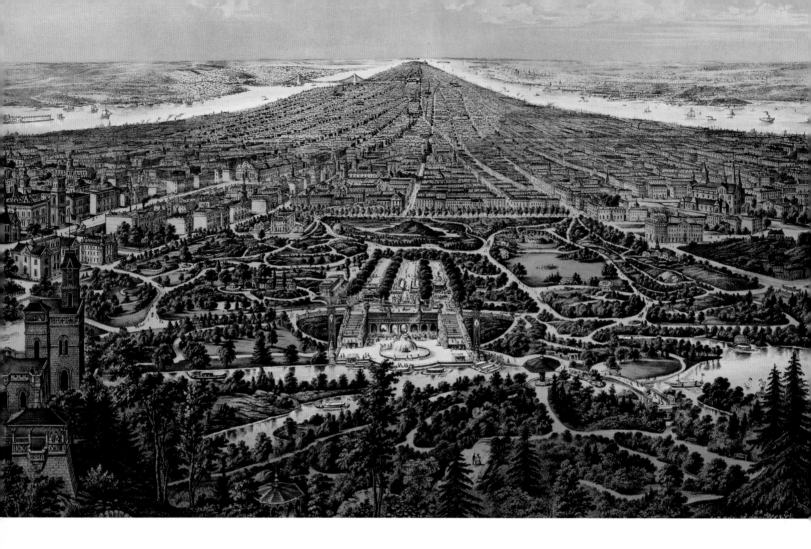

With the idea in place by the 1850s, officials searched for a suitable parcel of land. First choice was Jones Wood, a 150-acre tract between 66th and 75th streets and Third Avenue and the East River, close to the riverfront estates of rich New Yorkers. Jones Wood was already a popular picnic spot, a wooded space with small streams that offered cool breezes and a picturesque shoreline. But after an outcry that the parcel was too small and inconvenient, the Common Council settled on a rocky, swampy mass between 59th and 106th streets. (A decade later, the park would be extended to 110th Street.) In 1857, using eminent domain, the city paid off and kicked out 1,600 immigrant German and Irish as well as African Americans, who resided there in shantytowns and in a small enclave called Seneca Village, eking out a living raising hogs and rag-picking.

The land, described by one newspaper as "a dreary waste of sterile rocks, rising boldly and defiantly in the face of thrift and enterprise, relieved now and then by filthy sink-holes and pools of stagnant water," was turned over to Frederick Law Olmsted and Calvert Vaux. Their winning "Greensward" design promised to make Central Park a retreat of drives and walks, lakes and ponds, and woods and pasture. Neither had teamed up to work together before. Yet their plan to develop a rustic park that would mimic nature impressed the park's Board of Commissioners, headed by Andrew Haswell Green. Olmsted and Vaux also shared Downing's view that a park would be morally and culturally uplifting, and that it should be for all classes. Olmsted touched on this in a letter to a colleague, describing the park as "of great importance as the first real Park made in this country—a democratic development of the highest significance." In

An 1873 illustration of New York City looking south from Central Park shows Belvedere Castle at left, Bethesda Terrace in the center, and the Lake at right. In the distance on the left is the yet-to-be-completed Brooklyn Bridge.

A menagerie was not part of Olmsted and Vaux's original plan. But through the 1860s, bears, swans, and other animals owned by circuses, carnivals, private citizens, and hunters were donated to the park. Victorian-style structures to house them were eventually built behind the arsenal. The menagerie became very popular—as many as seven thousand people visited daily in 1873. By 1887, there were monkeys, polar bears, and an elephant.

Olmsted and Vaux's plans for a tranquil, meditative park gave way to one where children could sail down snow-covered hills on toy sleighs.

1865, he wrote, "It is a scientific fact that the occasional contemplation of natural scenes . . . is favorable to the health and vigor of men."

Central Park has been called nineteenth-century New York's biggest public works project. Twenty thousand engineers, laborers, stonecutters, and other workers dredged swamps, laid underground pipes for the new man-made lakes and pond, and set off gunpowder to blast rocky outcroppings and create a mostly pastoral, Romantic-style landscape. Laborers were paid approximately $1 per day for dangerous, backbreaking work. In December 1858, the first part of the park, the skating pond, opened. Over the next few years, drives, walkways, and bridges began welcoming park-goers as well. By 1866, eight million visitors passed through the various park entrances each year. In 1873, a final part of the park, Bethesda Fountain, or "Angel of the Waters," was unveiled in the Lake at Bethesda Terrace.

In the park's early years, Olmsted and Vaux insisted on maintaining a naturalistic aesthetic and a sense of serenity. Park police enforced their rules: They banned picnics, ball playing by anyone but schoolboys, workmen's wagons, and singing, among other activities. The lower classes felt unwelcome, but not for long. A decade later, Tammany Hall politicians, always seeking the populist vote, helped make Central Park a more democratic destination. When Boss Tweed and his cronies took control of the city charter in 1870, they relaxed the restrictive rules and added amusements such as pony rides, free concerts on Sundays, a free menagerie (one of the park's

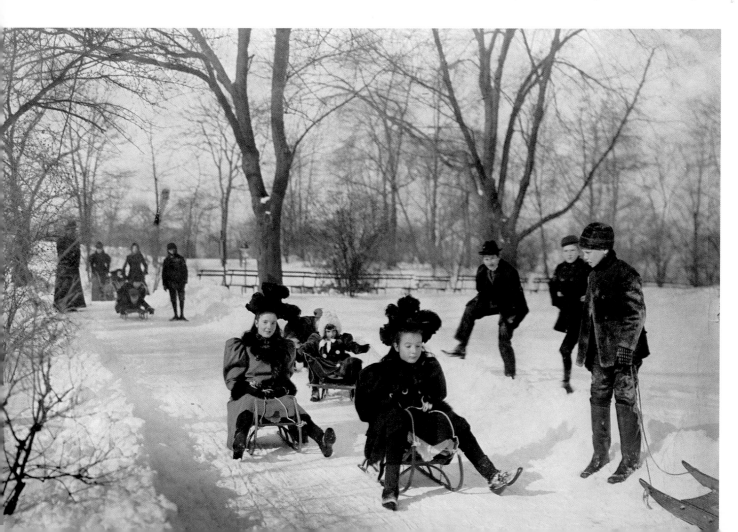

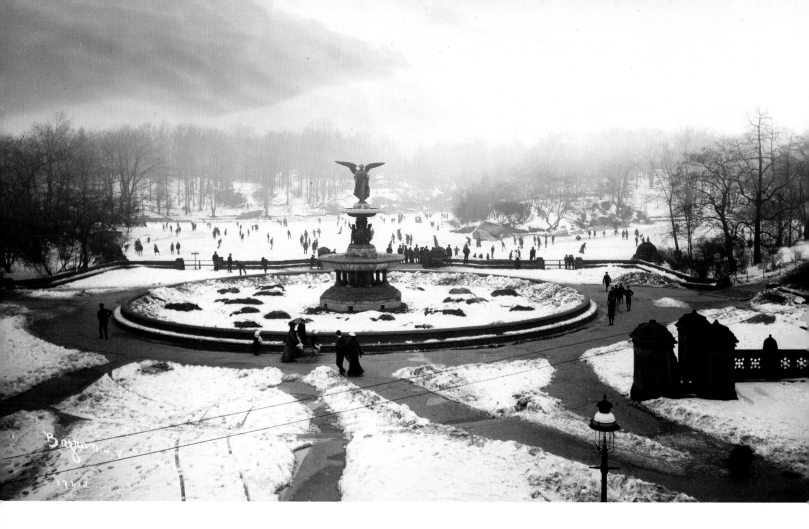

most popular venues), a carousel (powered by a mule walking in circles), and boat rentals on the lake. They took kickbacks from contractors, but they increased park attendance by 43 percent by 1873. Sunday was the park's busiest day; reportedly a barkeeper came up to Central Park one Sunday determined to find out why the men who used to spend the day in his saloon now preferred fresh air and green lawns. "The great advantage of the park is, that it is open to all, and that the poor enjoy it more than the rich, who can go where they like, and purchase what the Central gives gratis," wrote Junius Henri Browne.

By the 1880s, Central Park was known as the "lungs of the city." Ice-skating was a popular draw, one of the few activities men and women in polite society could enjoy together. Eager skaters would check to see if a red ball or flag had been hoisted on top of Belvedere Castle, which signaled that the

ice was thick enough. Upper-class park-goers glided on park paths in handsome sleighs after a snowfall. They attended trotting races, rode horses that were stabled in the park, and enjoyed afternoon carriage parades. "Ten thousand vehicles careening through the park this perfect afternoon," wrote Walt Whitman in May 1892. "Such a show! Private barouches, cabs, and coupes, some fine horseflesh—lapdogs, footmen, fashions, foreigners, cockades on hats, crests on panels—the full oceanic tide of New York's wealth and 'gentility.' It was an impressive, rich, interminable circus on a grand scale, full of action and color in the beauty of the day, under the clear sun and moderate breeze."

Bethesda Terrace and the Mall were fashionable promenade spots. "[We] went to see the grounds of the park down the Pall Mall promenade under the arches of the beautiful trees whose branches interlaced overhead," wrote twelve-year-old Naomi R. King,

The Lake in Central Park, just beyond Bethesda Fountain, began hosting skaters in 1858, before the rest of the park was completed. Olmsted and Vaux labeled it the "skating pond" in their original Greensward Plan. To boost the odds that it would freeze over, the Lake was drained of most of its water every winter.

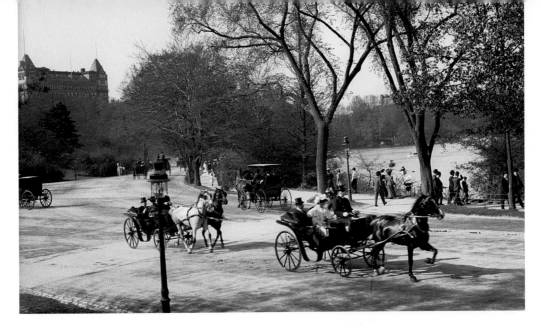

New York's elite turned out daily for late-afternoon rides in their carriages, costly vehicles fewer than 5 percent of city residents could afford to own. This "carriage parade" took place between 4:00 and 5:00 P.M. along the park's East Drive from 59th Street and Fifth Avenue to the Mall.

An authentic Italian-made gondola, given to the park by a city lawyer in 1862, enhanced the romantic atmosphere of the Lake. All kinds of craft were available for rent in the Lake's early days: gondolas, rowboats, and a multiseat swan boat that had room for many passengers.

Thousands of city residents came to Central Park in January 1881 to view the park's newest and most curious monument: an ancient Egyptian granite obelisk shipped to New York from Egypt. After the hieroglyphics-covered monument, nicknamed Cleopatra's Needle, arrived in New York Harbor, it took 112 days for laborers to carefully bring it to the park and position it upright near East 81st Street.

visiting the city with her well-to-do family in 1899. At the end of the Mall "was the bandstand where Sousa's celebrated band plays all during the summer, in front of it was the principal driveway of the park, across which was a mammoth fountain with massive beautiful figures."

A visit to Central Park was a rarer event for the impoverished of Lower Manhattan; it took at least two nickels to ride the elevated train or a horsecar to the park and back. But when it could be done, it was a wonderful treat. A trip to the park, "with a ride in the goat wagon, was something that came to you on your birthday if you were lucky," recalled future governor Al Smith, who grew up in a downtown tenement. "Our favorite way of reaching Central Park was on the open cars of the Second Avenue horsecar line in the summertime. They started from Fulton Ferry and gathered in all the downtown children lucky enough to get a trip to Central Park."

New York's enchanting park also impressed foreign visitors, who described it in glowing terms and helped elevate the metropolis in the eyes of Europe. "New York is very proud of Central Park; and well it may be so, for it is one of the finest in the world, there is nothing like it this side of the Atlantic," wrote an English journalist in 1880. "Twenty years ago it was a mere swampy rocky waste, now

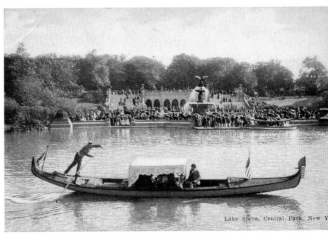

Lake Scene, Central Park, New Yo[rk]

it is a triumph of engineering skill . . . there are smooth green lawns, shady groves, lakes, beautifully wooded dells and vine-covered arbours. . . . From the terrace, which is the highest point, you enjoy a view of the entire park with its numerous lakes, fountains, bridges, and statues, spreading like a beautiful panorama round you."

Building the City's Small Parks and Playgrounds

The success of Central Park sparked a massive wave of park building all over the city. The timing was right. Changes in labor laws gave working people more free time to visit them. Labor movements had succeeded in shortening the standard workday to eight hours on average. Many workers already had Sunday off, and half-day Saturdays were catching on. The new elevated railroads allowed anyone who could scrape up the fare to escape what Walt Whitman called "the swarmingness of the population" for a few hours and enjoy a picnic along the East River or one of the seaside pavilions in Brooklyn. Social reformers continued to expound on the moral and cultural benefits of park-going. A lack of exposure to nature was triggering higher levels of crime and poverty in the city, the thinking was. More green spaces, they insisted, would boost physical and moral health.

In the 1870s, the new Department of Parks secured some of the last stretches of Manhattan's undeveloped land. A long, hilly ridge overlooking the Hudson was purchased in 1872; it opened as Riverside Park three years later, designed by Olmsted and Vaux. Piece by piece, land was acquired in the 1890s to create slender Highbridge Park, named for the 1848 High Bridge that carried Croton Aqueduct water over the Harlem River to Manhattan. Department officials revamped Washington, Union, and Madison Squares—three parks that had started out as burial sites and then served as military parade grounds. The 1887 passing of the Small Parks Act allowed the department to carve out plots in tenement districts for Mulberry Bend Park, Hudson Park, and DeWitt Clinton Park. Brooklyn enlisted Olmsted and Vaux to design the city's first park, Fort Greene Park, in 1867, and then had the two

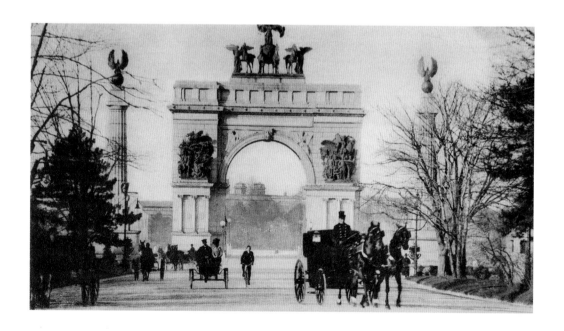

The Soldiers' and Sailors' (or "Defenders") Arch marked the main entry to Prospect Park at the park's grand Plaza. The Arch was built two decades after Brooklyn's version of Central Park opened in the 1860s and is dedicated to Union heroes of the Civil War.

design Prospect Park, the city's centrally located 585-acre park, which opened in stages between 1867 and 1873.

Olmsted and Vaux's original vision for Central Park was to re-create the tranquility of nature. But a boom in outdoor recreation led park officials to do more than design pastures and promenades in the newer parks. They created ball fields, wide walking paths, band shells, and roller-skating areas. They built ponds for sailing model boats and more lakes for winter ice-skating. In the summer, "floating pools" were docked off the Hudson and East rivers. Filled with river water, they were packed on sweltering days—until the rivers were deemed too polluted. In their place, the city built two real swimming pools in 1908, at public bathhouses on East 23rd Street and West 60th Street.

To ease the effects of the stifling (and often deadly) summer heat, officials transformed gigantic industrial piers off the East and Hudson rivers into parks. Piers at East 3rd Street, East 24th Street, Christopher Street,

and West 50th Street hosted ten thousand revelers a day. Mothers with babies, packs of boys and girls, and senior citizens swam in built-in pools, played games, or just watched boats go by amid a throng of food vendors and street musicians. In daytime, the piers resembled "one vast nursery," reported a 1905 *New York Times* article. At night, they became venues for romance. Each evening, girls were "eager to change their work clothes and get down to the pier," wrote the *Times*. "Dinner or no dinner, they must get there before 8 o'clock, when the band begins to play . . . then the fun is on. Few of the 'goils' come with 'fellers.' They find them though before the evening is out. A pretty girl seldom has to pay her own carfare home."

No recreational activity swept the city like cycling. Men and women took to the biking craze in the 1880s and 1890s, forming riding clubs that rode en masse through streets or conducted endurance races inside velodromes, or racing tracks. Riding in Central Park and Prospect Park was permitted but regulated,

and riders had to secure a bike badge first; special bicycle patrols were formed to catch rule-breakers or "scorchers," a slang term for cyclists who blazed down the streets aggressively. With so many New Yorkers giving bicycling a try, distinct lanes were a necessity. Brooklyn led the way, opening the first bike path in the nation in 1894, 5.5 miles long, from Prospect Park to Coney Island. Manhattan soon accommodated bikers by designating paths in Central Park and Riverside Park.

"The delights of winter cycling were appreciated and enjoyed by a host of wheelmen and wheelwomen yesterday," wrote the *New York Herald* on January 11, 1897. "From early morn till dusk they appeared in a never ending stream in the streets and roads best equipped for the sport. Central Park and its environs, the Boulevard, Riverside Drive, and all of the asphalted streets were thronged with riders of all sorts and conditions, mounted on wheels which had seen various degrees of service. . . . Riverside Drive was in splendid condition and lined with people viewing the handsome turnouts and the myriad of wheelmen, who invariably wended their way up to and by Grant's Tomb to the Claremont, where the wants of the inner man were catered to, apparently to their satisfaction."

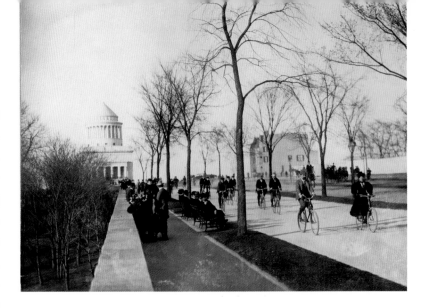

Parks also began to feature playgrounds. Before the 1880s, play areas for children, called "sand gardens," were usually attached to schools or settlement houses. But social reformers argued that play was imperative to a child's well-being. The New York Society for Playgrounds and Parks formed in 1891; it considered its mission "a moral movement not a charity." The Outdoor Recreation League, led by Henry Street Settlement co-founder Lillian Wald and Parks Commissioner Charles Stover, joined the fight to make playgrounds more accessible by including them in the plans for city parks.

By 1905, under the social-reform mayor Seth Low, nine playgrounds had been constructed; they featured maypoles and sandboxes, marble pavilions, running tracks, petting zoos, and even rows of rocking chairs for weary mothers. Tenement kids who otherwise would play street games like hon-pon, ringalevio, kick-the-wicket, and sixty-o in gutters could now run and tag each other in playgrounds. "As long as spring in New York is still the old spring of warm days and many long twilights, you cannot pass such a place as Tompkins Square, at Avenue A and Tenth Street, without hearing that song and that refrain some afternoon when school's just out," wrote one journalist in 1904. "Or, skip over a great distance to Hudson Park, the queer polygon where Eighth Avenue begins,

Wheelmen and wheelwomen in 1897 regularly pedaled to Grant's Tomb, a popular destination for West Side riders. "New Yorkers never wearied of wheeling," commented one writer. "Young people made up parties, properly chaperoned, to ride up through the park and along Riverside Drive to Grant's Tomb, dine at Claremont Inn, and return by night."

The Lower East Side's Hamilton Fish Park and its playground were completed at the same time in 1900. The playground was one of the first ever constructed in the city.

A boy gives his brother a piggyback ride at a playground on West 68th Street in 1895. Jacob Riis took the photo; Riis led the city's Small Parks Advisory Committee, which convinced the city to build playgrounds around the city.

for grass plots, a stone and brick pavilion arranged for concert purposes, and finally the playground with its baths and gymnasium," wrote the *New York Times*. "The baths are for the use of women and men as well. The playground is divided, one side being for boys and another for girls. There are men to keep order among the boys, and women attendants for the girls." On opening day in 1903, twenty thousand rain-soaked children mobbed the gates, disrupting a ceremony attended by Jacob Riis, who was instrumental in the city playgrounds movement. "As anxious as I was to get the children into this park, I am more anxious at this moment to get them out," quipped Riis, according to the *New York Herald*. "I came here to talk to the children, but I will wait until a fair day."

or Bayard Park on the Lower East Side, or any of the green oases, uptown and downtown, in the tenements deserts of the city."

One of the first playgrounds to open was at Seward Park, a patch of green amid the grimy walkups surrounding Canal Street and East Broadway. "There is space set aside

A City Gone Sports-Crazy

On weekday afternoons in the 1840s, young men often met after work to throw a ball around a field near the northwest corner of Madison Square. At this little-developed enclave on the outskirts of the city, where omnibus companies kept stables for their horses, the men formed teams, ran bases, and hit the ball with a bat. No one had any idea that the game, called "base ball," would take the city by storm by the end of the century.

By many accounts, modern baseball can be traced to Alexander Cartwright Jr., a twenty-five-year-old bank clerk and volunteer firefighter who was one of the men who played near Madison Square. He codified the loose rules the players used into fixed

regulations and supposedly umpired the first game played by the newly coined New York Knickerbockers, in Hoboken, New Jersey, in 1846. (They were trounced, 23-1, by a group that called themselves the New York Nine.)

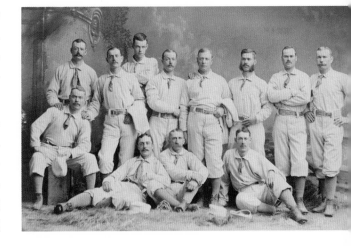

The Metropolitan Club played in New York from 1880 to 1887; they were the first team to play at the original Polo Grounds. Their white uniforms featured formal neckties.

The Bathtub of Washington Heights

The first polo grounds really were polo grounds—a field with no official name on Lenox Avenue between 110th and 112th streets. In 1880, the New York Metropolitans, a professional-level team, made it their home field. The team folded into another, the New York Gothams, who continued playing there. With baseball fever rampant in the city, games drew as many as twelve thousand fans, half of whom had to stand because there weren't enough seats.

In 1888, the owner of the team, now called the Giants, had had enough. The city had plans to build over the polo field anyway, so he commissioned a real stadium at Eighth Avenue and 155th Street for his increasingly popular team. Called the Polo Grounds, the wooden structure, with grandstand seating and a carriage drive in the outfield, was wedged between a steep cliff known as Coogan's Bluff and the Harlem River.

A mysterious fire destroyed it in 1911; another Polo Grounds rose at this same location in 1913. It was called "the bathtub" because of its long shape. Locals often gathered at the top of Coogan's Bluff to watch games for free. It was a quirky jewel box of a stadium, but the Giants did well there, winning ten pennants by 1924.

The World Series of 1905 at the Polo Grounds matched the New York Giants against the Philadelphia Athletics. The Giants won four out of five games, thanks in part to the ace pitching of Christy Mathewson.

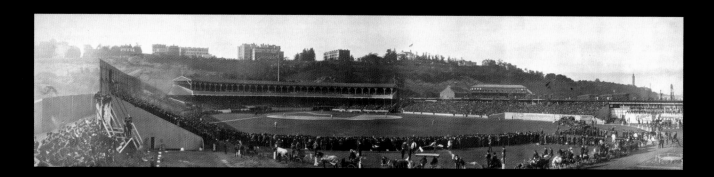

The sport caught on quickly, and clubs formed all over Manhattan and Brooklyn. Its popularity spread to other northeast cities; Union soldiers taught it to one another during the Civil War. In 1880, one of the first professional teams, the New York Metropolitans, turned a polo field on Lenox Avenue and 110th Street into its home turf.

By the 1890s, they had evolved into the New York Giants, who packed crowds at their new stadium, the Polo Grounds, on 155th Street and Eighth Avenue, at the bottom of Coogan's Bluff, which rose above the Harlem River.

Men of all classes, and some women, visited the new stadium. After a meeting

Christy Mathewson was the first great pitching star of professional baseball. He played for the New York Giants from 1900 to 1916 and led the team to one World Series win and three pennant-winning seasons. Mathewson was one of the first five players inducted into the Baseball Hall of Fame.

in 1894, William Steinway, a partner in his family's successful piano business in Queens, wrote in his diary about "[driving] to the Polo Grounds" and seeing "a most interesting baseball game between Cincinnati and New York. At least 15,000 spectators are there." Fans followed the scores in the new sports sections of newspapers. Celebrity players such as Giants Roger Connor and Christy Mathewson were cheered on when they won—and took heat when they lost. "The baseball season has ended, and New York has not won the pennant," wrote the *Sun* on October 4, 1891. "The team in the gentle springtime was expected to walk away with the bunting, while the other teams looked on in helpless astonishment. The result has not justified those rosy expectations."

Meanwhile, at Hilltop Park on Broadway and 168th Street, the New York Highlanders—the name contrasted with the team playing under the bluff just a few blocks away—were also cultivating a devoted fan base. Their stadium, with its covered grandstand and open-air bleacher seats, could fit sixteen thousand; in 1913, they were renamed the Yankees. And a team in Brooklyn called the Bridegrooms would by 1895 be nicknamed the Trolley Dodgers, a term used to refer to anyone from Brooklyn, because of the city's tangled web of streetcar lines.

From the very beginning, the Trolley Dodgers, who played in Eastern Park in the Brownsville section of the city, were embraced by Brooklynites. "The opening of the base ball season in Brooklyn at Eastern Park yesterday was a noteworthy event in many respects," wrote the *Brooklyn Daily Eagle* on May 2, 1895. "There were fully fifteen thousand people in attendance and it may be questioned whether better order or a more genial spirit could have been duplicated in any assemblage of equal magnitude. The character of the gathering was the best tribute to the popularity of base ball as a clean and wholesome amusement, and the fact that it is not an expensive one makes its claim more deserving."

Baseball was booming, but other sports continued to hold their own. Boxing had a

HARDIE HENDERSON
Champion Base Ball Pitcher

After a stint with the Baltimore Orioles, pitcher Hardie Henderson took the mound for the Brooklyn Grays from 1886 to 1887. The team would be renamed the Brooklyn Trolley Dodgers a decade later.

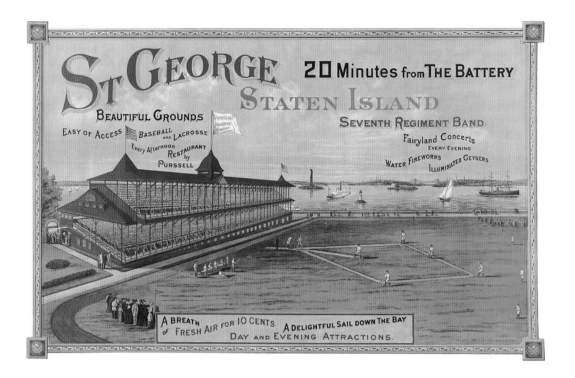

ST GEORGE **20 Minutes from THE BATTERY**

STATEN ISLAND

BEAUTIFUL GROUNDS

EASY OF ACCESS BASEBALL AND LACROSSE Every Afternoon RESTAURANT by PURSSELL

SEVENTH REGIMENT BAND

Fairyland Concerts EVERY EVENING WATER FIREWORKS ILLUMINATED GEYSERS

A BREATH of FRESH AIR FOR 10 CENTS A DELIGHTFUL SAIL DOWN THE BAY DAY AND EVENING ATTRACTIONS.

The St. George Stadium in Staten Island, located only 300 feet from a ferry, was a popular venue with New Yorkers when it opened in 1886. That April, the New York Metropolitans began their season against the Philadelphia Athletics, playing their first game in front of seven thousand people. The *Times* wrote, "The grand stand overlooks the bay, and a cool, refreshing breeze adds to the comfort of the onlookers. The playing grounds are neatly sodded, and altogether the Metropolitans can boast of one of the best parks in the country." Fans also enjoyed their view of the construction of the Statue of Liberty.

long history among the city's lower classes, who came to see pugilists such as Bowery resident Owney Geoghegan, who toiled in the gasworks along the East River by day but by night was a lightweight champion in the 1860s. Boxing was not legal in New York from 1859 to 1896, but there were ways to get around the law—for example, a bout could be held in a private athletic club. No wonder bars suddenly called themselves "sportsmen's clubs." These were rough-and-tumble dens in downtrodden areas, like one Geoghegan ran on the Bowery, or Water Street's notorious Sportsmen's Hall, a club run by Irish gangster Kit Burns. Here, men came to watch bareknuckle boxing, as well as dog-versus-rat fights in an enclosed pen (the latter until Henry Bergh's ASPCA cracked down in 1870).

One of the most popular clubs was Harry Hill's on Mulberry Street. Although it was more of a dance hall, it also hosted boxing bouts in small rooms. "At one end is the bar, from which liquors and refreshments are served, and at the other, is a stage, upon

which low variety performances and sparring matches are given," wrote James McCabe in 1882's *New York By Gaslight*. "The room is ablaze with light and heavy tobacco smoke. Tables and chairs are scattered through it. . . . From eight o'clock until long after midnight the place is filled with a motley crowd." More well-heeled patrons went to Madison Square Garden, on Madison Avenue and 26th Street. To evade the boxing ban, Madison Square Garden billed bouts as "exhibitions" or "illustrated lectures."

The upper classes also rallied around racetracks. Jerome Park, built by financiers and racing enthusiasts Leonard Jerome and Augustus Belmont, opened in 1866 in the Bronx and marked the return of thoroughbred racing to New York. A favorite of the newly rich and titans of industry, it wasn't the only track in the city: There were horse tracks in Sheepshead Bay (funded by Jerome), Brighton Beach, and in Queens. And the Harlem River Speedway, opened in 1898 beside the High Bridge, hosted carriage races that drew enormous crowds. Racing was a

After a thirty-seven-year ban, boxing was legalized in New York from 1896 to 1900. Fans crowded the matches held at Madison Square Garden, seen here in 1901. In August 1900, with the passage of the Lewis Law, boxing was once again outlawed (except in sportsmen's clubs). On August 30, 1900, in the Garden's last legal fight until 1911, James J. Corbett knocked out Kid McCoy in five rounds (out of a possible twenty-five).

wealthy man's pastime, but anyone could go to the track and gamble, which many New Yorkers, particularly young men with little money, apparently did in droves.

"Each racing-day the attendance is from ten to thirty or forty thousand," stated a 1905 article from *The Cosmopolitan*. "There is in the crowd a sprinkling of really respectable people, lovers of outdoor sport; there is a sprinkling of more or less reputable people directly and indirectly connected with racing. . . . And then, there is the crowd—thousands of young and youngish men, neglecting their work, wasting their small earnings,

Tourists flocked to the Harlem River Speedway to watch carriage and boat races, and visit the nearby Highbridge and Fort George amusement parks.

preparing themselves for that desperate state of mind in which accounts are falsified, tills tapped, pockets picked and the black-jack of the highwayman wielded."

Sodom by the Sea

Until the 1870s, Coney Island, a ribbon of land jutting off the southern end of Brooklyn into the Atlantic Ocean, was a summer resort area with a tawdry edge. Reportedly named for the rabbits that used to live there (*konijn* is Dutch for "rabbit"), it was dotted with a few hotels and restaurants. An enclave called Norton's Point at the western end consisted of a small number of bars, gambling houses, and brothels. Steamboat service linked it to Manhattan.

Everything changed when the trains arrived. Railroad magnates saw dollar signs and began developing the beachfront, advertising to city dwellers that they could leave Manhattan and be on the boardwalk in an hour. On the eastern end, Brighton Beach and Manhattan Beach were marketed to the upper middle class: the Brighton Beach Hotel, Oriental Hotel, and Manhattan Beach Hotel, all open by 1880, were immense Victorian-style wooden structures that featured bathing

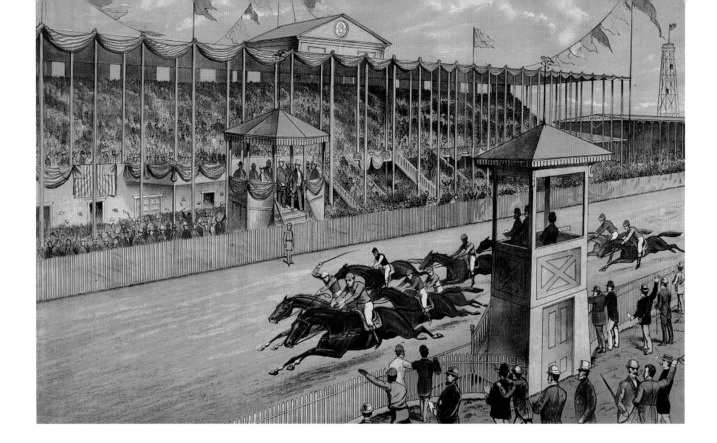

pavilions, verandas, several restaurants, fire-works, and entertainers such as John Philip Sousa. The Brighton Beach Race Course boosted the resorts' appeal among gentlemen. "I never saw so many prosperous-looking people in one place, more with better and smarter clothes, even though they were a little showy," wrote Theodore Dreiser on a visit to Manhattan Beach. "The straw hat with its blue or striped ribbon, the flannel suit with its accompanying white shoes, light cane, the pearl-gray derby, the check suit, the diamond and pearl pin in the necktie, the silk shirt. What a cool, summery, airy-fairy realm!"

While the eastern end nurtured refine-ment, the developers of the western end went after larger crowds and cheaper thrills. Railroad head Andrew Culver was among the money men who built hotels, bathing pavilions, and restaurants that could accom-modate thousands, such as the West Brighton Hotel, the Sea Beach Palace, and Charles Feltman's Ocean Pavilion, which had room for twenty thousand guests and a ballroom that held eight thousand. The Elephant Hotel, built in 1882 in the shape of a multistory pachyderm, ushered in a sense of frivolity and carnival. Sideshows, boardwalk games, freakish

The Brighton Beach Race Course opened in 1879 next to the Brigh-ton Beach Hotel, on the more refined eastern end of Coney Island, an upper-middle-class enclave of accommo-dations and attractions more genteel than of its noisy, colorful neighbor to the west.

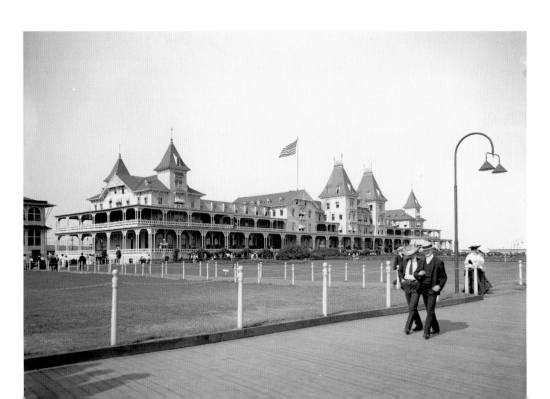

When the Brighton Beach Hotel opened in 1878, its accessibility to the railroad made it immediately popular. This ornate, three-story resort housed five thousand visitors, and it could feed twenty thousand guests a day. Ten years later, beach erosion threatened the hotel's beachfront lo-cation, so it was moved 520 feet farther inland on flat train cars pulled by six steam engines.

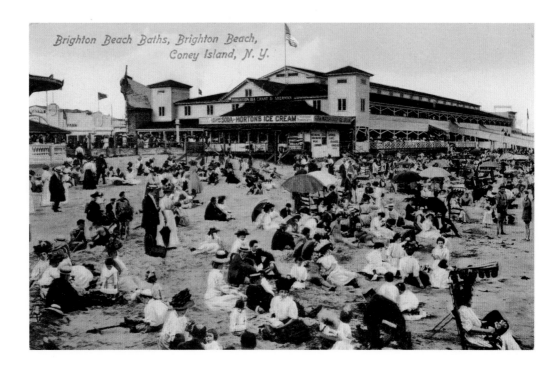

Brighton Beach Baths, Brighton Beach, Coney Island, N.Y.

Brighton Beach—its name alluding to the British seaside resort of Brighton—was developed in the 1860s on the eastern end of Coney Island. As Coney Island's west end became a tawdry entertainment wonderland, Brighton Beach remained a quieter spot for swimming, sunbathing, and middle-class entertainment like vaudeville shows and horse racing. The Brighton Beach Baths, a private beach club (shown here), opened in 1907, a year before the Brighton Beach Race Course closed.

Surf Avenue, seen here on July 16, 1913, was one of the main drags of Coney Island. The entrance to Luna Park is on the right, at West 10th Street; six blocks away is Steeplechase Park. Feltman's on the left was one of Coney Island's oldest restaurant (it opened in 1871); it reportedly introduced the hot dog to New Yorkers and made it a Coney Island staple.

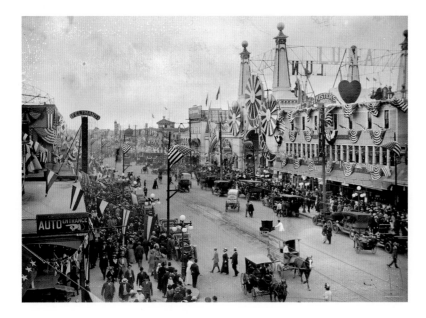

curiosities, lions, tigers, and elephants were all brought in to keep the throngs amused.

"Sodom by the Sea," as Coney Island was nicknamed, was off to a very popular start. It coincided with the growth of a working and middle class that craved release from the restraints of the industrial era's nine-to-five economy. They also sought a break from conventional social and romantic mores. The festive atmosphere and huge crowds made it easier for young men and women to socialize, flirt, and show affection. Form-fitting swimsuits revealed body parts that used to be hidden behind black wool "bathing dresses." Rides like the Tunnel of Love and the Cannon Coaster encouraged physical contact. In 1893 a popular sideshow called "The Streets of Cairo" took Coney Island's loosened decorum a step further by featuring "Oriental" dancers like Little Egypt and Ashea Wabe, who performed the "Hootchy Cootchy dance" in belly-revealing skirts.

With hotels open from May to September, millions traveled on ferries by railroad, or a combination of both, for a day's worth of lurid, lowbrow fun. A traveler writing in the London *Times* in 1887 reported: "They spread over the four miles of sand strip with . . . bands of music . . . in full blast; countless vehicles moving; all the miniature theaters, minstrel shows, merry-go-rounds, Punch and Judy enterprises, fat women, big snakes, giant, dwarf, and midget exhibitions, circuses and menageries, swings, flying horses, and fortune telling shops open; and everywhere

a dense but good-humoured crowd, sight-seeing, drinking beer, and swallowing 'clam chowder.'"

Coney Island wasn't the only amusement destination for New Yorkers. North Beach, on a bay in Astoria, Queens, was financed by William Steinway in 1886. A steamboat ride across the East River gave Manhattanites access to its rides, restaurants, and entertainment. Queens also had the Rockaways, a resort and amusement park on a peninsula south of Coney Island. Fort George Amusement Park, overlooking the Harlem Speedway, was dubbed "Harlem's Coney Island" when it opened in 1895, boasting three roller coasters, two Ferris wheels, hotels, restaurants, shooting galleries, and music halls. In 1907, the Golden City Amusement Park opened in Brooklyn's Canarsie neighborhood overlooking

Jamaica Bay. Golden City featured acres of seaside roller skating and dancing, a circus, amateur boxing matches in its own stadium, and novel rides like the Wild West railway "Over the Rockies" and "Human Laundry," which spun people around an imitation washing tub before hurling them down a laundry chute.

But these resorts couldn't top the spectacular enclosed amusement parks that began opening at Coney Island in the late 1890s, an effort by developers to make the resort less vulgar and more wholesome for families. Sea Lion Park featured the Flip Flap Railroad, an upside-down roller coaster, and the Shoot-the-Chutes water flume. Forty trained sea lions and a cage of wild wolves thrilled the crowds. Steeplechase Park had scale models of world landmarks such as the Eiffel Tower, and the Trip to the Moon attraction, which

Luna Park's Helter Skelter ride was a snaking, plunging slide for adults. To get on required a trip up an escalator; after twisting and bouncing down the slide, riders were spit out into a soft mattress at the end. After giving the ride a try, one impressed writer had this to say: "Suddenly childhood returned, and we slid and kept on sliding until we were altogether certain that we had lost the respect of any friend or relative who might happen to be in the crowd of spectators below."

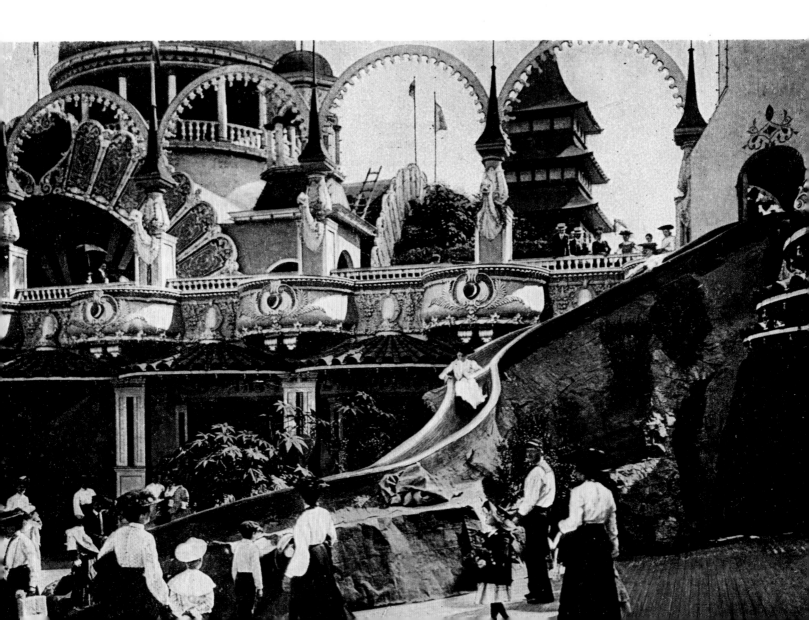

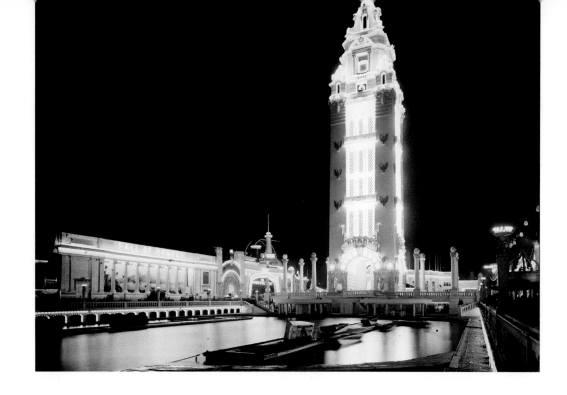

Dreamland at night in 1906, with its Shoot-the-Chutes water flume, Canals of Venice exhibit, and "Fire and Flames" disaster spectacle.

imagined a rocket ride. Dreamland appeared in 1904 and spared no expense: One million electric lights attracted visitors to its miniature railroad, fake Venetian canals, and equally fake Swiss alpine peaks. Three hundred dwarfs lived in its Lilliputian Village; a one-armed lion tamer commanded the big cat enclosure; and premature babies were displayed in incubators.

No place made an impression quite like Luna Park, which took over Sea Lion Park in 1903. New York had never seen anything like it: a city within a park lit up by even more electricity than Dreamland, with spires,

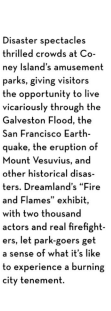

Disaster spectacles thrilled crowds at Coney Island's amusement parks, giving visitors the opportunity to live vicariously through the Galveston Flood, the San Francisco Earthquake, the eruption of Mount Vesuvius, and other historical disasters. Dreamland's "Fire and Flames" exhibit, with two thousand actors and real firefighters, let park-goers get a sense of what it's like to experience a burning city tenement.

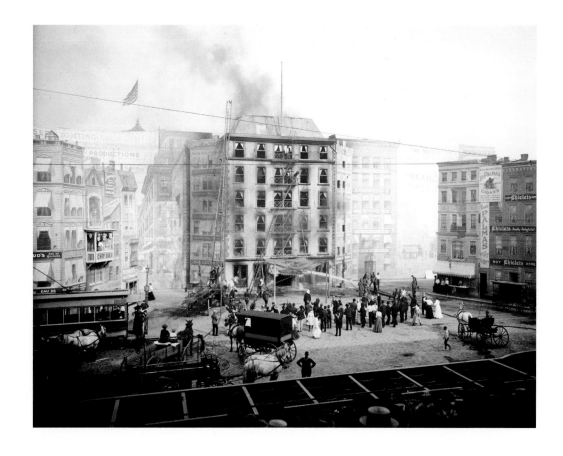

domes, minarets, and other fairy tale–like architecture. Elephants and camels strolled the grounds amid hundreds of attractions, wild animal shows, and the Trip to the Moon ride, which had relocated from Steeplechase. Like the other amusement parks, Luna Park featured disaster spectacles, which allowed visitors to get a feel for what it was like to experience a flood, volcano eruption, or other horrific disaster. Luna Park's "Fire and Flames" was a multi-story building set ablaze by real firefighters, who then rushed in and rescued "residents," really actors. Other disaster spectacles included the fall of Pompeii, the San Francisco Earthquake, and the Galveston Flood.

Coney Island was a popular topic for thinkers and writers at the time, who explained what its popularity said about American culture. "Coney Island exists, and will go on existing, because into all men, gentle and simple, poor and rich—including women—by some mysterious corybantic instinct in their blood, has been born a tragic need of coarse excitement, a craving to be taken in by some illusion, however palpable," wrote British journalist Richard Le Gallienne in 1905. "So, following the example of those old nations, whose place she has so vigorously taken, America has builded for herself a Palace of Illusion . . . and she has called it Coney Island."

Luna Park, decorated with hundreds of thousands of colored lights, opened on the night of May 16, 1903—the second of the three big Coney Island amusement parks (the others were Steeplechase and Dreamland) to make its debut. With more than sixty thousand people surging through the gates on opening night, the park ran out of change and let people in for free. Single rides cost a nickel; $1.95 scored admission to every attraction. That July, Luna Park saw more than 140,000 visitors in a single day.

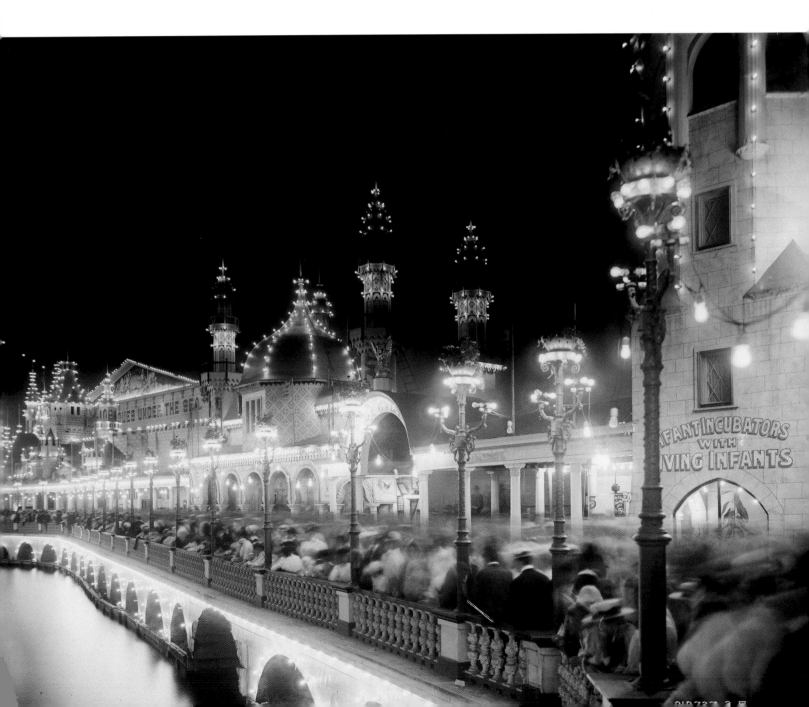

"Steeplechase—the Funny Place"

GEO. C. TILYOU'S COMBINATION BADGE

50c 50c

STEEPLECHASE THE FUNNY PLACE

Steeplechase owner George Tilyou, a Coney Island native, brought the Ferris wheel to Coney Island, along with scale models of world landmarks such as the Eiffel Tower and Big Ben.

It wasn't the first enclosed amusement park at Coney Island. That honor goes to Sea Lion Park, which opened in 1895. But Steeplechase Park came next, in 1897, on fifteen acres overlooking the beach. And thanks to its size and the dazzling attractions it offered, it's considered the forerunner of the modern amusement park and the place that ushered in Coney Island's title as the city and nation's top seaside playground.

Coney Island native George C. Tilyou filled his new park with fantastical, spectacular rides: the Barrel of Love, the Trip to the Moon, a human roulette wheel, a human pool table, and even a human zoo, where visitors were placed in cages. Tilyou also built intricate scale models of the Eiffel Tower, Big Ben, and Westminster Palace. Ninety thousand revelers visited on peak summer days, paying twenty-five cents to experience up to twenty-five rides and attractions.

The park's namesake ride was an ode to Coney Island's horseracing tradition. The Steeplechase Race featured six double-saddled mechanical horses that took riders more than 1,000 feet along a downhill track, simulating a real race and powered by gravity, with attendants dressed in jockey uniforms standing by.

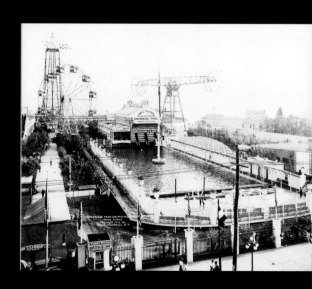

The giant pool at Steeplechase.

The Din and Dazzle of Broadway

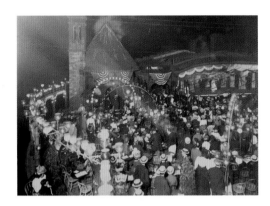

Like everything else in New York in the nineteenth century, the Theater District crept northward as the city grew. Manhattan's stages had once been centered on Broadway at Park Row; by the 1870s, dozens of venues—from the high-culture Academy of Music to the variety shows at Tony Pastor's—cropped up around Union Square. In the 1880s, many relocated again, this time to the new Theater District nicknamed "the Rialto," on Broadway between 23rd and 42nd streets. The 42nd Street area of Longacre Square (it wouldn't be renamed Times Square until 1904) was still a sparsely populated outpost, home to the carriage trade and close to the vice-ridden Tenderloin neighborhood of the West 20s and 30s. Not everyone thought "respectable" audiences would venture that far uptown for a show.

The doubters were wrong. By the end of the decade, theaters and concert halls all the way to 42nd Street would be known around the country. Businesses that thrived on the glitz and glamor of the theater world—the bars, cafés, and hotels—helped make the Rialto the ultimate entertainment mecca. "As many new plays are produced in New York in a season as are brought forward in London or Paris," wrote Moses King in 1892's *King's Handbook of New York City*. "Several hundred reputable actors and actresses find permanent employment in New York. . . . All America looks to New York for its dramatic entertainment. The people of the city and its visitors pay upward of $5 million a year for theatrical

On warm nights in the 1890s, New York's theater-going crowds kept cool on roof gardens, which featured musical comedies and other shows—plus refreshing breezes. The Casino Roof Garden, shown here, was the city's first; it opened in 1890 and overlooked Broadway and 39th Street.

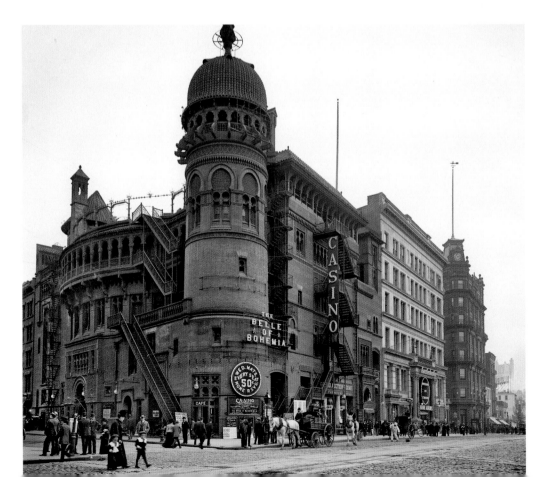

The Casino was the first theater to be lit by electricity. In 1900, it hosted the city's most popular show, an English musical called *Floradora*, which featured chorus girls who became stars in their own right.

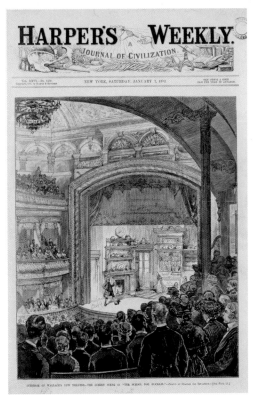

amusement. . . . In the business aspect of the drama New York is the first city in America. The purely artistic aspect is inseparable from the business phase."

About fifty theaters kept New Yorkers and tourists entertained from autumn through spring. There was the Metropolitan Opera House, the new-rich haunt funded by the Vanderbilts and other prominent families tired of being shut out of the Academy of Music. The Lyceum was another playhouse popular with the wealthy, one whose electric lights were personally installed by Thomas Edison. The Standard engaged audiences with Gilbert and Sullivan operettas, and the Moorish-style Casino Theatre, with its incredible roof garden—soon to be imitated by other theaters and hotels—featured light opera. Wallack's and Daly's, two venues that presented serious drama at Union Square and Madison Square respectively, were now on opposite sides of 30th Street; rich patrons even could order tickets to Daly's over the telephone.

"Fridays and Saturdays are our best nights," wrote Dora Knowlton Ranous, a teenage bit player at Daly's in 1879, in her diary. "I mean we have the largest audiences then; and last night there was only standing room when the curtain went up. Mr. Daly glides around behind the scenes with the pleasantest of smiles, and everyone is correspondently happy."

It wouldn't be dubbed the "Great White Way" until 1902. Yet since electricity had been introduced in the 1880s, Broadway dazzled with brilliant light. "Crowds throng the sidewalks; the lights of the omnibuses and carriages dart to and fro along the roadway like myriads of fire-flies," wrote James McCabe in 1882. "Here is a family—father, mother, and children—out for a stroll to see the sights they have witnessed a hundred times, and which never grow dull; there is a party of theater-goers, bent on an evening of innocent amuse-ment; here is a 'gang of roughs' swaggering along the sidewalk and jostling all who come within their way . . . Moving rapidly through the throng, sometimes in couples, sometimes alone, and glancing swiftly and keenly at the men they pass, are a number of flashily dressed women, generally young, but far from attrac-tive." The city was so enthralled by Broadway that a handful of theaters even remained open during the crippling Blizzard of 1888.

Edwin Booth Takes the Stage

Edwin Booth's first role, in 1849, was in a production of Shakespeare's *Richard III*. The Maryland-born son of an English actor who named his first-born after the actor Edwin Forrest, Booth traveled the country and the world, earning raves for his performances. He worked in New York City on and off between 1855 and 1860, returning to Gotham in 1862 for a production of *Hamlet* at the Winter Garden Theatre on Broadway and West 3rd Street.

In November 1864, Edwin Booth, John Wilkes Booth, and their actor brother Junius B. Booth Jr. put on a sold-out benefit performance of *Julius Caesar* at the Winter Garden Theatre. That performance was briefly interrupted by smoke from one of the several fires set simultaneously by a group of Confederate sympathizers, whose plot to burn down New York City aimed to create panic and bedlam.

Two days later, at Edwin Booth's home on 19th Street, he argued with his brother John, who defended the plot as necessary payback for Union wartime atrocities.

Edwin Booth accused his brother of treason and asked him to leave, but he apparently had no idea that John would soon plan to assassinate the president. Five months later, when he learned what John had done, he experienced deep shame and grief. "While mourning in common with all other loyal hearts, the death of the President, I am oppressed by a private woe not to be expressed in words," wrote Booth. John Wilkes Booth's actions led Edwin to retire from the stage, but he returned to the Winter Garden a year later, mostly due to financial pressures.

In 1869, he opened Booth's Theater, on Sixth Avenue and 23rd Street. It was "one of the leading playhouses of the city for 14 years," wrote Moses King. Booth did a run of *Julius Caesar*, but he also invited other actors to perform, including Sarah Bernhardt, who made her American debut here.

His last performance, in *Hamlet*, was at Brooklyn's Academy of Music in 1891. Two years later, he died at the Players' Club on Gramercy Park South, a social club he helped found. Booth's funeral was held at the Little Church Around the Corner, on East 26th Street, just a few blocks from the statue erected in his honor in 1918. The statue, in the center of private Gramercy Park, depicts Booth as Hamlet.

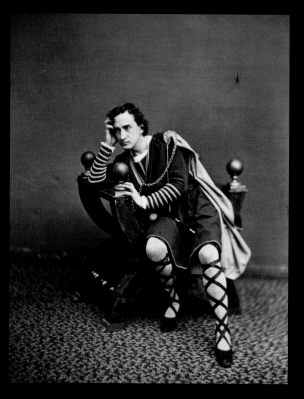

Edwin Booth played Hamlet in more than one hundred performances at the Winter Garden Theatre in 1865 before temporarily retiring from the stage after his brother assassinated Abraham Lincoln. When he returned, in 1866, he received sympathetic applause and cheers lasting several minutes.

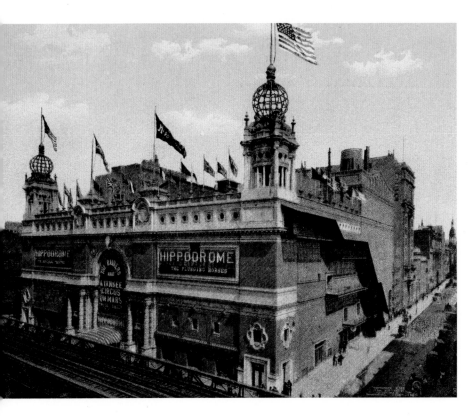

Built in 1905 by the developers behind Luna Park, the Hippodrome, on Sixth Avenue and 40th Street, was the biggest theater on Broadway. The cavernous space could fit a thousand performers, an enormous glass tank for diving shows, and room for circus elephants and horses to perform tricks.

John Koster and Albert Bial operated a popular concert hall on 23rd Street in the middle of the sex-and-sin Tenderloin district. Their infamous "cork room" (pictured here in 1892) was a hidden sanctum where wealthy men could spend private time with chorus girls.

A night at the theater, done with style, could last ten hours. First there were pre-show cocktails, ideally at the Hoffman House bar, Café Martin (where a lady was served alcohol if accompanied by a gentleman), or the Metropole, where show folks gathered. After the last encore, it was time for supper at Delmonico's or Sherry's, which had moved into a Stanford White–designed space at Fifth Avenue and 44th Street in 1898. The new "lobster palaces," such as Rector's on Broadway and 44th Street or Shanley's in Longacre Square, were also trendy haunts. A meal at one of these fancy eateries could cost up to $3 per person, noted Moses King. Revelers not ready to hop into their carriages and head home streamed into Jack's, on Sixth Avenue across from the Hippodrome, for a breakfast at sunrise of Irish bacon, eggs, and champagne.

The Rialto was filled with chorus girls, playwrights, musicians, gamblers, playboys, and other colorful characters. But most of the theaters catered to the bourgeois tastes of the middle and upper classes. A few were more tawdry or had a sexual, suggestive edge. The Casino switched to vaudeville in the mid-1890s, and other theaters and music halls—such as Koster and Bial's Music Hall on Sixth Avenue and 23rd Street and the Koster and Bial's new location in Herald Square that opened in 1893, or the Haymarket dance hall on Sixth Avenue and 30th Street in the Tenderloin district—featured more risqué shows. For real thrills, New Yorkers headed to the Bowery. "The third-class theaters are situated principally on the Bowery," wrote James McCabe. "The price of admission is low, and the performance suited to the tastes of the audience."

The Bowery was a carnival of music halls, saloons, and German beer gardens that attracted New Yorkers looking for a good time. "To see the Bowery in its glory, one must visit it at night," wrote McCabe. "It is a blaze of light from one end to the other. The saloons, theaters, concert-halls, and 'free-and-easys' are gayly ornamented with lamps of all colors, and the lights of the street vendors give to the sidewalks the appearance of a general

The Rich and Poor Dine Out

Well into the Gilded Age, New Yorkers of all classes had thousands of restaurants at their disposal. "Restaurants and cafes are abundant, of all grades, from Delmonico's famous establishment, where it will cost you from $3 upward for a good dinner, to the cheap down-town eating-houses," wrote Moses King in 1892.

For the wealthy, one top-of-the-line restaurant was Sherry's. After Louis Sherry opened his first restaurant on 38th Street and Sixth Avenue, his novel eatery, inspired by the latest food fads from Paris, quickly became a favorite of the city's old New York social elite. Mrs. Astor and the other members of the so-called "Four Hundred" flocked to his establishment for lunches and dinners, giving Sherry's a reputation as a haunt of the rich and powerful titans of industry.

Sherry moved his restaurant into a second location, a Stanford White–designed structure at Fifth Avenue and 44th Street, to compete with the eateries in new elegant uptown hotels like the Waldorf-Astoria. The new Sherry's "was the scene of many of the most elaborate dinners, dances, debutante presentations, and other functions," wrote the *New York Times* in 1926. "In the large ballroom were given some of the most important public dinners of that period." One such event was the infamous dinner on horseback hosted by uptown millionaire

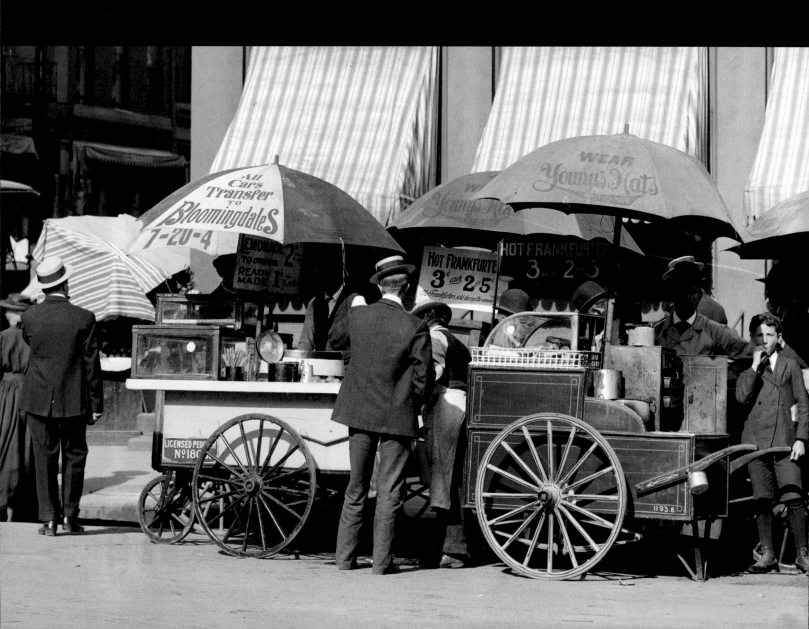

Childs Restaurant catered to working- and middle-class diners. The fast-growing national chain had several New York locations that emphasized cleanliness and low cost, earning a loyal following.

C. K. G. Billings in 1903. The guest list consisted of thirty-six of Billings's closest male (and rich) friends. Sherry's dining room was made to look like a forest, and each man's horse was brought up to the dining area in an elevator.

If Sherry's was an example of Gilded Age excess, then Childs was proof that New York had a growing working and middle class who wanted to eat in restaurants just like their wealthier counterparts. The first Childs got its start on Cortlandt Street in 1889. Operated by brothers Samuel and William Childs, the spare, functional establishment sold fast, inexpensive meals served by waitresses (not waiters, as was the norm in most restaurants) in crisp white uniforms, to emphasize cleanliness. Childs made a profit, and the brothers opened more locations. They introduced a cafeteria-style setup in 1898. The most expensive menu item in 1900 was a "Mexican Omelet"—just thirty cents.

Another dining option was the new ethnic restaurants popping up in or near immigrant neighborhoods. There, New Yorkers on a budget or rich people indulging in fashionable slumming sampled new cuisines. Not everyone recommended them, though. "In the Chinese district are several Chinese restaurants, dirty, foul-smelling, and cheaply furnished," wrote King. "National viands of mysterious character and national drinks are served at reasonable prices. Hebrew restaurants are numerous on the East Side, and even in the wholesale business district. There is a cheap Japanese restaurant on the East Side . . . in East Broadway and vicinity are several Russian restaurants. Spanish cooking prevails at several places off Park Row. In Mulberry Street are Italian restaurants of low order, and in Division Street are Polish eating places."

Food vendors selling hot dogs (seen here in 1906), clams, chestnuts, pretzels, and hot potatoes did a brisk business, catering to the appetites of hungry workers and commuters.

illumination. The concert halls are filled, and sounds of music and shouts of laughter float out from them into the street."

Not far from the Bowery was an entirely different type of Theater District, the Yiddish Rialto. At the Grand on Grand Street or the Thalia on the Bowery, stars like Jacob Adler performed Shakespearean drama, musical comedy, and vaudeville for thousands of Jewish immigrants clustered in nearby tenements. Yiddish theater was so popular, the Rialto would extend up Second Avenue to 14th Street at the turn of the century and turn some of its players into citywide stars.

The popularity of the Broadway stage made it the era of the "professional beauties." From chorus girls to starring actresses, the women of Broadway became famous and

envied, thanks to the new profession of press agents and devoted audiences who couldn't read enough about these new celebrities. Lillie Langtry, Lillian Russell, and Mary Anderson were among the most venerated. Also popular were the Floradora Girls, the chorus girls in the hit musical *Floradora*, which arrived from London and was staged at the Casino Theatre in 1900. Floradora girls occupied the best tables at Rector's and were courted by the city's most famous men—like architect Stanford White, who was enchanted by fourteen-year-old chorine Evelyn Nesbit.

The lives of these beautiful and admired stars were followed by the voracious gossip columns in New York newspapers, their hairstyles and clothes imitated by adoring women, their images used to hawk soap and other products, and their love lives chronicled—especially that of Lillian Russell, dubbed "the most beautiful creature since Helen of Troy" and known for her saucy personality. Russell's companion for decades was financier James Buchanan "Diamond Jim" Brady, a regular at Rector's known for his jewels, his bank account, and his hearty appetite. Together, these two larger-than-life characters formed *the* celebrity couple of the Gilded Age.

When the English musical *Floradora* opened at the Casino Theatre, this story of a young woman looking for love and trying to restore her inheritance became an instant smash. Rumor had it that the six original chorus girls, known around New York as the Floradora Girls, all married millionaires, which only increased the city's fascination with these glittery and dazzling celebrities.

Born Helen Louise Leonard, Lillian Russell made her New York City debut in 1880 at Tony Pastor's Union Square variety theater. A celebrated beauty who kept gossip columnists busy, she was one of the top singers of operettas in the country.

Jacob Adler: The Yiddish King Lear

Born in Odessa in 1855, Jacob Pavlovich Adler escaped pogroms and a draft precipitated by the Russo-Turkish War of 1877 to pursue his passion for theater. He joined his first troupe in Russia, and when Yiddish theater was outlawed there in 1883, he decamped to London. Unlike the biggest Yiddish stage stars of the era, he couldn't sing, and he was unable to perform in vaudeville or operettas, which dominated Yiddish stages. Instead, Adler focused on adapting classical plays for contemporary Jewish audiences.

In 1889, he sailed in steerage to New York, where he found his way into the burgeoning Yiddish Theater District. The Jewish Rialto, as it was dubbed, began growing in the 1880s (along with music houses, cafés, and photo studios catering to the actors and theatergoers) as Russian and Eastern European Jewish immigrants settled in the East Side tenement district. Offering inexpensive entertainment for immigrants unfamiliar with the city, the Yiddish Rialto eventually stretched from Grand Street to

East 14th Street and Avenue B. Adler and the theater company he founded took over Poole's Theatre on Third Avenue and St. Marks Place and renamed it the Union Theater, where he staged serious drama.

One of his biggest successes was in 1892's *The Jewish King Lear*, a variation on Shakespeare's classic. The role made his career and confirmed the "Great Eagle," as he was known ("Adler" is Yiddish for "eagle") to be the most prominent actor of New York's Yiddish theater. "It was in this era, the New York of the nineties, that we had our first great popular audiences—those lusty, unruly, noisy, madly devoted audiences of a time now past," Adler wrote in his memoir, describing the throngs of Jewish

Jacob Adler, the great star of Yiddish theater on the Lower East Side, took on classical and Shakespearean roles, making a name for himself in 1892's *The Jewish King Lear*. In 1901, he reprised the role in a benefit performance for the Outdoor Recreation League.

immigrants who filled the seats at the Union Theater and other playhouses of the Lower East Side well into the twentieth century.

One of Adler's most memorable performances was Shylock in Shakespeare's *The Merchant of Venice*. He appeared on both the Yiddish stage at the People's Theatre and again in 1903 in a Broadway production.

High Culture and Lowbrow Curiosities

Almost nothing on Broadway was meant to elevate the common New Yorker. For that, elite residents and city officials began planning and building grand new cultural institutions. The Metropolitan Museum of Art was founded in 1870 by private citizens to bring world-class art to the city. Museum trustees started with a purchase of 174 European old master paintings and displayed them first in a Fifth Avenue mansion, and then on West 14th Street, until a permanent building at Fifth Avenue and 82nd Street was completed in 1880. The Museum of Natural History, incorporated in 1869 by the New York State governor together with a Harvard-trained naturalist and prominent citizens such as Theodore Roosevelt Sr. and J. P. Morgan, got its start in the Arsenal inside Central Park. It moved to a Victorian Gothic building on Central Park West in 1877.

Privately endowed libraries such as the Astor Library, Tilden Library, and Lenox Library were open to all New Yorkers. To make their holdings more accessible, the families behind these institutions came together to create the New York Public Library in 1895. Also joining this new public library system was an organization called the New York Free Circulating Library, which had funded several no-cost reading rooms throughout the city. Additional backing from Andrew Carnegie helped build neighborhood branches of the New York Public Library, whose main branch, a Beaux-Arts masterpiece on the site of the no longer used Croton Reservoir on 42nd Street and Fifth Avenue, was unveiled in 1911.

It was not entirely accurate to complain, as one Australian visitor said in 1888, that "nothing could more strongly emphasize the general devotion of the citizens of

Before the Museum of Natural History had its own building on a plot of green space on Central Park West from 77th to 81st streets called Manhattan Square (seen here in 1905), the artifacts were displayed in the Central Park Arsenal from 1871, two years after the museum was founded, until 1877.

The Metropolitan Museum of Art opened in 1880. A new Fifth Avenue facade, designed by Richard Morris Hunt, was added in 1902.

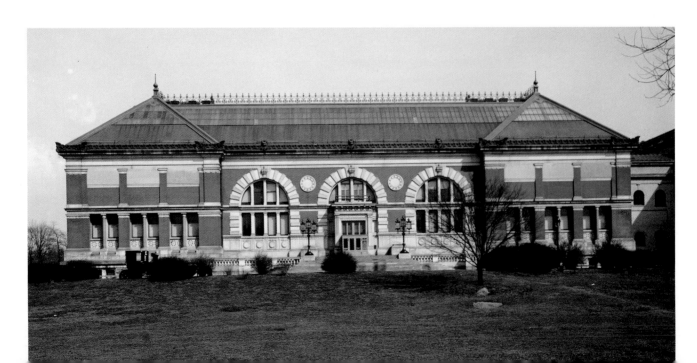

Nickelodeons in Every Neighborhood

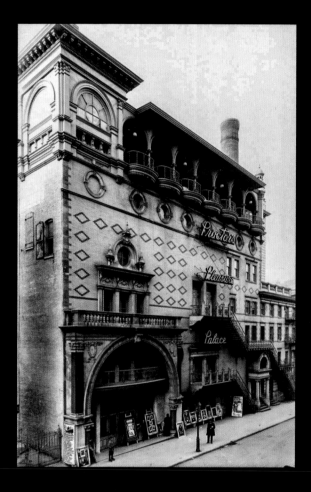

Vaudeville venue Proctor's Pleasure Palace on Lexington Avenue and 58th Street opened in 1895. Three years later, it was showing "motion pictures."

Since the first theater began showing short films on Edison's new Kinetoscope viewers in 1894, New York audiences have been enthralled by these "moving pictures." To capitalize on the trend, the Edison Manufacturing Company and the American Mutoscope and Biograph Company both began producing a variety of quick clips for working-class audiences: narrative features, comedies, and what were called "actualities." These films, which ran no more than a minute or two, captured real-life street scenes, news events, disaster spectacles, and other documentary-like moments.

The earliest actuality, *Herald Square*, appeared in 1896; it was a simple black-and-white clip that captured pedestrians, police, and mass transit in New York's newest shopping district. Both film companies began cranking out more over the next decade. *A Street Arab* in 1898; *Pilot Boats in the New York Harbor* in 1899; *New York in a Blizzard* in 1902; and *'Ghetto' Fish Market* in 1903 are silent movies composed of scenes and images that would be familiar to viewers at the time. Actualities were produced nearby: Edison built a studio on East 21st Street, and Biograph operated on the roof of 841 Broadway, at 13th Street, then in a house on 14th Street, before relocating to 175th Street in the Bronx.

By 1905, audiences could watch actualities and other clips in the new nickelodeon theaters. "Nickel madness" hit New York hard by 1906. Hundreds of these storefront theaters that charged five cents admission opened in middle- and working-class neighborhoods, with the highest number attracting audiences on Park Row and the Bowery. Viewers craved storylines with action and drama, and the actualities quickly fell out of favor. "New York's moving picture theaters are crowded with 250,000 people on weekdays and a million on Sundays, and a third of these are children," wrote the *New-York Tribune* in 1909. "No form of cheap theatre amusement has proved able to compete with moving pictures in the crowded districts, and the nickelodeon has become a neighborhood institution, and is more good than bad already, at that."

New York to the almighty dollar than the prevailing indifference to the literary and art treasures in their midst." While the museums and libraries were patronized by all classes, plenty of city residents did seem to prefer the less lofty allure of places like Barnum's American Museum. For twenty-five cents (the same price as a ticket to the Metropolitan Museum of Art), visitors could explore five floors of dioramas, live animal exhibits, live human exhibits (such as conjoined twins Chang and Eng, or the Fiji Mermaid), and a mind-boggling assortment of supposed historical and scientific oddities. P. T. Barnum ran the museum at Broadway and Ann Street from 1841 to 1865, when it was destroyed in a fire; he rebuilt and reopened for three years before a second fire in 1868.

No shortage of bawdy and bizarre institutions picked up where Barnum left off. The Eden Musée was a fabled wax museum on 23rd Street that also hosted vaudeville acts and installed two Kinetoscopes for viewing short moving pictures in 1894. Nickelodeons projecting short movies for a nickel a clip popped up after 1900 in

Opened in 1884, the Eden Musée, a house of grisly and gaudy amusements on 23rd Street, "is primarily a museum of wax groups," wrote Moses King in 1892 in *King's Handbook of New York City*, as well as a concert hall, variety house, and venue for notable celebrities, like Sitting Bull.

Union Square and Herald Square. New Yorkers in search of lowbrow fun flocked to Barnum's new circus and other circuses, fairs, and exhibitions. They also bought seats at Wild West shows, especially those featuring stars Annie Oakley and Buffalo Bill, who indulged audiences in a nostalgia for a mythical frontier culture.

A similar nostalgia show was staged in South Brooklyn's Ambrose Park in 1895. Instead of conjuring up the Wild West, it offered a romanticized version of an antebellum plantation, complete with five hundred "Southern colored people" hired to act out supposed scenes of daily life on a real one-acre cotton field. An ad for the show in the *Brooklyn Daily Eagle* promised that the cast would be "presenting home life, folk lore, pastimes of Dixie, more music, mirth, merriment for the masses." The show cost a quarter—but the price was reduced to five cents for those coming from Brooklyn.

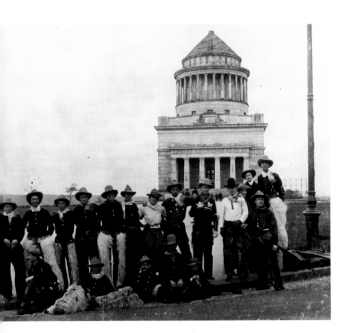

Wild West shows were traveling vaudeville acts that presented romanticized tales of America's western frontier. Buffalo Bill's Wild West show made regular visits to New York. When the show came in 1908, the cast took time out for sightseeing and posed at Grant's Tomb, at the time a must-see attraction in the city.

The City's Favorite Holidays

All the holidays are observed in New York with more or less heartiness," wrote James McCabe in 1872, "but those which claim especial attention are New Year's Day and Christmas." In colonial days, New Year's commanded the bigger celebration. But as the nineteenth century progressed and old Dutch traditions faded, December 25 supplanted January 1 as the most festive day.

McCabe revisited Christmas in New York a decade later. "Warm hearts beat under the warm clothing of the holiday makers," he wrote. "Broadway, from Bleecker Street to 34th, Sixth, Eighth, and Third Avenues almost along their entire length, 23rd, 14th, and Grand Streets, and the Bowery are all driving a thriving trade. . . . Huge piles of Christmas trees stand on the corners, and find ready purchasers, and wagons loaded with trees and evergreen decorations, wreaths, stars, festoons, and the like, pass along the uptown streets, disposing of their wares from house to house. The stores are all open and thronged with buyers. . . . Men, women, and children, loaded with merchandise, struggle along the packed sidewalks."

Christmas Eve in the East Side tenement district meant dealing with peddlers and vendors. "The ways are already lined with carts of special Christmas goods, such as toys, candies, Christmas tree ornaments, feathers, ribbons, jewelry, purses, fruit, and in a few wagons small Christmas greens such as holly and hemlock wreaths, crosses of fir, balsam, tamarack pine and sprigs of mistletoe," wrote Theodore Dreiser. "Meats are selling in some of the cheaper butcher shops for ten, fifteen, twenty cents a pound, picked chickens in barrels at fifteen and twenty. A four- or five-pound fish at fifteen cents a pound might make an excellent Christmas dinner for four, five, or six."

After tree-trimming on Christmas Eve, New Yorkers attended midnight or a morning church service. "Had a most satisfactory and delightful morning," wrote Maria Lydig Daly, wife of a judge, in her diary on Christmas Day 1865. "Went to 8 o'clock mass, saw the sun just rising above the buildings and park as I crossed Waverly Place, the sky as bright and clear as spring. I thought of the words of the old carol, 'Royal day that chasteth gloom.' And I went to St. Joseph's where the congregation was mostly poor people; I like to go to church with the poor, particularly on Christmas."

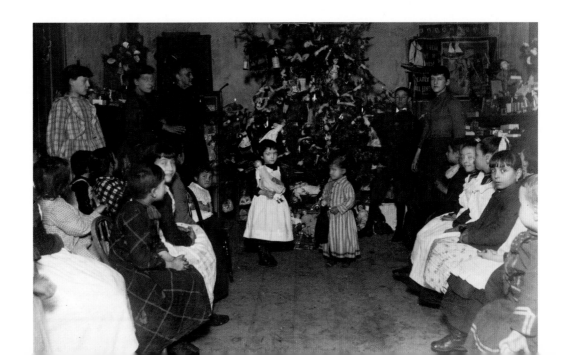

Jacob Riis took this photograph of a late 1890s Christmas in a tenement house in Gotham Court, one of the most decrepit alleys on New York's East Side. The tenement was run by a charity called the International Order of The King's Daughters and Sons.

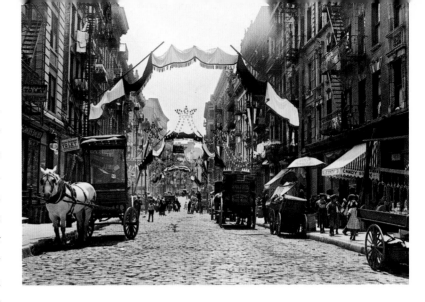

Christmas Day also involved the exchanging of presents. "This morning I got up very early and got my Christmas things," wrote fifteen-year-old Harlem resident Addison Allen in his diary in 1878. "I got a lot of candy, an orange and some figs and a nice large Magic Lantern, a book and a steam engine." A year later, Allen recorded his gift haul again: "Today is Christmas of 1879, and we have vacation from school from now till the fifth of January. Grace, Walt, and I got five dollars to do whatever we liked with for our Christmas. Mamie got quite a number of things. Mamma got from Walt a picture of him and from Papa a sealskin muff. We were all satisfied with our presents." For many New Yorkers, the rest of Christmas Day was reserved for visiting family or seeing a Broadway matinee.

Afterward, a great turkey dinner was standard, whether one lived in a Fifth Avenue mansion, a poor tenement, or one of the institutions that housed thousands of the poor, sick, and friendless. "[The poor] will not be forgotten on this morrow," wrote McCabe. "New York opens its great heart and its big pocketbook at this blessed time, and tomorrow huge tables will groan with good things, and tall Christmas trees stagger under the weight of toys and trinkets, for the children of the poor." Even prisoners were not forgotten. In an 1887 write-up of how the city heralded the holiday, the *New York Times* wrote that "at Ludlow-Street jail, where New-York tries to house all her criminal aristocracy, some forty-five gentlemen enjoyed turkey, stewed chicken, cranberry, and mince pies."

Christmas may have overshadowed New Year's Day by the late nineteenth century, but January 1 was still a day for the upper classes to enjoy New Year's "calling." All businesses were closed, carriages thronged the streets, and men paid social calls to the homes of family, friends, and female acquaintances, where they were "received" and treated to delicacies, wine, and punch. From 10:00 A.M. until 9:00 in the evening, doorbells rang, liquor was sipped, and New Year's greetings were exchanged. Ladies vied to secure the most callers, and young men pooled their lists together to visit as many young women's homes as possible.

"The Christmas festivities are scarcely over, when New York again puts on its holiday attire, and prepares to celebrate in hearty style its own peculiar day—the first day of the New Year," wrote McCabe in 1882. "Since the settlement of the colony of the Dutch, the first of January has been set apart by the dwellers in the metropolis for social observance, for renewing former friendships, strengthening old ones, and wishing each other health and happiness for the year just opening." Already a dwindling custom during the Gilded Age, by the turn of the century New Year's "calling" was on its last legs.

There were other days to mark with patriotism and parades, like Independence Day, when boys like Addison Allen ate ice cream and headed to Central Park to shoot off fireworks—though he notes in his diary that by 1879, they were "against the law to fire any." Decoration Day (later Memorial Day) meant military parades and marching bands. Evacuation Day—commemorated

Mott Street decorated for a religious feast in May 1908.

New York Invents the Christmas Tree

Considering that New York's patron saint is St. Nicholas, it's no surprise that the city is the birthplace of a host of contemporary Christmas traditions. Clement Clarke Moore's 1823 poem "A Visit from St. Nicholas" introduced the nation to a bearded man in a suit delivering a sackful of presents from a sleigh; *Harper's Weekly* cartoonist Thomas Nast in the 1860s put Santa Claus in a red suit and gave him a big belly, as well as a twinkling smile.

The city can also lay claim to the first Christmas tree market, at the Washington Market on the western end of Chambers Street. Here, an upstate farmer brought down a stack of fir and spruce trees to sell to city dwellers who, since the 1830s, had embraced the German tradition of a Christmas tree festooned with candles. He sold them for a dollar each—and quickly ran out of inventory.

That farmer's idea launched a tradition. "Every year now, at Christmas time, for two or three weeks, Vesey Place, from Greenwich to Washington Street, is occupied, by special permission, by the roughly constructed booths of the evergreen dealers," wrote the *New York Times* on December 23, 1876.

Another New York invention is electric tree lights. Candles affixed to Christmas tree branches were responsible for many fires every holiday season. So Edward H. Johnson, a partner in Thomas Edison's Illumination Company, put strands of red, white, and blue electric lights together and wrapped them around the tree in his family's home in 1882. Electric lights were safer and offered an enchanting glow. But they didn't catch on until 1895, when President Grover Cleveland decorated the White House Christmas tree with hundreds of multicolored electric bulbs.

As the curtain was falling on the Gilded Age, a new Christmas tradition was born in New York City—the public park Christmas tree lighting ceremony. In 1912, a 60-foot evergreen was trucked down from the Adirondacks to Madison Square Park, where it was propped up in a block of cement and decorated with 1,200 colored electric lights.

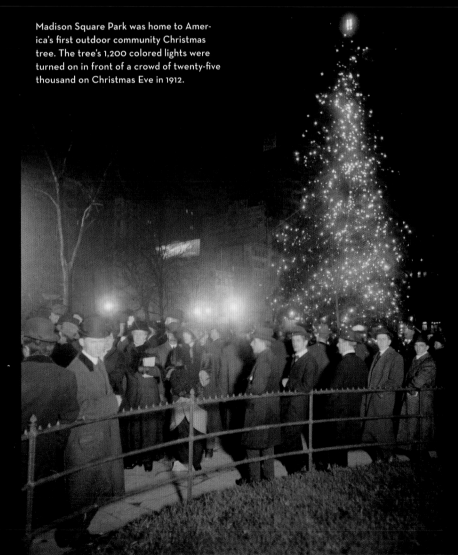

Madison Square Park was home to America's first outdoor community Christmas tree. The tree's 1,200 colored lights were turned on in front of a crowd of twenty-five thousand on Christmas Eve in 1912.

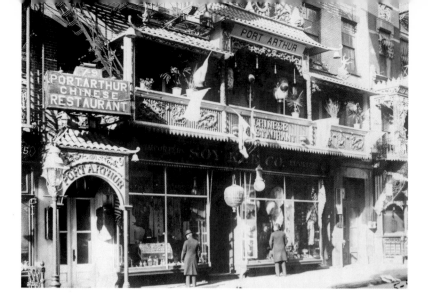

every November 25, the day the British left New York after the Revolutionary War ended in 1783—was celebrated less and less each year until 1883, the holiday's centennial year. Twenty thousand people participated in a four-hour parade that day. Hundreds of ships sailed through the Hudson and East Rivers, a fireworks display illuminated the sky, and restaurants like Delmonico's hosted banquets.

Thanksgiving, a national holiday only since 1863, had been celebrated at New York dinner tables for years with turkey (or pigeon, duck, or partridge) as the main course; dessert meant pumpkin or squash pie. Hotels and restaurants served lavish Thanksgiving dinners with many courses as well. Charities held Thanksgiving feasts for the poor, the sick, and the institutionalized. Easter was commemorated by dyeing eggs and turning out for a festive, joyful parade. After attending Easter Sunday services at one of the fashionable Fifth Avenue churches, residents would promenade up the avenue from Washington Square to Central Park, a loose procession anyone could join that was part fashion show,

part celebration of the holiday and the end of winter.

In the 1880s, a curious new holiday caught the attention of some New Yorkers, who began making yearly pilgrimages to Mott and Doyers streets to take in the colorful paper lanterns, flags, and lights of Chinese New Year. "Chinese flags and banners, intermingled with the Stars and Stripes, were seen waving from windows and stretched across the streets, which were densely packed with white people, who crowded the sidewalks and roadways, jostling against one another, but all good-humored," wrote the *New York Times* in 1896.

The Port Arthur Restaurant opened on Mott Street in 1897. As the first Chinese restaurant in the city to have a liquor license, it was a favorite spot for tourists looking to celebrate Chinese New Year.

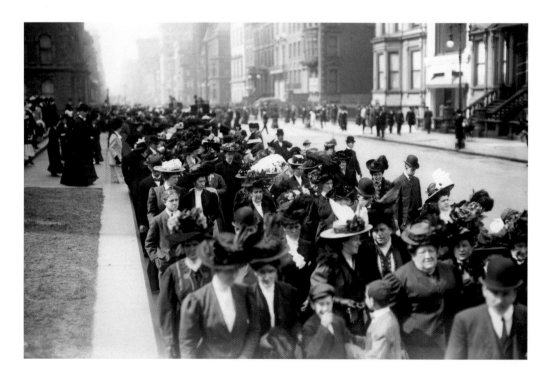

"It is a tradition in New York that on Easter Sunday the best-looking and best-dressed folks in town walk up the Fifth Avenue on their way home from church," wrote *Harper's Weekly* in 1905 (seen here in 1908). "The truth is that the tradition has pretty well wrecked the show. On Upper Fifth Avenue it is somewhat too dense now either for beauty or comfort."

Crime and Sin in the City

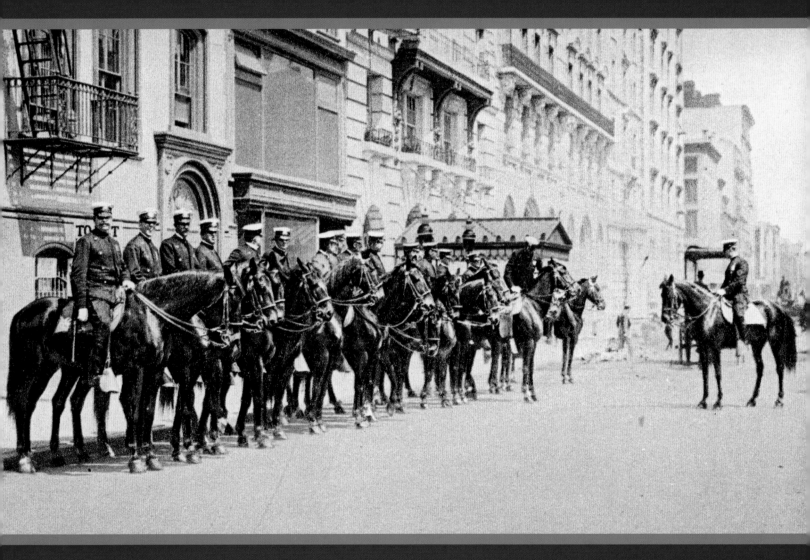

A bird's eye view of New York, approximately 1880–1890. By now, Manhattan Island is developed all the way up to Yorkville and into Harlem. Brooklyn's houses, streets, and church steeples stretch far into Kings County. The Queens waterfront is also ablaze with light and activity from factories and other buildings. Consolidation looms on the horizon.

Policing the Nineteenth-Century City

At half-past ten last evening, [Franklin Hughes] Delano, wending his way home from a dinner at John Astor's, was set upon and robbed by three men on the corner of Fifth Avenue and Eleventh Street," the lawyer George Templeton Strong wrote in his diary on January 25, 1870. "Of course there was no arrest. Crime was never so bold, so frequent, and so safe as it is this winter. We breathe an atmosphere of highway robbery, burglary, and murder. Few criminals are caught, and fewer punished."

Strong's disgust with rising crime and inattentive police would have resonated with Gilded Age New Yorkers, who inhabited a city in which the police department reflected deep-seated governmental corruption. The first recruits, part of a new force called the Municipal Police, hit the streets in 1845. These eight hundred men replaced a loose band of night watchmen, constables, and marshals. Known as "leatherheads" for the leather caps that protected them from falling bricks and thrown rocks as they patrolled the city, they were no longer able to guard a metropolis whose crime rate was burgeoning along with its prosperity and population (515,547 in 1850). The seventeen wards of Manhattan were divided into districts, each with a station house commanded by a captain and two sergeants. Modeled after the military-style London police, the Municipals were identified by their "MP" pin and eight-point-star copper badge, which reportedly led New Yorkers to nickname them "coppers."

Under the Democratic-led city of the 1850s, the department earned a reputation for misconduct and inefficiency. Rather than being hired based on ability, patrolmen were appointed to the force first by aldermen and then by the Board of Police Commissioners. Under this system, police jobs were prizes handed out in exchange for political favors or cash bribes. Some of the recruits were gang members; a patrolman position could be had for $40. Then there was the issue of uniforms. Many would-be cops refused to wear one, believing that it infringed on personal freedom, identified them to criminals, and made them look like servants. Street toughs

"The uniform of the force is a frock coat and pants of dark blue navy cloth, and a glazed cap," wrote James D. McCabe in 1872's *Lights and Shadows of New York Life*. "In the summer the dress is a sack and pants of dark blue navy flannel. The officers are distinguished by appropriate badges. Each member of the force is provided with a shield of a peculiar pattern, on which is his number."

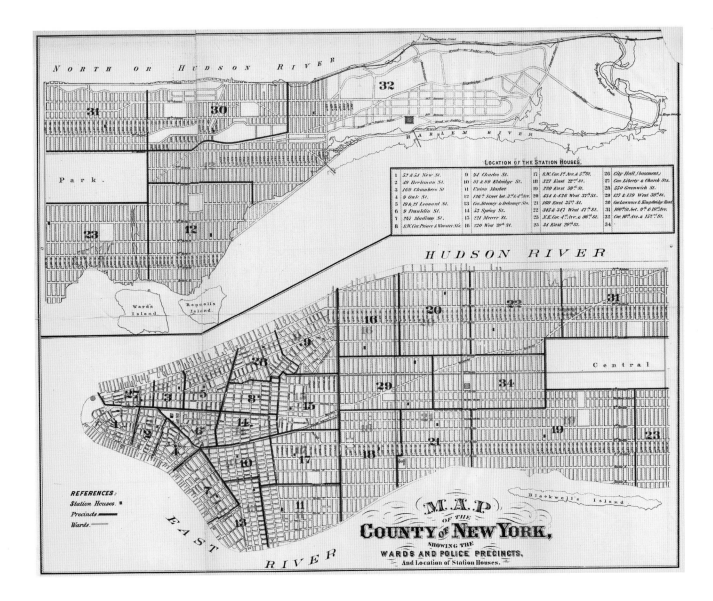

LOCATION OF THE STATION HOUSES.

1	52 & 54 New St.	9	94 Charles St.	17	S.W. Cor. 1st Ave. & 5th St.	26	City Hall (basement)
2	49 Beekman St.	10	81 & 89 Eldridge St.	18	327 East 22nd St.	27	Cor. Liberty & Church Sts.
3	160 Chambers St	11	Union Market	19	220 East 59th St.	28	550 Greenwich St.
4	9 Oak St.	12	126th Street bet. 3rd & 4th Av.	20	434 & 436 West 37th St.	29	137 & 139 West 30th St.
5	19 & 21 Leonard St.	13	Cor. Attorney & Delancey Sts.	21	160 East 35th St.	30	Cor. Lawrence & Kingsbridge Road
6	9 Franklin St.	14	53 Spring St.	22	345 & 347 West 47th St.	31	100th St. bet. 9th & 10th Ave.
7	247 Madison St.	15	221 Mercer St.	23	N.E. Cor. 4th Ave. & 86th St.	32	Cor. 10th Ave. & 152nd St.
8	S.W. Cor. Prince & Wooster Sts.	16	230 West 20th St.	25	34 East 29th St.	34	

REFERENCES:
Station Houses. ■
Precincts ▬▬▬
Wards. ▬▬▬

MAP OF THE COUNTY OF NEW YORK,
SHOWING THE
WARDS AND POLICE PRECINCTS,
And Location of Station Houses.

In the early years of the police department, precinct numbers were the same as ward numbers. A station house was built in the center of each precinct. As the city's population grew, new precincts were created and older ones abolished. The Hardy Map of Police Precincts shows the number of precincts and wards in 1871.

mocked officers in uniform by calling them "liveried lackeys." All of this internal dissent and corruption left New Yorkers with little confidence in the Common Council's decision to form a professional force in the first place.

"Strangers frequently doubt whether New York possesses a police; the doubt is justifiable, for these guardians of the public peace are seldom forthcoming when they are wanted," wrote essayist Isabella Bird in her 1854 travel book about visiting the United States, *The Englishwoman in America.* "They are accessible to bribes, and will investigate into crimes when liberally rewarded; but probably in no city in the civilised world is life so fearfully insecure. The practice of carrying concealed arms, in the shape of stilettos for attack, and swordsticks for defence, if illegal, is perfectly common; desperate reprobates, called 'Rowdies,' infest the lower part of the town; and terrible outrages and murderous assaults are matters of such nightly occurence as to be thought hardly worth notice."

In 1857, the Republican-controlled state government, eager to grab power from the city Democrats, abolished the Municipal Police and replaced them with the new

state-run Metropolitan Police, tasked with also patrolling Brooklyn, Staten Island, and Westchester (which included the Bronx at the time). Mayor Wood refused to disband the Municipals, and for a few months the city had two warring departments. This was great news for criminals, who would be arrested by one force and then released by the other. Station houses became battlegrounds. Some Municipals defected to the Metropolitans. Ethnic factions defined the two patrols. Immigrants, in particular the Irish—who composed 27 percent of the force in 1855—dominated the Municipals, while the Metropolitans, approximately three hundred men who were largely untested, were mostly American born.

The power struggle culminated in the bloody Police Riot of June 16, 1857. As Metropolitan captain (and future police chief) George Washington Walling attempted to serve the mayor an arrest warrant, Wood barricaded himself in his City Hall office with some Municipal patrolmen for protection. Men from the Metropolitan force then charged the building. The two groups, along with an assortment of pro-Municipals—"suckers, soaplocks, Irishmen, and plug-uglies," as George Templeton Strong called them—clubbed and pummeled each other on the building's front steps until the Seventh Regiment restored order. "Cartridge boxes and steel have a soothing effect on the pugnacious instincts of angry men," commented the *New York Times* on June 17. Disgusted with city officials, "upwards of 2,000 citizens of the highest respectability and social position have offered to enroll themselves into a special police" to protect the city's well-being and keep the peace, the *Times* reported. It's unlikely that Mayor Wood appreciated the offer, especially

George W. Walling

since respectable citizens weren't his typical constituents.

With the police in disarray, "the city had become greatly demoralized," wrote Augustine E. Costello in his 1885 book *Our Police Protectors*. "During the civil strife of the police, the repression of crime had been

George Washington Walling served as police chief from 1874 to 1885. His law enforcement career spanned the most tumultuous events in New York police history. As a Metropolitan Police captain, he was involved in the 1857 police riot; he was also a precinct captain during the Draft Riots in 1863, when patrolmen were cited for helping to quell some of the destruction and violence.

An 1875 portrait of the patrolmen who worked out of the 21st Precinct station house, on East 35th Street in what was then the Gashouse District. Thanks to the Gas House Gang, it was one of the city's most crime-ridden neighborhoods. Crime ruled inside the precinct house too: Alexander "Clubber" Williams earned a reputation here for brutality and corruption before being transferred to a station house in the Tenderloin.

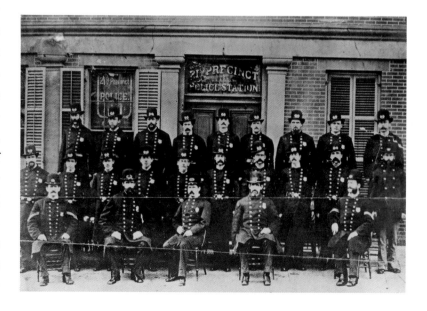

neglected. Gangs of rowdies had organized, whose purposes were disorder and plunder." The law enforcement vacuum led to the deadly two-day war between bitter rival gangs, the nativist Bowery Boys and the Irish immigrant Dead Rabbits. Fighting between the two gangs rocked Baxter Street on July 4 and 5, as the rest of New York was lighting fireworks to celebrate Independence Day. Armed with knives, paving stones, and pickaxes, about a thousand men brawled while random looters took advantage of the chaos. At least ten men were killed and dozens injured before the Seventh Regiment once again broke up the fighting. After the State Court of Appeals upheld New York State's right to create the Metropolitan police force, Mayor Wood reluctantly disbanded the Municipal Police.

Over the next decade, the 2,000 Metropolitan officers in Manhattan (and approximately 368 in Brooklyn) evolved into a more professional department. They were credited with helping to quell the 1863 Draft Riots; telegraphs linking every precinct house were used to inform sergeants where mobs were forming, so patrolmen could be sent quickly—which may have decreased casualties. The force "was being educated in the practical school of a Policeman, and the results were beginning to be felt and appreciated," wrote Costello. Policemen adopted an official uniform: a blue knee-length frock coat, blue trousers with a white stripe going down the side, and a navy blue cloth cap. In 1870, a new era for this nattily dressed force was on the horizon. That's when Boss Tweed and his Democratic cronies revised the city charter, taking back the police from state control and establishing the Police Department of the City of New York.

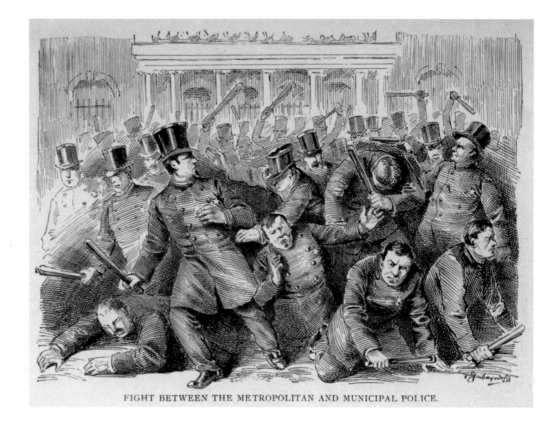

A sketch of the 1857 Police Riot, when the two warring city police departments battled on the steps of City Hall. The riot stemmed from the ongoing fight between Democratic Mayor Fernando Wood and the Republican state government for control over the city.

FIGHT BETWEEN THE METROPOLITAN AND MUNICIPAL POLICE.

THE NEW YORK METROPOLITAN POLICE.

A PICTORIAL ANALYSIS OF THE REPORT TO THE LEGISLATURE.

1. These gentlemen, finding the garroting business on the decline, resolve to become guardians of law and order, and enter the Metropolitan Police.

2. Policemen are but men, and when young and fascinating women happen to get into the police-stations, who can blame them if they are civil and gallant?

3. As to poor devils, houseless wretches, with no good looks, and steeped in poverty and misery, can a high-bred policeman be expected to cringe to such as these? No, no; let them eat the bread of sorrow.

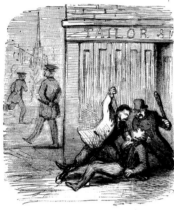

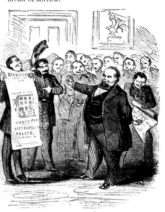

4. If a rowdy who votes with the Republicans happens to stick his knife into his neighbor's midriff, the judicious Metropolitan policeman instantly discovers a fight between two small boys at the next corner and hastens to interfere on behalf of law and order.

5. But if a poor wretch of a Democrat steals a loaf for his starving family, the zeal and fury of the Metropolitan police know no bounds, and the fellow is lucky if he be not brained on the spot.

6. A high-minded Commissioner scorns the idea of accepting a house bought by the members of the force; but somehow the house *is* bought, and the title-deeds are slipped into somebody's pocket without his knowledge and tremendously against his will.

7. The powers that be ask no favor; but when they want new clothes a friendly captain goes round with the hat, and as for the patrolman who declines to put in a quarter, he had better emigrate to California by the next steamer.

8. The consequence of which is, that the poor patrolman is unable to procure the food which his sick wife requires, and his children go without stockings and without new frocks.

9. The police service continues, however, to be admirably efficient, and quite a number of hack-carriages are actively employed on pressing police duty, as above depicted.

In an 1859 *Harper's Weekly* illustration, Thomas Nast skewers the Republican-backed Metropolitan Police as a politically motivated, comically corrupt force that looks away when the poor need help and criminals strike innocent victims—especially Democrats.

Reforming the Force

A tramp is arrested by a police officer in 1897. "New York is the paradise of tramps," wrote James D. McCabe in 1881. "They haunt the beer saloons and low class bar-rooms, beg for drinks, and will even drain the few drops left in the empty beer kegs on the sidewalks." Tramps began appearing on city streets in the 1870s, a consequence of rootlessness after the Civil War and the brutal recession of 1873.

The city was in charge of its police again, with the patrol district now limited to Manhattan and the towns of southern Westchester County that would eventually make up the Bronx. Yet with Tweed holding the reins, the department was riddled with patronage. Positions continued to be doled out to or bought by political loyalists. Officers accepted free beer sent to station houses by local saloons. Bribery swelled: to look the other way when multiple votes were cast at the ballot box on Election Day, to leave a brothel alone, to undo an arrest, and to ignore the 1866 state Excise Law, which mandated that taverns shut down on Sundays. Armed with wooden daysticks and much longer nightsticks—the thinking was that at night crime was more rampant, and police needed greater protection—cops were frequently accused of brutality. That was certainly the case during the Tompkins Square Park riot of January 1874, when police swung billy clubs at masses of unemployed workers. In turn, the police were often targeted and attacked by ruffians, leading many to begin carrying their own pistols.

When the police did make an arrest, it was usually for drunkenness, disorderly conduct, or assault and battery. But as New York grew, crime surged as well, terrifying law-abiding

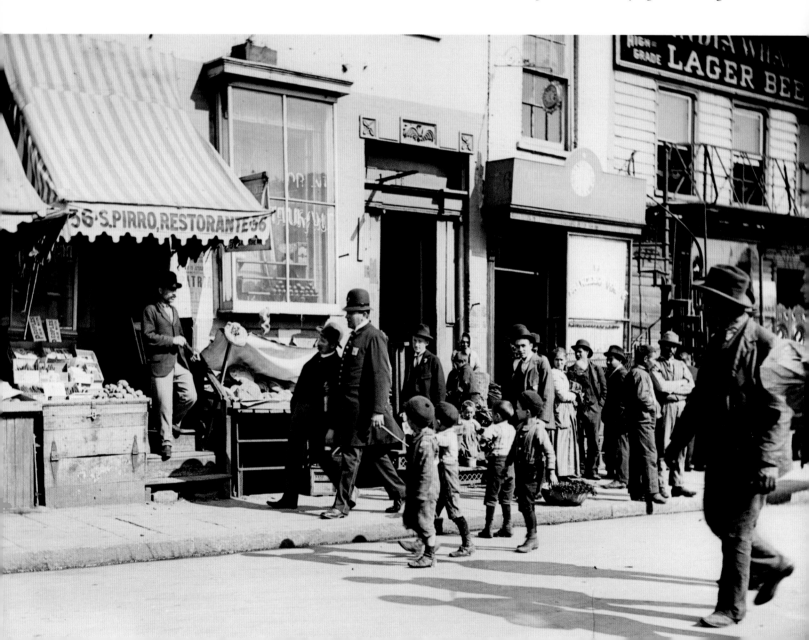

New Yorkers—thanks to the explosive coverage of robberies, bank heists, and assaults in the city dailies. Pickpocket gangs lifted wallets from purses and satchels on street cars and ferries, in saloons and cafés, and even in fancy shopping emporiums. Many pickpockets were teenage boys; others were mothers, fathers, and young kids who operated as a family. Pickpocketing was a pastime popular with newsboys, too. "A newsboy, when offering to sell a paper, and while holding it before his customer's face, will skillfully extract from the change pocket in his customer's overcoat all that may be there," wrote James D. McCabe in 1882. Meanwhile, confidence men hung around hotels and restaurants, where they would identify a mark, pretend that the two were acquainted, and then convince the mark to lend him money. "Strange as it may seem, this is one of the most successful tricks played in the city," wrote McCabe.

Sneak thieves robbed private houses. "The dinner hour, which in winter is after dark, is their favorite time for entering houses," explained McCabe. "They gain admittance by open doors or windows, or by false keys, and take anything within their reach." Roughs were known to "attend picnics and celebrations in the suburbs or on board steamers, and to break up the enjoyment of the occasion by beating and robbing the pleasure seekers," McCabe

stated. The promenades of Central Park, once considered a refuge for women who wanted to escape the leers of men on city streets, were no longer as safe as they had been when the park first opened. A writer for a British periodical in 1884 put it this way: "The Central Park, so called from being a magnificent expanse of wilderness in the centre of nothing, is ill-kept and ragged, and at night is unsafe for either sex."

Newspaper accounts of bank heists and violent assaults panicked upper-class New

Patrolmen carried a baton in their side pocket to defend themselves and subdue unruly suspects. Two types were used—a shorter daystick and a nightstick at least twenty-two inches long.

"Beauties of street-car travel in New York," reads the caption to this 1871 Harper's Weekly cover illustration. By the 1870s, pickpocketing had become endemic in the city; it was a crime committed by men and women equally.

In 1867, the police arrested 345 people for pickpocketing—a testament to either how good the criminals were or the ineffectiveness of the police force then. Frank Leslie's Illustrated Weekly covered the pickpocketing surge.

An Irresistible, Unwinnable Con Game

A swindler to lure players would place three cards on the table, usually two ordinary playing cards and then a third ornamental card, which the swindler would keep a sharp eye on.

Of all the human bloodsuckers which infest [Coney Island], none thrive better than the 'three-card monte men,'" wrote the *New York Times* in 1870. The game goes back centuries and has thrived in the metropolis at least since the 1850s, when men set up stands openly along City Hall Park and in front of gambling dens along the lower ends of Broadway and the Bowery—one of several cons that lured gamblers who should have known better.

It's a simple, irresistible game: A mark bets that he can guess which card or shell has money hidden under it. A shill under the guise of an innocent passerby pretends to help the mark cheat the dealer, who uses quick hand moves to prevent the mark from ever guessing the correct card. Swindlers were sometimes picked up by police and arraigned in court, but for the most part a player who lost money would be out of luck. "It is absolutely certain that anyone dueling with [three-card monte men] will be gulled and cheated, and their only safety is in giving the rascals a wide berth and thus deprive them of their business," the *Times* added.

Yorkers. At least they could afford to hire private watchmen. "Many of the millionaires in recent years have felt constrained to secure private protection for themselves, their family, and their property," wrote Moses King in his 1892 *King's Handbook of New York*. "Several well known men have stalwart body guards. . . . In Upper Fifth Avenue and vicinity there are some two-score watchmen thus employed by Gould, Sage, the Vanderbilts, the Rockefellers, the Astors, and others of their class. These watchmen are strong and brave men, several of them ex-policemen. They are well armed; and by night they practically constitute a subsidiary police force for that part of the town."

With so much attention paid to crime, the job of a policeman was trying. True, the position was considered a step up the ladder for men who could meet the new basic

Five Crimes of the Century That Captivated the City

1. THE ROBBER BARON SHOT TO DEATH INSIDE A POSH HOTEL

James Fisk was known in New York as an unscrupulous financier who triggered a stock market plunge in 1868 thanks to his scheme to manipulate the price of gold. But it was his love life that made headlines in 1872. Fisk's longtime mistress was actress Josie Mansfield, a voluptuous woman praised for her beauty and desirability. Mansfield eventually left Fisk for one of Fisk's business associates, Edward Stokes. Mansfield and Stokes then tried to blackmail Fisk by revealing details of his affair with Mansfield. In response, Fisk planned to have the new couple charged with extortion. That was too much for Stokes. Armed with a pistol, he stormed into the lobby of the posh and popular Broadway Central Hotel on the corner of 3rd Street and fired a fatal bullet into Fisk's stomach. Before Fisk succumbed to his wound, however, he identified his attacker to police. Stokes's first trial ended with a hung jury, but a second trial resulted in a guilty verdict, and Stokes went to prison for four years.

2. A CRIME OF PASSION IN LITTLE ITALY

After she arrived on Mott Street from Italy in 1892, Maria Barbella, twenty-four, found work as a seamstress and contributed her $8 weekly salary to help support her family. She also began seeing Domenico Cataldo, who operated a shoeshine booth on Canal Street. After Cataldo put knockout drops in her drink one night, she alleged, he took advantage of her—but subsequently refused to marry her. After months of taunts and beatings by Cataldo, Barbella slit his throat with a straight razor while he was playing cards on East 13th Street. Her 1895 trial was a media sensation, her story so well known that Macy's reportedly sold Maria Barbella dolls. Still, she was found guilty of murder and became the first woman sentenced to the electric chair in New York state. That notoriety earned her great support and sympathy from around the world, including in Italy. Granted a new trial in 1897, she was acquitted and disappeared from public life.

3. THE "SCATTERED DUTCHMAN" AND THE CITY TABLOIDS

The torso and arms were found first, on June 26, 1897, by boys playing on a pier off East 11th Street. The rest of the body came ashore along High Bridge and at the Brooklyn Navy Yard. Police were stumped but eventually identified the body parts as those of William Guldensuppe, a German masseur. A story finally emerged: Guldensuppe had been killed by a barber who was the lover of a woman Guldensuppe was also involved with, named Augusta Nack—who happened to be Guldensuppe's landlady on West 39th Street. The murder was grisly, but what made the investigation and subsequent trial so riveting was that reporters from city tabloids didn't just report the story. Rather than wait for the police, they actually investigated and helped solve the crime in a frantic race to scoop their competitors on Park Row. Both the barber, Martin Thorne and Nack were found guilty in December 1897. Thorne was electrocuted at Sing Sing, while Nack served ten years in prison.

4. THE ARCHITECT AND THE "RUINED" ARTIST'S MODEL

When former artist's model and *Floradora* chorus girl Evelyn Nesbit entered a Manhattan courtroom to testify at the 1907 murder trial of her husband, railroad scion Harry K. Thaw, lawyers, spectators, and members of the press listened with rapt attention. Thaw was being tried for the murder of Stanford White, the brilliant architect behind Madison Square Garden, the Arch at Washington Square, and other heralded city structures. Dressed as a schoolgirl and speaking in a quavering voice, Nesbit told her story. Six years earlier, when Nesbit was sixteen, White plied her with alcohol and then seduced her in his West 24th Street apartment. Thaw married Nesbit in 1905, but he couldn't let go of his rage at White for his transgression. On the balmy night of June 25, 1906, Thaw shot White to death on the roof of Madison Square Garden. The first trial resulted in a deadlocked jury, and the second ended with his commitment to a hospital for the insane. Stanford White wasn't there to defend himself, but Gilded Age New Yorkers had sympathy for Thaw, who was only defending his wife's virtue.

5. A CHORUS GIRL GETS AWAY WITH MURDER

Like Evelyn Nesbit, nineteen-year-old Nan Patterson was a *Floradora* girl, part of a spectacularly popular Broadway show that was the toast of the city's glamorous entertainment world. In 1902, Patterson met the wealthy forty-year-old gambler Caesar Young, and the two quickly began a passionate affair, even though they were both married to other people.

Young reportedly promised Patterson that he would divorce his wife, but he apparently waffled on his pledge. On the morning of June 4, 1904, Patterson and Young were taking a hansom cab to a Hudson River pier where

Nan Patterson

Young and his wife were to board a transatlantic ship for a European vacation. At West Broadway and Franklin Street, the cab driver heard a gunshot. Young lay dying in Patterson's lap, a bullet in his chest.

Patterson told police that Young shot himself because he was upset that she was leaving him. Investigators, however, determined that she had to have pulled the trigger: The bullet entered Young's body in such a way that he couldn't have done it by his own hand. Arrested for murder, she was held at the new Tombs, Manhattan's city prison, built in 1901 on the site of the old building, where crowds of supporters gathered under a new Bridge of Sighs and shouted "Free Nan!" The trial attracted a ton of media interest and resulted in two mistrials. Apparently, juries had a hard time believing that such a pretty young woman could commit murder.

Evelyn Nesbit was the former *Floradora* chorus girl at the center of the infamous Stanford White murder trial. Nesbit's husband, Harry Thaw, shot White at Madison Square Garden because he was furious that White allegedly seduced Nesbit before she married him.

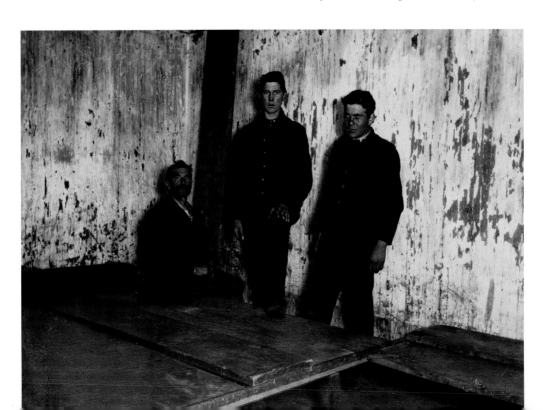

out of Grand Central Depot, or they were part of the Broadway Squad, a unit that recruited tall men (who were more visible on the street) to help control the flow of traffic on Lower Broadway, the most congested part of Manhattan.

The typical patrolman spent his week looking out for criminals, quelling riots, assisting pedestrians across streets, guiding lost children, arresting truants, breaking up domestic disputes, reporting broken street lamps, inspecting steam boilers (which had a tendency to blow up and cause great damage to life and property if not properly cared for), and rounding up rabid dogs. "They have abundant opportunities to do good, and when temptation the other way is not too strong, or nature too weak, they obey their better selves," wrote Junius Henri Browne in 1868 in *The Great Metropolis*. "Not infrequently they prove themselves heroes in guarding honesty and innocence, and have yielded their lives to protect the defenseless and succor the distressed."

Bad cops made headlines. Matthew T. Brennan, dubbed "the felon's friend" by the *New York Times* in December 1873, was one of several police commissioners arrested for aiding loyalists who plundered the city treasury. William "Big Bill" Devery, a Tam-

requirements: be a U.S. citizen, be in good health, live in the patrol district you want to serve, and not be over thirty-five years old. But the pay wasn't great and conditions could be brutal. A patrolman (the force in the 1870s consisted of about 2,400 men, which increased to approximately 4,000 in the 1890s) earned a starting salary of $1,200 per year. A number of men "on reserve" slept together at night in rows of single beds in the foul barracks of station houses, ready to go to the scene of a riot or gang fight at a moment's notice. A one-hundred-hour workweek was not uncommon. Some men were assigned to the Harbor Patrol Unit. Others worked

Like all station houses, the 27th Precinct's Church Street Station had a basement equipped with wooden benches where the city's homeless could bunk for the night. In 1870, newly arrived immigrant Jacob Riis spent the night in this very room; twenty years after that he returned to photograph it. Six years later when Theodore Roosevelt became police commissioner, he abolished these filthy makeshift lodging houses.

William "Big Bill" Devery's penchant for receiving payoffs is satirized by *Harper's Weekly* in 1902. Devery worked his way up from patrolman to the first Chief of Police after the consolidation of New York City in 1898. In a career the *New York Times* called "most picturesque and stormy," he was "indicted several times" and "faced charges of extortion, blackmail, and oppression," but was never convicted.

The squad receiving orders at the new police station in the Tenderloin district in 1908. The Tenderloin—illustriously called "Satan's Circus" by reformers—stretched west of Broadway to Eighth Avenue between 23rd and 42nd streets; its vice-ridden streets were packed with saloons, brothels, gambling dens, and music halls.

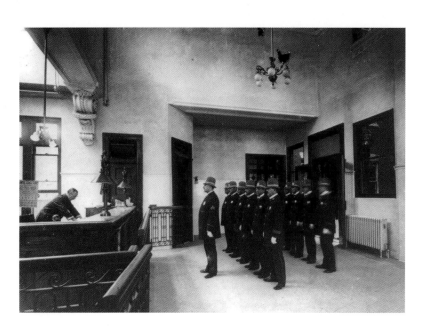

many district leader, started as a patrolman and moved up the ladder to Chief of Police in 1898. Between those years he worked out of the Eldridge Street station house and was tried and acquitted several times on corruption charges. "As chief of police, he is a disgrace, but as a character, he is a work of art," journalist Lincoln Steffens wrote of Devery. Alexander "Clubber" Williams was a precinct captain in the 1870s in the Gashouse district

whose aggressive tactics earned him a fierce reputation and then a transfer to the seedy district west of Union and Madison squares between 14th and 42nd streets. "I have had chuck for a long time, and now I'm going to eat tenderloin," he said when asked about his new position. The name "tenderloin" stuck for this neighborhood of vice, where Williams collected protection money from madames and casino owners.

No one doubted that Charles Becker, a gambling squad lieutenant working in the Tenderloin, was a cop on the make. He got his start on the force as a bouncer at Atlantic Garden on the Bowery, where he became friendly with Bowery saloon owner "Big Tim" Sullivan, the head of Tammany Hall for Manhattan's East Side. Becker paid Sullivan $250 to secure him a patrolman's job. By the 1890s, he was taking huge kickbacks to protect the owners of gambling dens and brothels. But when casino owner and mobster Herman "Beansy" Rosenthal was gunned down at the Hotel Metropole on 42nd Street in 1912, Becker was arrested for arranging the murder. After two trials and two guilty verdicts, Becker was electrocuted in a gruesome execution at Sing Sing. He was the first city cop to get the death penalty. That he was a brutal criminal was never in question. But Becker professed his innocence in the Rosenthal murder until the end.

Changes finally came to the police department after the Lexow Committee (see sidebar, page 212) addressed widespread charges of corruption in 1894. The next year under Mayor William Strong, Theodore Roosevelt, a progressive Republican, became president of the Police Board and one of the four city police commissioners. Roosevelt brought a reformer's zeal to the job and vowed to professionalize the force. He banned political

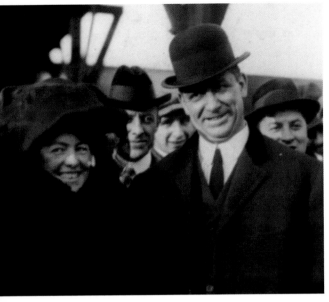

appointments, enforced disciplinary rules, rewarded good conduct and bravery, and adopted a civil-service model for hiring and promoting officers. He launched the first bicycle squad and had every officer carry the same department-purchased revolver (he also made sure they underwent professional training when it came to using it). He enjoyed checking up on the men who served him by going on midnight rambles to root out bad or lazy cops. Roosevelt took these nighttime excursions with his friend Jacob Riis or in the company of other police brass—often while he was still dressed in the suit he had put on for a fancy dinner earlier in the evening.

The *Evening World* reported on June 14, 1895, about a walk Roosevelt took after midnight with fellow police commissioner Avery D. Andrews. "In the Fifteenth Precinct [the East 30s] the Commissioners found patrolmen actually sleeping on their posts," detailed the *World*. In the Tenderloin, "the Commissioners found great laxity on the part of the patrolmen . . . Roosevelt determined to teach them a severe lesson by making charges against them, and appearing as complainant at their trials, to be presided

over by the other police commissioners. "I shall hereby hold the roundsmen responsible for the delinquencies of his men and upon a repetition of this neglect I shall hold not only the roundsmen but sergeants and captains responsible," stated Roosevelt, according to the *World*.

Roosevelt's time as the city's top cop only lasted two years. Though he couldn't permanently rid the force of its infrastructure of corruption, he is credited with setting a more honest tone for the twentieth century. Enforcing the Excise Law was an achievement he was especially proud of. He also ended the use of station houses as homeless

Charles Becker, a commander of the strong-arm squad and anti-vice unit that patrolled the Tenderloin (shown here with his wife) never denied that he was a corrupt cop. But he insisted that he did not order the 1912 death of a Tenderloin gangster. A jury didn't buy it, and he earned the distinction of being the first and only New York City police officer ever executed at Sing Sing.

Theodore Roosevelt took the job of police commissioner with an eye toward reorganizing and reforming the force. Determined to weed out lazy and corrupt cops, he personally approached patrolmen caught napping or drinking on the job in the wee hours of the morning.

Sworn in on May 6, 1895, as one of New York's four police commissioners, Theodore Roosevelt said in a speech a few months later, "I wish to make every honest and decent member of the force feel that he has in me a firm friend and that I shall wage a merciless war on corruption."

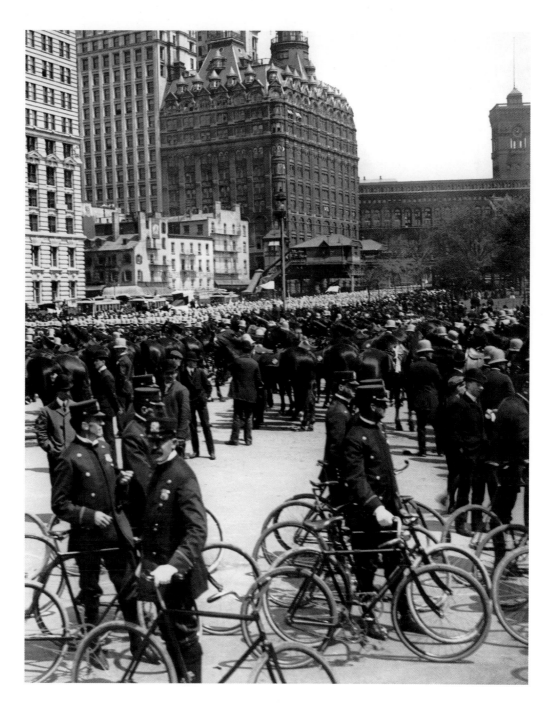

Commissioner Theodore Roosevelt launched the New York Police Department bicycle squad in 1895. That first year, the twenty-nine-man unit made 1,366 arrests.

shelters—"which were simply tramp lodging houses, and a fruitful encouragement to vagrancy," Roosevelt wrote—a practice dating back to the early days of the Municipals, when the city had no charity lodging houses for the poor. In his 1913 autobiography, he summed up his fight to clean up the department this way: "Every discredited politician, every sensational newspaper, and every timid fool who could be scared by clamor was against us. All three classes strove by every means in their power to show that in making the force honest we had impaired its efficiency; and by their utterances they tended to bring about the very condition of things against which they professed to protest. But we went steadily along the path we had marked out. The fight was hard, and there was plenty of worry and anxiety, but we won."

Charles Parkhurst and the Lexow Committee

On February 14, 1892, Charles Parkhurst had had enough. From his pulpit at the elite, Gothic-style Madison Square Presbyterian Church on East 24th Street, Reverend Parkhurst alleged in a fiery sermon that Tammany Hall and the police department had conspired to protect purveyors of crime and vice in the city—the brothels, the gambling halls, the saloons, the opium dens. He charged that they refused to enforce the excise laws or keep the city morally clean. "In its municipal life our city is thoroughly rotten. . . . Every step that we take looking to the moral betterment of this city has to be taken directly in the teeth of the damnable pack of administrative bloodhounds that are fattening themselves up on the ethical flesh and blood of our citizenship," thundered Parkhurst, who was also president of the Society for the Prevention of Crime. "While we fight inequity, they shield and patronize it."

His sermon made headlines the next day and caused a stir among ordinary citizens—as well as among the political establishment and police commissioners Parkhurst had blamed. Challenged to deliver proof that city government and the police were in cahoots, he had nothing to show; he'd based his sermon on news articles. Humiliated yet determined to prove his allegations, he decided to take his own tour of the metropolis's red-light districts looking for evidence. In the company of a private detective who acted as a guide, the minister set out on several nighttime trips to see the sleazy underworld of the city.

What he found repulsed him. In Chinatown, a father, mother, and small child smoked opium together. In a Cherry Street dive, little girls bought booze to take back to their fathers at home. The Golden Rule Social Club on Bleecker Street featured basement rooms containing men dressed as women. On East 27th Street, naked prostitutes played leapfrog with the detective. (That episode was the inspiration for a Tenderloin rhyme:

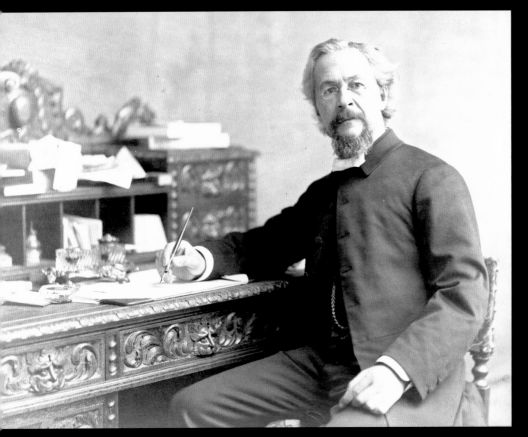

Charles Parkhurst, minister at Madison Square Presbyterian Church, worked to expose corruption in New York City's police department and the force's collusion with the city's Democratic political establishment. In a famous sermon in 1892, he said, "Any one who, with all the easily ascertainable facts in view, denies that drunkenness, gambling, and licentiousness in this town are municipally protected, is either a knave or an idiot."

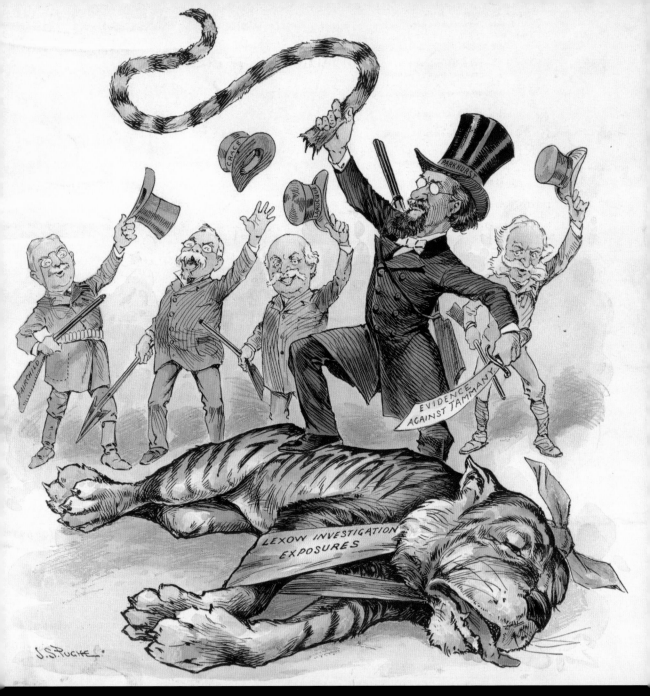

The cover of this 1894 issue of *Puck* magazine shows a triumphant Charles Parkhurst, who has slain the ferocious Tammany tiger with the help of the Lexow Committee, which found extensive corruption among Tammany officials and the police.

"Dr. Parkhurst on the floor/playing leapfrog with a whore.") A month after his sermon, he had enough documentation of open, unpoliced sex and sin that state senators began to investigate.

In 1894, the Lexow Committee, its name taken from the state senator who chaired it, included ten thousand papers linking the po-

fraud, and other illegal activity in the city's red-light districts, all for the purpose of keeping Tammany Hall in power. The details of the Lexow Committee were a national sensation; the committee concluded Parkhurst was right and recommended police department reforms.

With new mayor William

in command of the police department, reform began taking place. But not for long. In 1897, with Tammany leaders elected to the top rungs of city government once again, celebrations rang out in the Tenderloin. Crowds blew horns and shook rattles and happily shouted the refrain, "Well, well, reform has gone to hell!"

The Pioneering Detective
Work of Thomas Byrnes

Aside from Theodore Roosevelt, perhaps no one professionalized the police force and drove down crime rates more than detective turned superintendent of police Thomas Byrnes. "Byrnes was a 'big policeman,'" wrote Jacob Riis, who befriended Byrnes as a police reporter in the 1880s. "We shall not soon have another like him, and that may be both good and bad. He was unscrupulous, he was for Byrnes—he was a policeman, in short, with all the failings of the trade. But he made the detective service great. He chased the thieves to Europe, or gave them license to live in New York on condition that they did not rob there. He was a Czar, with all an autocrat's irresponsible powers, and he exercised them as he saw fit."

Born in Ireland in 1842, Byrnes became a patrolman in 1863, securing promotions and then gaining fame as the captain who cracked the infamous $3 million bank heist at the Manhattan Savings Institution in 1878. Yet it was after his 1880 appointment to inspector and head of the detective bureau—and then his tenure as superintendent from 1892 to 1895—that he really made his mark. Besides upping the number of detectives from twenty-eight to forty men, Byrnes greatly expanded the Rogues' Gallery, a data bank located at police headquarters at 300 Mulberry Street that catalogued criminals' arrest photos along with details of their histories and other information that could be used to identify a crook before or after he committed an offense. "[A suspect] can grow or shave

Thomas Byrnes started his police career as a patrolman in the pivotal year of 1863, the year of the Draft Riots. He ended it in 1895, when Teddy Roosevelt came in vowing to clean up the force. In the ensuing decades, he headed up the detective squad and ushered in crime-fighting tactics such as the Rogues' Gallery, the "third degree," and the "dead line"—all to great effectiveness. "He was a great actor," Jacob Riis wrote, and therefore an effective detective.

off a beard or mustache, he can change the color of either, he may become full faced or lantern jawed in time," Byrnes explained to a reporter. "But the skilled detective knows all this and looks for distinguishing marks peculiar to his subject."

Byrnes also coined the term "dead line," a boundary he placed on Fulton Street at the edge of the financial district. If a policeman spotted a known crook below this dead line, he could arrest the suspect immediately, even if the suspect hadn't been engaging in criminal activity. Byrnes's dead line probably wasn't legal. But in Gilded Age New York, when Wall Street banks and Maiden Lane jewelry stores were repeatedly and successfully targeted by thieves, no one raised a fuss. In fact, Byrnes's

An image from his 1886 book *Professional Criminals of America* shows Thomas Byrnes watching as police restrain a suspect in order to take his photo for the Rogues' Gallery.

Byrnes's *Professional Criminals of America* also reprinted the mug shots of male and female criminals contained in the Rogues' Gallery. Byrnes included written descriptions of each suspect as well as the crimes they had committed. Michael "Pugsley" Hurley, a member of the Patsy Conroy Gang, was arrested for masked burglary in 1874. Frank McCoy, aka Big Frank, held up a bank and a Brooklyn pawnbroker. Peter Ellis, known as Banjo Pete, was also a bank robber who "was formerly a minstrel, but drifted into crooked channels about 18 years ago," wrote Byrnes.

focus on protecting Wall Street won him praise (and rumored payouts, among other examples of graft he sank his hands in) from the city's bankers and titans of industry, who took no chances and also employed their own security guards.

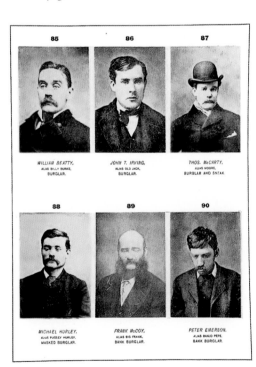

"Nearly all of the large mercantile and banking houses and manufacturers have [private watchmen] . . . ," wrote Moses King in 1892. "Maiden Lane, the headquarters of the jewelry trade, is guarded at night by a regularly organized company of watchmen. . . . The district is patrolled throughout the night, and every store is entered and inspected several times between dark and daylight." Byrnes also established a separate detective bureau nearby on Wall Street, staffed with his top men. "The result of this system is that professional thievery has been almost entirely driven out" of the financial district, stated King. It also made Byrnes very popular among new rich and the members of Mrs. Astor's Four Hundred, who quietly sought his help in dealing with blackmailers as well as with the thieves who made off with jewelry and other goods from their mansions.

In addition, Byrnes pioneered an interrogation tactic he called "the third degree" to pressure suspects into coming clean: The

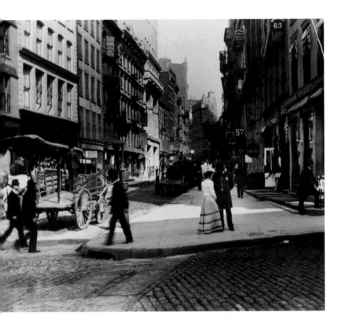

crime, along with names and mug shots of those who had committed them. The schemes and strategies of bank robbers, forgers, sneak thieves (burglars who didn't use violence), safecrackers, shoplifters, pickpockets, and con men and women were laid out in detail. Byrnes reportedly knew personally every criminal who operated in New York City.

Byrnes left the force in 1895, pushed into retirement by Theodore Roosevelt, who was about to become president of the Police Board. Roosevelt felt that Byrnes's suspiciously close associations with Wall Street didn't fit his new ethical guidelines. "He made life in a mean street picturesque while he was there, and for that something is due him," wrote Riis. "He was the very opposite of Roosevelt—quite without moral purpose or the comprehension of it, yet with a streak of kindness in him that sometimes put preaching to shame. Mulberry Street swears by him today, even as it does, under its breath, by Roosevelt. Decide from that for yourself whether his presence there was for the good or the bad."

first degree meant questioning, the second intimidation, and the third physical pain. "Take, for instance, the case of [Mike] McGloin, the Bowery tough, a lad of eighteen, who was accused of the murder of Michel Hannier, an old Frenchman," stated the *New York Times* on September 21, 1902. "Failing to secure a confession by ordinary means, Superintendent Byrnes is said to have had the prisoner placed in a cell from which a view of the courtyard could be had. At midnight, the lad was suddenly aroused. Before him in the brilliant moonlight that flooded the yard stood what seemed to him to be the ghost of his victim, but which in reality was a cleverly disguised detective. The boy shrieked in terror, confessed to everything, and was hanged in due course."

His other innovation was the Mulberry Street Morning Parade. Each day, Byrnes would release recently arrested suspects from their holding cells and march them past his detective squad. Ideally, the squad members would recall the suspects having committed other crimes. Furthermore, Byrnes's 1886 book, *Professional Criminals of America*, contained a rundown of every kind of street

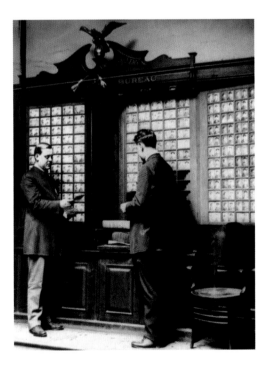

The Rise of Criminal Gangs

The first organized street gang, the Forty Thieves, began stealing and fencing goods in seedy Five Points in 1826. Edward Coleman started the gang in the back room of a groggery disguised as a vegetable stand on Centre Street. Coleman (who would earn distinction as the first man hanged in the New York City Halls of Justice, nicknamed the Tombs—in 1839, for killing his wife) ran it on a quota system: Members had to steal a certain number of items or they were kicked out. The Forty Thieves consisted mostly of young Irish immigrant men and a small number of African Americans with few prospects, who joined the gang to secure a better social status within their own community in a city that despised them.

Similar gangs of young adult men formed in and around Five Points in the first half of the nineteenth century, among them the Kerryonians, Chichesters, Patsy Conroys, Shirt Tails, and Roach Guards. (It's generally believed that the Roach Guards later became the gang known as the Dead Rabbits; "rabbit" was slang for a tough guy, and "dead" referred to "best.") They decked themselves out in distinctive colors and clothes. The Shirt Tails

wore their shirts untucked, the Plug Uglies pulled their giant hats down to their ears like helmets, and the Dead Rabbits made red stripes their official color. Gang members staked out turf, extorted local businesses, and stole merchandise. Some, like the Bowery Boys, forged alliances with Tammany Hall. They used clubs, brickbats, and hobnail boots to battle one another as well as Nativist gangs such as the True Blue Americans and the American Guard. The latter were working-poor, American-born men who dressed as dandies but fought like savages.

In the years following the Civil War, these gangs, loosely organized and serving in part as social clubs similar to volunteer fire-houses, evolved into larger, more sophisticated organizations extending past neighborhood boundaries. Like the legitimate businesses of the postwar boom years, the gangs were aggressively focused on making money. They extorted cash from saloons and stores, robbed banks, and ran gambling, counterfeiting, and prostitution rings. The Whyos dominated from the 1860s to the 1890s, rising from the ashes of older Five Points gangs. "A bad lot of them live in Pell Street, and they

Gang members stand menacingly and suspicious residents watch out their windows in Bandit's Roost, a back alley on Mulberry Street that was known for its criminals and poverty. Jacob Riis took this photo in 1888 and included it in *How the Other Half Lives*: "Here, in this tenement, No. 59 ½, next to Bandit's Roost, fourteen persons died that year, and eleven of them were children," he wrote.

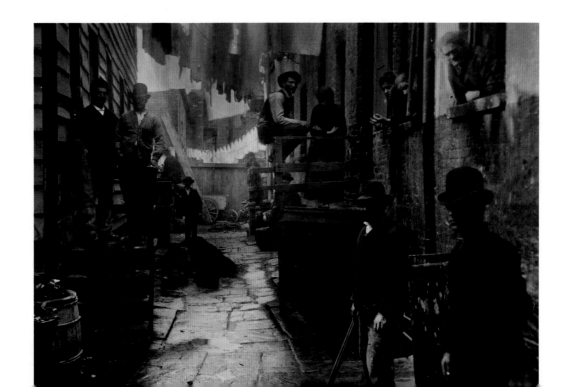

have a fondness for dropping bricks from the roofs on policemen," stated the *Sun* on September 15, 1884. One Whyo, Piker Ryan, reportedly carried a list of gruesome acts he would commit for the right price: a punch in the face cost $2; "doing the big job," $100. Gang members "lived off crooked politics, receiving money for voting a score and more times and for using strong-arm methods to keep decent citizens from voting," wrote Herbert Asbury in a July 20, 1919, *Sun* article. In 1928, Asbury would publish his book *Gangs of New York*, a history of the city's gangs. "They would do any sort of criminal job for hire. Murder was cheap and maiming was cheaper."

Dozens of Gilded Age gangs expanded all over New York. The Gophers terrorized Hell's Kitchen, looting the New York Central Rail Yards on the West Side. They battled the Hudson Dusters, who congregated on the Lower West Side. The Hell's Kitchen Gang and Charlton Street Gang were river pirates. "For many years the members of this ruffianly horde had preyed upon the shipping in both the North and East Rivers, along the Staten Island, Brooklyn, and New Jersey shores, and Hoboken as well," wrote George Washington Walling in his 1887 book *Recollections of a New York Chief of Police*. "'Dead men tell no tales' was their motto, and many a poor seafaring

wanderer has been foully murdered by them, within sight of the home from which he had been so long absent, for daring to defend his property."

River pirates were some of the most daring and successful criminals in the city, targeting mainly sailing vessels docked at the Hudson and East rivers on foggy, stormy nights, on the lookout for harbor police and private watchmen, wrote James D. McCabe in 1882. "They operate in gangs of three or four, each of which has a large, swift rowboat, equipped with bags and tarpulins," explained McCabe. "They row silently and with muffled oars along the wharves, darting under the piers occasionally to escape observation, until they reach the vessel, or vessels, they have marked during the day for robbery. . . . Approaching the vessel silently, they clamber on board by means of her chains, or by a rope left hanging over the side. Moving cautiously about her decks, they secure whatever they can lay their hands on, fill their bags, and lower them into the boat. . . . If pressed too hard by the police boat, in their efforts to get away, they at once open fire upon it, and sharp skirmishes often occur between officers of the law and the thieves."

Some gangs launched junior divisions for younger boys. The Forty Thieves created a subset called the "Forty Little Thieves" for kids who could act as lookouts and pickpockets. Entirely new gangs of adolescent "hoodlums," as they were called, also appeared. The Daybreak Boys were juvenile

A typical Bowery Boy, in his signature top hat. The Bowery Boys battled their rivals the Dead Rabbits in 1857 during a deadly two-day gang fight on Bayard Street in Five Points.

A member of the Dead Rabbit Gang; "rabbit" was slang for "tough guy," and "dead" meant "the best."

Bottle Alley off of Baxter Street was the headquarters of the Whyo Gang, a powerful criminal organization in the post-Civil War city that grew out of the earlier Five Points street gangs. Jacob Riis wrote in *Battle with the Slum* in 1902: "In 15 years I never knew a week to pass without a murder there, rarely a Sunday. It was the wickedest, as it was the foulest, spot in all the city. . . . The old houses fairly reeked with outrage and violence."

Born Paolo Vaccarelli in Sicily in 1876, Paul Kelly was a former boxer turned gang leader in what remained of Five Points. A sophisticated dandy, Kelly was one of the first "celebrity" gangsters, and he recruited men who would later become feared gangsters in the early twentieth century, such as Al Capone.

river pirates who were supposedly responsible for at least thirty murders. The Baxter Street Dudes was a collection of newsboys and bootblacks led by a kid named Baby-Face Willie and headquartered in the basement of a dive bar. Women and girls even joined all-male gangs in some cases. Hell-Cat Maggie was a fearsome fighter who participated in many Five Point rumbles and who filed her teeth into saber-like points. Sadie the Goat, part of the Charlton Street Gang in the 1860s, robbed her victims by head-butting them in the stomach first. The Gophers even formed an all-female offshoot called the Lady Gophers, headed by Battle Annie, known as the "Queen of Hell's Kitchen" after the turn of the century.

The police had some success over the years in tamping down on gang activity. But it wasn't until the 1890s, under police chief Thomas Byrnes, that the Whyos and other large-scale operations dissipated in the city. Many gangs fell apart on their own, replaced by criminal outfits that reflected changes in immigration in the 1880s and 1890s. Edward "Monk" Eastman, a Jewish former pet-shop owner, ran the Eastman Gang of two thousand men on the east side of the Bowery. His main rival was Italian-born Paul Kelly, leader of the Five Points Gang, which ruled the west side of the Bowery. Kelly was a small, dapper ex-boxer who operated his growing crime syndicate from the New Brighton

Athletic Club, a stable turned sporting club and café on Great Jones Street. There, Kelly and his goons could host bareknuckle boxing matches and engineer the election wins that would put grateful politicians in their pocket, without police interference. Both gangs were allied with Tammany Hall and battled over neutral territory. Meanwhile, just to the west, brutal Chinese gangs, or *tongs*, the On Leongs and Hip Sings, fought for control of Chinatown's underworld. They organized sophisticated operations that controlled the opium trade, gambling dens, and political patronage.

Organized crime plagued nineteenth-century New York, but it was also romanticized. By the end of the 1890s, the mythology began ebbing. "[The gangster] can dance with the prettiest blonde in the dance halls. He can obtain credit at the saloons, and he is known to thousands as he walks along Allen, Rivington, Hester and Stanton Streets," wrote the *New York Press* on September 27, 1903. "He may organize a gang of his own. His henchmen will steal for him and report the proceeds of a day's work as faithfully as if they were accounting for the returns from a legitimate business. He can 'control' votes for Election Day and become a political power. . . . Only the most imaginative person could surround such a character with the halo of romance. Sordid, unmagnetic, every act the result of cold-blooded calculation, one's pulse is not quickened upon hearing of the thug's exploits. Chivalry he has none. Of bulldog grit when it comes to saving his own skin and evading the penalty of his own misdeeds he has enough and to spare."

Arriving to take the place of Eastman and Kelly in the 1910s and beyond were more and bigger crime bosses who ran more sophisticated syndicates that went beyond East Side territorial wars.

The Queens of the Underworld

ELLEN CLEGG,
ALIAS ELLEN LEE,
SHOP LIFTER AND PICKPOCKET.

MARY HOLLBROOK,
ALIAS MOLLY HOEY,
PICKPOCKET.

MARGRET BROWN,
ALIAS OLD MOTHER HUBBARD,
PICKPOCKET AND SATCHEL WORKER.

CHRISTENE MAYER,
ALIAS KID GLOVE ROSEY,
SHOP LIFTER

LENA KLEINSCHMIDT,
ALIAS RICE—BLACK LENA,
SHOP LIFTER.

MARY CONNELLY,
ALIAS IRVING,
PICKPOCKET AND SHOP LIFTER.

Margaret Brown (#117), also known as Old Mother Hubbard, was added to the Rogues' Gallery in 1883, when she was fifty-five years old. Byrnes wrote that Brown "makes a specialty of opening hand-bags, removing the pocket-book, and closing them again." Brown was caught shoplifting from Macy's on 14th Street and did a stint in the penitentiary on Blackwell's Island.

Out of the approximately one thousand photos in the Rogues' Gallery at police headquarters at 300 Mulberry Street, "there are but 73 portraits of females," wrote James D. McCabe in 1873. They made up just a fraction of New York's known and wanted criminals. But these women (as well as the lady thieves whose images weren't filed away on Mulberry) were a colorful and dangerous lot of pickpockets, shoplifters, robbers, and fences.

Prussian immigrant Marm "Mother" Mandelbuam pilfered millions in stolen goods from the 1860s to the 1880s, operating out of a Clinton Street dry-goods store that was a cover for the web of con men and pickpockets she controlled. Sophie Levy Lyons was known as "Queen of the Underworld" for her talent for shoplift-

ing and blackmail. Old Mother Hubbard came to New York from Ireland and embarked on a fifty-year career as a pickpocket and shoplifter. Both Lyons and Mother Hubbard made it into police chief Thomas Byrnes's book, *Professional Criminals of America*.

So did Annie Reilly, an Irish immigrant Byrnes called "the Cleverest Woman in her line in America." Reilly would secure work as a children's nurse in the homes of wealthy families, then make off with jewelry and other items. Reilly "gains the good-will of the lady of the house," explained Byrnes, then a few days later would take off with valuables amounting to four or five thousand dollars. Bertha Heyman was a well-known "confidence woman" who tricked men into lending her money, then disappeared. "This woman is considered

by the police the boldest and most expert of the many female adventuresses who infest the country," wrote the *New York Times* in 1883, upon her arrest yet again.

"Women do not often succeed in effecting large robberies, but the total of their stealings makes up a large sum each year," wrote McCabe. "They are not as liable to suspicion as men, and most persons hesitate before accusing a woman of theft. Yet, if successful, the woman's chances of escaping arrest and punishment are better than those of a man."

Another type of female swindler operated quite successfully in the Gilded Age, when clairvoyants, mediums, and psychic healers held sway over the popular culture. These "sharpers" typically hung out a shingle and passed themselves off as fortune-tellers.

Police Courts, Prisons, and "Halls of Justice"

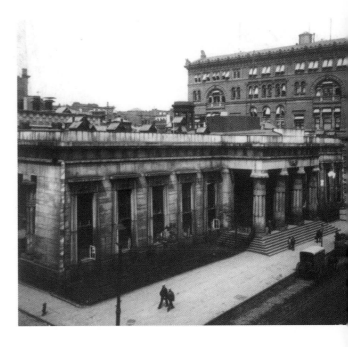

"What is this dismal-fronted pile of bastard Egyptian, like an enchanter's palace in a melodrama?" asked Charles Dickens in his book *American Notes*, which chronicles his trip to America in 1842. Dickens had come across the four-year-old New York Halls of Justice, colloquially known as "the Tombs." The building, on the marshy, filled-in site of the old Collect Pond, got the nickname thanks to its "gloomy and funereal appearance and associations," wrote Moses King in 1892, adding that "it is deplorable that its really noble proportions are dwarfed by its

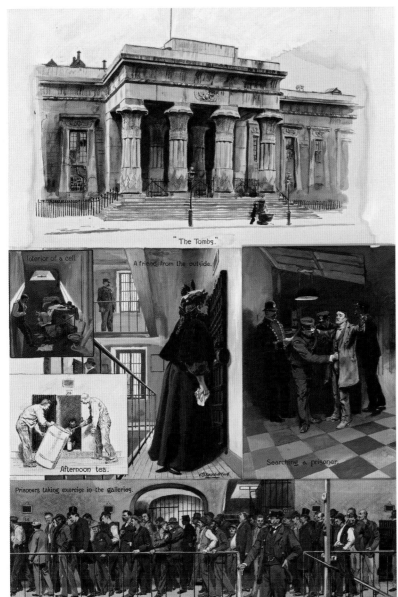

"The Tombs."

Interior of a cell.

A friend from the outside.

Afternoon tea.

Searching a prisoner.

Prisoners taking exercise in the galleries.

location in a low hollow." This hulking, Egyptian-style granite building on Centre Street at the edge of Five Points housed one of the city's six police courts and a principal jail during the Gilded Age. Connecting the two was a footbridge known as "the Bridge of Sighs," because men condemned to the gallows crossed it on their way to an interior courtyard, where they were hanged out of view of the public.

The Tombs wasn't the first stop for a man or woman suspected of committing a crime in late nineteenth-century New York. First, a suspect would be taken to a station house. If the offense was minor—drunkenness, for example, or petty thievery—he or she could pay a fine (or perhaps a bribe) and be released. If the crime was more severe, he or she was transported to one of six police courts. Besides the court at the Tombs, the

Handing Down the Death Sentence

New Amsterdam's earliest executions took place in public. Men and women were hanged, shot, or burned at the stake for murder, arson, sodomy, or kidnapping, often in front of a huge audience at various makeshift spots in Manhattan—among them at the potter's field that would later become Washington Square, on an island in Collect Pond, and in a field near Peter Stuyvesant's Bouwerie.

By the 1830s, public execution was considered cruel, an event that aroused a sense of brutality in New Yorkers that more refined residents didn't approve of. As a result, an 1835 law mandated that hangings, now the preferred method, be done in private. After hanging condemned men on the grounds of Bellevue Hospital and then on Blackwell's Island, the city decided to build a gallows in the courtyard of the new Halls of Justice—known by city residents as the Tombs. This dreary, faux-Egyptian building opened in 1838, contained a small yard hidden between a courthouse and city prison. When a prisoner's execution date arrived, officials set up the gallows, took the condemned to the yard over a footbridge known as the Bridge of Sighs, then meted out the punishment.

The first person executed there was Edward Coleman, founder of the Forty Thieves Gang; the Five Points resident had brutally beaten his wife to death after suspecting her of infidelity. The last man to go to the gallows in the Tombs was Henry Carlson, in 1888, convicted of killing a policeman. The death penalty wasn't abolished; hanging was simply replaced in 1890 by something new—the electric chair—and executions from then on were administered by the state. The infamous gallows at the Tombs, the site of at least fifty executions, often several at one time, were never used again.

In Brooklyn, the Raymond Street Jail, opened in Fort Greene in 1836, was the site of nine state-sanctioned hangings, the last one in December 1889. Tailor John Greenwell, a thirty-year-old German immigrant with a long rap sheet and an Anglicized name, was led to the gibbet early in the morning to hang for the murder of a milliner during a botched robbery of his DeKalb Avenue home.

A new "Bridge of Sighs," seen here in 1905, connects the new Tombs, built three years earlier, with the Manhattan Criminal Courts Building. The new building looked nothing like the Egyptian-style mausoleum it replaced, but the nickname stuck.

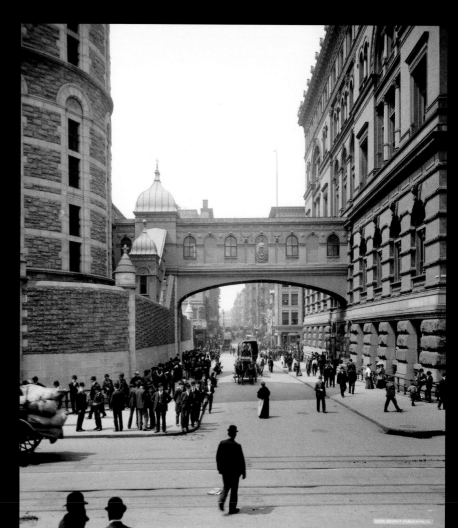

Jefferson Market Courthouse, on Sixth Av-
enue and 10th Street, and the Essex Market
Courthouse, on Essex Street, were also way
stations for assailants, drunkards, vagrants,
and thieves. Jefferson Market, co-designed
by Central Park landscape architect Calvert
Vaux, also contained what King called "a
minor city jail."

Mark Twain described a night he spent
in a station house in an 1867 letter to the
California newspaper that employed him as
a traveling correspondent:

> *I was on my way home with a friend
> a week ago—it was about midnight—
> when we came upon two men who were
> fighting. We interfered like a couple of
> idiots, and tried to separate them, and a
> brace of policemen came up and took us
> all off to the Station House. We offered
> the officers two or three prices to let us go
> (policemen generally charge $5 in assault
> and battery cases, and $25 for murder in*
> *the first degree, I believe) but there were
> too many witnesses present, and they
> actually refused. They put us in separate
> cells, and I enjoyed the thing consider-
> ably for an hour or so, looking through
> the bars at the dilapidated old hags, and
> battered and ragged bummers, sorrow-
> ing and swearing in the stone-paved*

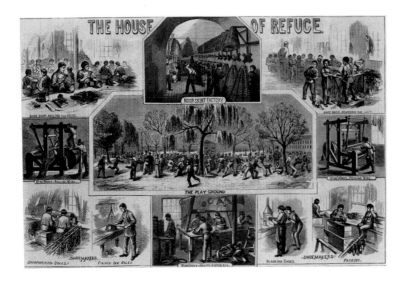

THE HOUSE OF REFUGE.

Located on Randall's Island in the East River, the House of Refuge was a coed reformatory for children convicted of crimes. "Inmates" as they were called, were housed in dormitory-like rooms, given work assignments, and taught a trade, like shoemaking or printing.

halls, but it got rather tiresome after a while. . . . We sat on wooden benches in a lock-up partitioned off from the Court Room, for four hours, awaiting judgment—not awaiting trial, because they don't try people there, but only just take a percentage of their cash, and let them go without further ceremony.

Twain was released that morning. But if he had been convicted, he might have been sentenced to a short stint at the city's penitentiary or workhouse, both on Blackwell's Island. Of the penitentiary, King wrote, "Persons convicted of misdemeanors are confined here, and the number of prisoners averages 1,000 a day." The workhouse, however, "is intended to be an institution for the punishment for the large class of petty criminals, always abounding in large cities," explained King. "Most of the 22,000 inmates committed to the institution belong to the class known as 'drunks.'" At these granite and stone institutions, thousands of convicts, men and women, lived in cells and labored indoors or outside, cutting stone, doing masonry, sewing, or cleaning.

Child criminals were placed in the House of Refuge, established on Randall's Island in 1854. With the welfare of children a top priority of the charity-minded Gilded Age, this institution was designed to reform the boys and girls who ended up there. That involved being put to work to learn a skill, as twelve-year-old Naomi R. King saw when she visited the House of Refuge with her family on a trip to New York City in 1899. In the laundry department, "here we saw the boys themselves barefooted at work on the huge iron rollers run by steam," she wrote in her travel diary. "The boys had a sturdy and stolid look in their faces. Some were even sullen as if they didn't relish bystanders gazing at them. We went up to the knitting room. Here we saw boys at work so fast and furious over their knitting machines. . . . We didn't go to the girls' department or the other manufactures in the building. We passed however a large hall of locked cells which the larger boys sleep. They lock them up to prevent making their escape."

Federal criminals served their sentences at the Ludlow Street Jail, a "gloomy-looking brick edifice," as James D. McCabe called it. Boss Tweed was sent here, but luckily for him, prisoners with money could pay to be housed in a superior cell and eat better food than poorer prisoners. The Tombs, too, had a

class system within its walls. "Over the Centre Street entrance are six comfortable cells, for the use of prisoners who can afford to pay for them," wrote McCabe in 1882. "The windows of these cells look out upon the street, so that the inmates are not entirely separated from the world around them. Forgers, defaulters, and criminals who have moved in the higher walks of life, are the occupants of these cells."

Though it was mainly a prison where the accused waited until they were tried, some convicted criminals served time in the Tombs as well. Each of its four floors housed a different type of offender, wrote one-time police chief George Washington Walling. Lunatics and sentenced criminals were housed on the first floor, while murderers, highway robbers, and burglars resided on the floor above. The third floor housed those arrested for grand larceny, and the fourth held prisoners arrested for small misdemeanors. Most inmates were men, but about four hundred women lived in a separate women's prison in a courtyard within the main building, and a small ward was set aside for boys as well.

What was it like to be condemned to the dank, dreary, overcrowded Tombs, before it was replaced by a newer facility in 1903? "The cell is narrow and small, but is rather better, on the whole, than one would think from looking at the entrance," wrote Walling. "The floor is of cement, and gets damp and cold. There is a hard, uncomfortable iron bed, one or two necessary articles of furniture; and these are all. Here, as in Ludlow Street Jail, if one wants luxuries he has to pay for them, and the messengers are said to make a very good thing of it. They offer to get cigars, tobacco, fruit, etc., for them and then charge them double prices. The prisoners cannot rebel, and their persecutors have absolute power."

Walling continued, "the dull monotony of existence continues until the prisoner's term expires. Occasionally he sees visitors, who are allowed to talk to him at the cell door. Perhaps he is confined in the Tombs only temporarily before being conveyed to Blackwell's Island. When his time comes to start he is hustled out with a dozen or more other prisoners, all of whom are packed into the 'Black Maria' (a police wagon used to transport prisoners) and driven rapidly over the pavements toward Blackwell's Island."

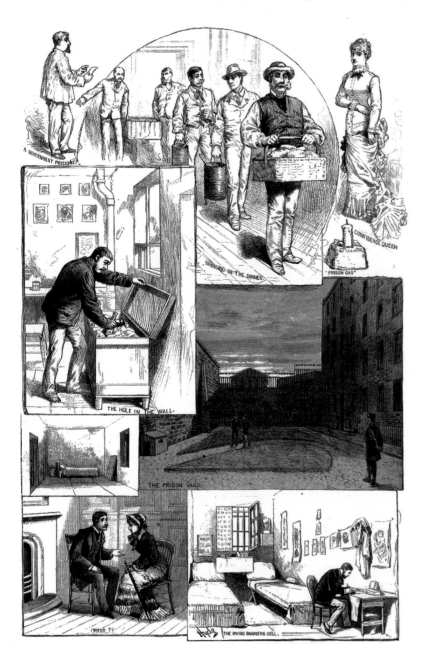

A GOVERNMENT PRISONER.

BRINGING IN THE DINNER.

CONFIDENCE QUEEN

"PRISON GAS"

THE HOLE IN THE WALL.

THE PRISON YARD.

THE PAYING BOARDER'S CELL.

Jacob Riis's colleague Richard Hoe Lawrence took this photo of a well-dressed man being pushed into a cell in 1895.

Wringing the City's Red-Light Districts Dry

Sin could be easily found in many pockets of the Gilded Age city. On Greene Street south of Houston Street, the metropolis's red-light district before the Civil War, several brothels still operated in the shadow of a precinct house. Discreet directories, such as *The Gentleman's Companion* from 1870, published the address of each house and rated them for cleanliness and the attractiveness of the ladies employed there. Meanwhile, immigrant women offered their services on the streets of Chinatown and Little Italy, and in the sailors' dives of Water Street. The African American neighborhood along Bleecker Street near Minetta Street and Minetta Lane was filled with working girls. Around the corner at Sixth Avenue and West 4th Street, a dive bar called the Golden Swan—nicknamed "the Hell Hole" by its customers—catered to neighborhood lowlifes (as well as lowlife-loving artists and writers such as John Sloan and Eugene O'Neill). Bleecker Street itself was home to all-male bars, such as the Slide and the Black Rabbit, that doubled as sex clubs.

"It is a fact that 'the Slide' and the unspeakable nature of the orgies practiced there are a matter of common talk among men who are bent on taking in the town or making a night of it," wrote the *New York Herald* in

Corner grog shops, or groggeries, were able to circumvent the Sunday excise laws because they billed themselves as groceries that sold some food. In nineteenth-century tenement districts, every corner had at least one groggery.

an article headlined "Depravity of a Depth Unknown in the Lowest Slums of London or Paris Can Here Be Found," on January 5, 1892. "In comparison to 'the Slide' an ordinary concert hall is a place of worship," the *Herald* added.

By the end of the nineteenth century, the city had two major nighttime pleasure playgrounds: the Tenderloin and the Bowery. The former, whose name came from precinct captain Clubber Williams's famous comment, was a byproduct of the new Theater District. From the 1870s to 1900, Broadway between 14th and 34th streets was lined with legitimate stages and concert halls, as well as posh restaurants and hotels. On the side streets stretching west to Eighth Avenue and north through the 30s and into the 40s, houses of prostitution, gambling meccas (Frank Farrell's "House with the Bronze Door" and Canfield's attracted the city's wealthiest men), and saloons sprang up, their owners eager to take advantage of the crowds and excitement that raged all night under the new electric lights that illuminated Broadway.

During the day, the grand emporiums of Ladies' Mile catered to wealthy shoppers. By evening, ladies themselves were for sale. The Seven Sisters brothels on West 25th Street between Sixth and Seventh Avenues catered to well-dressed men with money. Fancy hotels had rooms for the wealthy, while lodging houses catered to customers renting by the hour. Exotic French prostitutes could be found on West 39th Street, dubbed "Soubrette Row" (a "soubrette" was a flirtatious young woman). Streetwalkers visited dance halls such as Koster and Bial's, on Sixth Avenue, where the salacious cancan was performed. They also met customers at the Haymarket, on 30th Street, a combination restaurant, dance hall, and variety show that counted Diamond Jim Brady as a regular. He left his diamonds and other pricey baubles at home, however, as there was a good chance they would be stolen from him.

The tenement-fronted streets of the Tenderloin, specifically in the West 20s, were part of an African American residential neighborhood at the time. There, black-owned nightclubs like Ike's Professional Club catered to a mixed-race crowd. Black entertainers and celebrities, such as boxer Jack Johnson, would come to listen to the black singers and pianists (like Eubie Blake) who played Ragtime—a new genre of music created

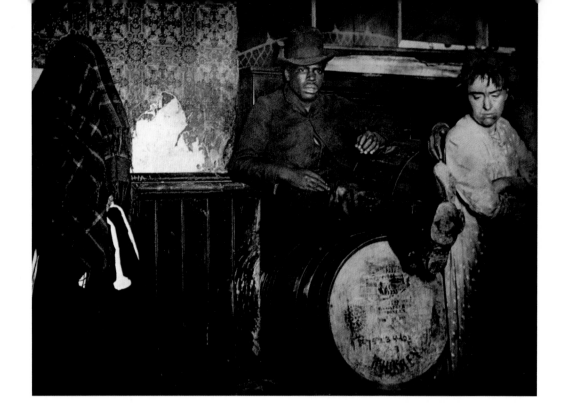

Bleecker Street near Minetta Street and Minetta Lane in Greenwich Village was a small African American enclave known for its black-and-tan clubs—bars where both blacks and whites could mingle. This practice was looked down upon by the majority of the city, including Jacob Riis, who took this photo and wrote about the "common debauch" he found at one club.

by African Americans characterized by unpredictable beats and a bluesy, jazzy sound. The clubs also catered to white couples "out sight-seeing or slumming," as author James Weldon Johnson, who had moved to the Tenderloin in 1901, put it. The musicians at Ike's and other clubs helped turn Ragtime into the soundtrack of the Tenderloin at the turn of the century.

While the Tenderloin attracted a higher-class clientele and plenty of tourists, the Bowery in the late nineteenth century was a slummer's and working-class man's paradise. Cheap hotels, beer gardens, concert halls, "resorts," and third-rate theaters brought single males and garishly dressed prostitutes to this commercial sex center under the gritty elevated train tracks. Silver Dollar Smith's, across from the Essex Market Courthouse, was a popular haunt, with its sparkling chandelier and silver dollar coins affixed to the floor. At Lyon's restaurant, open around the clock, cops sat with pickpockets who sat with Tammany men. McGurk's Suicide Hall was a dance hall with prostitutes awaiting customers upstairs; it was considered a downtown version of the Haymarket.

The police in both neighborhoods took kickbacks to leave the proprietors of vice alone. Occasionally Thomas Byrnes would order a raid, just to get moralizing ministers such as Charles Parkhurst and Thomas Talmage temporarily off his back. If a madame or one of her girls was charged with prostitution,

Broadway and the Bowery ran parallel to each other in Lower Manhattan, but the two famous thoroughfares couldn't have been more different. While Broadway was lined with respectable businesses, shops, and churches, the Bowery was a seedy stretch of beer gardens, dance halls, and bars—and the working-class men and women, as well as the upper-class slummers, enjoyed every minute of the nightly revelry.

Tammany-backed district leaders and judges would arrange for bail money. If necessary, they would buy them out of a sentence on Blackwell's Island, and then it was back to business. Yet the enormous sums in protection money they demanded could make it hard to make a living. One madame in the Tenderloin reportedly was raking in $1,500 a month, but over five years, she had to pay police $30,000. When she didn't pay up on time, a patrolman beat her on the street. She later testified in front of the Lexow Committee, the state investigation into Tammany-backed police corruption.

The ten thousand bars in the Tenderloin, along the Bowery, or in any corner of the rest of the city paid scant attention to the state's Excise Law, which required bars to close at 1:00 A.M. until sunrise the next day and to refrain from selling alcohol on Sundays. But even if they did follow the law, it wouldn't have kept crusaders such as Parkhurst, Talmage, and Anthony Comstock, the self-appointed head of the New York Society for the Suppression of Vice, from going after the saloons. By the 1880s, groups specifically dedicated to temperance, such as the Anti-Saloon League, had descended on Manhattan, attempting to dry up the nation's most sinful city. They had on their side Theodore Roosevelt, the new police commissioner. Roosevelt was not a Prohibitionist; his reason for enforcing the Excise Law was to prevent police corruption.

"The saloon was the chief source of mischief," wrote Roosevelt in his autobiography. "It was with the saloon that I had to deal, and there was only one way to deal with it. That was to enforce the law. The howl that rose was deafening. The professional politicians raved. The yellow press surpassed themselves in clamor and mendacity. A favorite assertion was that I was enforcing a 'blue' law, an obsolete law that had never before been enforced. As a matter of fact, I was only enforcing honestly a law that had hitherto been enforced dishonestly. There was very little increase in the number of arrests made for violating the Sunday law. Indeed, there were weeks when the number of arrests went down. The only difference was that there was no protected class. Everybody was arrested alike, and I took especial pains to see that there was no discrimination, and that the big men and the men with political influence were treated like every one else."

Roosevelt made the case that enforcing the Excise Law made life better for the poor

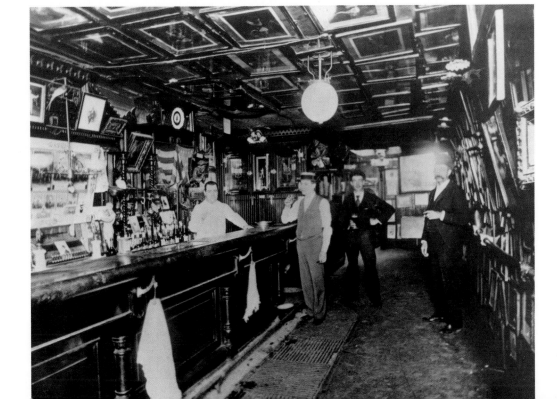

Steve Brody, a Bowery "character," as the *New York Times* called him, found fame when he claimed to have jumped off the East River Bridge in 1886. He opened a popular saloon on the Bowery that also served as a museum of his famous bridge stunt.

and vulnerable. "The warden of Bellevue Hospital reported, two or three weeks after we had begun, that for the first time in its existence there had not been a case due to a drunken brawl in the hospital all Monday," he wrote. "The most touching of all things was the fact that we received letters, literally by the hundred, from mothers in tenement-houses who had never been allowed to take their children to the country in the wide-open days, and who now found their husbands willing to take them and their families for an outing on Sunday."

Roosevelt's efforts to enforce the Excise Law earned him few fans outside of the drunk tanks of Bellevue. He alienated workingmen and the city's huge German immigrant population, which congregated at taverns and beer gardens, especially on Sundays—the most lucrative day of the week, in fact, for

barkeepers. Temperance supporters felt emboldened, however, and they managed to get a bill called the Raines Law passed by the state in 1896. This legislation banned Sunday alcohol sales . . . except in restaurants or hotels with at least ten beds. Of course, New York's clever saloonkeepers quickly figured out a way to get around the Raines Law: They began serving meals—which could be as little as one pretzel or something inedible called a "brick sandwich," with two pieces of bread and a real brick in the middle. They also rented out spare rooms in the back and second floor of bars. Technically, they were now hotels, and these new cheap lodging places encouraged prostitution—something the temperance crowd had not foreseen. By the early 1900s, the Raines Law was deemed a failure. The prohibitionists, however, were not giving up just yet.

Ernst Roeber was a popular wrestler known as the "Adonis of the Bowery." After retiring in 1902, he opened his saloon at Sixth Avenue and 13th Street. Like other saloons at the time, it was an all-male preserve under fire by the growing temperance movement.

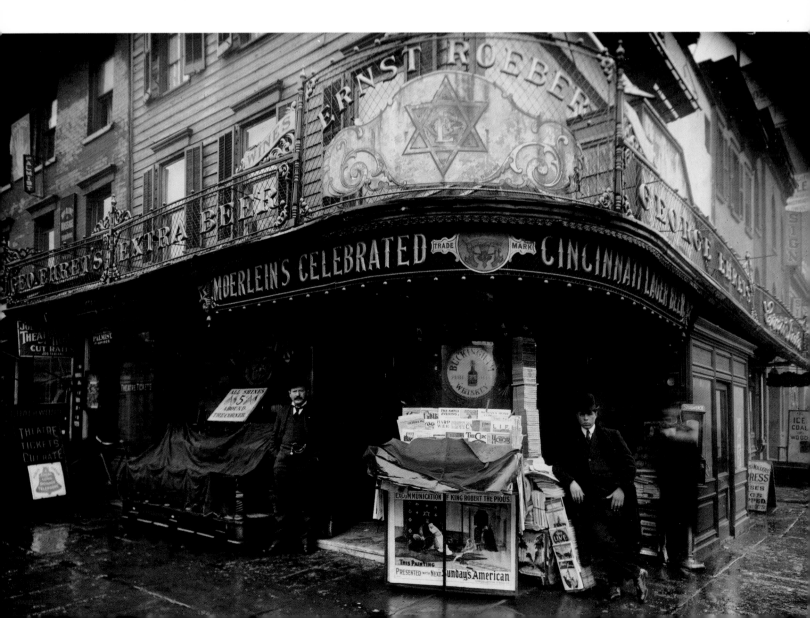

The New Woman Takes New York

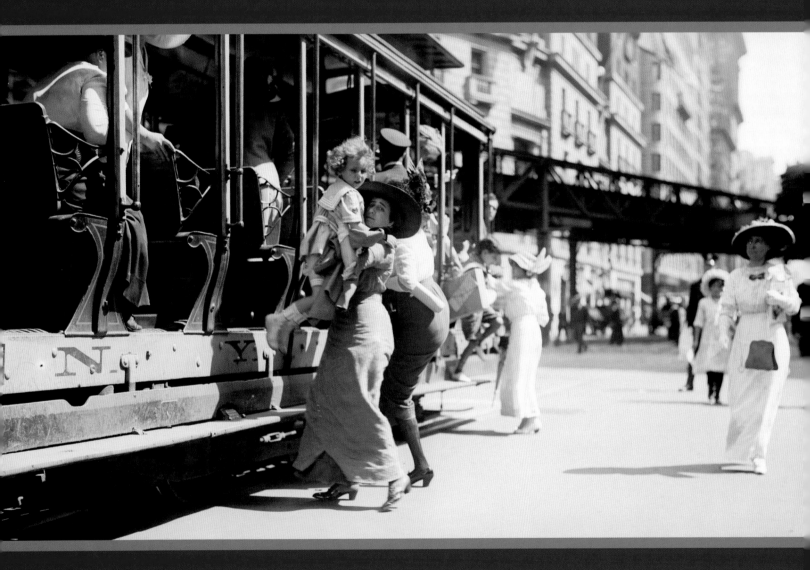

Two women help a child onto a Broadway streetcar in 1913. Though women gained greater independence and autonomy as the Gilded Age progressed, they were still expected to make the sphere of home and family life their primary focus.

The Woman Question

On February 27, 1870, a short article with the headline "Woman's Bondage" ran in the *New York Times*. The anonymous male writer sounded off on a topic that had kicked up a great deal of controversy in the city before the Civil War: equality between the sexes. Now, with the war in the past and New Yorkers looking forward to an era of growth and prosperity, what was referred to as "the woman question" was again stirring things up in downtown barrooms and Fifth Avenue drawing rooms.

Since the first women's rights convention was held in upstate New York in 1848, "strong-minded women," as equal rights supporters were derided, pushed for women to participate in life beyond home and family: to be free to work, to marry or not, and most importantly, to vote. After pausing during the war, New York–based leaders Susan B. Anthony and Elizabeth Cady Stanton brought the movement back into the spotlight. They ran acerbic editorials in *The Revolution*, the newspaper they launched from Park Row. ("Men their rights, and nothing more; women

their rights, and nothing less" was the weekly's motto.) They held dynamic lectures at venues like Steinway Hall on East 14th Street and the Brooklyn Academy of Music. And they were inspired by British philosopher John Stuart Mill, who in 1869 published a much talked about essay insisting that humanity would be better off if men no longer subordinated women.

The *Times* writer called out Mill and other supporters, arguing that the wives, mothers, daughters, and sisters in the Metropolis already possessed equal rights. "What, for example, constitutes the subordination of women in New-York?" the writer asked. "Here a woman can hold and part with property, including real estate, in entire independence of her husband, can escape his control if he abuses her, can maintain views totally opposed to his own, and be upheld by public opinion for doing so, can preach, lecture, practice medicine, write to the newspapers, wear trousers, do almost anything, in fact, with few or none to challenge her caprices. There is something like perfect equality in this."

Elizabeth Cady Stanton (left) and Susan B. Anthony, approximately 1870. Stanton and Anthony first teamed up in 1851 to expand the rights of women and champion the right to vote, as well as advocate for temperance and for equal rights for African Americans. Both women continued to work together closely through the turn of the century. Suffragist Anna Howard Shaw described the relationship between Stanton and Anthony this way: "She [Anthony] often said that Mrs. Stanton was the brains of the new association, while she herself was merely its hands and feet; but in truth the two women worked marvelously together, for Mrs. Stanton was a master of words and could write and speak to perfection of the things Susan B. Anthony saw and felt but could not herself express." Neither Stanton nor Anthony lived to see women in New York get the vote in 1917.

Demorest's *Illustrated Monthly* presented the latest dress styles and patterns for fashion-forward women. Launched by Ellen Louise Demorest (née Curtis), a successful hat designer who went by Madame Demorest, her Gilded Age fashion magazine was at the height of its popularity in the 1870s.

Women in the Metropolis didn't really have "perfect" equality. The vote wouldn't be won in New York State until 1917. Equal pay for equal work was just a slogan, and even when an equal pay law was enacted in 1911, it only applied to teachers (who were overwhelmingly female). Juries were comprised only of men because women were not considered educated enough. Even the simple act of having dinner in a fine restaurant was almost impossible until the 1890s if a female diner was unescorted by a man; it implied she might be a prostitute, and management would not seat her. And when the bicycle craze swept the city in the 1880s, health experts seriously debated whether cycling was too strenuous for women and should be discouraged, if not banned.

But a series of state court decisions before the Civil War granted women some important rights. They could own real estate, control their bank accounts, and end a marriage for reasons such as bigamy, insanity, or fraud while retaining custody of their children. Women

were never legally barred from working outside the home, but with the opening of a handful of women's colleges (like the city's Female Normal College, established in 1869 and renamed Hunter College in 1914, or Barnard College in Morningside Heights, which began accepting students in 1889), a professional career—or at least, the pursuit of higher education—was more accessible than ever.

By 1870, a number of women had established successful careers in the city, like Dr. Elizabeth Blackwell, the nation's first female doctor, and Brooklyn native Dr. Susan Maria Smith, the first African American female physician in New York. Newspaper columnists Jane Cunningham Croly, whose pen name was Jennie June, and the *New York Ledger*'s Fanny Fern (born Sarah Willis), were journalists covering the issues of the day. Charity Organization Society founder Josephine Shaw Lowell was appointed Commissioner of the New York State Board of Charities in 1876. Ellen Louise Demorest's monthly fashion

Victoria Woodhull: Suffrage, Socialism, and Sexual Freedom

Victoria Woodhull broke all conventions for women in the Gilded Age: She worked as a stockbroker, founded a weekly newspaper, advocated radical ideas about sex and matrimony, and mounted a campaign for president in 1872—even though women could not yet vote.

As a passionate supporter of suffrage and the first female presidential candidate, Victoria Woodhull blazed a trail for women. Yet her advocacy of more radical ideas, such as socialism and free love—not to mention her accusations of adultery against esteemed Brooklyn preacher Henry Ward Beecher—proved to be too controversial for 1870s New York City.

A traveling medium from Ohio, Woodhull arrived in the Metropolis in 1868 with her sister, Tennessee Claflin. The two attractive and bewitching women—who courted controversy by wearing their hair short and donning skirts that only reached their ankles—entertained audiences with their predictions of the future. They had the good fortune of captivating the city's richest man, Cornelius Vanderbilt, who became their most prominent client (Vanderbilt also reportedly became Claflin's lover). Vanderbilt helped set up the sisters in a Broad Street office, where they opened a brokerage firm and traded stocks on Wall Street.

These "lady brokers" found financial success and made a name for themselves as a curiosity, but Woodhull was more interested in a political career. In 1870, the sisters launched a newspaper, *Woodhull and Claflin's Weekly*. They wrote provocative editorials calling for women's suffrage and labor reform. Even more revolutionary was the sisters' support of free love, which they defined as the ability to marry, divorce, and have children without government interference. "Yes, I am a free lover. I have an inalienable, constitutional and natural right to love whom I may," Woodhull said in an 1871 speech at Steinway Hall.

Shortly after starting *Woodhull and Claflin's Weekly*, Woodhull announced that she was running for president in 1872. After Woodhull boldly addressed Congress in 1871 and argued unsuccessfully that the Constitution already gave women the right to vote, Stanton and Anthony threw their support behind her, eager to capitalize on the spotlight she put on the suffrage movement. Woodhull was a candidate on the new Equal Rights Party platform. She spoke out in favor of social welfare programs for the poor and an eight-hour workday. Labor leaders planned to cast their ballots for her, but her female supporters, of course, could not.

On Election Day, Woodhull spent the night in the Ludlow Street Jail; she had been arrested on a charge of sending obscene information through the mail. The arrest was probably retaliation for a front-page article she published just before the election, which claimed that eminent abolitionist and Brooklyn preacher Henry Ward Beecher, a critic of hers, was an adulterer and hypocrite. Though ultimately dropped, the charges against Woodhull left her reputation in tatters. Bankrupt and ostracized, she and her sister moved to England permanently in 1877.

and pattern magazine, *Madame Demorest's Mirror of Fashions,* reigned in the 1860s and 1870s; Croly did a stint as editor. Demorest also invented a clever device that discreetly elevated and lowered a lady's hoop skirt to keep ground-skimming hemlines from collecting dirt from New York's notoriously gritty streets.

Still, middle- and upper-class women who were part of the labor force were the exception. What kept them out was the prevailing notion that a "true woman" should find happiness and fulfillment in the home. "Woman is the moral power of society, but it does not follow that it is her duty to use this power coercingly in political or public life," said a male lecturer at Brooklyn's State Street Congregational Church in 1871. "The busy, bustling world is not the place for her mission." Female advice guides and periodicals (like *Godey's Lady's Book* and *Peterson's Magazine*), backed this up, emphasizing that women should focus on shaping the moral values of their children. "What do women want with votes, when they hold the sceptre of influence with which they can control even votes, if they wield it aright?" asked the female author of an etiquette guide from 1878. When a woman "fulfills her sphere of a wife, a mother, a teacher . . . it is [she] who has it in her power to influence for good or for evil the men with whom she is thrown. The silent influence of example in her home does much."

At the beginning of the Gilded Age, New York was a sex-segregated city—at least for the comfortable classes. Men operated in the public sphere, working outside the home and engaging in politics or business with other men at clubs, restaurants, and saloons. Women tended to the domestic realm. When they socialized, it was with other women, perhaps meeting for lunch at a department store restaurant on Ladies' Mile or at one of the popular "confectioneries" that served sweet treats, like Maillard's in the Fifth Avenue Hotel opposite Madison Square. They drove the popular women's club movement, joining groups like the Women's Christian Temperance Union and Sorosis, which centered on

The interior of Maillard's, a chic confectionery on the ground floor of the Fifth Avenue Hotel. Instead of meeting at traditional restaurants, which were the domain of men, women visited confectioneries or ladies' lunch rooms when they wanted to grab a bite away from home.

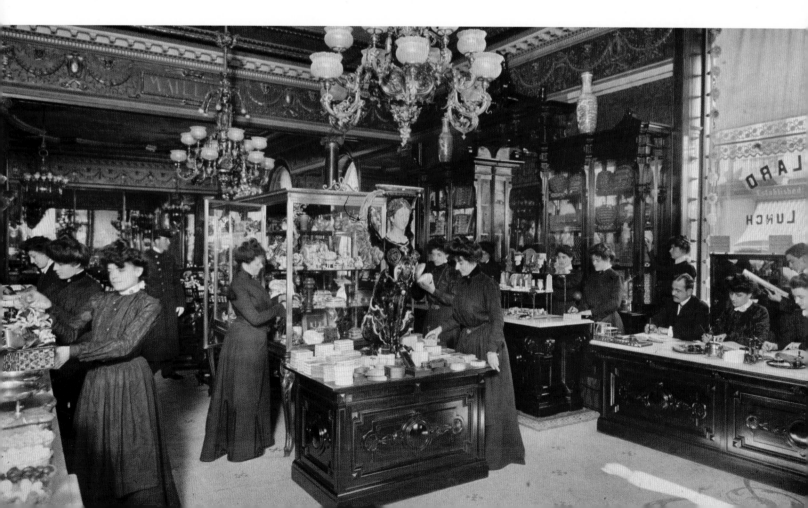

Where New York Women Had Their Babies

The last decade of the Gilded Age was a transformative time for childbirth. In 1900, less than 5 percent of expectant mothers nationwide gave birth in hospitals. At a time when female modesty was a major consideration and the science of obstetrics still relatively primitive, the vast majority of pregnant women had their babies under the care of a midwife, general practitioner, or experienced female family members. Yet after the turn of the century, home births would decline steeply. In 1909, only 40 percent of women in New York relied on a midwife. By 1916, the New York Lying-In Hospital recorded more inpatient deliveries than outpatient for the first time.

One reason for the change of venue had to do with the new perception of maternity hospitals. For most of the nineteenth

Female staff at Sloane Maternity Hospital on Amsterdam Avenue and 59th Street. Built and endowed in 1886 by Mr. and Mrs. William D. Sloane (Mrs. Sloane was the daughter of William H. Vanderbilt), Sloane was intended to be "a place in which the poor may be properly and comfortably cared for" in an era when women of all classes were just beginning to consider giving birth in a hospital under the care of a doctor rather than at home with a midwife.

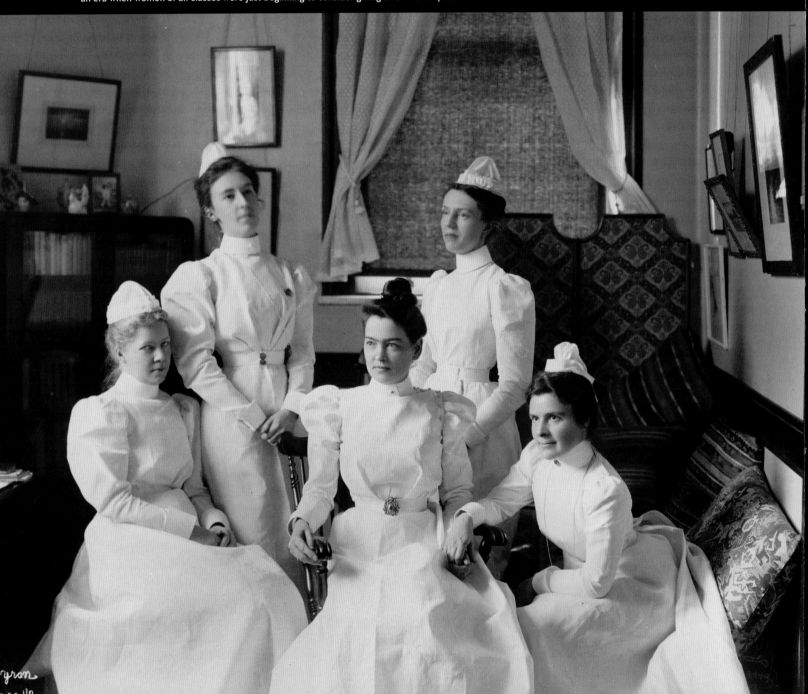

century, they were small facilities where poor and working-class women who could not give birth at home (or had no home to give birth in) delivered their babies. Middle-class and wealthy women were encouraged to give birth at home, which was thought to be more "morally uplifting" as well as safer. Safety was no small concern in an era when women routinely died during childbirth itself, or in the days immediately after from an infection known as puerperal (or "childbed") fever.

By the 1880s, medical advances, such as the use of forceps to aid delivery, and an understanding that puerperal fever was caused by bacteria entering the bloodstream through tears and cuts that happened during childbirth, helped make maternity hospitals more attractive, especially for women who expected to have a difficult delivery or who had lost a previous infant during childbirth. Expectant mothers in New York had their choice of several well-regarded and groundbreaking hospitals.

SLOANE MATERNITY HOSPITAL

Endowed by the Vanderbilt family so all of its beds "were free to perpetuity," Sloane opened in 1887 on Amsterdam Avenue and 59th Street. "Each of the delivery-rooms contains a table of special design, and the high character of the service is shown by the fact that in 2,000 cases, many of them emergency cases brought to the hospital in ambulances, only 11 deaths are recorded," wrote Moses King in *King's Handbook of New York* in 1892.

THE NEW-YORK INFIRMARY FOR WOMEN AND CHILDREN

The infirmary was established by Elizabeth Blackwell, the first female physician in America, and her physician sister Emily Blackwell, in 1854. Through the Gilded Age, it was one of the few medical facilities where women and kids could be treated by female doctors. In addition to a maternity ward and an operating room, it also supported a women's medical college.

THE NEW YORK MEDICAL COLLEGE AND HOSPITAL FOR WOMEN

Established in 1863, the mission of this hospital on West 54th Street was "to treat 'self-supporting' young women, whose only home is the boarding-house, where, when overtaken by sickness, they may receive skillful treatment from phy-sicians of their own sex at a moderate cost, or free when necessary," wrote King. Its maternity ward boasted that only one mother was "lost" in twenty-nine years.

THE NEW-YORK MOTHERS' HOME

In 1888, a Catholic religious order founded this hospital on East 86th Street to serve "destitute women and unmarried young girls, hitherto respectable, about to become mothers," wrote King. In 1891, the hospital cared for 138 women.

THE LADIES' HEBREW LYING-IN SOCIETY

Incorporated in 1877 and run by United Hebrew Charities, this "lying-in" facility (where a new mother was confined to bed as she recuperated from childbirth) cared for poor Jewish mothers in a building on St. Marks Place.

THE MIDWIFERY DISPENSARY

This Broome Street hospital, founded in 1890 and staffed by trained doctors, offered free assistance to midwives who found themselves in the middle of a difficult birth in the East Side tenement district. It became the New York Lying-In Hospital later that year.

educational and professional advancement. Even the layout of Central Park reinforced the idea that men and women occupied distinct worlds. Frederick Law Olmsted and Calvert Vaux designed the park with a ladies' skating pond and a ladies' "refreshment saloon," where women unescorted by men could enjoy light snacks in a respectable atmosphere.

A collision of economic and social changes after the Civil War would chip away at the divide between the male and female spheres. Anthony and Stanton's push for equal rights, with the help of other female firebrands, made it acceptable for women to do more than be the "angel of the home" who nurtured her family, as women's magazines often put it. The mechanized, modern city—with sidewalks brightly lit by electricity, reliable public transportation, and a professional police force—made the streets safer for women, which increased their independence. Even the rise of sports like cycling and tennis ushered in fashion changes that did away with the waist-cinching corsets and heavy hoopskirts of their mothers' generation in favor of relatively loose clothes that gave women more physical freedom to go along with their greater personal freedom. By the close of the Gilded Age, women still didn't have the right to vote—but that goal was within sight.

Shop Girls, Servants, and Sewing Women

With men away on the battlefields, women poured into the city's booming work world during the Civil War. Once the war was over, many stayed on. Despite the "true womanhood" ideal, one-fourth of all women in New York did paid work, reported the *New York Herald* in 1869. These mostly young, unmarried women—many poor and working-class natives, others new arrivals from small towns and Europe, and still others who were Civil War widows with children—weren't pursuing careers or staking a claim in equality. They took on ten-hour shifts six days a week as shop girls, sewing ladies, and domestics because they needed the money.

This army of workingwomen changed the look and feel of the city. They crowded into streetcars and elevated railroads during rush hour, clad in flimsy dresses or shirtwaists, clutching an overhead strap in one hand and a dime novel in the other. They packed lunches of apples and bread, or they stopped for a sandwich at the new quick-lunch counters popping up in the city. If they didn't live in a tenement, they rented a room in a women's

Shop girls visiting a millinery store on Division Street, as seen in an 1890 *Harper's Weekly* cover. Shop girls and other workingwomen were ubiquitous in New York as they made their way to and from the retail emporiums and factories that employed them every day.

Hotels for Working Women Only

During the Gilded Age, 25 percent of all women in New York City were in the labor force—and where these mostly young, unwed wage earners were to live was a concern to reformers. While single workingmen could rent a room or apartment in one of the new "bachelor flats" that appeared in the city in the 1880s and 1890s, women didn't have that option; living on their own in a tenement or apartment house was not considered respectable. Reformers feared that without proper accommodations, these struggling women might be forced to turn to cheap boardinghouses or lured into prostitution.

To the rescue came working-women's groups, which began building special hotels where female workers could live safely and inexpensively. One of the first was the Home for Working Women on Elizabeth Street, a six-story brick building housing five hundred women. "It is supplied with a reading room, a reception-room, a parlor, a restaurant, and a laundry," wrote James McCabe in 1872. The weekly fee was $1.25—steep for very low-level workers, who earned as little as $3 a week.

Dry-goods magnate A. T. Stewart employed thousands of sewing girls and shop girls in his two emporiums along Ladies' Mile on Broadway. That may have been his motivation to build a luxurious cast iron, mansard roof building that would serve as Stewart's Working Women's Hotel, "a home for women who support themselves by daily labor." Stewart did not live to see the five-hundred-room hotel on Park Avenue and 33rd Street open in 1877, the same year it closed. With weekly rates advertised as "less than $5 a week," it was too expensive for most working women and was soon converted to a regular hotel.

Another wealthy New Yorker, Margaret Louisa Vanderbilt Shepherd (granddaughter of Commodore Vanderbilt), funded the construction of the Margaret Louisa, a women's hotel run by the YWCA on 16th Street near Fifth Avenue. A room cost 60 cents per day, with another 85 cents for three meals. Thousands of nurses, teachers, dressmakers, and stenographers boarded at the Margaret Louisa after it opened in 1891, but they had to provide references and could only stay about four weeks.

On Hudson and West 12th streets in Greenwich Village,

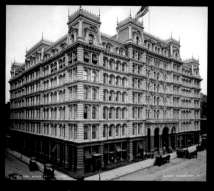

In 1877, dry-goods millionaire A. T. Stewart spent his own fortune to construct his Working Women's Hotel on Park Avenue and 33rd Street. Intended for shop girls, the hotel ultimately failed because the weekly rates were too high for most shop girls to afford.

wealthy William Martin opened the nonprofit Trowmart Inn, for the woman who "is of the class who labors for a small wage, and whose parents have no home within the city," explained the *New York Times* after the hotel opened in 1906. Four dollars per week landed a woman a small room with a single bed and washstand, plus two meals a day.

Martin had an unusual reason for funding the Trowmart: Respectable women needed an appropriate venue where they could be courted by marriage-minded men. "Girls of gentleness and refinement do not care to be courted upon the open highway, nor in public parks . . . had they a proper place in which to entertain their admirers, would develop into happy, excellent wives and still happier mothers," wrote the *Times*.

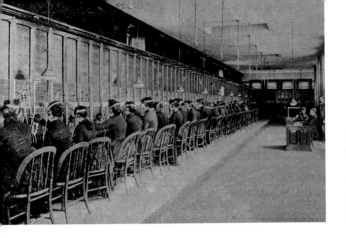

boardinghouse or in one of the new working women residences funded by benevolent groups and sympathetic millionaires, such as the Park Avenue and 34th Street Working Women's Hotel built by dry-goods magnate A. T. Stewart. "Next come trooping the shop-girls, chatty and laughing, or outworn and weary…and hither and thither they disperse to many a bindery and tailor-shop, to attics and back-rooms innumerable," Walt Whitman wrote in the 1850s, but it was a fitting description for decades.

"It is said that there are more than forty thousand women and girls in New York dependent upon their own exertions for their support…," wrote James D. McCabe in 1872. "They all labor under two common disadvantages. They are paid less for the same amount of work than men, and being more helpless than men are more at the mercy of unscrupulous employers. The female clerks and shop girls received small wages, it is true, but they are generally paid regularly and honestly. The sewing women and factory hands are usually the most unfortunate, and these constitute the great bulk of the working women in New York." While the working girls were mostly downtown, uptown women of privilege were often indifferent to their struggles. "While yet your breakfast is progressing, and your toilet unmade," wrote Fanny Fern in a 1968 essay addressed to middle-class wives, "comes forth through Chatham Street and the Bowery, a long procession of them by twos and threes to their daily labor."

Workingwomen became the heroine of popular books and songs, like "She's Just a Little Working Girl." One novel, *Bertha, the Sewing Machine Girl,* was adapted into a play in 1871 that debuted at the Bowery Theater. While working girls were celebrated in pop culture, writers and moralists tried to make sense of what their presence meant to the social order of the city. Newspapers covered them frequently. According to the *Herald,* most fell between ages fifteen and forty. Servants, teachers, cooks, dressmakers and seamstresses, and laundresses were the most common jobs. Makers of artificial flowers, housekeepers of boardinghouses, copyists, "hair workers" (hairdressers and wig makers), midwives, milliners, nurses, straw workers (makers of hats and bonnets), "tailoresses," and saleswomen rounded out the list.

Some did their work piecemeal from home, but most headed to an office or factory, like Sadie Frowne, a sixteen-year-old Polish immigrant toiling in a Brooklyn dress company at the turn of the century. "Often I get [to work] soon after six o'clock so as to be in good time, though the factory does not open till seven," wrote Frowne. She operated a foot-powered sewing machine and pocketed $7 each week. "At seven o'clock we all sit down to our machines and the boss brings to each one the pile of work that he or she is to finish during the day. … All the time we are working the boss walks around examining the finished garments and making us do them

Operators at the switchboard of the Metropolitan Telephone and Telegraph Company in 1893. By the end of the 1880s, the job of telephone operator was almost exclusively female because phone company officials wanted customers to hear a pleasant, friendly voice.

Sewing flags at the Brooklyn Navy Yard in 1900. A team of fifty women and several men were employed as sewers at the Navy Yard, which required that every newly built battleship leave the yard with 250 American flags on board. "The sewing machines are run by electricity, but much of the difficult and tedious hand embroidery is done by skilled needle-women," explained one newspaper in 1913. The pay was between $1.50 and $2.50 per day.

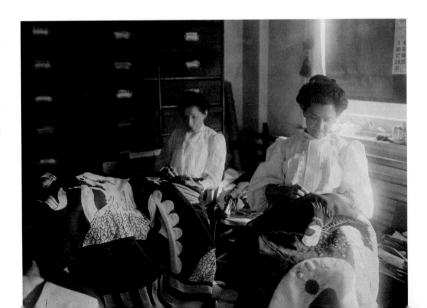

over again if they are not just right. So we have to be careful as well as swift." The work wasn't easy, but it gave her pocket money and a sense of autonomy. "Sometimes we go to Coney Island, where there are good dancing places, or to Ulmer Park [an amusement park in Bensonhurst, Brooklyn] to picnics," wrote Frowne. "Lately, he [her boyfriend, Henry] has been urging me more and more to get married—but I think I'll wait."

The job of a cook, maid, or children's nurse paid less than factory work because the job usually included room and board. "Situations," as they were called, could be challenging. The boss was typically the lady of the house, and upper-class women tended to look down on the Catholic immigrant girls who cooked and cleaned for them. If the job took them away from the city, it could also be isolating. A twenty-year-old named Agnes wrote about her job as a baby nurse. "After I had rested and enjoyed a holiday I secured another situation, this time to mind the baby of a very rich couple," she wrote. "It was the first and only baby of the mistress, and so it had been spoiled till I came to take charge. It had red hair and green eyes and a fearful

temper—really vicious. I had thought that this place would be an easy one . . . in the end the baby was too much for me. I was made to carry it about, and to get up and walk with it in the night, and at last my health broke down and I actually had to go to a hospital."

While women's rights supporters repeated the mantra of equal pay for equal work, no law pressed business owners to pony up. "It is argued on one side that women, compared with men, receive the most wages," wrote the *Herald*. "Their living, it is claimed, costs them less; that a female eats ordinarily one-third less than a man; that she always, in the same boarding house, obtains her living at a lower figure than a male, and that she can make her own dresses, underclothing, hats while a man has to resort to a tailor and furnisher for his wear. It is also contended that every female lives expecting to be married at some period of her life, and in this hope never endeavors to get a complete mastery over her trade, but looks to the marriage union as a relief from all work and service not purely household. . . . Young girls are bred to the idea of marriage, and they are nurtured to believe that this is their mission on earth."

Reformers, Activists, and Suffragists

Taking part in charity or reform work was a noble venture for middle- and upper-class women of the Gilded Age. It was also one of the few acceptable ways these well-off women could escape the domestic sphere and participate in public life. It's no surprise, then, that the

workingwomen's movement, the push for suffrage, and the drive for temperance—three national social campaigns that gained real power in the late nineteenth century—owe their success to female leadership and support. Of those, the fight for the rights of female workers, which

came on the heels of the larger labor movement picking up steam in the city, was most visible.

One of the earliest organizations assisting female wage-earners was the Working Women's Protective Union. Launched in 1863 with the backing of prominent men like Brooklyn abolitionist and preacher Henry Ward Beecher, the union really relied on its staff of female legal assistants and superintendents (and later, funds from female philanthropists) to aid the working women who came to the office desperate for help—to recover withheld wages, for example, or fight a corrupt boss who promised a job that didn't exist. "Out of two hundred complaints against employers in a single year, it secured a fair settlement of nearly two-thirds," wrote James McCabe. "In 1869 it procured work for 3,379 women and girls. It also looks after friendless and homeless women who seek assistance, and helps them secure employment."

Susan B. Anthony and Elizabeth Cady Stanton formed the Working Women's Association in 1868, which encouraged female workers to form protective unions. As the labor movement for both men and women grew in the 1880s and 1890s, unionized female workers made small gains, securing better paychecks and safer conditions. But union power didn't flex its muscle until the creation of the International Ladies' Garment Workers Union (ILGWU). Founded in 1900, the ILGWU sought to improve conditions in the thousands of sweatshops that employed foreign-born, mainly female workers like Sadie Frowne, many of whose bosses wouldn't allow them to unionize. "I pay 25 cents a month to the union, but I do not begrudge it because it is for our benefit," she wrote. "There is a little expense for charity, too. If any worker is injured or sick we all give money to help."

In November 1909, the ILGWU called for a general strike in support of the female workers at a factory in Greenwich Village called the Triangle Waist Company. The young sewers and dressmakers there had tried to organize their own union, but company owners blocked them. The day before

The Working Women's Protective Union, organized in 1863 and located on Bleecker Street, helped thousands of women secure unpaid wages from deceptive employers. "The Union has done much good since its organization," wrote James McCabe. "It has compelled dishonest employers to fulfill their contracts with their operatives, and in one single week compelled the payment of the sum of three hundreds and twenty-five dollars, which had been withheld by these scoundrels."

Suffrage supporters leave City Hall in 1908 after attempting an impromptu meeting with Mayor George McClellan. The suffragettes "had the most interesting time in their experience yesterday when they rode downtown in a procession of taxicabs, tried for an interview with the Mayor in City Hall, spoke to a howling mob in Chambers Street, back of the Court House, [and] to a less aggressive one on Park Place, under the protection of a squad of fifty mounted and foot police," wrote the *New York Times*.

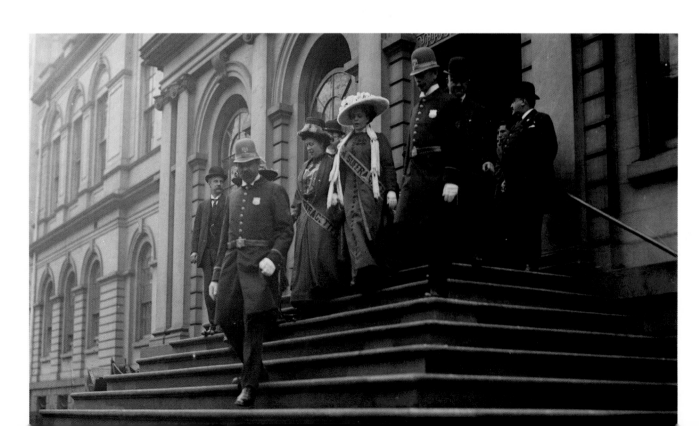

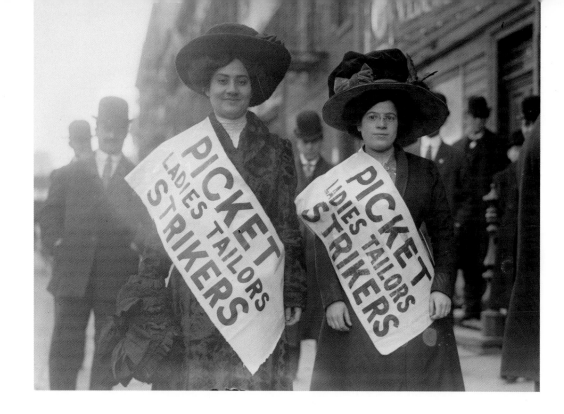

Two women take to the picket line in 1910 during the "Uprising of the 20,000" garment workers strike, at the time the largest walkout by women in American history. The strike was only a partial success, with 339 out of 353 garment firms in the city meeting the workers' demands for a fifty-two-hour workweek, four paid holidays a year, and the end of a rule that forced garment workers to buy the machines and materials they used while on the job.

In the 1880s, Alva Vanderbilt was known as a new rich socialite determined to be accepted by old-money New York. But then she shocked the city by divorcing William Vanderbilt in 1895 for adultery. "I was one of the first women in America to dare . . . to criticize openly an influential man's behavior," she reportedly said. After her equally wealthy second husband, Oliver Perry Belmont, died in 1908, she reinvented herself again, throwing herself into social activism and becoming a prominent supporter of equal rights, labor unions, and suffrage—opening her pocketbook to donate millions of dollars to advance these causes.

Thanksgiving, twenty thousand fellow garment industry workers walked off the job en masse in Brooklyn and Manhattan. What was dubbed the "New York Shirtwaist Strike" or the "Uprising of the Twenty Thousand" made headlines for weeks. "I am a working girl, one of those who are on strike against intolerable conditions," proclaimed Clara Lemlich, a twenty-three-year-old Ukrainian immigrant whose call to arms two days earlier during a meeting at Cooper Union roused other women to join the walkout.

More surprising than the fact that a twenty-three-year-old was helping lead the strike was the middle-aged woman in the fur coat lending her presence and bank account. It was former new rich social climber Alva Vanderbilt Belmont, who had traded in her extravagant balls for serious equal rights activism. Belmont divorced Vanderbilt in 1895 and married his friend Oliver Hazard Perry Belmont a year later. Upon her second husband's death, she began funding suffragist parades and marches as well as labor causes through an organization called the Women's Trade Union League, whose members included other socialites such as Anne Morgan (daughter of

financier J. P. Morgan) and Brooklyn's Mary Dreier and Elizabeth Dutcher.

The wealthy women who came to the aid of so many struggling working girls were mocked by the press and dubbed the "mink brigade." But Belmont and Morgan paid bail and fines for strikers who were arrested, and

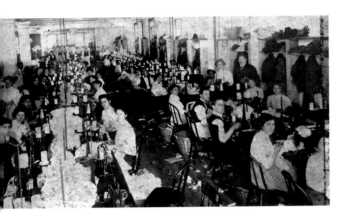

Belmont threw open the doors of her New York mansion for rallies. She displayed her famous party spirit by leading a parade of limousines emblazoned with strike slogans through the financial district of downtown Manhattan. She also invited a band to play for the strikers. "In order that the shirtwaist strikers might realize that she is continually mindful of their welfare Mrs. Oliver H. P. Belmont sent the 69th Regiment band to play to them yesterday afternoon in Rutgers Square," wrote the *Sun*.

Triangle owners settled the strike in February, offering concessions such as a fifty-two-hour workweek, and they agreed to no longer charge workers for supplies. But as city residents would find out a little more than a year later on March 25, 1911, the Triangle factory remained a dangerous deathtrap. A swift-moving fire broke out that Saturday afternoon on the eighth floor—where locked exit doors trapped employees, including some former strikers, and the only way out was to jump to the street below. The fire killed 146 workers and horrified all of New York City, whose residents took up collections for the workers' families. Workingwomen at the end of the Gilded Age had a lot more power than they did decades earlier. But there was still much to be done to make job sites across the city safer—and to get city officials to create and enforce effective workplace protection laws.

Like other sweatshops and garment factories in New York, the Triangle Waist Company factory (seen here in 1908) employed mainly young Jewish and Italian immigrant girls and women. Workers from Triangle helped spark the 1909 "Uprising of the 20,000," and though the factory's owners agreed to give in to the demand for better hours and wages, they refused to allow the workers to form a union. A little more than a year later, a fire broke out in the factory that killed 146 workers.

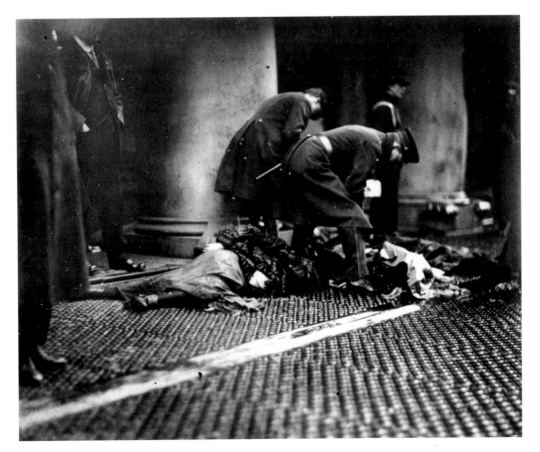

The street was "strewn with bodies," one headline read, after a fire consumed the top three floors of the Triangle shirtwaist factory at Greene Street and Washington Place on March 25, 1911. Trapped behind locked exit doors and unable to escape the swiftly moving flames, dozens of mostly female workers leaped to their deaths on the sidewalk below. A total of 146 workers perished, and several were burned so badly that their remains were never identified. Three months after the disaster, labor activists pressured the city to form an investigative committee, which prompted the creation of strong new laws calling for better safety measures and a state department of labor to enforce them.

The "New Woman" Captivates New York

There had been much said in the newspapers concerning the new woman and what kind of creature she was," stated the *Brooklyn Daily Eagle* in March 1895. "The pictorial papers had ridiculed her, showing her standing at bars drinking on street corners smoking cigars. This ridicule, however, would not prevent the coming of the new woman. She would occupy any and every place, which an intelligent human being could fill, the bar, the pulpit, the legislative hall, and will be found in every trade and profession."

Emerging in the 1890s in the wake of the equal rights movement was the educated, independent "new woman." The name came from Irish novelist and suffragist Sarah Grand, who published an essay in 1894 titled "The New Woman Problem." Grand believed that the contemporary man (who "snarls about the end of true womanliness" and "cants on the subject of the sphere") wasn't happy with the equality-minded, autonomous females of

the end of the nineteenth century and instead wanted to return to the days of the delicate, saintly wife and mother who devoted her life to the domestic sphere. "True womanliness is not in danger, and the sacred duties of wife and mother will be all the more honorably performed when women have a reasonable hope of becoming wives and mothers of *men,*" she wrote. The term caught on, and Grand's essay inspired cheeky, sometimes snarky responses from male writers. "She wants, and we say it soberly, with no mind for current slang, the earth," commented one *New York Times* writer. "The 'new woman' will assert her rights and in time create a new man to help her make over the world."

Newspaper writers responded with jokes, but the new woman quickly became a modern ideal of femininity. Her appeal was obvious: She was bright and fun-loving, and she pursued higher education the same way bright young men did. Between 1890 and 1920, women made up 60 percent of all high school graduates, and female enrollment in college was rising as well. She probably had a job, and she may have had a career; 10 percent of the workforce in 1900 now comprised professional women. Her image was defined by the illustrations of Charles Dana Gibson, a young artist who worked for various popular magazines. His "Gibson girl" was a flawless beauty with soft, warm features. She epitomized the look and energy of the new woman, and her face appeared everywhere from editorial cartoons to advertising posters and product packaging.

New York was enthralled by the "new woman," the feminine ideal that emerged in the 1890s (seen here on the cover of the Sunday edition of the *New York Journal*). Independent-minded and active, she occasionally drank, often rode a bicycle, and took part in city social events and nightlife.

The new woman studied music and art, played tennis, and rode a bicycle (about which Susan B. Anthony famously said, "the bicycle has done more to emancipate women than anything else in the world. It gives women a feeling of freedom and self-reliance. I stand and rejoice every time I see a woman ride by on a wheel . . . the picture of free, untrammeled womanhood."). She even occasionally drank and lit up a cigarette. Older New Yorkers did a double take when she strolled through the city wearing one of the newly fashionable "rainy daisy" skirts, which cleared the ground by a scandalous six inches. (The skirt was named after Henry James's uninhibited heroine Daisy Miller.) Instead of being weighed down by the heavy, curve-creating corsets, petticoats, and hoopskirts of her mother's generation, the new woman cut a slender silhouette in a long skirt and crisp shirtwaist, her abundant hair piled on her head.

The new woman's loose clothes and independence signaled sexual freedom, and this had moralists in a panic. Yet equal rights proponents liked her because she didn't depend on a man for money or status, and this promised to make marriage more equal. Suffragist and writer Winnifred Harper wrote in *The New Womanhood* in 1904, "The finest achievement of the new woman has been personal liberty. This is the foundation of civilization; and as long as any one class is watched suspiciously, even fondly guarded, and protected, so long will that class not only be weak, and treacherous, individually, but parasitic, and a collective danger to the community. . . . As long as caprice and scheming are considered feminine virtues, as long as man is the only wage-earner, doling out sums of money, or scattering lavishly, so long will women be degraded, even if they are perfectly contented, and men are willing to labor to keep them in idleness!"

On the other hand, some equal rights supporters thought of the new woman as an insult to the millions of independent women who came before her. "I hate the phrase 'new woman,'" wrote American author Emma Wolf in her popular 1896 novel, *The Joy of Life*. "Of all the tawdry, run-to-heel phrases that strike me the most disagreeably. When you mean, by the term, the women who believe in and ask for the right to advance in education, the arts, and professions with their fellow-men, you are speaking of a phase in civilization, which has come gradually and naturally, and is here to stay. There is nothing new or abnormal in such a woman."

Women walk across the new Williamsburg Bridge in 1903.

An 1897 stereograph has a comical take on the rise of the "new woman"—she's dressed in men's clothes, smoking a cigarette while a man does the laundry.

New York's Outer Boroughs

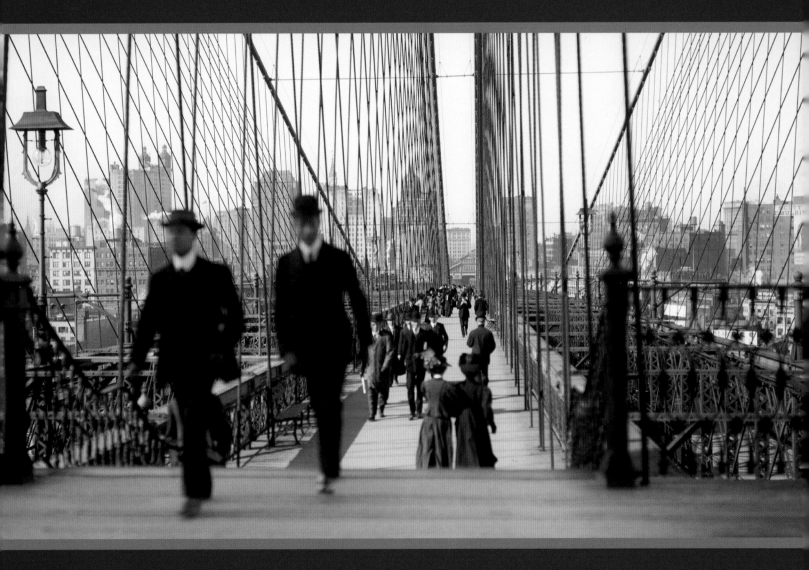

Two men stroll across the Brooklyn Bridge in 1903, twenty years after
the graceful steel and stone span, with its central elevated promenade, was
completed for walkers. When it opened, the bridge cost a penny per person
to cross. The pedestrian toll was repealed in 1891.

BROOKLYN
Boomtown Across the River

On the bracing winter morning of January 1, 1855, the mayor of Brooklyn, George Hall, delivered an enthusiastic inaugural message to the city's Common Council. Inside the seven-year-old City Hall, he addressed a packed room of councilmen and citizens. They may have postponed their New Year's visiting, but this was a historic day in Brooklyn, after all: A charter granted by the state in 1854 had taken effect, uniting Brooklyn with the city of Williamsburg (the "h" at the end was now officially dropped) and the village of Bushwick. The "consolidated" city instantly became the nation's third largest, with 200,000 residents across 25 square miles.

Mayor Hall boasted of Brooklyn's remarkable growth since 1834, the year Brooklyn expanded from a village to a city and Hall served an earlier term as mayor. "The population of the city, at that time, consisted of about 20,000 persons residing, for the most part, within the distance of about three-quarters of a mile from the Fulton Ferry," said Hall. "Beyond this limit, no streets of any consequence were laid out, and the ground was chiefly occupied for agricultural purposes." Two weekly papers kept tabs on local news and events. Gas lamps illuminated just sixteen streets. "There were two ferries by which communication was had with the city of New York, ceasing at twelve o'clock at night," continued Hall. "Of commerce and manufactures it can scarcely be said to have any."

Twenty-one years later, Brooklyn was a boomtown. In 1855, "516 streets have been opened for public use, old roads have been discontinued and closed, hills have been leveled, valleys and low lands filled up . . . almost the whole surface of the city has been completely changed," Hall pointed out. "Thirty miles of rail road track," had been laid; twelve omnibus lines and thirteen ferries transported Brooklynites back and forth to various points in Manhattan around the clock. Almost four thousand streetlamps lit city roads. Sewers, cisterns, and wells were in the ground. "There are two public parks, one of which will rival in magnificence as respects its natural position and commanding prospect, those of any other city in the Union," boasted Hall. Twenty-seven public schools, 113 churches, seven newspapers,

Brooklyn's Greek Revival-style City Hall was erected in 1848. A fire destroyed the cupola and statue of Justice in 1895. The cupola was rebuilt three years later, the same year Brooklyn joined the consolidated City of Greater New York, and City Hall was downgraded to Borough Hall.

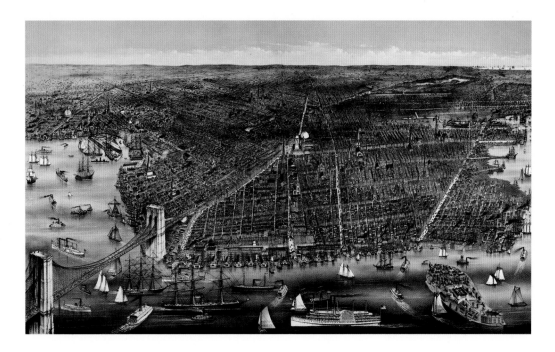

its own police force and fire department, plus hospitals, asylums, and dispensaries solidified Brooklyn's identity as a metropolis on the rise . . . one that might finally overtake its neighbor across the river in power and population.

Brooklyn had been playing reluctant second fiddle to New York ever since the late seventeenth century. Established in 1636 in what the English later named Kings County, Brooklyn was one of five towns settled by the Dutch. Gravesend, the sixth town in Kings County, was founded by English immigrants fleeing religious persecution in Massachusetts. While Manhattan's Dutch colonists were traders and merchants intent on developing commerce, Kings County was a farm town, later known for the quality of its vegetables—"prodigious quantities of which are taken across the water daily," wrote one English visitor in 1830, of all the wagons of produce he witnessed being loaded onto ferries. In the eighteenth century, after the British took control of all of New Netherlands, the people who lived and worked in Brooklyn were largely Dutch and English. About one third of the population were enslaved African

Americans, who toiled on Brooklyn's farms before they were gradually freed between 1799 and 1827, the year the state of New York abolished slavery.

As the nineteenth century continued, the prosperity of the two cities became more entwined. In the 1830s, Brooklyn Heights landowner Hezekiah Pierrepont subdivided 60 acres of land on the bluff overlooking the river and sold them to mansion-building New York businessmen, who were lured by the new steam ferries that swept them to lower Manhattan in twelve minutes. These newcomers helped turn Brooklyn Heights into the first commuter suburb. What started as an enclave of seven houses ballooned to six hundred by the beginning of the Civil War. Fueling more growth was an influx of German and Irish immigrants, who altered the city so much that by 1855, half the population was foreign-born. Germans settled in Williamsburg and Bushwick. The Irish colonized a part of Fort Greene, called Young Dublin, and Vinegar Hill, a working-class neighborhood beside the Navy Yard named for a battle in the Irish Rebellion of 1798. This first wave

of newcomers built vessels in the Navy Yard, worked the docks, and labored in Brooklyn's many sugar refineries, glass factories, iron-works, ropeworks, and breweries.

"Brooklyn people believe that [after] many decades elapse, their city will be more populous than New York," commented one guidebook in 1871, when Brooklyn had more than 400,000 citizens. But to the dismay of residents who hoped to overtake Gotham, Brooklyn's population was dwarfed by the almost one million residents of New York. And despite its industrial muscle, the city's fortunes were largely dependent on those of its neighbor.

"Candor certainly compels the acknowledgment that [Brooklyn's growth] was chiefly attributable to the overflowing prosperity and greatness of its giant neighbor, New York," wrote historian Henry Stiles in his 1869 book *A History of the City of Brooklyn.* "Many thousands of its counted population were scarcely more than semi-denizens," wrote Stiles. "They were the merchant princes, and the master artisans doing business in the metropolis, employing other thousands as clerks, accountants, journeymen and apprentices. . . . Thus Brooklyn held the anomalous position of outnumbering, at night, its day population by tens

of thousands." These semi-denizens were the "flood-tide" Walt Whitman heralded in his 1856 poem "Crossing Brooklyn Ferry"—the "men and women attired in the usual costumes," who labor all day in Manhattan only to return "on the ferry-boats, the hundreds and hundreds that cross," back to various points along the shore of Brooklyn at night.

Whitman often wrote proudly of his beloved city's identity as a middle-class refuge. Whitman moved to Brooklyn as a child and spent a chunk of his adult life there, serving a two-year stint in the 1840s as editor of the *Brooklyn Daily Eagle* (he was fired after clashing with his slavery-supporting publisher). A habitual wanderer of Brooklyn's mishmash of streets that conformed to no overall grid, he was continually energized by the beauty of its "ample hills," seashore, and people. "It may not be generally known that our city is getting to have quite a world-wide reputation," Whitman wrote in *Brooklyniana 7,* part of his series of dispatches about Brooklyn's history, in 1862. "We have now marked advantages for residents. There is the best quality and cheapest priced gas—the best water in the world—a prospect of moderate taxation—and, we will say, for our city authorities, elected year after year, that they

Sugar production was an important industry in Brooklyn in the late nineteenth and early twentieth centuries. Raw sugar harvested in the Deep South and Cuba would arrive at enormous refineries like the one pictured here, the Havemeyer family's American Sugar Refining Company. After it was filtered, the sugar was turned into syrup, then dried, graded, and sold.

To satisfy demands for housing in the booming Brooklyn of the second half of the nineteenth century, prime farmland was sold and developed into blocks of brownstone and brick row houses.

will compare favorably with any of similar position in the United States." That was a jab likely aimed at New York, which was mired in the corruption of Tammany Hall at the time.

Rather than a city with splendid architecture, Brooklyn's greatness was "its hundreds and thousands of superb private dwellings, for the comfort and luxury of the great body of middle class people—a kind of architecture unknown until comparative late times, and no where known to such an extent as in Brooklyn, and the other first class cities of the New World," wrote Whitman. "Why then should not Brooklyn, in the experience of persons now living, become a city of a great million inhabitants? We have no doubt it will." In the Gilded Age, Brooklyn would embrace its identity as a place of prosperity for the middle class, while hoping that the future would bring it power and prestige to rival the great city across the river.

Building a World-Class City

At the start of the Civil War, 40 percent of Brooklyn wage earners crossed the East River into New York for work. As the postwar economy kicked in and a second wave of immigrants moved into the city, the number would only rise. Whether they were rich, poor, or part of the vast middle class, these laborers, clerks, domestics, and lawyers needed homes to return to. And with a manufacturing boom already under way in Brooklyn, thousands of workers who would be filling jobs in factories and refineries would also be seeking a place to live in the city. From Red Hook to Bedford to Greenpoint, farmland was fast being turned into residential neighborhoods. "Twenty-five years ago corn grew on Montague Street—Court Street had no existence, and the fashionable locality of South Brooklyn was but a dreary sand-hill," wrote the *Brooklyn Daily Eagle* on February 16, 1868. Now, "buildings and dwellings have sprung up as if by magic. Long rows of brown stone [*sic*] and brick buildings have risen, seemingly, in the space of a single night. The past year has seen no diminution, and in fact, the new buildings of 1868 exceed in value those of last year."

Rich residents lived in the Heights, on well-tended streets named after their ancestors: Joralemon, Pierrepont, Remsen, Livingston. A commercial sector developed on Montague Street in the 1870s. But the Heights would remain an elite neighborhood of homes, churches, and cultural institutions, like the Brooklyn Academy of Music, which hosted concerts and speaking engagements by national figures like Mark Twain and Booker T. Washington. The Heights wasn't the only moneyed district. On Clinton and Washington avenues, in an area known as the Hill

(soon to be Clinton Hill), "there grew up a fine array of frame and brick villas, set in spacious grounds, with carriage drives and trees, conservatories, flower beds, croquet and tennis grounds, and a combined effect of semi-rusticity," stated an 1890s *Harper's Weekly* article. "This Hill splendor and comfort . . . is the seat of a comfortable circle of those rich who typify the spirit of Brooklyn in their love for their homes, for quiet, and for the charms of nature."

New neighborhoods for the middle and working classes were appearing as well. In South Brooklyn, tidy row houses had sprouted all the way to the dry docks, grain warehouses, and storage facilities of Red Hook and the industrial edges of the Gowanus Canal. "Pretty residential districts," as *Harper's* called them, could be found in East New York, Flatbush, and "along the shore of the Harbor, between Brooklyn and Fort Hamilton." Two African American communities, Weeksville and Carrville, were squeezed out as the surrounding neighborhoods of Bedford and Stuyvesant Heights became posh communities of ornate brownstones. African Americans who were displaced relocated to an existing black enclave near the Hill, to Fort Greene, and to downtown Brooklyn.

Immigrants changed the look of neighborhoods. Swedes and Norwegians lived on Fourth Avenue closer to downtown and near Fort Hamilton in Bay Ridge. Poles opened shops in Greenpoint, Williamsburg, and on Fourth Avenue farther out by Green-Wood Cemetery. Jews also settled in Williamsburg. In his autobiographical novel *Black Spring*, Henry Miller recalled the gritty view outside his working-class family home on Driggs Avenue in the 1890s, where he spent the first ten years of his life. There were "soot-covered walls and chimneys of the factory opposite

us and the bright, circular pieces of tin that were strewn in the street. . . . I remember the ironworks where the red furnace glowed and men walked toward the glowing pit with huge shovels in their hands."

Brooklyn had its slums, particularly along the waterfront, where docks and piers attracted vice and crime. But it also had forward-thinking businessmen who took a cue from the squalid tenement districts of Manhattan and invested in decent housing—especially for the workers in their factories. Alfred Treadway White was a Brooklyn Heights mogul who built "workingman's cottages" and model tenements on Warren and Hicks streets. Constructed between 1877 and 1890, each four-room apartment rented from $8 to $11 a month. In 1886, industrialist Charles Pratt, a Clinton Hill resident, put up apartments for the families of the men who worked for him at his Greenpoint kerosene refinery, Astral Oil Works. The Astral Apartments spanned the length of Franklin Street and were intended for "the widow who has

The Cornell Mansion at 222 Columbia Heights was built in 1865 and exemplifies the type of elegant mansion Brooklyn Heights was known for in the Gilded Age. Brooklyn Heights native Seth Low, who served as mayor of both Brooklyn and New York, lived here.

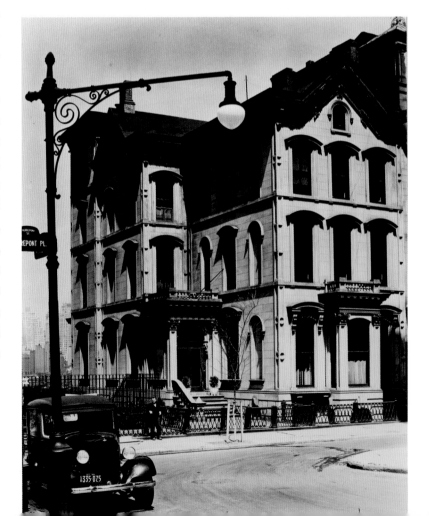

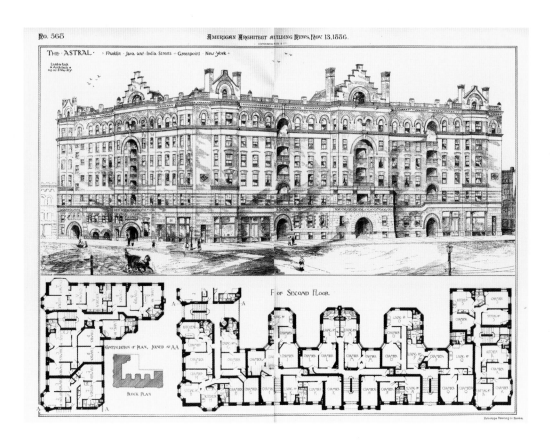

lived in affluence but has been reduced in circumstances," "the shop-girl," "the clerk, or tradesman," and "the great body of first-class mechanics who have families," stated Pratt.

If there was an equivalent street in Brooklyn to Manhattan's Ladies' Mile, it might have been Fulton Street, where dry goods emporiums sold the latest fashions and furniture. Wechsler & Abraham opened in 1865; by 1893 it was renamed Abraham & Straus—the same Nathan and Isidor Straus who ran Macy's. Loeser's department store sold clothes and home goods like artwork, pianos, and carpets. Hurd, Waite & Co. opened in 1884 with thirty-three departments selling clothes, hats, shoes, art, and furnishings. Between the grand stores were smaller boutiques, millineries, bric-a-brac stores, and candy stores. "It is not always easy to pass the streets in the neighborhood of the more showy windows," stated *Harper's Weekly*. "The music of [ladies'] voices beats upon an atmosphere in which

the odor of cologne is perceptible, and the scene is rendered gaudy by the flowers and gay colors that are woven to and fro past the splendor of the window decorations. . . . Carriages are few, men are in a ridiculous minority, and the police gain the appearance of giants among so many women."

Saturdays may have been Brooklyn's main shopping day. But Sundays in Brooklyn were set aside for churchgoing. If New York's social world revolved around society events, much of Brooklyn looked to their church not just for religious uplift but also as a social anchor. With 352 churches by the early 1890s, the nickname "city of churches" was more appropriate than ever. Brooklyn was home to nationally known preachers like Henry Ward Beecher (see sidebar, page 256), who led the city's abolitionist movement in the 1850s and continued speaking out about temperance, suffrage, and other social issues of the day. Beecher spoke from the pulpit

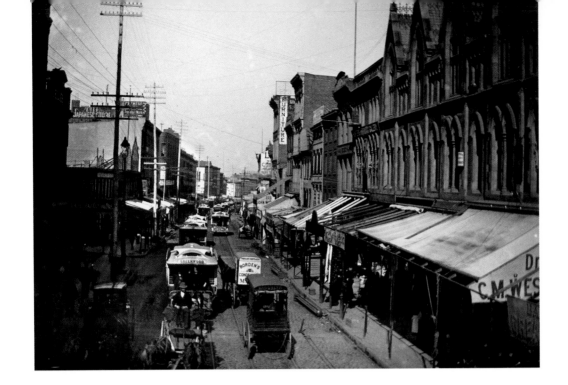

of the Plymouth Congregational Church in Brooklyn Heights, where he ministered to an overflow crowd of thousands, including many who ferried over from Manhattan. Reverend and anti-vice crusader T. D. Talmage attracted so many followers to the Central Presbyterian Church, a tabernacle had to be built on Schermerhorn Street to hold them all. The Brooklyn Sunday School Union Society was held in such high regard that public schools had an annual day off in June to celebrate the society with a holiday known as Brooklyn Day.

While Brooklyn officials continued improving city infrastruture and transportation—

extending elevated railroads and surface railroad lines to Coney Island—they also created public parks. Rural cemeteries like Green-Wood and the Evergreens showcased the city's rolling hills and greenery. But a real park adjacent to the city and accessible to the rest of Kings County (which Brooklyn annexed in 1894) "would become a favorite resort for all classes of our community, enabling thousands to enjoy pure air, with healthful exercise, at all seasons of the year," said James Stranahan, Brooklyn politico and chairman of its Parks Commission. Central Park co-designers Frederick Law Olmsted and Calvert Vaux began work on the 585-acre Prospect Park on a site beside Mount Prospect and opened much of the park to the public in 1867—though the park, with its distinct regions of a meadow, a wooded ravine, and a lake, wouldn't be complete until 1873. Also in 1867, Calvert and Vaux set out to create Washington Park in Fort Greene, which opened to great fanfare in this well-to-do district. More parks, baseball fields, and bicycle lanes were in the planning stages—as was a monumental transportation project that would bring both positive and negative changes to the city.

The East River Bridge Rises

Terrible accident—collision of the Brooklyn ferry boats *Hamilton* and *Union*," screamed a headline in the *New York Times* on November 15, 1868. A boy was killed and eighteen passengers were wounded, the *Times* explained, when a ferry that left Brooklyn at 7:15 A.M. overloaded with a thousand commuters drifted into the path of a departing ferry as it was about to reach its slip in Manhattan. Crowds of riders panicked, causing a deadly stampede. "The terrible accident of yesterday morning has given fresh significance to the bridge movement of last year. Parties interested in that lofty enterprise see new and valuable arguments for the necessity of a bridge over the East River, the plan of which contemplates having one end near the Brooklyn City Hall, and the other near the New-York City Hall."

It was not the first time the routine ferry trip between Brooklyn and Manhattan turned deadly. Even in the best weather, the multiple ferries crisscrossing different routes between the two cities were dangerous. Between 1841 and 1860, ferries had collided at least forty-nine times. Wind, rain, snow, and ice made the two-cent passage especially treacherous;

in the frigid winter of 1866–67, ice choked the East River, stranding boats in the water and making it impossible for workers to get to their jobs for days. "There is no order, no system, nothing to prevent the rushing of hungry hundreds on to the boat, from which other hundreds are trying to escape," an earlier *Times* article complained in July 1867. "The two throngs meet, tussle, squeeze, pick pockets, tread on toes, and idly swear."

The vulnerability of the ferries was a strong argument in favor of constructing an East River Bridge. The idea for a bridge wasn't new; the first proposal dated back to 1802. But advocates had never advanced past the idea stage partly because of the river itself, a deceptively placid-looking tidal strait with currents strong enough to drown swimmers and wreck ships. Even if a bridge could be constructed to withstand the currents, it would have to be tall enough to allow ship traffic to continue undisturbed. The busy harbor was nineteenth-century Brooklyn and New York's biggest money-maker, and vessels of all kinds had to be able to move freely.

In 1867, the state legislature passed a charter that gave the go-ahead for the formation of a private company, the New York Bridge Company, to select an engineer and get started. (Five members were Brooklyn politicians, and the sixth was Boss Tweed, who made sure he received a cut of the money the state agreed to put out for construction.) A brilliant German-born engineer named John Roebling presented plans for a suspension bridge anchored by two 268-foot towers. The

Builders on the Brooklyn Bridge, still missing its roadway and steel lattice. Residents of New York and Brooklyn watched the bridge rise during construction between 1870 and 1883. One of those observers was Walt Whitman, who in 1878 wrote, "to the right the East River—the mast-hemm'd shores—the grand obelisk-like towers of the bridge, one on either side, in haze, yet plainly defin'd, giant brothers twain, throwing free graceful interlinking loops high across the tumbled tumultuous current below. . . ."

They were known as "Beecher Boats," the ferries that departed from the Manhattan side of the East River every Sunday morning, bringing thousands of the curious and the devoted to Brooklyn Heights to hear Dr. Henry Ward Beecher. Beecher, the longtime minister at Plymouth Congregational Church on Orange Street, wasn't just famous in New York; he was the most renowned preacher in America. President Lincoln praised him. Mark Twain and Walt Whitman sat in his pews to witness Beecher's impassioned and energetic sermons, "sawing his arms in the air, howling sarcasms this way and that, discharging rockets of poetry and exploding mines of eloquence, halting now and then to stamp his foot three times in succession to emphasize a point," Twain wrote.

Part theologian and part showman, Beecher brilliantly transformed the stern Christianity of the early nineteenth century into one that was based not on human sinfulness but on a gospel of love. He was further held in high regard because of the national adulation of his sister, Harriet Beecher Stowe, the author of the blockbuster anti-slavery novel *Uncle Tom's Cabin* and a host of other fictional works that appealed to middle America, particularly women. Influenced by Stowe, Beecher became a strident abolitionist. He famously held mock "slave auctions" where he implored his congregants to donate money so the church could purchase a slave's freedom. During the Civil War, President Lincoln sent him on a speaking tour of Europe, during which he won popular support for the Union cause.

After the war, Beecher returned to Plymouth Church, his popularity (and fees he collected from his writings and speaking engagements) at an all-time high. He took on the social causes of the 1860s and 1870s, supporting temperance and suffrage for women. He also became embroiled in a sex scandal in 1872 that shocked his moralistic congregants and became a national obsession. The married Beecher, now almost sixty years old, was publicly accused of carrying on an affair with a congregant named Elizabeth Tilton, who was also married. The accuser was Victoria Woodhull, the spiritualist-turned-women's rights advocate who was running for president that year. In her newspaper, *Woodhull and Claflin's Weekly*, Woodhull wrote, "I intend that this article shall burst like a bombshell into the ranks of the moralistic social camp." She wasn't kidding. Within hours, copies of the *Weekly* were selling for $40 each. Not only did she reveal Beecher's affair, she accused him of being a "free lover" because

Henry Ward Beecher, photographed by Mathew Brady between 1855 and 1865. Beecher popularized "romantic Christianity," which viewed God as loving rather than punishing and judgmental. Nationally known and revered, Beecher was so popular that after his death at age seventy-four in 1887, the city of Brooklyn declared a day of mourning.

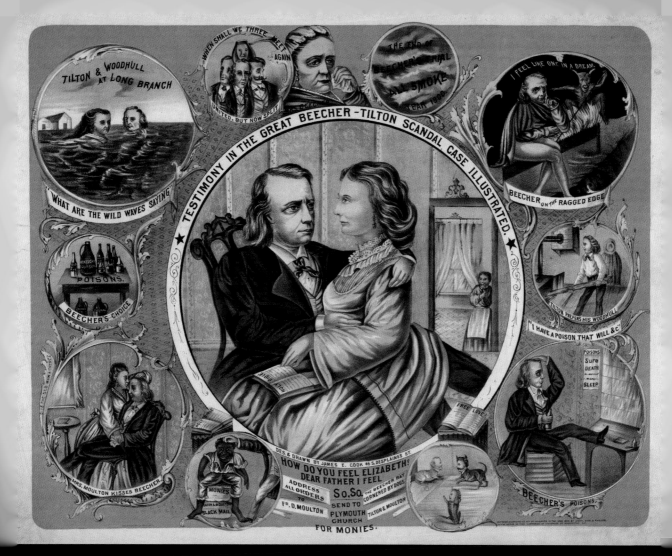

Victoria Woodhull publicly accused Henry Ward Beecher of adultery in a newspaper story she published in 1872. Plymouth Church investigated and cleared Beecher of the charge, but in 1875 the husband of the woman he supposedly had an affair with, Elizabeth Tilton, filed suit against Beecher for adultery. The preacher fought the charges in a long trial that gained national attention. Ultimately the jury failed to come to a decision, and Beecher was off the hook.

he was linked to numerous other women over the years while calling out Woodhull's support of free love.

Woodhull exposed Beecher as a hypocrite. For the next three years, he would be embroiled in a series of highly publicized investigations and trials. The first focused on Woodhull. Anthony Comstock, crusader against vice, pressured the Brooklyn district attorney (who worshipped at Plymouth Church) to have Wood-

hull arrested for sending obscenity through the mail. After three months in the Ludlow Street Jail, she was released without charge. Beecher then had to contend with the angry husband of Elizabeth Tilton. A church committee was appointed to investigate the charges of adultery, which Beecher explained away by saying, "She thrust her affections on me unsought." Tilton's husband sued Beecher for "alienation of affection" in 1875. After a six-month lu-

rid trial in Brooklyn City Court, an undecided jury handed Beecher the equivalent of an acquittal.

Through it all, the Beecher boats kept coming; his popularity never waned. At the top of the to-do list for tourists visiting New York was to witness Dr. Beecher at his pulpit. When he died in his sleep in 1887, Beecher was lionized in newspapers, his sex scandal glossed over. He was laid to rest in a triumphant funeral at Green-Wood Cemetery.

cables holding the bridge would be made of steel, a material that would be vital to New York's future but at the time was untested. With the ferry mishaps in mind, Brooklyn residents threw in their support. Perhaps a bridge would increase property values, as newspaper editorials reasoned, and it might be the key to making Brooklyn a bigger, more powerful metropolis. In March 1869, the *Brooklyn Daily Eagle* wrote that "within less than five years every part of Brooklyn will be within easier reach of the business centre of New York than the upper portion of that city now is. . . . A great future is opening before our city."

Five years, however, was wishful thinking, in part due to a series of tragic accidents. While Roebling was surveying the land at Fulton Ferry, his foot was crushed by a boat. The injury led to tetanus, which killed him in July 1869. His son and partner, Washington Roebling, took over as chief engineer—but in 1872, three years after construction had officially begun, the younger Roebling developed a crippling case of decompression sickness, a mysterious ailment that struck many laborers who worked inside the pressurized underwater chambers known as caissons. Construction continued with Roebling bedridden at his Columbia Street home, where he watched the bridge's progress through a telescope and gave instructions to his wife, Emily, to relay to the engineers. Through the 1870s and early 1880s, residents of both cities witnessed the steady rise of the bridge.

Opening day of the longest suspension span in the world was slated for May 24, 1883. Schools closed, workers took the day off, and thousands of New Yorkers attended ceremonies. Sailing vessels glided under the bridge as bands played, cannons were fired, and fireworks blazed the sky. President Chester Arthur and New York Mayor Franklin Edson walked together to the Brooklyn side, where Brooklyn mayor Seth Low greeted them warmly and told the crowd that "Brooklyn will grow by reason of this bridge, not at New York's expense but to her permanent advantage." Emily Roebling was the first of about 150,000 private citizens to cross the bridge by foot. Residents of both cities were bridge-obsessed. "A clamorous and swelling multitude pressed against the barriers which encircled the Sands Street entrance when the strains of a patriotic air rang through the building which will serve as a depot," wrote the *Brooklyn Daily Eagle* on opening day. "It was all [police] could do with the best efforts of two or three hundred officers to hold the dense and swaying throng in check."

The Brooklyn Bridge finally linked the two "twin cities" of the East River, as poet Emma Lazarus called them. It changed Brooklyn immediately. The ferries still ran, but commuters didn't have to rely on them and instead could take a trolley across the bridge or simply walk. It served as a lifeline to New Yorkers looking for a way to escape the

May 24, 1883, was opening day of the Brooklyn Bridge. Fourteen tons of fireworks were set off in the evening to celebrate. The *New York Times* wrote that the fireworks "broke into millions of stars and a shower of golden rain which descended upon the bridge and the river."

On opening day, the *New York Times* reported, "The pleasant weather brought visitors by the thousands from all around. . . . It is estimated that over 50,000 people came in by the railroads alone, and swarms by the sound boats and by the ferry-boats helped to swell the crowds in both cities. . . . The opening of the bridge was decidedly Brooklyn's celebration. New York's participation in it was meager, save as to the crowd which thronged her streets."

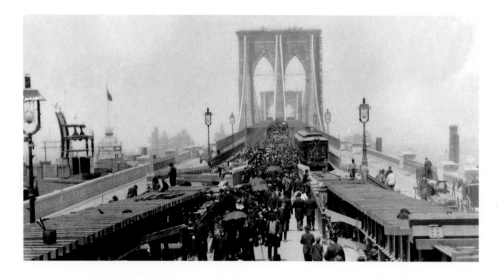

crowded tenement districts yet remain close to the city where they worked. The bridge threaded Brooklyn and Manhattan together, but it was still Brooklyn that was dependent on its glamorous, increasingly vertical neighbor. Though proposals to unite the two cities into one municipality went as far back as 1868, it was now much easier to imagine a day when the two really would become one.

QUEENS
Farms, Then Factories

Manhattan residents may have looked down on Brooklyn as a middle-class bastion. But they barely thought at all of Brooklyn's more rural neighbor to the east. The Queens of the Gilded Age was known for its racetracks, tree nurseries (which supplied many of the great trees in Central Park and Prospect Park), industrialized East River shoreline, and the boardwalk at Rockaway Beach. Queens had other achievements: It was the nation's number one source of produce, and steamboat excursions from Manhattan brought daytrippers to lovely picnic spots close to Long Island Sound. Brooklyn had a long history and deep pride that was reinforced by its sports teams, dense urban neighborhoods, and churches. As pleasant as they were, the many municipalities in Queens were too sparsely populated and spread out to be known for any one thing or to rally as one entity.

Like Brooklyn, Queens was founded in the early seventeenth century by the Dutch. Most settlers were also from the Netherlands, but some English and a contingent of Quakers lived there too—as did African Americans, brought to work on the farms as slaves until New York State put an end to slavery in 1827.

Seth Low: Reform-Minded Mayor of Brooklyn and Greater New York

In a city where political corruption was par for the course, Seth Low was an anomaly—a jovial reformist politician known for being nonpartisan, generous, and efficient. He was ambitious too, doing stints as a charity head, educational leader, president of Columbia University, writer of the consolidated city's new charter . . . and the only man to serve as both mayor of Brooklyn and then mayor of the City of Greater New York.

Born to an educated, well-off Brooklyn Heights family in 1850 (his father, importer A. A. Low, ran Brooklyn's record-breaking Sanitary Fair benefit during the Civil War), Low graduated from Columbia College, made his money in his family's tea and silk business, and then entered public service, heading up the Bureau of Charities in Brooklyn before becoming the Republican mayor of the city in 1881. His term as mayor was marked by the opening of the Brooklyn Bridge in 1883 and the burgeoning progressive movement that sought to overhaul patronage in favor of merit appointments for city workers and invest time and money in housing and education for poorer residents. "Mayor Low's administration has been such an advance upon all previous ones that many people fail to realize it," wrote one Brooklyn newspaper. "No wires are now being pulled to secure a renomination, no men are being put to work in order to vote on election day, but the mayor is making personal visits to the several wards in order to observe their sanitary condition, school accommodations, and the like."

After two consecutive two-year terms in office, Low left in 1885—only to become mayor of

Progressive reformer Seth Low served two terms as mayor of the city of Brooklyn and then one term as mayor of the consolidated city of New York. He wrote, "the great city can teach something that no university by itself can altogether impart: a vivid sense of the largesse of human brotherhood, a vivid sense of man's increasing obligation to man; a vivid sense of our absolute dependence on one another."

New York sixteen years later, a newly consolidated city he enthusiastically supported by helping to write the charter for the new metropolis. His election as mayor in 1901 came in a year that saw backlash against corruption and scandals on the part of Tammany Hall Democrats. Low, a friend of fellow good government crusader Theodore Roosevelt, continued reforming police and public schools while monitoring the beginning of construction for the new subway. His defeat in 1903 (politicians served two-year mayoral terms at the time) signaled the end of his political career. Yet he remained active in public life as an arbitrator between labor unions and corporations and serving as the chairman of the board of Tuskegee Institute, one of the first colleges established for African American students, in Tennessee. "He gave the city a clean and progressive administration along the lines he had successfully introduced in Brooklyn, with the result that he was mentioned for mayor years after he left office in 1903," wrote the *New York Times* in his 1916 obituary.

Colonists willing to farm the rich but boggy soil were awarded land grants, which allowed them to grow grain and vegetables while raising livestock. In 1664, after seizing New Netherlands from the Dutch, the English named the area Queens County. (Until 1898, Queens also included the towns and villages of Nassau County, Long Island.)

For such a regal-sounding place, Queens remained overwhelmingly rural and isolated. Today's Queens sprang from three colonial-era towns: Newtown to the west, Flushing (the name was originally Vlissingen, after a city in the Netherlands) on the east, and Jamaica to the south, where a marshy inlet and scattered small islands made it a magnet for the fishing industry. Just like Kings County, each town in Queens consisted of smaller villages and hamlets, such as Dutch Kills, College Point, Richmond Hill, and Astoria—which was cleverly named for John Jacob Astor in 1839 because the developer hoped it would convince Astor to invest there, the story goes.

Geographically, Queens was at a disadvantage: Though surrounded by water, it was farther from New York Harbor and the downtown city itself, at least compared to Brooklyn. Getting around within Queens was a struggle as well. Small creeks across the land could be traversed by boat to get from one town to another. But it wasn't until the early nineteenth century that private companies came in to build several for-profit turnpike roads. Users had to pay a toll, but the turnpikes made it easier to cart goods around in wagons and carriages, and they forged stronger connections between independent towns and villages. In the 1830s, stagecoach companies established set routes on the turnpikes, and restaurants and taverns popped up where travelers could stop for a rest before hitting the road again.

By the Civil War, Queens was still the country. The entire county had a mere 30,249 residents—in contrast to Brooklyn's bustling 266,661 and Manhattan's incredible 813,669. Slowly, it opened up to outsiders. Flushing became a fashionable, "somewhat aristocratic" enclave, wrote George von Skal in his *Illustrated History of the Borough of Queens*, from 1917. Rich New Yorkers looking for fresh air on the edge of suburbia built mansions there and relied on the new railroad stops to speed them to the ferry and then into Manhattan for work. Jamaica also had a well-to-do contingent living in elegant houses financed by money made in New York. Vernon Avenue in Ravenswood became a short-lived Gold Coast on the East River shoreline. Hallet's Cove, a small inlet in Astoria, earned a reputation as a retreat for serenity-seeking New Yorkers.

For the wealthy, Queens had another draw: horseracing. "Queens has the distinction of being the cradle of horse-racing in America," wrote von Skal. Through the nineteenth century, grand racetracks attracted rich men and women from all across the New York region. The Centreville Course near today's Corona, the National Course close to Newtown, and the Union Course of Woodhaven originally had no grandstands; men would arrive and watch the races on horseback and ladies would view them from their carriages. In the late 1800s, "the Centreville has fallen into disuse; the Fashion, Union, and Long Island tracks are still the scenes of spirited contests between trotters," wrote Junius Henri Browne in 1869's *The Great Metropolis*. "They are not so popular as they once were; for they are out of the way, and the roads leading to them are not desirable."

Labor and Leisure

By the arrival of the Gilded Age, the urbanization of Queens was under way. In 1870, it finally had its first city. Long Island City was created from parts of the villages of Astoria, Ravenswood, and Hunters Point. Factories that had opened along the riverfront before the war—a turpentine refinery, carpet manufacturer, a shipyard, among others—attracted more industry in the postwar bonanza economy. John D. Rockefeller's Standard Oil built enormous looming oil tanks near the shoreline, which was hazardous because the tanks had a tendency to catch fire. ("Another of those great conflagrations which occur as regularly in the neighborhood of Hunter's Point as steamboat explosions on the Mississippi," wrote the *New York Times* of one blaze in 1873.) The new factories were welcomed by a workforce with a high proportion of German and Irish immigrants, who had settled in Queens in the 1840s and 1850s. German beer gardens took over Middle Village; a Prussian band played for thousands at Schuetzen Park in Astoria. The Irish colonized Astoria, Jamaica, Flushing, and the Rockaways.

Queens had become a place of industry, where businessmen and real estate speculators

One of three tollbooths located on Jamaica Plank Road, which was built in 1850 through Jamaica Village and led to the Brooklyn ferry. The tolls were removed after consolidation in 1898.

took over sleepy villages and built thriving municipalities. Two wealthy industrialists went a step further by founding and financing entire company towns. Conrad Poppenhusen was a German immigrant who made a fortune manufacturing rubber. In 1868 he chartered the village of College Point in Flushing and opened a new factory there—along with workers' housing, a boulevard, a rail line, and the Poppenhusen Institute, a community center that offered job training, the first free kindergarten in the nation, a bank, a courtroom, and a library. The point of it all was to improve "the moral and social condition of the working classes" of College Point, wrote the *New York Times* in 1870.

William Steinway, also a German immigrant and the well-to-do head of his family's piano company, bested Poppenhusen's generosity. Steinway was looking for a place to build a new piano factory, and he found it on 400 acres of pristine land near Astoria. Besides building the factory, he created a new village, called Steinway, with warehouses, a lumberyard, and a foundry. He built employee housing he described as "country homes with city comforts" and a

Hard rubber baron Conrad Poppenhusen turned isolated College Point, Queens, into a factory town of rubber manufacturers, homes for workers, schools, and his Poppenhusen Institute—a community center with its own police station, courthouse, and the nation's first free kindergarten.

On a triangle of land is Steinway Piano Factory number 3, part of the enormous Steinway factory complex occupying the newly named enclave of Steinway Village, part of Long Island City.

drew thousands of city dwellers looking for a break during the "heated term," as summer in New York was known. "Rockaway to the middle classes is what Long Branch is to the fashionables," wrote the *New York Times* in 1894. Golf and tennis clubs, vaudeville houses, and "moving picture" theaters entertained visitors as well. "Society leaders, princes of finance, politicians . . . in fact, the world, his wife and his sweetheart, have a recurring or permanent regard for the Rockaways, which they make their summer resort or regular home," was the way one guidebook put it. It wasn't quite the sensory experience of Coney Island, but for many working New Yorkers, the surf, sea breezes, and pleasure haunts of Rockaway Beach were close to heaven.

network of railroads, trolleys, and horsecars so workers could navigate their neighborhood. He bought a nearby estate that became his summer home; for his employees and the public he constructed an amusement park on Bowery Bay, called North Beach, as an alternative to tawdry Coney Island.

Better ferry service and rail connections also helped Queens shed some of its rural feel. In 1854, a Long Island Railroad station at Hunters Point connected riders to Flushing, while a new ferry from Hunters Point to Manhattan's East 34th Street and James Slip in Lower Manhattan was launched in 1859 and 1861 respectively. The Hunters Point ferry eased the congestion on an older ferry line that crossed the East River from Astoria. And when the railroad was extended to Rockaway Peninsula in the 1870s, what had been a small beach resort accessible only by a long trip on the ferry and then a stagecoach was now easily reached by train.

Far Rockaway's hotels, boardwalk, and amusement parks—like Seaside Park—

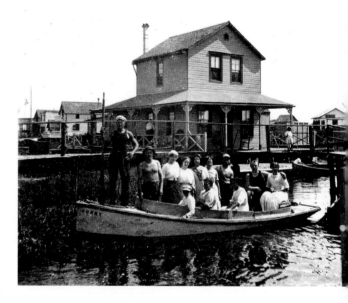

In the 1880s, Broad Channel became a stop on the new railroad running to Jamaica Bay, Queens. Broad Channel grew into a bayside resort enclave with hotels and pleasure boats.

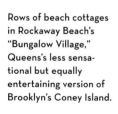

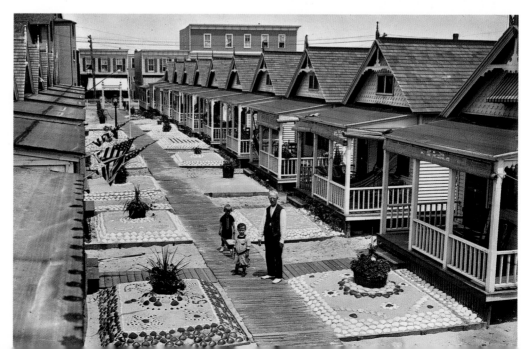

Rows of beach cottages in Rockaway Beach's "Bungalow Village," Queens's less sensational but equally entertaining version of Brooklyn's Coney Island.

STATEN ISLAND
New York's Rural Retreat

In 1889, the southern-most town on the Staten Island Railroad was Tottenville. Unlike the north shore of Staten Island, which was becoming more industrial, Tottenville remained an enclave of oystermen and "pretty houses," as one nineteenth-century guide described it.

In the spring of 1894, with the city in the grip of a terrible depression and the vote on consolidation still three years away, Staten Island was discovered by New York. "Staten Islanders all believe that it is New-York's most attractive suburb," wrote the *New York Times* in April. "They have believed this for several generations. . . . but New-Yorkers have been slow in finding out what to those who know has seemed a truism." Financial distress had driven city residents to seek cheaper housing on Staten Island, a real estate man told the *Times*. Now, "hundreds of families from upper New-York and Harlem are coming down here this year with the desire to secure better homes and more conveniences than they could have in the city. The net result is that the boom, which we have always known was sure to come, is upon us now, when, perhaps, we least expected it."

It took more than two and a half centuries, but Staten Island was finally having its moment—transitioning from a rural county of oyster fishermen and vegetable farmers to a potential suburb with industry, commerce, and a substantial middle class. "For people who desire to live economically and yet be close to their places of business and the shop, Staten Island certainly offers remarkable attractions," continued the *Times*. "The contrast between the bustle of lower Broadway and the quiet beauty of the villages at the other end of the ferry is remarkable, and impresses one so favorably at the first visit that a desire to return and occupy one of the pretty cottages seen on every hand is sure to be created."

Staten Island shares a similar history to that of the other former colonies of New Netherlands. The first permanent European settlement (of 19 Dutch and French colonists)

Alice Austen: Staten Island's Pioneering Photographer

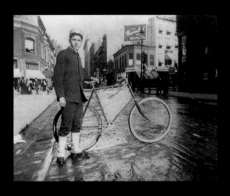

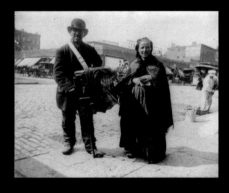

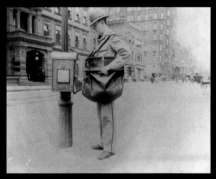

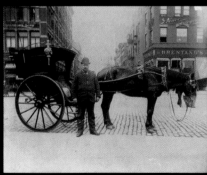

As an only child growing up with family money in a refurbished Dutch farmhouse overlooking the narrows on Staten Island, Alice Austen might have been expected to make her debut into society and then marry well. Instead, she fell in love with photography. In 1876, a sea captain uncle brought her her first camera, a wooden box with a tripod. Just twelve years old, Austen took to it immediately and began experimenting in a makeshift darkroom she fashioned out of a closet in her family home.

At a time when photography was so new that its potential as an art form was still in question, Austen was creating exquisite and naturalistic images of her comfortable upper-class life: her friends on the lawn of her home, Clear Comfort; parties in her parlor, dancing school, beach outings, and sporting events at the Staten Island Cricket Club. She and her young friends seem to epitomize the sporty,

active "new woman" archetype. By her early twenties, she turned the camera toward New York's struggling classes. Few women pursued photography because the equipment needed at the time was heavy and hard to carry around. Austen lugged her tripod, camera, and other gear across on the ferry to Lower Manhattan, where she captured newsboys, bike messengers, vendors, street musicians, and others she approached beside the harbor and grimy streets. Those images were collected in a portfolio in 1893 called "Street Types of New York City."

Throughout her life, Austen took more than eight thousand images chronicling the world, never paid for her work but doing it out of her love of the craft. Yet she always returned home to Clear Comfort and her quiet life with Brooklyn schoolteacher Gertrude Amelia Tate, her companion. Her images of lower-class Manhattan residents reveal a gentle humanity amid poverty, and her chronicles of upper-class Staten Island are testaments to what life was like in the city's smallest and most rural borough before it was fully suburbanized.

After photographing her friends and relatives enjoying upper-class pursuits such as lawn tennis and picnics near her home on Staten Island, Alice Austen turned to more serious subject matter. At the request of the U.S. Public Health Service, she documented the new immigrants held at the Quarantine Hospitals on Swinburne and Hoffman islands. She also ventured into Manhattan to capture images of poor and working-class men and women who eked out a living in low-level jobs like bicycle messenger (above), postman (above), organ grinder (above), and hansom cab driver (above). She collected these photographs into a portfolio, "Street Types," but otherwise never appeared to have tried to sell her work.

was established in 1661. Three years later, New Netherlands was the 102-square-mile island, with sandy beaches surrounding high hills and marshy grasslands, taken over by the English in 1683 and renamed Richmond County. (The new name didn't quite stick.) Divided into four original towns and numerous tiny villages, Staten Island's population by the early eighteenth century was just eight hundred, which may not have included the African American slaves who labored on farms. Surrounded by New York Bay on one side and tidal straits known as "kills" (the Dutch word for creek) on the other, the only way to get to and from Staten Island was by ferry.

By the mid-nineteenth century, Staten Island had attracted a diverse manufacturing base. Shipbuilding, textile dye factories, breweries, a brickworks company, the nation's first linoleum factory, and a Goodyear rubber facility established themselves on the north and south waterfronts. Factory owners took advantage of the bays and kills surrounding the island that made it relatively easy to ship fin-

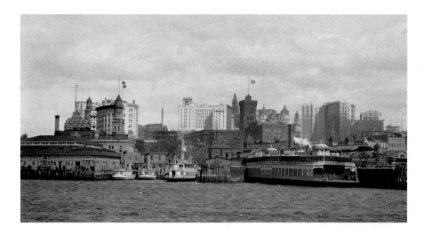

ished goods out to Manhattan or New Jersey. Industry attracted German, Irish, and English immigrants, as well as African American oyster fishermen from Virginia and Maryland, who helped make oyster harvesting big business in oyster-crazed Greater New York. These newcomers changed the face of an island that was once almost exclusively Dutch and English.

Immigration was a divisive issue on Staten Island, and it led to an ugly episode. The New York Marine Hospital, outside of Tompkinsville on the north shore, was the city's quarantine hospital, where immigrants showing signs of illness had to disembark from

The Staten Island Ferry at a Lower Manhattan pier at the foot of Whitehall Street in 1900. While bridges linking Brooklyn and Queens to Manhattan had been built or were in the planning stages, Staten Island remained accessible only via the ferry—until the Verrazano-Narrows Bridge connecting Staten Island to Brooklyn went up in the 1960s.

The white marble Randall Memorial Church at Sailors' Snug Harbor, a facility dedicated in 1801 to "aged, decrepit, and worn-out sailors" by shipping merchant Robert R. Randall. Fifty-five buildings joined the complex throughout the nineteenth century, including living quarters, a sanitarium, music hall, and hospital. At the turn of the century, approximately one thousand sailors lived at Snug Harbor, on Staten Island's North Shore.

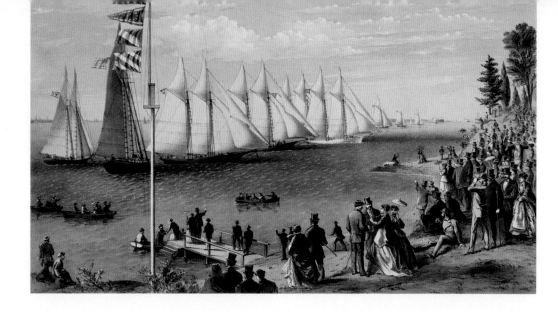

The traditional starting point for the New York Yacht Club's annual regatta was on the eastern shore of Staten Island beside the Narrows, as seen in this Currier & Ives lithograph from 1869.

their ship before the rest of the passengers were allowed to proceed to New York. After Staten Island endured a deadly yellow fever epidemic in 1853, residents began to blame and resent the hospital—and burned it to the ground in 1858. This act "resulted in a proclamation declaring the island to be in a state of revolt, and its occupation by several regiments of militia," explained *Harper's Weekly*. The "Quarantine War" ended with the building of two new hospitals on manmade Hoffman and Swinburne islands on Staten Island's southern shore.

Yet even with an influx of newcomers and industrialization, Staten Island's population in 1870 hovered around only 33,000 people. They were concentrated at the northern end of the island in towns and villages—that were closest to the ferries traveling between Brooklyn, New York, and Perth Amboy, New Jersey. Some wealthy New Yorkers occupied country estates or vacation villas on the bluffs overlooking New York Harbor, like Cornelius Vanderbilt, a Staten Island native (see sidebar, page 268). The dependence on a ferry ride twice as long as the one to Brooklyn may have scared away some potential Manhattan residents, especially after the boiler on one ferry docked in a slip in Manhattan ferry exploded in 1871, killing at least 40 people. The disaster dominated newspaper headlines for weeks.

Other well-to-do city dwellers began making regular trips for recreation purposes: to visit the boardwalk and amusement park at South Beach, to take in a baseball game at the new stadium at St. George, or to play sports. "Staten Island has always been looked upon as the home of the athlete," stated an 1887 magazine article. "During the summer months the ranks of the residential population are very largely increased by the addition of hundreds of lusty young fellows devoted to the pursuit of base ball and cricket, of lawn tennis, yachting and rowing, who find on the grassy meads of the beautiful island the space for their favorite games that the bricks and mortar of Manhattan Island begrudge them."

It wasn't until the end of the Gilded Age that Richmond began resembling something akin to suburbia. "Staten Island is certainly a charming suburb, and well deserves the influx of the population it is receiving this year," concluded the 1894 *Times* article. "It is so convenient to the city, and so well supplied with city comforts, yet is so thoroughly countrified in its wide stretches of hill and valley, its great lawns and gardens, and its attractive villas, that its future seems certain. Unless land values increase too rapidly, it will soon be thickly dotted with the homes of New-Yorkers of the substantial upper and middle classes."

Cornelius Vanderbilt Launches the Staten Island Ferry

When he died in 1877, Cornelius Vanderbilt was the richest man in the nation. One of the first robber barons of post–Civil War New York, Vanderbilt made his astounding $100 million fortune in shipping and transportation, building and creating a national network of ship travel and railroads for freight and passengers. His descendants dominated the business and social worlds of the Gilded Age; their Fifth Avenue mansions were showcases for the family's wealth and power. And it all began when this shrewd and calculating businessman began operating a ferry line in New York Harbor from Staten Island to Manhattan.

Vanderbilt was born on Staten Island's North Shore in 1794, in a farmhouse overlooking the Narrows separating the island from Manhattan. The rocky spit of land, closer to New Jersey than New York, was populated with a collection of small Dutch and English villages near the harbor to the north, and with farms farther south. In this era before steamships, shallow sailboats called periaugers operated by private citizens were used to transport passengers and goods to and from Manhattan, Brooklyn, and New Jersey. Vanderbilt's father, a farmer, operated one of the ferries, and his son picked up the trade as a teenager. By the time he had his own boat, he charged eighteen cents per trip to Manhattan.

In the 1830s, Vanderbilt built up a fleet of powerful steamships that began plying the waters. He wasn't the only steam ferry operator, but he may have been the most ruthless, always undercutting his competition. In the 1840s, his ferry service, which changed hands and ultimately became the Staten Island Ferry when the city took over the route in 1905, opened up this rural, semi-isolated island to development and population growth.

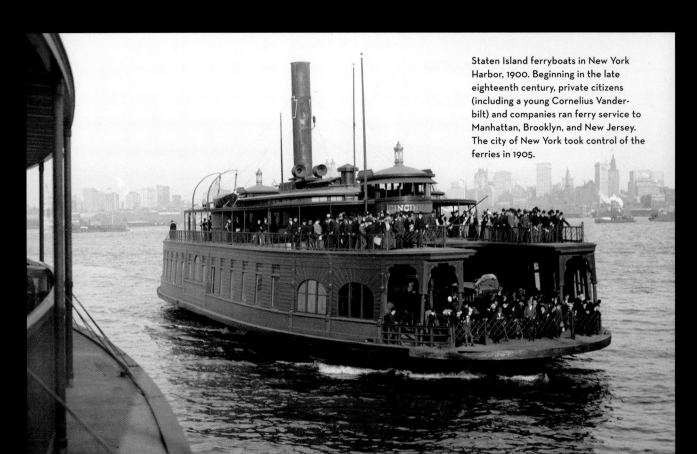

Staten Island ferryboats in New York Harbor, 1900. Beginning in the late eighteenth century, private citizens (including a young Cornelius Vanderbilt) and companies ran ferry service to Manhattan, Brooklyn, and New Jersey. The city of New York took control of the ferries in 1905.

THE BRONX
The "Annexed District"

For almost two hundred years, the municipalities that make up today's Bronx belonged firmly to Westchester County. Westchester and Eastchester were the first towns in this territory north of the Harlem River. The rest of the Bronx was composed of four former manors that had been owned by well-to-do families: Pelham, Morrisania, Phillipsburg, and Fordham. Like the towns and villages of Brooklyn, Queens, and Staten Island, they were rural outposts surrounded by farms that grew wheat and vegetables and raised cattle. The Bronx was a relative backwater before the nineteenth century. Boston Post Road, a colonial-era mail route that began in lower Manhattan and wound through what later became the town of Kingsbridge. Stages took travelers across the bridges of the Harlem River to Manhattan, a long and precarious ride in bad weather.

By 1830, the Bronx had just 3,023 residents—but the population was about to surge. Huge public works projects like the Croton Aqueduct and High Bridge were launched in 1837. Immigrant laborers from Ireland and Germany found work there, and thousands of these newcomers settled in the nearby towns and villages of the Bronx. They soon opened saloons and breweries; many became shop owners.

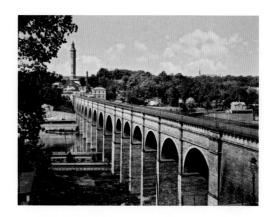

When the New York and Harlem Railroad cut through the Bronx by 1840, everything changed. New villages such as Melrose, Tremont, and Riverdale popped up along the railroad tracks. Towns were established, too: West Farms in 1846 and Morrisania in 1855. Resort communities across the East River, like Clason Point, began catering to new residents, offering hotels, amusements, and entertainment. Financiers Leonard Jerome and August Belmont built the luxurious Jerome Park Racetrack in Fordham, a magnet for wealthy sporting men and accessible by train. "The price of admission is high, but the grounds are thronged with vehicles and persons on foot," observed James McCabe in 1872.

In 1874, the state annexed Morrisania, West Farms, and Kingsbridge to New York as new wards of the city. It was the first move

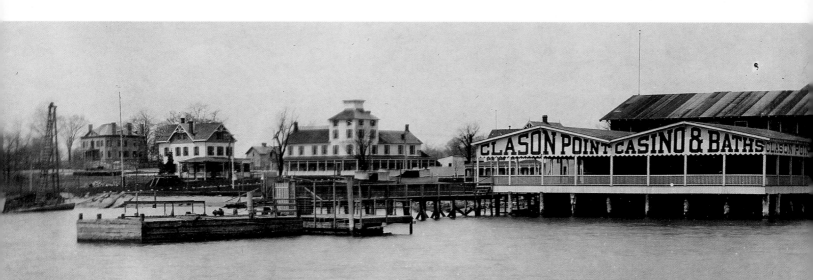

New York's Rural Cemeteries

Rolling hills, miles of carriage drives, trees and ponds to inspire relaxation and contemplation—before a massive wave of park-building took hold in New York City in the late nineteenth century, city residents found peace and relaxation in the "rural cemeteries."

Built from the 1830s to the 1860s in Brooklyn, Queens, and the Bronx after a city law banned burials south of 86th Street, these cemeteries weren't just for the dead but the living as well. Even after city parks went up, the rural cemeteries remained popular venues.

GREEN-WOOD CEMETERY

Brooklyn's oldest rural cemetery was established in 1838 and became "the place where its people long to sleep when 'life's fitful fever' is over," wrote one observer. This 400-acre necropolis on the heights above New York Bay was

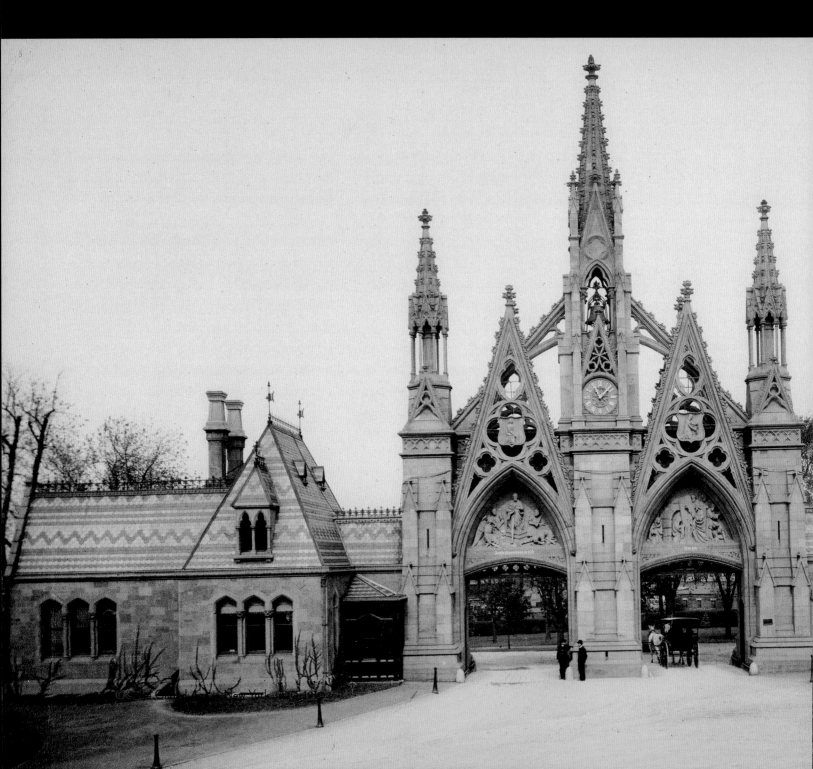

second only to Niagara Falls as the nation's biggest tourist attraction. Preacher Henry Ward Beecher, *New-York Tribune* founder Horace Greeley, Ward McAllister, and Boss Tweed are buried there—though Tweed's corpse somehow got past the cemetery rule that forbade the burial there of anyone who had committed a crime or served time in prison. A monument to 103 people whose remains could not be identified in the aftermath of the Brooklyn Theatre Fire in 1876 stands not far from the Gothic front gatehouse.

WOODLAWN CEMETERY

When the hills and woodsy landscape of this burial ground opened in 1865, the Bronx was still part of Westchester County, and funeral trains could be arranged to bring wealthy Manhattan families to a burial site. An avenue going from Central Park to Woodlawn was planned, according to one guide, but never built. Alva Vanderbilt Belmont and Elizabeth Cady Stanton sleep here.

THE EVERGREENS CEMETERY

Remains of some victims of the Triangle Shirtwaist Fire in 1911, the General Slocum disaster of 1904, and the Brooklyn Theatre Fire of 1876 rest at the Evergreens, established in 1848 on the border of Kings and Queens counties.

Two very different men are buried here as well: Tony Pastor, whose famous vaudeville theater on 14th Street entertained the city, and Anthony Comstock, the anti-vice crusader whose 1873 Comstock Law made it a federal crime to give out information about birth control. Many of the tombstones feature German names, a reflection of the enormous German population that moved into Eastern Brooklyn in the late nineteenth century.

CYPRESS HILLS CEMETERY

During the Revolutionary War, the high land and ocean views on this site on the border of Brooklyn and Queens made it an excellent military fortification. Seventy years later it became a burial ground. Interred here are veterans from all major wars, fallen policemen, and the remains of Confederate soldiers held as prisoners of war in and around New York.

Green-Wood Cemetery's Gothic front entrance, 1836. Half a million visitors came to the cemetery annually in the 1860s for carriage rides, quiet contemplation, and sculpture viewing among the cemetery's rolling hills, valleys, ponds, and paths. Its popularity inspired Brooklyn to embark on building a true public park, Prospect Park.

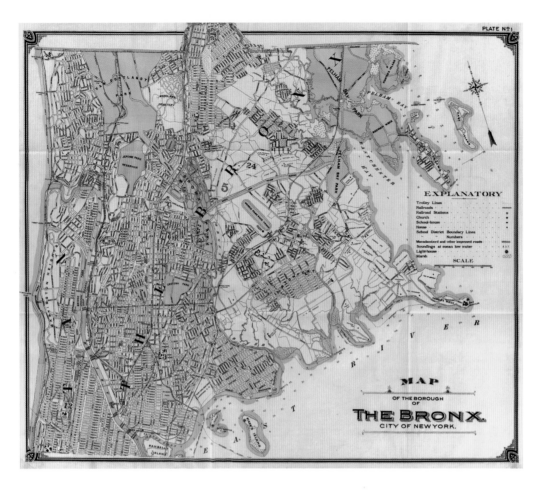

EXPLANATORY

Trolley Lines
Railroads
Railroad Stations
Church
School-house
House
School District Boundary Lines
 Numbers
Macadamized and other improved roads
Soundings at mean low water
Lighthouse
Marsh

SCALE

MAP
OF THE BOROUGH
OF
THE BRONX.
CITY OF NEW YORK.

The Bronx in 1900, after it was annexed in fragments to Manhattan and then the new consolidated metropolis.

toward consolidating different municipalities into Greater New York. The metropolis was inching northward, and by annexing land from Westchester, the boundaries of the city could easily expand to accommodate the growing population. "The increase of this City will within a short period, without doubt, require most of the area included within the southern part of Westchester for the homes of her artisans and merchants," predicted the *New York Times* in 1869. Businessmen, too, would need to build homes in "the southerly part of Westchester," the *Times* added.

While the city wrestled with consolidation, the Bronx was undergoing a rapid transformation from country to suburb. Elevated trains that had been extended on Third Avenue past Harlem were bringing thousands of new residents desperate to escape the teeming tenement districts. Apartments and houses were going up; a proposal for an elegant boulevard called the Grand Concourse was in the works. Plans for Bronx Park were also being considered, which would bring a zoo and botanical garden to undeveloped land beside the Bronx River. These wouldn't be built until all of the towns of the Bronx were annexed to New York in 1895, and consolidated in 1898. But unlike the population of Brooklyn, the approximately 89,000 people living in the soon-to-be borough of the Bronx had nothing to lose and no plans to resist.

The Rocking Stone is an Ice Age relic, "so nicely balanced that a very slight exertion will rock it upon its base," according to the *New York Times*. Found in Bronx Park, this 7-foot-tall, 30-ton cube of granite sits inside the Bronx Zoo, which opened in 1899.

The Modern Metropolis Comes Together

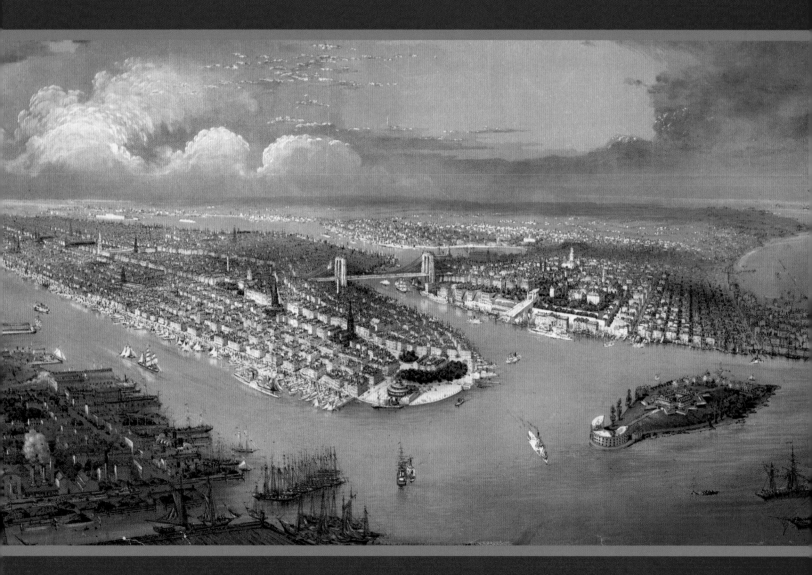

A bird's-eye view of New York, approximately 1880–1890. By now, Manhattan Island is urbanized all the way up to Yorkville and into Harlem. Brooklyn's houses, streets, and church steeples stretch far into Kings County. The Queens waterfront is also ablaze with light and activity from factories and other buildings. Consolidation looms on the horizon.

The "White Hurricane" Wallops New York

Sleet began icing the streets late in the afternoon. It was March 11, 1888, a Sunday, and the noontime temperature had clocked in at forty degrees. The winter had been relatively warm, and the official forecast—made from the roof of the five-story Equitable Building at 120 Broadway—called for a day of clouds and light rain. Instead, New York watched as a wintry mix of snow and rain came down, whipped by an increasingly frigid wind.

By early Monday the sleet had turned to snow, and the temperature fell to twenty-one degrees. Wind gusts of up to seventy-five miles per hour carried snowdrifts so high they were hard to distinguish from the heavy gray clouds. "When dusk came there was no abatement of the fury of the blizzard," wrote the *New York Sun* on March 13. "It howled more and more loudly, accentuated by the darkness and absence of all distracting sounds. . . . The city went into its gas-lighted rooms and its heated houses, and its parlors and beds tired, wet, helpless, and full of amazement."

By 7:00 A.M., trains running in and out of the city were stuck: Thousands of trapped passengers waited for help in unheated cars on snowy elevated tracks. Enterprising men and boys reportedly hoisted ladders to the platforms and charged from twenty-five cents to a dollar to help riders escape. The storm continued all day. Shop girls stranded at Macy's napped on mattresses in the furniture department. "The girls thought it great fun to camp out in that fashion at first, but before morning doubtless many of them wished they were home," according to a report by the *New York Sun*. Cafés, hotels (including the exclusive Hoffman House at Madison Square), and saloons kept their doors open—some throwing champagne parties, others offering cheap booze to marooned customers. Two-thirds of Manhattan's light poles came crashing down, leaving live wires in the streets; power company officials decided to turn off electricity to preempt greater catastrophe. Gas streetlamps were blown out by the wind, or they stopped working when the cold froze gas lines, which were

After a storm, piles of snow remain on Broadway between 29th and 30th streets in this 1905 photo. Removing snow was the job of the Sanitation Department, which relied in part on unemployed men looking to earn extra cash to shovel it away from roadways.

The Grand Opera House, on Elm Place and Fulton Street in downtown Brooklyn, was buried in snow after the "White Hurricane" took the region by surprise in 1888. With the city at a standstill, coal and milk in short supply and railroads not running at all, the *Brooklyn Daily Eagle* urged city residents to "preserve a cheerful temper and to lend a helping hand."

mostly aboveground. As a result, the city was plunged into darkness. The only connection to the outside world was the transatlantic cable buried underground.

The five-year-old Brooklyn Bridge had to be closed to pedestrians, and locomotives were attached to the cable cars to power them back and forth across the bridge, in an effort to keep some traffic moving. "About the bridge the blizzard roared with terrific violence," wrote the *Brooklyn Eagle*. "It held the great structure croaking in its freezing grasp for hours, burying it under snow, pelting it with hail, seeming to tear it from its fastenings with tremendous power, so that the poor policemen who were obliged to stay upon the structure, felt momentarily that the whole vast iron span was about to be precipitated into the invisible river below. It was a night of such wildness that the bridge men had never seen before."

Late Monday night the gas jets in tenement houses went off, and coal to heat stoves was in short supply. "Coal delivery stopped with the blizzard and the grocer's coal bin was soon depleted," reminisced one New Yorker who had experienced the storm as a boy living in a tenement near West Broadway. "There was much suffering for want of coal." Pipes that brought water to communal hallway sinks froze. No one wanted to go out in the blizzard, so tenants dumped their garbage "and worse" into the sinks.

The ferocity of the storm caught Gotham very much off guard. "The angry wind nipped at the hands of pedestrians, knifed through their clothing, froze their noses and ears, blinded them, hurled them backward into the slippery snow, its fury making it impossible for them to get to their feet, flung them hatless and groping for support against the walls, or left them to sleep, to sleep forever,

under the snow," wrote José Martí, the exiled Cuban poet, in a dispatch to the Spanish-language newspaper *La Nación*, which was based in Buenos Aires.

Early Tuesday morning, with the thermometer registering one degree, the blizzard had ceased. New Yorkers began digging out. The Brooklyn Bridge reopened—but the walkways were so jammed, hundreds of people decided to walk across ice floes in the river instead. It took a week for regular train, telegraph, telephone, and garbage collection service to resume. "New Yorkers, especially in the poorer and congested neighborhoods, had simply dumped their garbage into the streets," remembered one resident who witnessed the blizzard from Stuyvesant Square.

Two hundred residents were killed initially, while many more died later from injuries sustained during the storm. One casualty was Roscoe Conkling, a former Republican senator who could not find a cab and was forced to walk from his Wall Street office to the New York Club at Madison Square. After a harrowing journey through darkness and snowdrifts, he made it to the club—but ignored the cold that he had caught when he was exposed to the elements, and died a month later of pneumonia.

The twenty inches of snow that fell didn't break records. This blizzard left its mark in a different way—by revealing the inadequacies of New York's infrastructure. "People vexed

To get the city moving again after the blizzard, snow had to be carted by horse to be dumped into the rivers. "Through the white hummocks move leagues of men. The snow already runs in dirty rivers in the busiest streets under the onslaught of its assailants. With spades, with shovels, with their own chests and those of the horses, they push back the snow, which retreats to the rivers," wrote Jose Martí in *La Nación* in 1888.

at the collapse of all the principal means of intercommunication and transportation became reflective, and the result was a general expression of opinion that an immediate and radical improvement was imperative," wrote the *New York Times* on March 13, 1888. "Now, two things are tolerably certain—that a system of a real rapid transit which cannot be made inoperative by storms must be straightway devised and as speedily as possible constructed, and that all electric wires—telegraph, telephone, fire alarms, and illuminating—must be put underground without delay."

Prior to the blizzard, officials had mandated that the unsightly, potentially dangerous network of wires roping the city be buried underground. Western Union, the Brush Electric Light Company, and other big communications companies, however, fought the city, unwilling to pay the extra cost. The wires would become a focal point of the 1888 mayoral election, as politicians were hitting back. After Mayor Hugh Grant was inaugurated in January 1889, his administration launched a strong battle against the companies that had resisted the city's efforts to put the wires underground years earlier. While legal injunctions kept the wires on city streets through much of the year, a gruesome

accident in October shifted the fight drastically. In broad daylight, a workman high up on a telegraph pole at Chambers and Centre streets touched a live wire. In an instant, flames shot from his mouth and nose, and smoke curled around his hands. For thirty minutes his lifeless body hung on the wires in front of a horrified crowd before he could be safely removed. "The accident, unfortunate and sad as it was, will undoubtedly have a beneficial result," wrote the *New York Times*.

The blizzard focused the city's attention on the vulnerability of the thousands of wires that filled the skies, seen here on Wall Street. As ice and snow built up on wires, some began to snap. Power companies shut down service, plunging the city into darkness and cutting off communication.

"Occurring as it did almost within the shadow of City Hall . . . it was witnessed by so many prominent persons connected with the City Government and interested in its affairs that the imminent danger of longer permitting electric lighting wires to remain above ground was brought home with the most effective force. Action must quickly follow." It did; the accident helped sway the courts to force the communications companies to bury the wires underground, a process that was fully completed two years later.

A month and a half before the blizzard, Mayor Abram Hewitt had proposed that the city borrow $50 million to build an underground network of electricity-powered trains. His idea floundered. But with fresh memories of halted trains and a paralyzed city,

New Yorkers were ready for a transit system designed to withstand storms, similar to the one in London. A public referendum in 1894 came down in favor of approving the funds to develop the new subterranean system.

The Blizzard of 1888 tested the city. Its infrastructure failed—yet residents persevered. "For two days, the snow has had New York in its power, encircled, terrified, like a prize fighter driven to the canvas by a sneak punch," Martí, *La Nacion* correspondent, wrote after the storm finally let up. "But the moment the attack of the enemy slackened, as soon as the blizzard has spent its first fury, New York, like the victim of an outrage, goes about freeing itself of its shroud . . . Man's defeat was great, but so was his triumph."

"Beautiful, Fairy-Like Electric Light"

In the mid-1880s, New York's new electrical illumination—emanating from streetlights, hotel lobbies, theater facades, and billboards—dazzled the senses. Residents and visitors alike were absolutely enchanted. "The effect of the light in the squares of the Empire City can scarcely be described, so weird and so beautiful is it," wrote one British traveler in 1882. Light was "thrown down upon the trees in such a way as to give a fairy-like aspect."

The first electric street lamps were installed along Broadway from 14th Street to 26th Street in 1880. Built by the Brush Electric Light Company and powered by a small generating station on 25th Street, they

offered a cleaner, whiter illumination than the gaslights that had lit the city since the 1830s. The tangle of black wires festooned to wooden poles that carried the electricity may have been an eyesore, but the light itself was captivating.

A reporter from the *Truth* standing at Broadway and 19th Street watched the first lights as they were switched on December 20, 1880. He described it in vivid detail: "the newborn light burst forth, shedding its white splendor over the thronged thoroughfare and bringing out on the stone pavement innumerable sharply cut silhouettes that sped along in a fantastic manner, dancing, swaggering, gliding, and many passersby turned

their heads and rolled their eyes to see their shadowy outline."

Electric light was not only alluring, but also made the city feel safer. Powerful arc lamps perched on a 160-foot tower illuminated the streets surrounding Madison Square Park, packed with shoppers and theatergoers. Blinding arc light created a sense of safety, but it was so harsh that women complained it gave their skin a ghostly pallor. Security trumped vanity, however, and seventy arc lamps were installed along the new Brooklyn Bridge when it opened in 1883. By 1886, 1,500 arc lamps illuminated the city. After the Statue of Liberty was dedicated that October, arc lights in the pedestal and torch shined so bright that the statue served as an official lighthouse, visible 24 miles out to sea.

Though outside attractions and large indoor spaces continued to rely on arc lights, Thomas Edison's new incandescent bulbs were favored indoors. The warmer, softer glow made rooms, faces, and objects appear more magical. By the 1890s, many newspaper offices, the New York Stock Exchange, and department stores were lit by these "little globes of sunshine," as one publication called them. Edison's company began selling electricity to private customers, with J. P. Morgan among his earliest subscribers. The days of the lamplighters, men who carried ladders and turned on and off the gas streetlights manually, were numbered.

New York's light became a metaphor for the city's energy—a metropolis that never slept, blasted colorful advertisements on multistory billboards, and as of January 1, 1908, celebrated New Year's Day by dropping a brilliant ball decorated with one hundred lightbulbs in Times Square. A gas- and oil-lit city that once mostly shut down at dusk now pulsed until dawn. Light allowed factories and

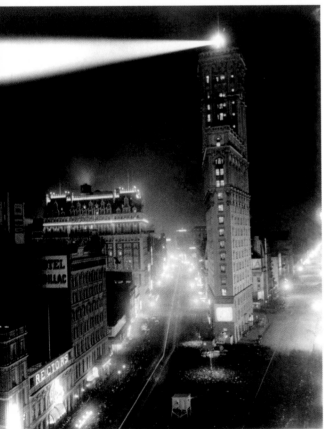

Broadway south of 42nd Street in 1908. The *New York Times* chronicled the new tradition of dropping an electric ball in Times Square to ring in the new year. "Tens of thousands stood watching the electric ball. And then—it fell. The great shout that went up drowned out the whistles for a minute. The vocal power of the welcomers rose above even the horns and the cow bells and rattles. Above all else came the wild human hullabaloo of noise, out of which could be formed dimly in words: 'Hurrah for 1908.'"

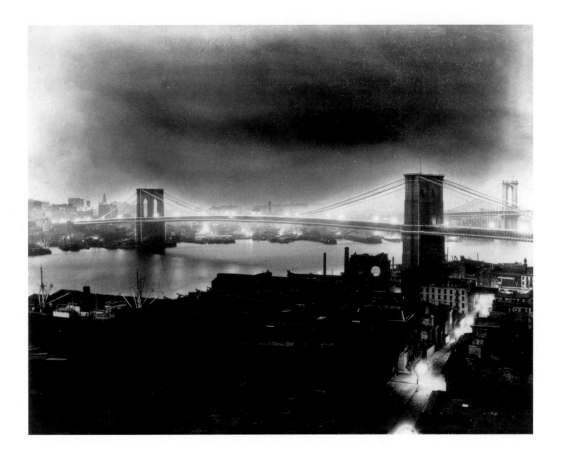

The powerful arc lamps on the Brooklyn Bridge lit up the night sky just before the Broadway Theater District began blazing with street and marquee lights. The illumination from the bridge was so powerful, social reformer Helen Campbell recalled visiting a poor tenement family living near the bridge that relied on the bridge lights to see the garments they were making.

"The Electric Light," an 1880 lithograph by Currier & Ives, depicts Thomas Edison standing in New Jersey (where his laboratory was based), touching palms and cigars with Charles Brush in New York. Edison and Brush were pioneers in the development of artificial light—Brush with his powerful arc lights and Edison with his softer incandescent bulbs.

offices to function at night and thus lengthened the workday; an entire culture of night shifts and nightlife blossomed. "New York is lavish of light, it is lavish of everything," wrote British writer H. G. Wells in 1906 after a trip to the city. Theaters, restaurants, and clubs glowed around the clock from the Bowery to Columbus Circle.

"The Sleeplessland of New York leads a double life," wrote the *New York Times* on January 8, 1905. "Its laughter, gaiety, and music; its ceaseless rush of pleasure and business never stop. Day and night, for every second of the twenty-four hours, the tide of human life ebbs and flows, with the dinner hour as the dividing line. . . . Shop windows that are dressed to attract the passing throngs at midnight even more alluringly than they are at midday; restaurants that are busiest between the time the theatres close and the milkman starts on his morning rounds; hotels

that employ a larger staff of clerks at night than they do when the sun shines; blazing cafes and barrooms where everybody seems to be spending money—a literal paradise for revelers of all descriptions and nationalities who seem to have forgotten that there is such a thing as sleep or a municipal 'lid.'"

FDNY: From a Volunteer Force to Professional Firefighters

Around the time Andrew Haswell Green was proposing his idea of a modern, consolidated city, New York's fire department was modernizing as well. What began in the Dutch colonial era as four citizen fire wardens and a leather bucket brigade had grown into an all-volunteer organization of hundreds of men. Through the late eighteenth and early nineteenth centuries, these volunteers, often working-class Irish immigrants, established fire companies and houses all around Manhattan. Besides saving lives and property, fire companies acted as social and political clubs and were often a springboard into politics. (Boss Tweed began his career as a volunteer fireman.)

By the middle of the century, firefighting became more sophisticated. With the opening of the Croton Aqueduct, more water was available to battle flames; the buckets had long been dispensed with in favor of hoses, fire hydrants, and hand-drawn engines. Proud of their gear and status, firefighters paraded through the city and developed a strong camaraderie within their companies—but they often fought with other companies and earned

New York's Bravest from Engine Company 72 pose with their motor-powered high-pressure engine truck in the driveway of their East 12th Street station house, about 1910.

reputations as brawlers. "Whether firemen, or volunteers, or political torch-bearers, they are very arbitrary in their march," wrote Charles Dickens in 1861 after a visit to New York. "They allow no omnibus, or van, or barouche, to break their ranks; and I have often seen all the immense traffic of Broadway . . . stand still, be-numbed, while a band of men, enclosed in a square of rope, dragged by a shining brass gun or a brand new gleaming fire-engine."

Their image began to change in 1865, when the Metropolitan Fire Department was established—a response to pleas from residents who felt that the growing city needed a professional force. "The time was when a volunteer fire department was practicable in New York, but that era has long since passed," read an anonymous pamphlet. "When the metropolis was a modest little city, where livery men talked about 'over-driving' if their horses were taken to the Reservoir, in Fortieth Street, and Eighth Street was far out of town; when everybody in the department knew everybody else, and the decent virtues of our ancestors had not been supplanted by the crimes of rascality, and corruption, that now seem to be all-pervading, the voluntary system worked admirably." Like the Metropolitan

A member of the FDNY turns on high-pressure hoses at one of the city's 834 fire hydrants in 1908.

Police Department of the late 1850s, the Metropolitan Fire Department was a salaried, professional force working in New York City yet controlled by New York State. And as with the police, this arrangement didn't last long. With the passing of the Tweed Charter in 1870, the Democratic-controlled city took over its own fire department. The letters MFD were replaced with FDNY on equipment and gear. Telegraph wires connected stations to alarm boxes on streets, eight hundred of which were installed by 1892, according to *King's Handbook of New York.*

Brooklyn and Long Island City, Queens, had their own paid professional firefighters. After the city consolidated in 1898, the three forces, along with volunteer departments from Staten Island and other parts of Queens, were combined into one unit of more than four thousand men. Horse-drawn engines were replaced by motor vehicles by about 1911, but real change didn't come to the department until two fires devastated the city: the Triangle Shirtwaist Company fire in 1911 and the burning of the "fire-proof" Equitable Building, an early downtown skyscraper, in 1912. The FDNY was now tasked not just with firefighting but with fire preventing—inspecting buildings, enforcing fire safety codes, and building high-pressure pumping stations so water could reach the upper floors of the new high-rises.

Steel Towers Reach Toward the Sky

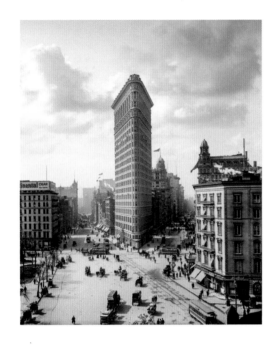

In 1906, H. G. Wells chronicled his recent first trip to New York. Coming into New York Harbor, he wrote, he was awed by the gravity-defying buildings of Lower Manhattan. "Against the broad and level gray contours of Liverpool one found the ocean liner portentously tall, but here one steams into the middle of a town that dwarfs the ocean liner," recalled Wells. "The sky-scrapers that are the New-Yorker's perpetual boast and pride rise up to greet one as one comes through the Narrows into the Upper Bay, stand out, in a clustering group of tall irregular crenellations, the strangest crown that ever a city wore."

Wells likely caught a glimpse of the twenty-story Broad Exchange Building, completed in 1901, and the domed, twenty-story New York World Building, opened in 1890 on Park Row, one of many newspaper headquarters that reached to the clouds. He may have seen the 1895 American Tract Society

Building at Nassau and Spruce streets, with its winged caryatids on the upper corners, and across from Trinity Church, the U-shaped, eighteen-story Manhattan Life Insurance Building: After it opened in 1894, it was the tallest in the world for seven months. Just fourteen years later, the Singer Tower would stand tall at a dizzying, incomprehensible forty-one stories.

The skyscraper era had arrived, and these towering edifices owed their existence to an engineering breakthrough. Walls of brick and masonry had to be extremely thick to support several stories, leaving little room for office space. A steel skeleton, however, was just as strong but much thinner. With steel prices falling in the 1880s and the demand for office space soaring, developers turned to steel, which had other advantages: It was fireproof and could withstand wind. New

"I found myself agape, admiring a skyscraper—the prow of the Flatiron Building, to be particular, ploughing up through the traffic of Broadway and Fifth Avenue in the afternoon light," wrote H. G. Wells in 1906 after a trip to New York. Completed in 1902 and overlooking a less glamorous Madison Square than that of a generation earlier, the Flatiron wasn't New York's tallest building, but its loveliness made it an icon of the Gilded Age city.

The Singer Tower, seen here under construction, would loom forty-one floors above Liberty Street and Broadway; it was the tallest building in the world for just one year after it opened in 1908.

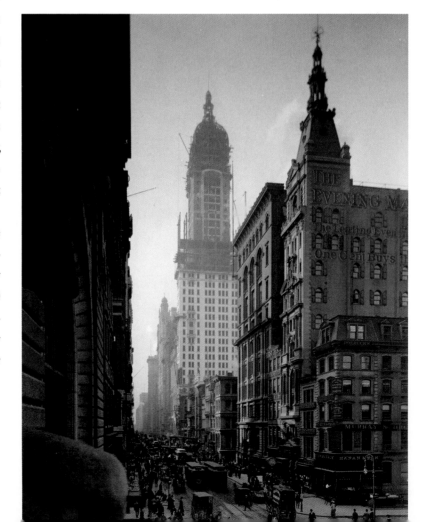

Newspaper Row was home to some of the tallest buildings in New York. Left to right: New York World Building (1890); New-York Tribune Building (1875); New York Times Building (1889). The white building behind the New York Times Building is the twenty-story American Tract Society Building (1895).

The Woolworth Building, at Broadway opposite City Hall Park. This "cathedral of commerce," as it was called when it was completed in 1913, towered fifty-seven stories over Lower Manhattan. At the building's opening ceremony, President Woodrow Wilson pushed a button from inside the White House and eighty thousand brilliant lights immediately illuminated the building.

Yorkers witnessed this firsthand in 1889 as the slender Tower Building was going up at 50 Broadway. Workers had almost completed the thirteen-story building when an 80-mile-per-hour wind suddenly roared through Lower Manhattan. Startled crowds watched, expecting this early example of a steel-frame building to topple. It didn't budge.

New York was seized by skyscraper fever. During construction of the wedge-shaped Flatiron Building in 1902—as its skeleton slowly crept higher at the busy junction of Broadway, Fifth Avenue, and 23rd Street—crowds regularly watched while standing in front of the Fifth Avenue Hotel across the street. "The peculiar office structure appears to exercise a strange fascination over some minds, for not only do hundreds of people stand for five and ten minutes at a time looking up at it, but many of those who have detached themselves from the groups are obliged to return in a minute or two to examine the structure from another point of view," wrote the *New York Times*. In 1909, the Metropolitan Life tower stood like a slender sentry across the way from the Flatiron on Madison Avenue and 24th Street. The 1913 completion of the Woolworth Building on Lower Broadway opposite City Hall made it the tallest skyscraper in the city—a neck-cramping fifty-seven stories.

Of course, not everyone agreed that the mania for tall buildings improved the Metropolis. Upon his return from Europe just after the turn of the century, author Henry James—bewildered by the changes to the smaller-scale city he was accustomed to, having spent part of his childhood a block from Washington Square—wrote that the "multitudinous skyscrapers" appeared to look like "extravagant pins in a cushion already overplanted, and stuck in as in the dark, anywhere and anyhow."

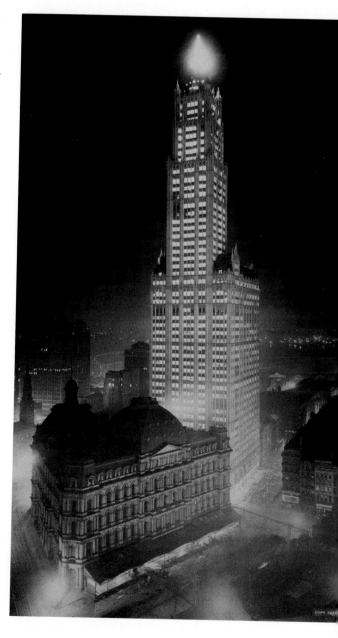

The Rise of the Model Tenement Movement

From the time "tenant houses" first became the default type of residence for New York's poor in the mid-nineteenth century, reformers had tried to design these substandard, unsanitary buildings healthier and safer for the people who made their homes inside them. The Tenement House acts of 1867, 1879, and 1901 were steps in the right direction, mandating outside-facing windows for ventilation and light, and requiring running water in all apartments. But some progressive-minded New Yorkers with deep pockets felt that the best way to reform housing was to get rid of the tenements altogether in favor of better-designed dwellings. This model tenement movement spanned the Gilded Age and produced some novel buildings.

THE WORKINGMEN'S COTTAGES OF ALFRED TREDWAY WHITE

After visiting London and observing how city officials there housed the poor, Brooklyn philanthropist and social reformer Alfred Tredway White funded the construction of a series of apartment houses in South Brooklyn (today's Cobble Hill). The Home Buildings, Tower Buildings, Workingmen's Cottages, and Riverside Houses were completed between 1878 and 1890 and offered features such as outside staircases, a toilet in each apartment, and recessed balconies. Jacob Riis praised White's buildings, saying that they were "like a big village of contented people, who live in peace with one another because they have elbow-room."

CHARLES PRATT'S ASTRAL APARTMENTS

Pratt, an industrialist and philanthropist living in Brooklyn, was inspired by White to build innovative apartments in 1886 for the families of the men who worked for him in his Greenpoint oil refinery. Kitchens were equipped with coal boxes as well as sinks that had hot and cold running water; each apartment had a

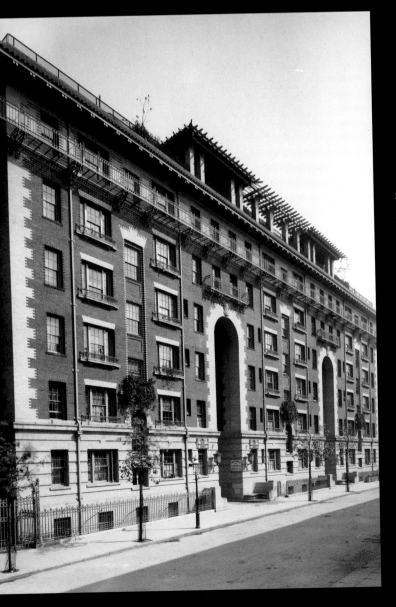

Steel baron Henry K. Phipps established a fund to build model tenements in the city. The first Phipps Houses opened in 1906 on East 31st Street (seen here). They were more expensive than the typical three-room tenement—$14 a month versus the $10 a month tenement dwellers paid for equal-size living quarters. But each Phipps apartment had its own bathroom, a courtyard for ventilation instead of an airshaft or alley, and entrances that doubled as social centers. "That they are in no wise looked upon as a charity is apparent, since [tenants] pay four per cent on the investment of one million dollars, which Mr. Henry K. Phipps . . . donated for the purpose," commented one magazine in 1908.

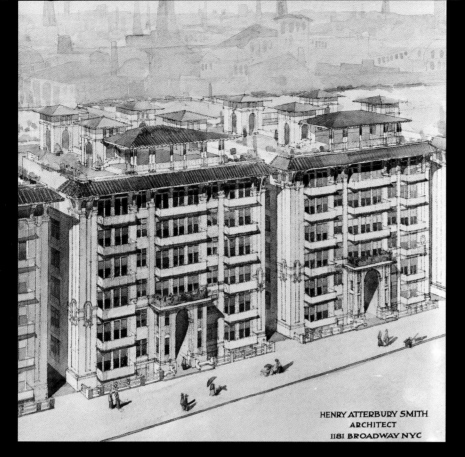

HENRY ATTERBURY SMITH
ARCHITECT
1181 BROADWAY NYC

In the early 1900s, Dr. Henry L. Shively was the head of the tuberculosis clinic at Presbyterian Hospital. He believed that more sanitary living conditions would improve a tuberculosis patient's odds of survival. The doctor, in partnership with the philanthropist Mrs. William K. Vanderbilt, constructed apartments on East 78th Street and Cherokee Place beside the East River. The spacious dwellings offered lots of light and cross-ventilation, and they were designed to be easy to disinfect and clean. The apartments were intended for families with one or more members suffering from the incurable disease.

THE SHIVELY SANITARY APARTMENTS

Tuberculosis was the city's second-biggest killer in the early twentieth century, and the white plague, as it was called, was especially endemic in New York's tenement districts. A stretch of Lower Manhattan on Cherry Street and another in central Harlem were labeled "lung blocks" because of all the residents living there who had contracted the illness. The Shively Sanitary Apartments (also called the East River Homes), on 77th Street and Cherokee Place near the East River, were designed in 1910 to offer the maximum amount of sunshine and ventilation to help combat the spread of the disease. Open staircases, accessible roofs, and windows arranged for better ventilation were some of the complex's features, designed by physician Dr. Henry Shively and funded by Anna Vanderbilt, the second wife of W. K. Vanderbilt.

dumbwaiter and a chute to the cellar for the disposal of ashes. Bathtubs were located in building basements, and windows on the staircases could be removed in the summer so that residents could catch cool breezes.

THE PHIPPS HOUSES

Henry Phipps was a steel magnate who devoted his fortune to building decent housing for the city's poor. "I shall like the buildings to have all the light and air possible; to have them fire-proof and thoroughly sanitary, and so far as possible, to have spaces around them in which the children could play," Phipps told the *New York Times* in 1905. The first Phipps model tenement went up two years later on East 31st Street. About 150 apartments

housed eight hundred residents, who enjoyed steam heat, hot water, laundry facilities, tubs for bathing, and outside-facing windows. By 1912 two more Phipps buildings had been built, both in the San Juan Hill neighborhood.

THE MONROE MODEL TENEMENT

The six-story Monroe, built in 1879 and the first model tenement in Manhattan, had forty apartments, with outside-facing windows, washrooms, ash chutes, tubs, sinks, and fireproof balconies and stairwells. Monroe Street was a waterfront block in the squalid, gang-infested tenement district of Cherry and Water Streets. The demand for apartments in the building far exceeded the number of flats.

The City Stretches from River to River

New York was reaching for the sky—and extending to every corner of Manhattan. The West End, west of Central Park, was one of the last areas on Manhattan Island to be urbanized. Elegant town houses and fashionable flats went up on wide new avenues throughout the 1890s. While Columbus and Amsterdam avenues carried elevated trains, stately Riverside Drive briefly rivaled Fifth Avenue in its number of opulent Gilded Age mansions. A generation earlier, the West End had been dotted with small villages and leftover estates along its meandering, colonial-era thoroughfare, Bloomingdale Road. In the 1890s, Bloomingdale Road was graded, paved, and renamed the Boulevard, then absorbed into Broadway.

The small villages—Harsenville around West 70th Street, Stryker's Bay in the West 80s, and Bloomingdale in the West 90s—quietly vanished as magnificent luxury residences such as the Ansonia, the Apthorp, and the Belnord took their place. Morningside Heights, a new district between the West End and Harlem that boasted a new neighborhood park designed by Frederick Law Olmsted and Calvert Vaux, earned the nickname "New York's Acropolis" after Columbia University relocated there

in the 1890s. A woman's college, Barnard, that was connected to Columbia moved to Morningside Heights as well. Barnard built a separate campus to meet the demands of the new breed of independent-minded young women who sought a college education just like their brothers and beaus.

Developers also carved up the former villages and farms of Harlem. With elevated trains established on several avenues, brownstones and flats intended for a middle class went up at a rapid clip. No longer a sleepy rural outpost, Harlem had its own shops and entertainments. There was even an opera house, built by Oscar Hammerstein on 125th Street in 1889, that featured performers such as Lillian Russell and Edwin Booth. Harlem was no Rialto, of course; it offered a slower, less expensive urban lifestyle with more breathing room than Manhattan. But the broad new neighborhood stretching river to river became something of a joke to city dwellers who craved the growing Bohemian sensibility of Greenwich Village, the intimacy of Gramercy Park, or the exclusivity of Fifth Avenue or the West End.

"[T]he chief charm of old Harlem—its well-bred seclusion—was destined to be

The Harlem River, seen here in 1902, separated Harlem in Manhattan from the Bronx. With industry along the river growing rapidly and the population of the Bronx set to surge in the early years of the new century, short iron swing bridges were built over the water to link the two boroughs.

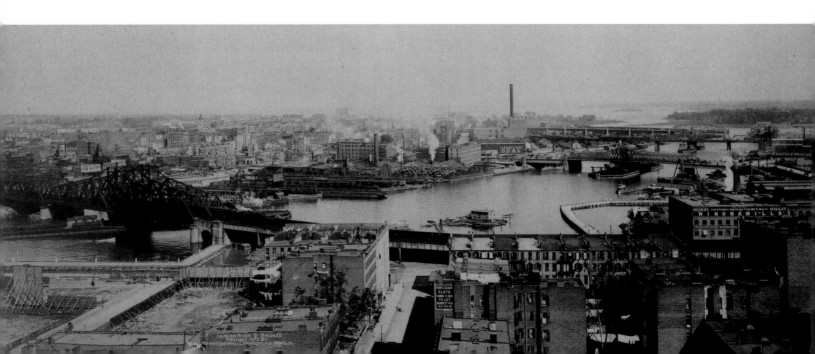

transitory," wrote *Harper's Weekly*. "Later, when New York's business centre moved steadily up-town, greatly increasing the value of real estate and the cost of living, a horde of New-Yorkers moved to the north, and Harlem soon became a haven for the clerks and small merchants, the family man and the newly married couple and the young professional man, who all flocked thither." The cookie-cutter apartments were nothing to be proud of, explained *Harper's*. The Harlem flat was "a frail, angular, overelaborated structure, which at the advent of spring occasionally showed strange crevices on its sides, preparatory to descending in a cataract of bricks."

Looking down on the middle-class denizens of Harlem wouldn't continue much longer, however. The district was in store for economic and demographic shifts that would transform it once more. In the early 1900s, an oversupply of new housing sent rents spiraling downward. The cheaper rents attracted immigrant Jews and Italians, as well as Irish and Finns. They also appealed to African Americans. Black New Yorkers had always lived in Harlem, particularly on West 130th Street. (They were also routinely charged more in rent, according to Jacob Riis's *How the Other Half Lives*.) But after the real estate downturn, their numbers increased significantly. Between 1910 and 1920, New York's black population rose 66 percent due to the Great Migration from the South. Many of these new arrivals settled in Harlem, as did African Americans who had previously lived in the Tenderloin, Greenwich Village, or San Juan Hill in the West 60s. While some immigrants stayed as the face of Harlem shifted, white middle-class residents began moving out.

New York in 1890 had 1.5 million residents, but Manhattan was bursting at the seams. In 1895, the city annexed the eastern part of the Bronx from Westchester County; it had already acquired the towns in the western and southern sections in 1874. Brooklyn's wide swatches of farmland south of Prospect Park—once located in independent Kings County towns but since 1894 annexed to the city of Brooklyn—were becoming spacious suburban neighborhoods of single-family homes. New housing in Staten Island and Queens was turning these once-sleepy communities into suburbs.

With the growth of new rail lines extending into New Jersey, Westchester, and Long Island's Nassau County (which split off from Queens County in 1898), it was now possible to make it into Manhattan from one of these areas in less than an hour. What were once isolated local towns were fast becoming desirable commuter suburbs that offered "country homes near the city," as the *New York Times* put it in 1890. Yonkers and Bronxville, Hackensack, Teaneck, the Oranges, and Great Neck became sought-after towns for commuters who worked in the city but didn't want to live there—or couldn't afford to.

New York's disappearing village outposts were mourned by old-timers. "Nowhere on the whole northern front of the advancing city is the imminently impending ploughing under of the old by the new accented with such dramatic intensity as in the vicinity of 97th Street and Park Avenue; where a score or more of little houses, surviving from a primitive rural time, stand close under the shadow of the stately armory of the Eighth Regiment and are pressed upon closely by solidly built blocks of handsome dwellings of almost literally the present day," wrote historian Thomas Allibone Janvier in *In Old New York*, published in 1894. These houses, which, Janvier noted, now sat in a hollow created when the streets around them were

brought to grade by the city, were "no more than shanties" and seemed to have no place in the gleaming, mechanical Gotham. "In the meantime these shanties of low degree give a touch of the picturesque to a neighborhood that otherwise—save for the redeeming glory of the armory—would be an ill-made compromise between the unkempt refuse of the country and the dull newness of the advancing town."

Others took a less charitable view; they were glad to see these hardscrabble homes and their occupants go, seeing it as a sign of progress. "Upper Fifth Avenue was a dirt road, and squatters who lived on the offal of the city were the principal dwellers in what is now its most attractive part," wrote the *New York Times* in 1895. "Two bone-burning establishments furnished these filthy scavengers with the means for sustenance. . . . There were nearly 5,000 of

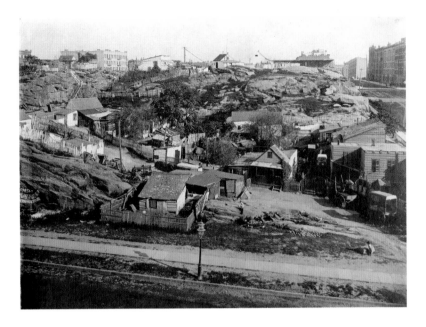

these unclean, disreputable squatters in the territory under consideration. As the city increased its population, these gruesome people were forced further north. And it is only recently that they have been almost completely swept off the island."

A shantytown on Fifth Avenue and 116th Street in 1893, with contemporary tenement buildings constructed along its outer edges.

Getting Around the Modern Metropolis

Horseless carriages," as cars were called, made a mass debut in the city on Decoration Day in 1896, at a race that began at City Hall and ended in Westchester. They came out again in 1899 as part of an automobile parade that wound its way from Fifth Avenue at 34th Street to Claremont, near Grant's Tomb. "Get a horse!" cheeky kids would shout at drivers, mocking what some dubbed "devil wagons" and what seemed like a passing fad for millionaires such as Diamond Jim Brady, who tooled around town in the city's first electric car.

It wasn't a fad. So many automobiles began appearing in New York in the first decade of the new century that the state began licensing drivers. Automobile taxis—so named because of the "taximeters" on their dashboards that tallied the mileage—powered by gas hit the streets by 1900. Easy to spot with their red and green paneling, these taxis charged fifty cents a mile—a rate only affordable to the rich. "But a few short years ago the passer on the Avenue could pride himself on a count of twenty automobiles in his walk from Murray Hill to the Plaza; now he can

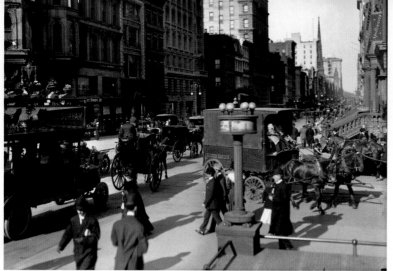

Carriages and wagons pulled by horses still dominate at the busy intersection of Fifth Avenue and 42nd Street in 1910. By 1920, automobiles would take over, necessitating the creation of a traffic control tower in the center of the intersection.

easily number hundreds," wrote the author and critic William Dean Howells in 1910.

Once a novelty, automobiles were quickly replacing horse-drawn carriages as the city's primary vehicle on city streets—which were increasingly paved with hard, smooth, easier-to-clean asphalt rather than granite block or cobblestones, which collected dirt and manure and were less sanitary. "The smoke and smell of the asphalt kettle, the clank and rumble of the huge rollers, and the bustle and the jargon of gangs of pavers are familiar to the residents of nearly every quarter of New-York," wrote the *New York Times* in 1899. "The tenement districts and the fashionable residence streets have been treated with undeviating impartiality, and the beneficial effects of the new pavements have been demonstrated by a marked decrease in the mortality statistics from the tenement localities."

Cars were considered a vast improvement over horses, whose clip-clopping created a con-

Madison Square Garden hosted the first major automobile show in the United States on November 3, 1900. More than forty thousand people attended the weeklong event, which featured cars with electric, steam, and gasoline engines.

stant din. William Dean Howells complained that hearing "the sharp clatter of the horses' iron shoes" against the pavement tormented him. Automobiles were more hygienic than horses; the typical street previously contained piles of manure. No wonder electric-powered streetcars were so popular when they appeared in the 1890s, despite the fact that they were powered by unsightly overhead cables. The new motorized buses that replaced horse-drawn omnibus lines in 1905 were also heralded as cleaner, healthier, and more modern.

Yet no mode of transportation revolutionized New York like the subway. Underground mass transit had been tried before in Manhattan in 1870, when Alfred Ely Beach dug a 312-foot tunnel under Broadway from Warren to Murray streets for his pneumatic subway, powered by an enormous fan. The city's Tammany Hall–backed mayor wouldn't approve funding, however, and Beach's subway was abandoned. But with the Blizzard of 1888 paralyzing the city for days, officials realized that a subway was a necessity. A public referendum in 1894 opened the way toward funding, and soon planning began.

The financier August Belmont headed the newly formed Interborough Rapid Transit Company, which took charge of the first leg of the system. Ground was broken in March 1900 at City Hall, where the first station would be a grand starting point for a line stretching up the East Side and West Side into the Bronx and extending downtown and into Brooklyn. For four years workers excavated tunnels, blasted rock with dynamite, and laid down track. After finishing the City Hall station, the "sandhogs" progressed north, building stations every five blocks or so. This was perilous work, and sixteen men died doing it.

Long Island Motor Parkway

The starting line at the Vanderbilt Cup race on William K. Vanderbilt II's Long Island Motor Parkway in 1914.

William Kissam Vanderbilt II loved speed. The twenty-six-year-old Harvard dropout and great-grandson of railroad titan Cornelius Vanderbilt (and son of Alva Vanderbilt Belmont) was a pioneering auto racing enthusiast in the early days of the sport, when cars could cost up to $3,000 and racing them was a hobby reserved for rich men.

In 1904, he launched the Vanderbilt Cup, a race held on public roads—some paved, others not—on Long Island, where Vanderbilt had a country estate. It was a huge success, with American drivers going up against English, French, and Germans. (An American won.) The Cup proved to be so popular that more than 250,000 spectators crowded the narrow roads to get a closer view of the drivers—and in 1906, one spectator was killed.

After the fatality, public officials barred Vanderbilt from holding the race again, until he proposed the idea of building a private road strictly for automobiles. Forbidden to police and without speed limits, the road would stretch from Flushing, Queens, to the central Long Island town of Ronkonkoma and also serve as part of the racetrack for the Vanderbilt Cup. He got the go-ahead, and in October 1908, enough of the Long Island Motor Parkway had been built for Vanderbilt to resume holding his namesake race. Overpasses and bridges were built in place of intersections, and viewers were herded into grandstands.

Auto racing grew in popularity (even if most New Yorkers still couldn't afford to buy a car), and the Vanderbilt Cup continued to thrill audiences. But the road itself was marred by setbacks. Only a portion of the planned road was ever completed. The private road soon was open to anyone who paid a $2 toll, a price that kept many of the increasing number of regular drivers from using it when races weren't being held. There were at least two deaths during the 1910 Vanderbilt Cup, which effectively ended races on that highway. Vanderbilt paid for much of the road out of his own pocket, and by 1937, owing back taxes, he offered it to the state, which carved it up into new public highways and bike paths, some of which still exist in Queens today.

Brooklyn workers pave a street with hot asphalt. Before city streets were smoothed over with hot asphalt, roadways were made of granite, cobblestone, dirt, gravel, wood, and mud. Asphalt was seen as much more sanitary and easier on carriages and wagons.

A gruesome accident involving two automobiles in Manhattan in 1900. The introduction of motor vehicles to the city drove up accident rates. "Automobile death harvest doubled in three years," read a headline in the *New York Times*. In 1910, 112 New Yorkers were killed by automobiles, wrote the *Times*. By 1912, the number of fatalities had surged to 221. "In other words while there were last year fewer people killed in the streets by street cars and wagons than there were three years ago, there were very nearly twice as many killed by motor vehicles."

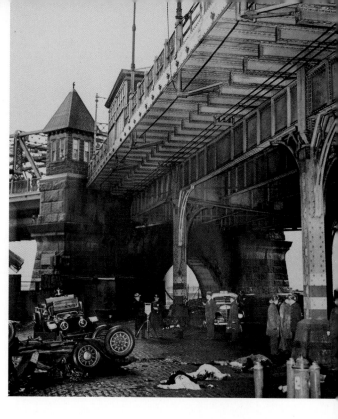

"Morning and night the hordes of clerks and stenographers and business men who fill the offices of down-town New York have poured across Newspaper Row and City Hall Park with scarcely a glance at the labor progressing underfoot that is going to bring them so many minutes nearer their work in the morning, and at night so many minutes nearer their play," stated a 1902 article in *The Century*, which questioned what effect the new subway would have on the city.

The answer would begin to emerge on October 27, 1904, the day the first 9 miles of track out of a planned 700 opened. This was a triumphant moment for the metropolis: At 2:00 P.M., factory whistles blew in celebration. "From the Battery to Harlem, at the same time, the tugs, ferry boats, and steamships

on the two riverfronts were blowing their greeting, vying with the steam whistle of hundreds of power plants, the chiming of church bells, and the cheering of the citizens," wrote the *New York Times* the next day. "The city was in an uproar from end to end as general manager Hedley opened the kiosk door and descended the steps to the station platform where the first train of eight cars stood waiting."

After a ceremony, Mayor George McClellan took the controls and drove the subway from City Hall's beautifully tiled and

Building the first subway at Fourth Avenue at Union Square, June 8, 1901. Subway workers used the "cut and cover" method, which involved cutting a deep trench and then building a temporary roadway over the excavation site.

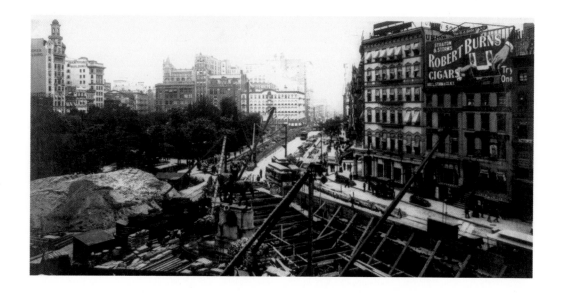

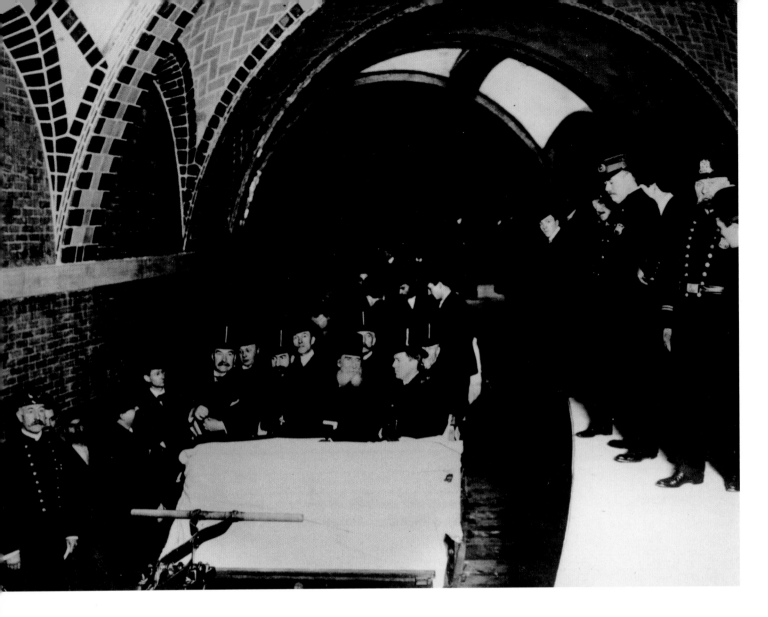

chandeliered Beaux-Arts station to 42nd Street. There, the tracks crossed west to Broadway and continued up the west side to 145th Street in Harlem. Trains ran back and forth all day on the local track. An estimated 150,000 New Yorkers squeezed onto the crowded, newly opened platforms and caught their first rides. "New-York played with its new toy, the subway, last night, with characteristic energy and spirit, and found it as much fun as going to the show, seeing the Bowery or 'doing' Chinatown," wrote the *New-York Tribune* on October 28, 1904. "Most of the superlative adjectives in the dictionary were applied to the subway by women passengers, but the most popular verdict was 'simply perfectly grand!'"

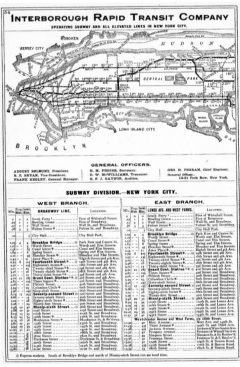

Mayor George McClellan (seated on the far right) and other city officials take a tour of the City Hall subway station as construction nears completion on January 1, 1904. City Hall, with its arched ceilings and colored tiles, was the crown jewel station of the new system, which would open with great fanfare on October 27 of that year.

The Interborough Rapid Transit Company map from 1906 shows elevated train and subway routes crisscrossing under and over Manhattan.

Gotham Comes Together

It requires no spirit of prophecy to foretell the union of [New York and Brooklyn] at no distant day," said former Brooklyn mayor and congressional representative Henry C. Murphy in 1857. Murphy was one of the six men who made up the New York Bridge Company and spearheaded the creation of the Brooklyn Bridge. "The [East] River which divides them will soon cease to be a line of separation, and bestrode by the colossus of commerce, will prove a link which will bind them together."

Murphy may have predicted the consolidation of the two great East River cities. But it was city planner and visionary Andrew Haswell Green who in 1868 first officially proposed combining Manhattan with Brooklyn and other neighboring municipalities into one vast "Imperial City." Green was an esteemed leader who had a hand in the creation of Central Park, the Bronx Zoo, the Public Library, and the Washington Bridge over the Harlem River (in 1888). "Green's Hobby," as his idea was known, initially had a mixed reception. He got the ball rolling in 1874 by annexing three towns from Westchester to New York. But that was just the start. To Green, consolidation was an effort to thwart mismanagement and corruption of the waterfront by so many different municipalities. Support grew slowly, mostly from merchants and anti-graft progressives.

Finally, in 1890, a committee was formed to examine the idea. "Public improvements, such as streets, drains, sewers, parks, facilities for rapid transit, bridges, and other measures for the convenience of densely populated communities, will all be better devised, constructed, and administered under the agencies of a single government," a document

City Hall in 1900, with Tweed Courthouse behind it. Two years earlier, City Hall ceased to serve Manhattan only and now housed administrative offices for the consolidated city.

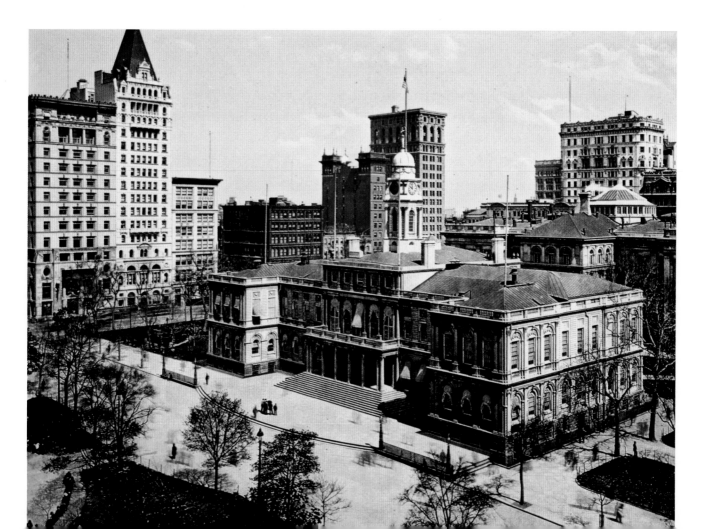

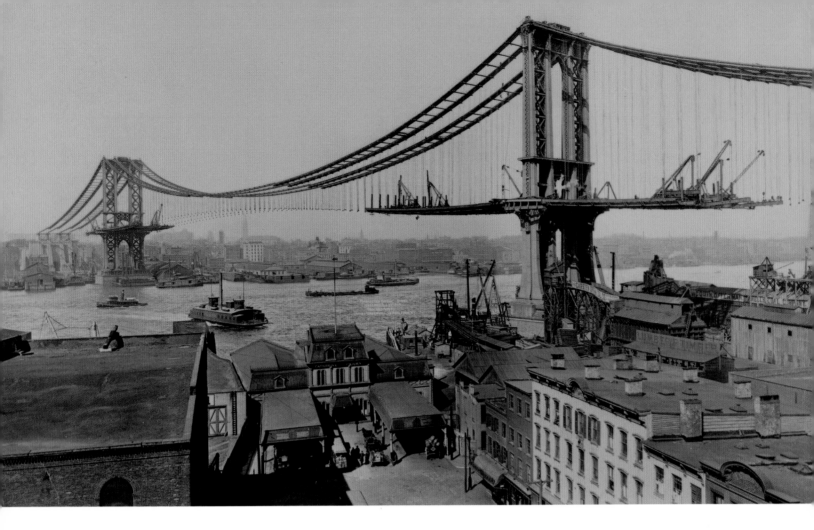

published by the committee stated. "There will be fewer office-holders for the taxpayers to support, administration will be less costly, and fresh impetus given to advantageous development." On the other hand, Manhattanites weren't so keen on picking up Brooklyn's debt. And Brooklyn worried that Manhattan's poorest immigrants would move in, or that taxes would go up. Brooklyn saw consolidation as a threat to its civic pride and prominence as a metropolis in its own right.

While the small towns and villages of Queens and Staten Island supported the idea of a Greater New York, Brooklyn held out. It was the third-largest city in the country, a manufacturing powerhouse that refined sugar, built ships, and made clothes, cigars, and other goods in its many factories. It had lovely neighborhoods, a reputable school district, and its own police, fire, sanitation, and parks departments. Unlike much of Queens and Staten Island, which were just

beginning to transition from rural to suburban, Brooklyn had been an established city for decades, with an independent identity. When debated in newspapers and at political events, consolidation remained wildly upopular with Brooklynites. In November 1894, the *Brooklyn Daily Eagle* asked voters to say no to consolidation, "for now is not the time for it. Brooklyn is a city of homes and churches. New York is a city of Tammany Hall and crime government. Rents are twice as cheap in Brooklyn as in New York. . . . Government here is by public opinion and for the public interest. If tied to New York, Brooklyn would be a Tammany suburb, to be kicked, looted, and bossed as such." The 1894 referendum passed in Brooklyn by about three hundred votes. Green pushed consolidation through legislative channels in 1896 and helped write the charter a year later, to take effect on January 1, 1898.

To celebrate, William Randolph Hearst raised money for a public parade from Union

The Manhattan Bridge, which began construction in 1901, opened in 1909; it was the third bridge to connect Lower Manhattan to Brooklyn. That same year, farther up the East River, the Queensboro Bridge would link Manhattan to Queens.

Square to City Hall on New Year's Eve 1897, complete with floats and marching bands. Too bad not everyone felt so festive, especially across the East River, where consolidation was deemed "the Great Mistake." Manhattan Mayor William Strong, who had rejected the charter, suggested holding a funeral instead. The front page of the *Brooklyn Daily Eagle* on December 31, 1897, featured an image of Brooklyn City Hall with the headline "The Passing of the City of Brooklyn." A short article blamed the state of New York for allowing consolidation to go forward: "In 1896, the State Legislature deprived the one million institutions of Brooklyn of their municipal independence in disregard of the votes of their own representatives," the piece contended.

No matter—with or without the support of every resident of the fifty-six municipalities joining forces, New York would double its population and become a 320-square-mile metropolis. At midnight, a giant new city flag was lit up by blue and white lights at City Hall. A hundred-gun salute and fireworks display in City Hall Park topped off the festivities. The state's new charter uniting the boroughs of New York City commenced. The metropolis was already connected by elevated trains and telephones; it was six years away from being linked by the subway. A majestic bridge across the East River tied together the two twin cities, and by 1910, three more bridges would thread Manhattan to not just Brooklyn but Queens as well. Andrew Green's "Imperial City" was born.

Lower Manhattan as seen from one of the towers of the Brooklyn Bridge, 1910. The Park Row terminal in the center was the last stop on the BMT elevated line. On the left, the magnificent Beaux-Arts Municipal Building is still under construction and not quite at its final forty-story height.

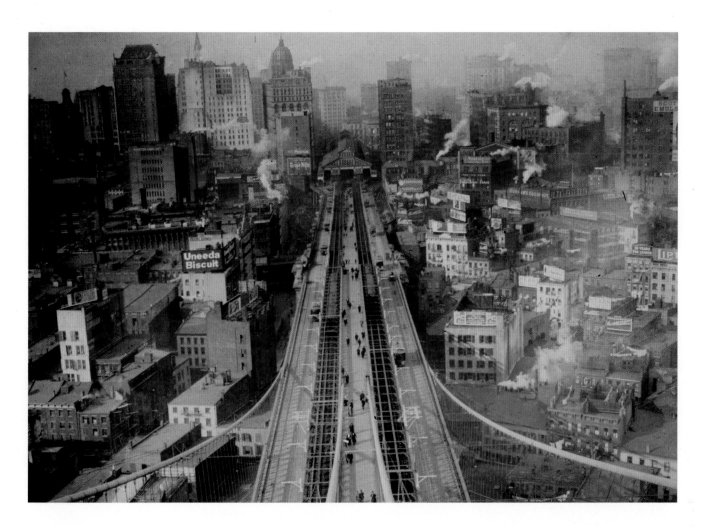

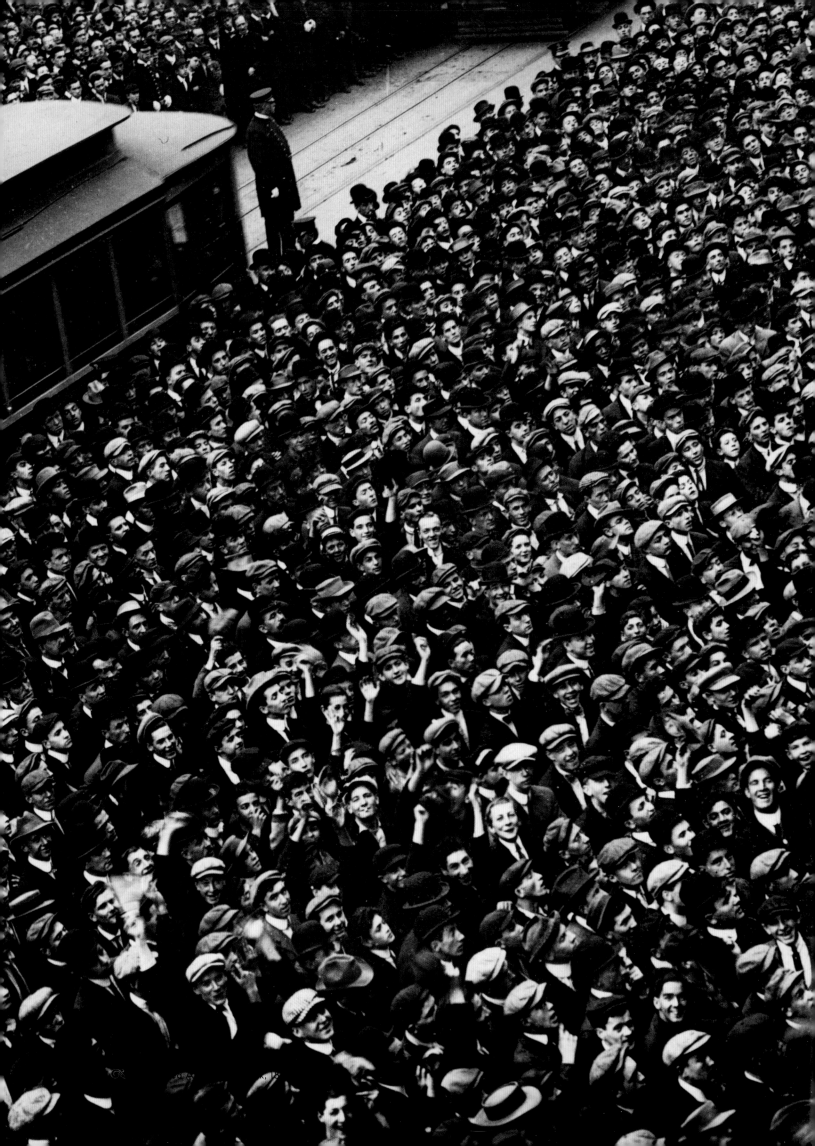

Picture Credits

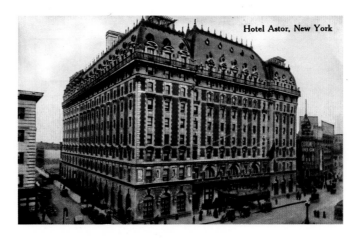

Hotel Astor, New York

Alamy: 6; **Art Resource**: 137; **Corbis**: 38; **Getty Images**: 91, 133, 211, 235, 236, 246, 254, 263, 272, 273, 275, 291, 292, 296-297; **Granger**: 26, 35, 42, 54, 58, 154, 229, 25; **Library of Congress, colorized by Sanna Dullaway**: 2, 11, 33, 231, 247, 274, 282; **Museum of the City of New York**: 58, 61, 66, 70, 71, 72, 74, 78, 83, 86, 90, 103, 104, 109, 122, 166, 168, 169, 170, 171, 193, 197, 200, 203, 208, 214, 217, 221, 252, 262; **Scott Ransom**: 180; **Shutterstock**: 130; **The New-York Historical Society**: 10, 43, 49, 72, 77, 99, 102, 146, 226, 276; **The New York Public Library**: 224, 245; **University of Maryland**: 85, 109, 112, 163, 176, 178, 185, 190

All other images are from the Library of Congress, nineteenth-century books, and other public domain sources.

TEXT CITATIONS:

Naomi R. King travel diary:
New York travel diary, 1899. Manuscripts and Archives Division. The New York Public Library. Astor, Lenox, and Tilden Foundations.

Addison Allen diary:
Courtesy of The New-York Historical Society. BV Allen, Addison - MS 766.

Index

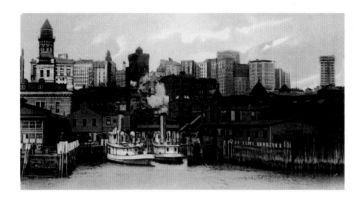

PAGE NUMBERS IN ITALICS REFER
TO PHOTOGRAPHS AND ILLUSTRATIONS.